OVERVIEW

OVERVIEW

A NEW PERSPECTIVE OF EARTH

 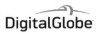

AMPHOTO BOOKS
Berkeley

DigitalGlobe

BENJAMIN GRANT

To my parents

For teaching me the importance
of keeping things in perspective

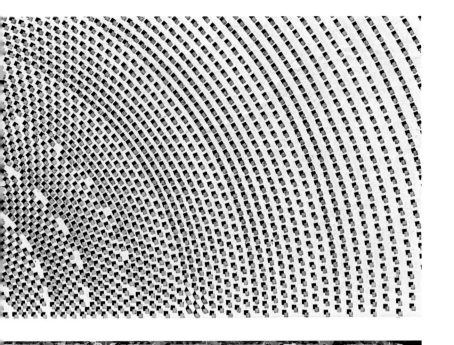

CONTENTS

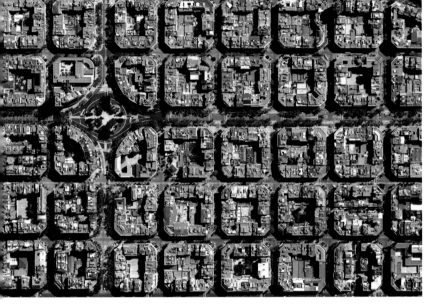

WHERE WE

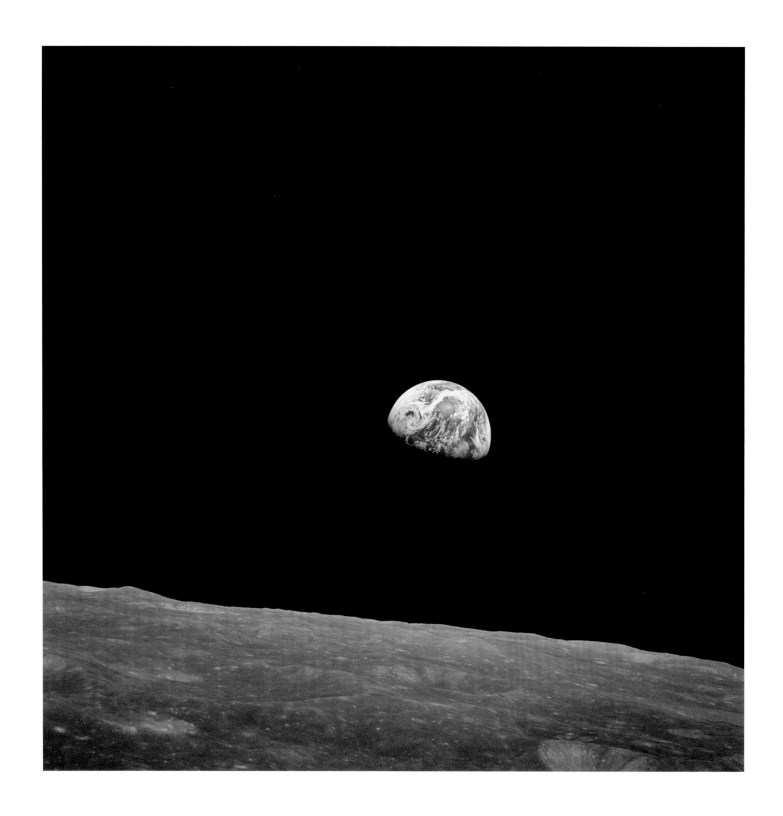

A NEW PERSPECTIVE OF EARTH

It is Christmas Eve, 1968. The Apollo 8 spacecraft is sweeping around the dark side of the Moon to begin its journey home. As Earth climbs above the Moon's horizon, astronaut Bill Anders points his customized Hasselblad 500 EL camera out the window and takes one of the most important photographs of all time—*earthrise*.

"It's ironic," Anders remarked later. "We came to discover the Moon and we actually discovered Earth."

Until now, slightly more than 550 humans have made the journey into space where they could gaze down in wonder at our small blue planet, floating in the infinite vastness of the cosmos. The experience has given them a new perspective, allowing them to appreciate the true extent to which everything on Earth is connected and interdependent. The anecdotes and descriptions provided by these astronauts led science writer Frank White to coin a term for this profound psychological shift. He called it the "Overview Effect."

Cameras, either in the hands of our astronauts or attached to satellites suspended in orbit, show us that which we cannot see from Earth's surface. Recent advances in technology have yielded extraordinarily detailed images of the entire Earth, and this book contains a purposeful selection and composition of such views. By engaging with these far-flung perspectives, we can not only share in the sensation described by astronauts such as Bill Anders, but also discover a new way to appreciate and evaluate the condition of our planet.

EARTHRISE
Photograph by Bill Anders
December 24, 1968
Courtesy of NASA

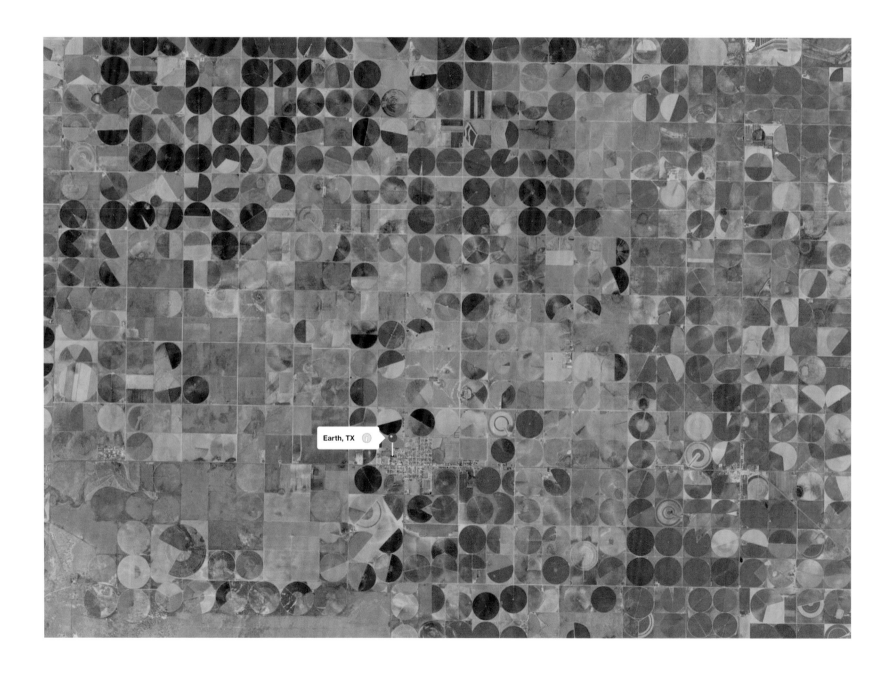

INTRODUCTION

This all began with an accident. I was preparing for a meeting of a space club that I started and since the upcoming talk was focused on satellites and how they affect our daily lives, I was playing around on a mapping program. I typed "Earth" into the search bar to see if it would zoom out to show the entire planet. When I pressed enter, to my surprise, it did the opposite of what I hoped for, and zoomed in.

The map had indeed settled on Earth—Earth, Texas. I was astounded by what I saw. My screen had filled with a stunning patchwork of green and brown circles. I saved the image (seen here on the left) and showed it to my friends; they, too, were amazed. It turns out my entire screen contained pivot irrigation fields, created by sprinklers that water crops in a circular pattern.

THE FIRST OVERVIEW

34.236687°, -102.419596°
Earth, Texas, USA
December 14, 2013

A few months before I discovered Earth in Texas, a friend shared a short film with me called *Overview*. The film introduced me to the idea of the "Overview Effect"—an idea that changed the way I see our planet and its place in the universe. Coined by Frank White in 1987, the "Overview Effect" refers to the profound emotional sensation that astronauts experience when given the opportunity to look down at Earth from space. From a distant vantage point, one has the chance to appreciate our home as a whole, to reflect on its beauty and its fragility all at once.

The anecdotes of the astronauts in the film inspired the map search for "Earth" that fortuitously led me astray a few months later. They also helped me realize that there needs to be a dramatic shift in the way our species views our planet before we can truly understand the full extent of our impact. As inspirational as this idea was, I had no clue how I, or anyone for that matter, could make that shift happen. For me, everything changed once I saw those crop circles.

CIUDAD NEZAHUALCÓYOTL

19.403572°, −99.013351°

Ciudad Nezahualcóyotl, a municipality of Mexico City, Mexico, is characterized by its long, straight, and gridded streets. With a population of more than 1 million people (the entirety of Mexico City contains approximately 9 million residents), the area is home to many of the capital's citizens who have migrated there from other parts of the country.

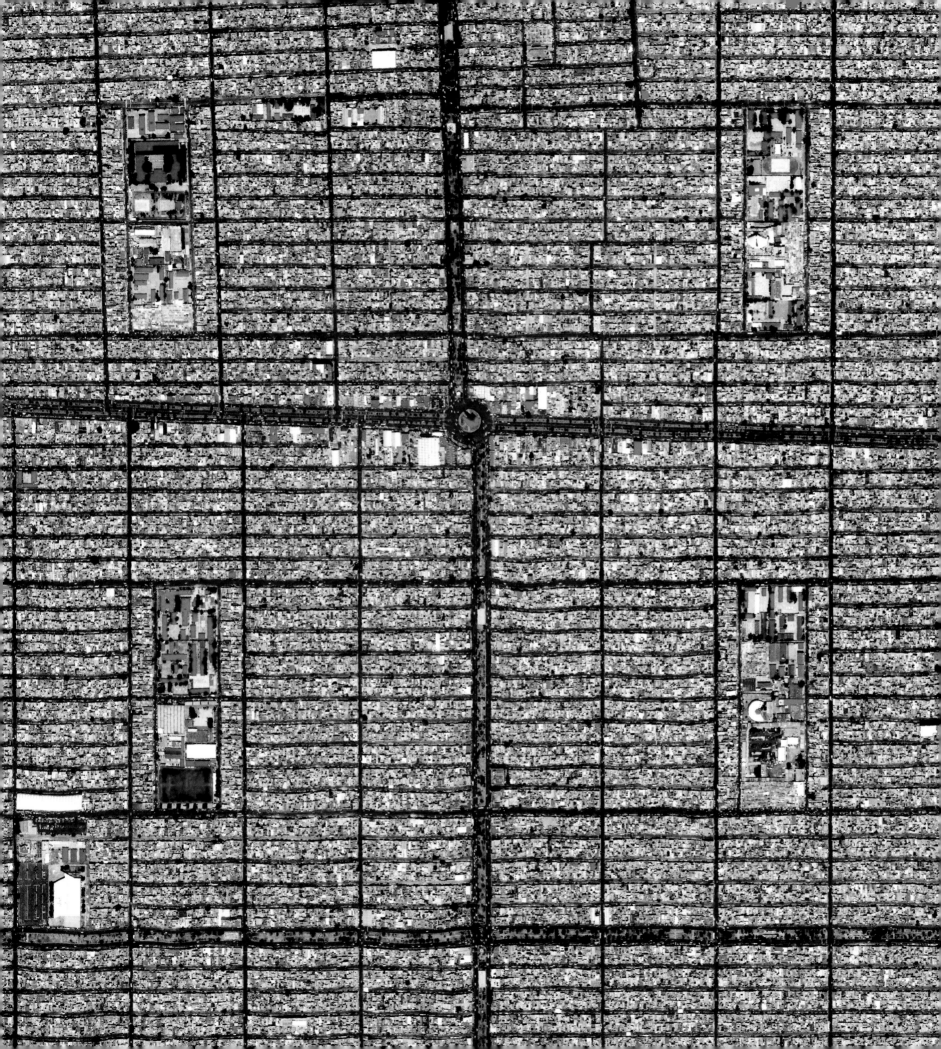

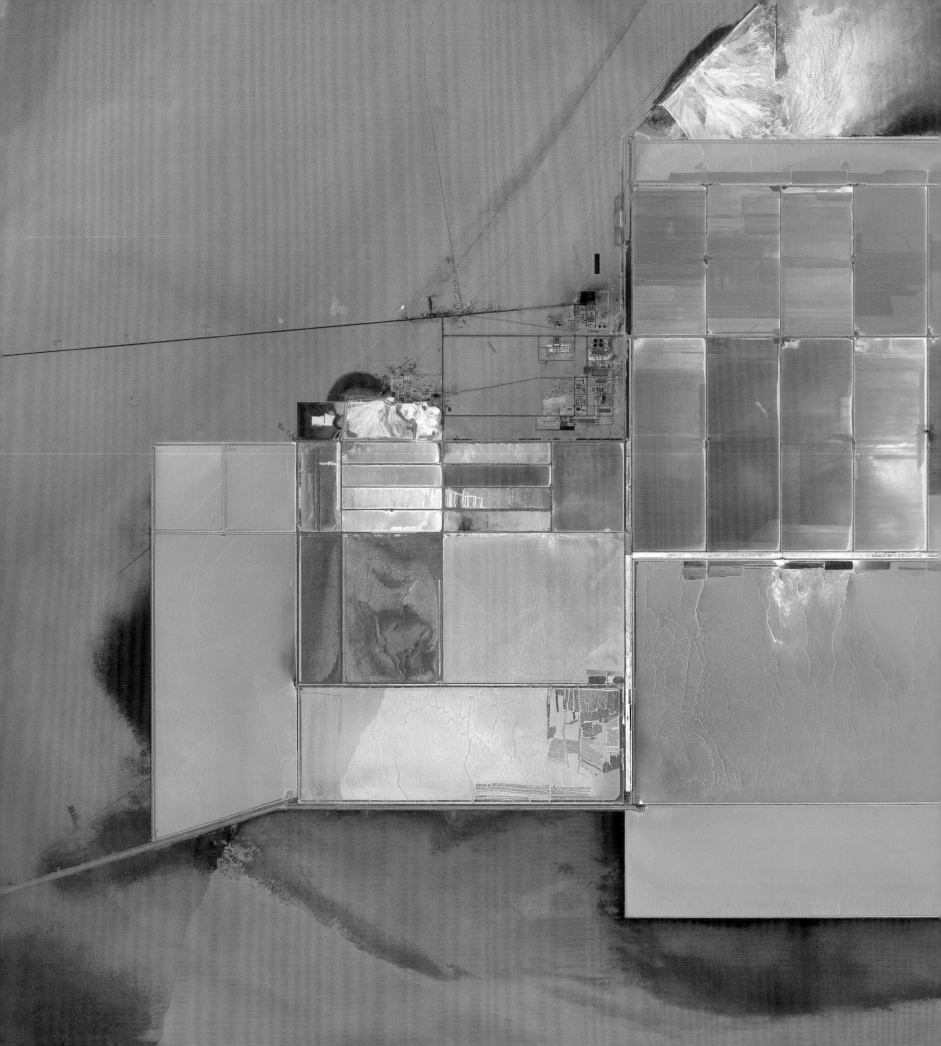

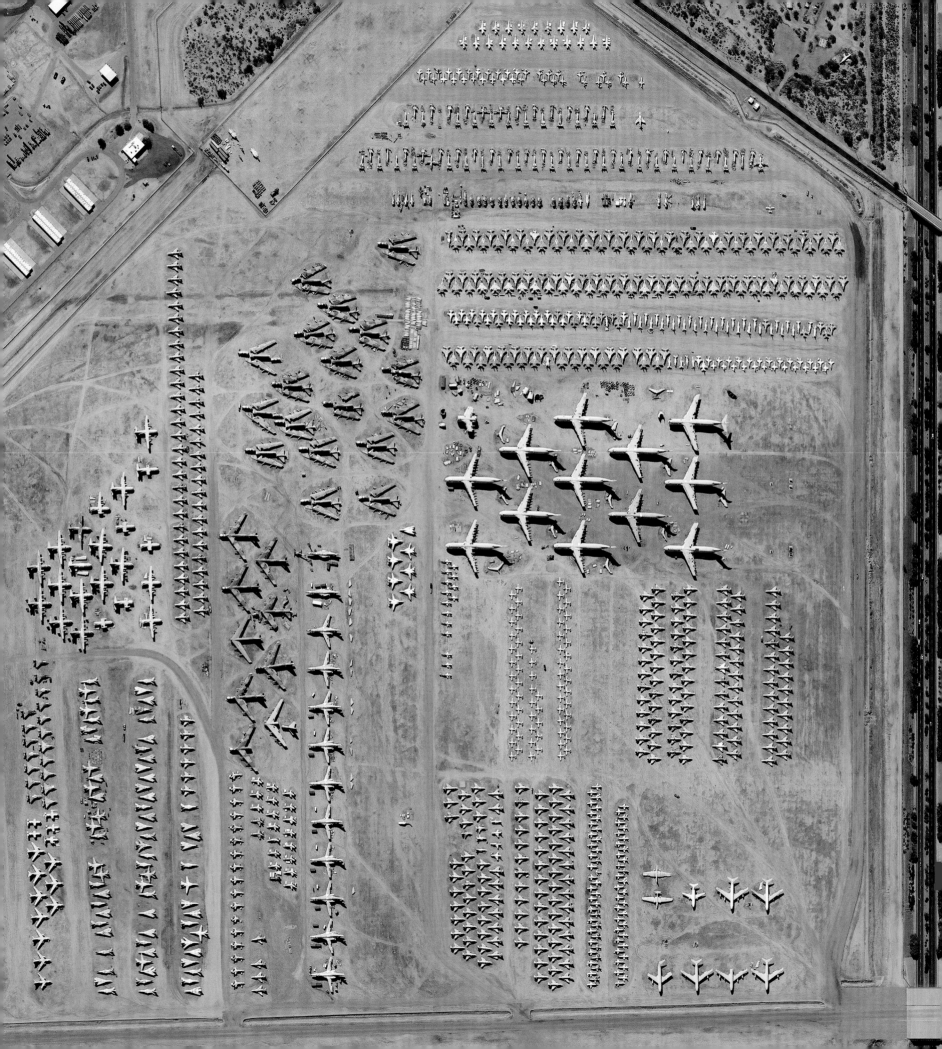

PREVIOUS PAGE

LOP NUR POTASH EVAPORATION PONDS

40.445902°, 90.833588°

The Lop Nur Potash Ponds are located in the Taklimakan Desert of China. The area is a dismal location for agricultural activity, yet the sandy landscape is rich with potash—a form of potassium salt that is a major nutrient for plant growth and a key ingredient in fertilizers. The salts are pumped to the surface from underground brines and dried in massive solar ponds that stretch across the landscape for more than 13 miles (21 kilometers). The bright colors that are seen in this Overview occur because the water is dyed blue, as darker water absorbs more sunlight and heat, thereby reducing the amount of time it takes for the water to evaporate and the potash to crystallize.

LEFT

DAVIS-MONTHAN AIR FORCE BASE AIRCRAFT BONEYARD

32.151087°, −110.826079°

The largest aircraft storage and preservation facility in the world is located at Davis-Monthan Air Force Base in Tucson, Arizona, USA. The boneyard—run by the 309th Airspace Maintenance and Regeneration Group—contains more than 4,400 retired American military and government aircraft.

A few days later, in December 2013, I launched Daily Overview. I have posted a new view from above on the project's website and social media feeds every day since. I am deeply humbled by the enthusiastic and far-reaching reception the project has received, and to date, stories about Daily Overview have been viewed on the web or in print in more than 230 countries. A global community in the hundreds of thousands has gathered to view, contemplate, and discuss the images on a daily basis. To me, the fact that these Overviews have been displayed in magazines and museums—and now in this book—speaks not only to the awe-inspiring vantage point that they offer, but also to the power of the "Overview Effect" in action.

For this book I have created more than 200 Overviews, each consisting of a composed final image that has been made by stitching together numerous satellite photographs. All of the Overviews in this book have been created from DigitalGlobe's 15-year time-lapse image library, containing the world's highest quality satellite imagery. When I first started the project, I decided that all of the images would focus on places of human impact. Accordingly, the first eight chapters are organized by the major themes that arose over the course of the project, categorizing the most visible manifestations of our activity that can be seen from a cosmic perspective ("Where We Are"). The final chapter, however, serves as a contrast to the preceding images and instead focuses on places where our impact is less obvious ("Where We Are Not"). In select chapters I have also created a Juxtapose feature, which uses two Overviews to show how one location has changed over time. Finally, by supplementing every Overview with a concise explanation, I aim to inspire in you the same curiosity about the planet that was ignited in me with each daily installment.

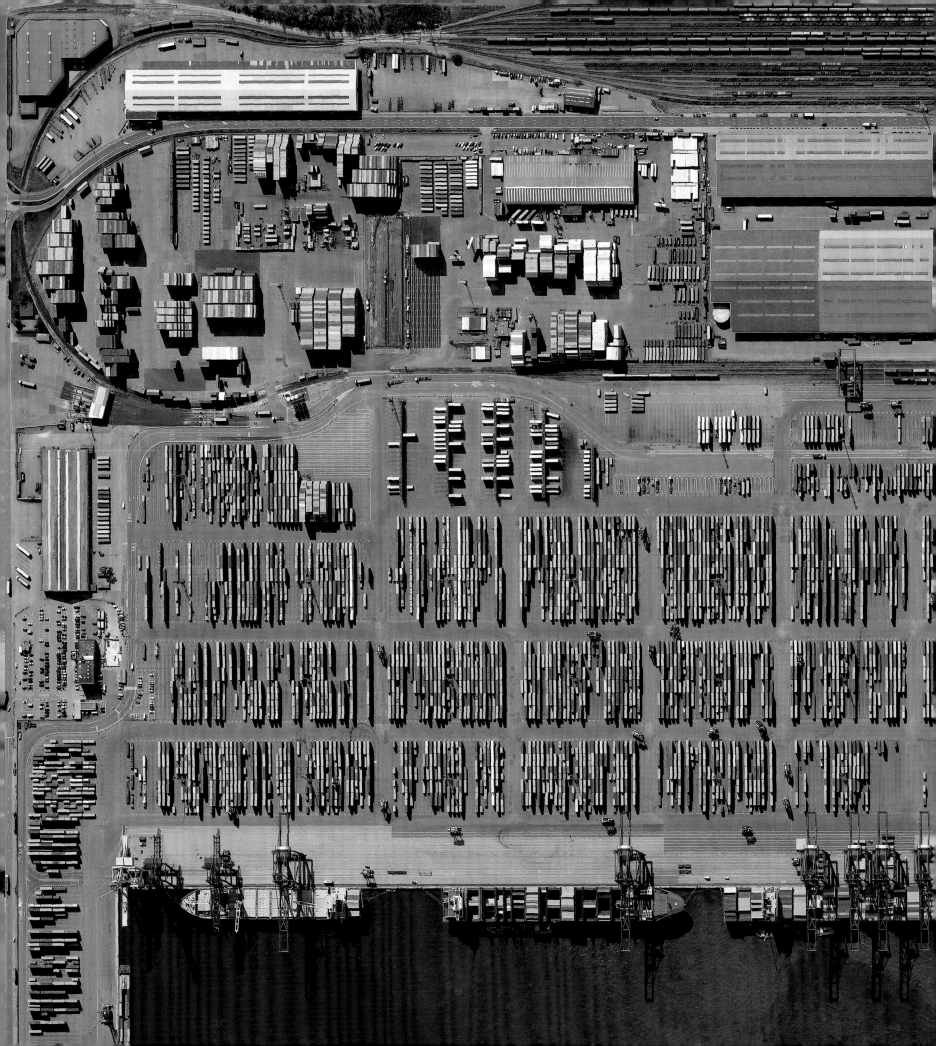

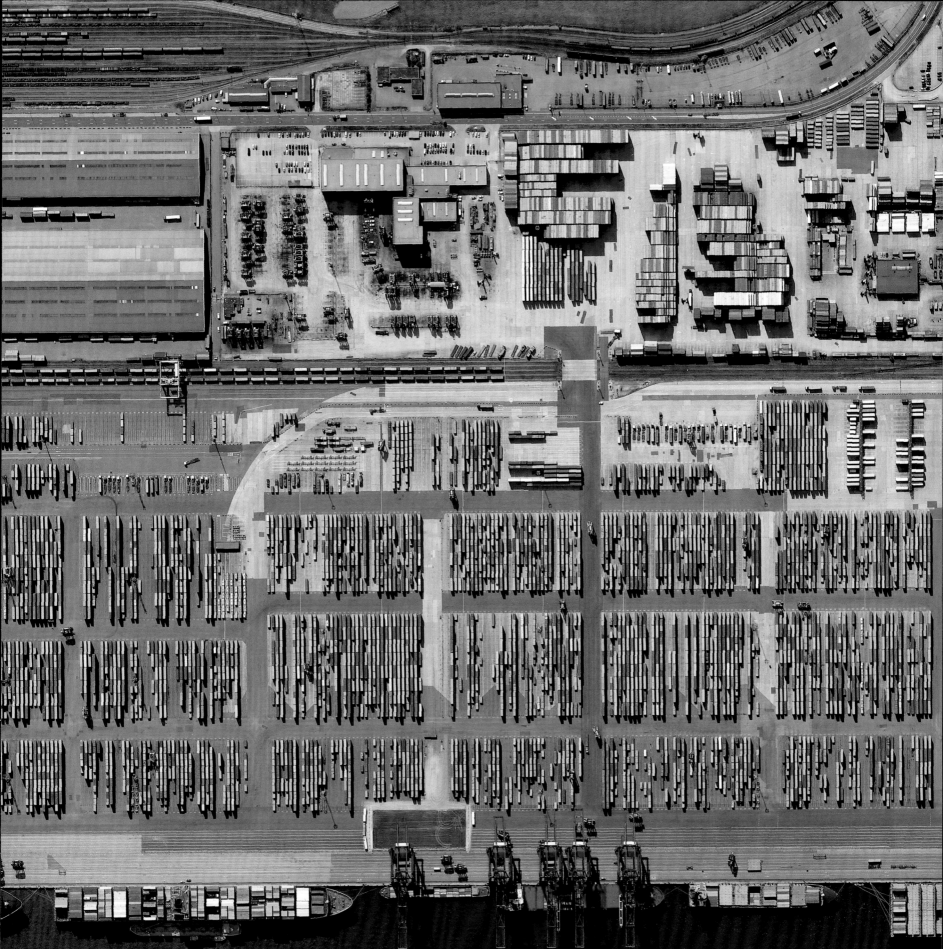

For me, an Overview is most compelling when I show it to people and they excitedly ask, "What is that?" That is an opportunity to go beyond the aesthetics and elevate the Overview to something more than just a beautiful image. When people lean in for a closer look, I can see a desire to increase their awareness of the vastness of our planet and what we are doing to it.

When we are removed from our usual line of sight on the Earth's surface, we can see things differently. We can better understand the intricacy of the things we have constructed, the sheer complexity of the systems we have developed, and the impact that we have had on the planet. We can see our world more completely. If we embrace and learn from this new perspective, I am optimistic that we will create a smarter and safer future for our one and only home.

PREVIOUS PAGE

PORT OF ANTWERP

51.320417°, 4.327546°

The Port of Antwerp in Belgium is the second largest port in Europe, behind the Port of Rotterdam (seen on pages 152–53). Over the course of a year, the port handles more than 71,000 vessels and 314 million tons of cargo. That weight is roughly equal to 68 percent of the mass of all living humans on the planet.

RIGHT

GEMASOLAR THERMOSOLAR PLANT

37.560755°, −5.331908°

This Overview captures the Gemasolar Thermosolar Plant in Seville, Spain. The solar concentrator contains 2,650 heliostat mirrors that focus the sun's thermal energy to heat molten salt flowing through a 460-foot-tall (140-meter) central tower. The molten salt then circulates from the tower to a storage tank, where it is used to produce steam and generate electricity. In total, the facility displaces approximately 30,000 tons of carbon dioxide emissions every year.

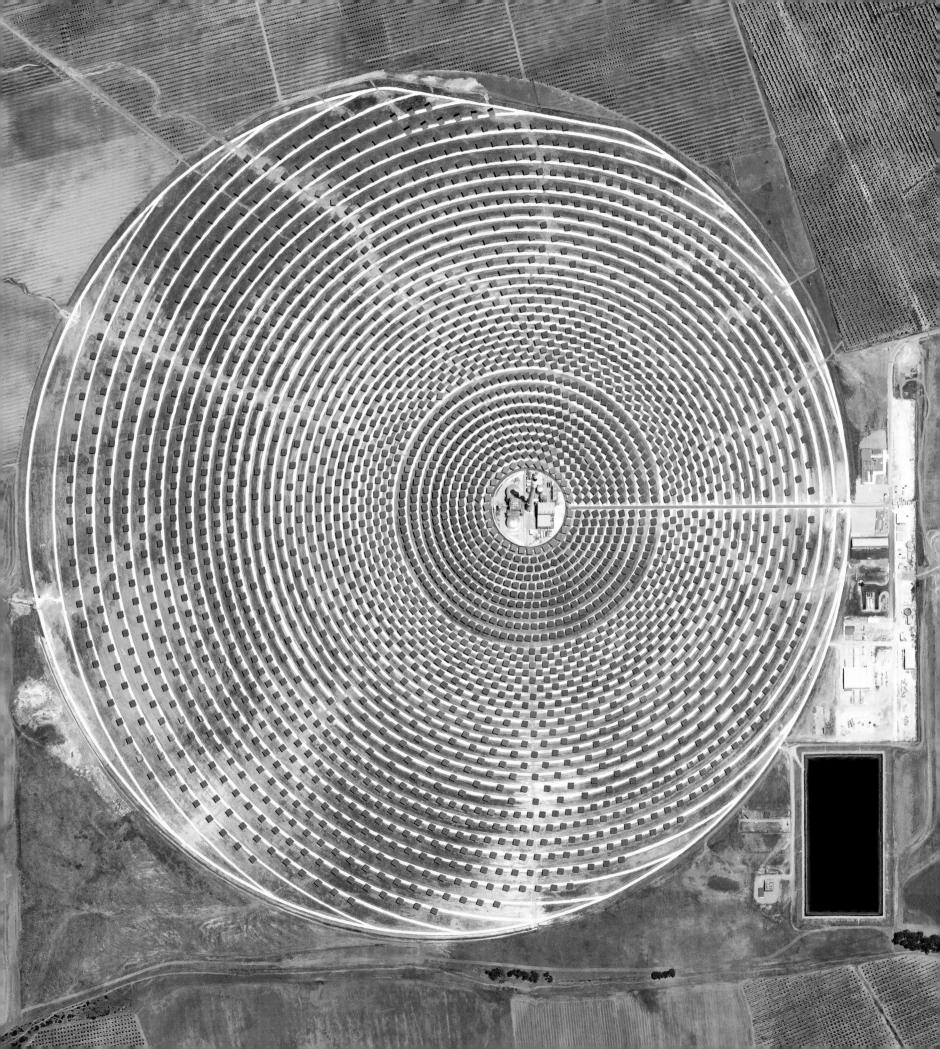

"Man must rise above the Earth—to the top of the atmosphere and beyond—for only thus will he fully understand the world in which he lives."

Plato, *Phaedo (On the Soul)*

WHERE WE HARVEST

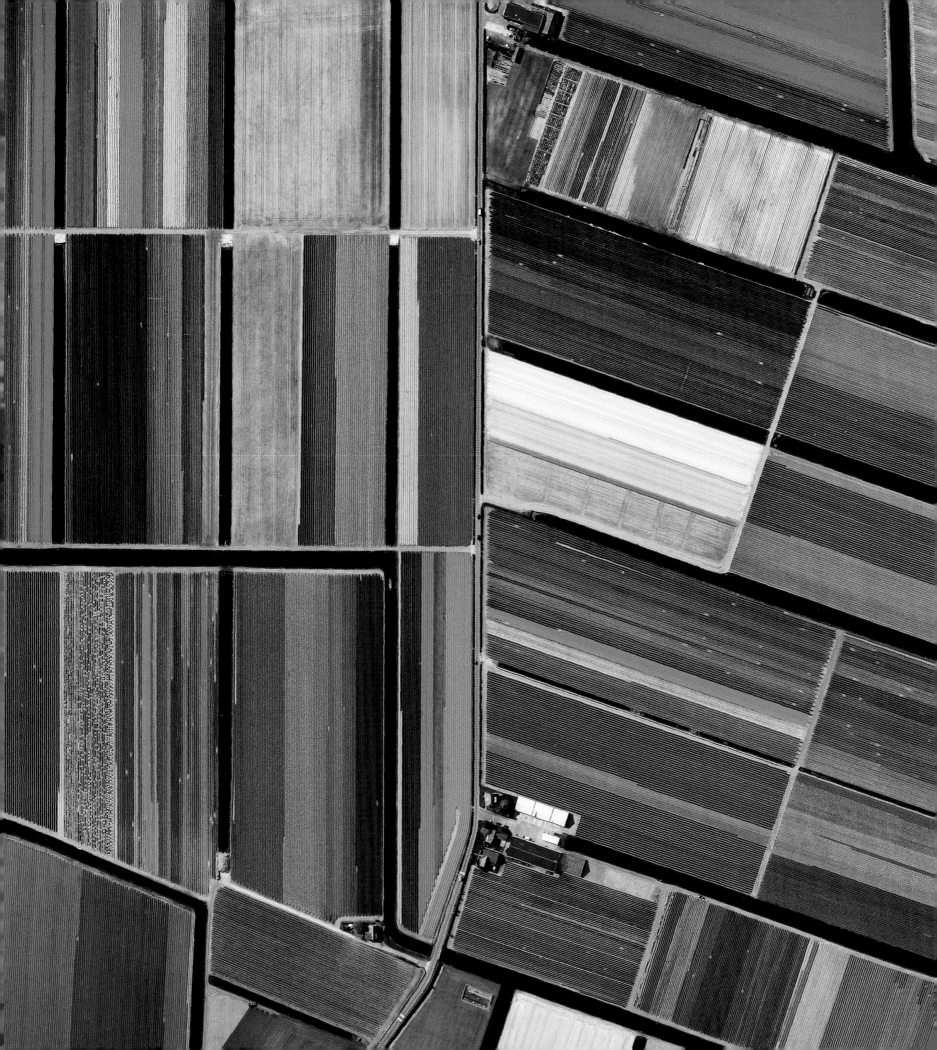

"The single greatest lesson the garden teaches is that our relationship to the planet need not be zero-sum, and that as long as the sun still shines and people still can plan and plant, think and do, we can, if we bother to try, find ways to provide for ourselves without diminishing the world."

Michael Pollan, *Omnivore's Dilemma* (2006)

WHERE WE **HARVEST**

Civilization arose only after agriculture was developed. Our ability to stay in one place and devote time to pursuits other than searching for and gathering sustenance was dependent on the production of a reliable food supply. What you will see in this chapter are the latest manifestations of this ancient pursuit—a collection of images presenting particularly stunning examples of humans harnessing the landscape of the planet to cultivate plants and raise animals.

From above, the places where we harvest often have a textile-like appearance. Repetitive patterns illuminate techniques that have enabled us to utilize the landscape for our needs, with precision and on a massive scale. The patterns that emerge are largely a product of what is being grown and the technology that is used to do so. These tessellations show us that our need to feed ourselves has a far-reaching impact on the surface of the planet—be it on land or in the sea.

It has been estimated that approximately 40 percent of the land on Earth is devoted to agricultural purposes. As our population numbers have exploded, the way we harvest has already been forced to adapt significantly. Technological advances, such as widespread adoption of advanced farming equipment and powerful chemicals, have dramatically increased crop yields and the size of our livestock. Furthermore, catastrophic issues, such as the depletion of water resources or overfishing of aquatic life, require our attention and should force us to consider where our foods of the future will come from. As we look to feed ourselves in the midst of these crises, we must be cautious not to starve our planet first.

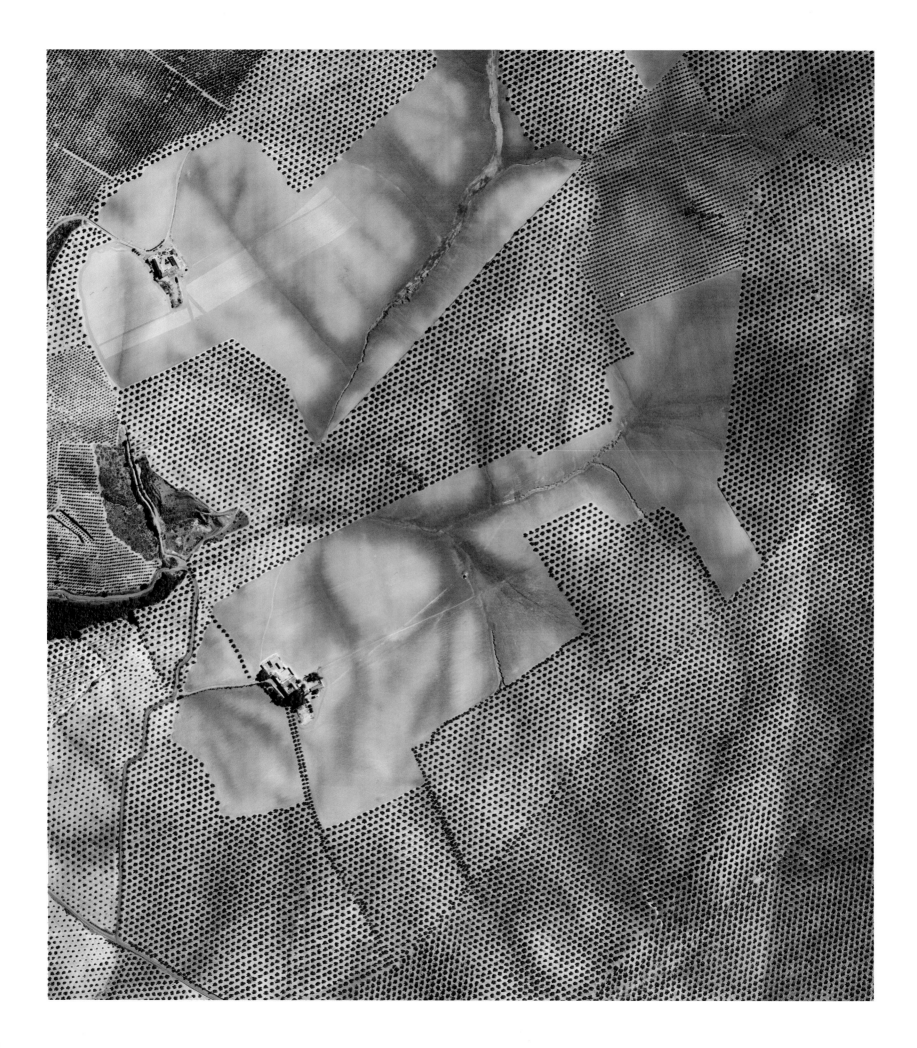

OLIVES

37.263212°, −4.552271°

Olive tree groves cover the hills of Córdoba, Spain. Approximately 90 percent of all harvested olives are turned into oil; the remaining 10 percent are eaten as table olives. With rising temperatures and phenomenal weather variations in growing regions, olive groves on high hills or slopes will probably suffer less, but groves located on low-altitude areas or plains could become totally unproductive.

PALM TREES

3.189536°, 101.497815°

Palm tree plantations surround the city of Kuala Lumpur, Malaysia. The trees are cultivated in terraces cut into the contours of hills, to avoid erosion caused by streaming water. Malaysia is now one of the world's largest exporters of palm oil—used primarily as a cooking ingredient—shipping nearly 18 million tons per year. The rapid expansion of palm oil plantations in the world's tropical regions is becoming an increasingly significant source of carbon emissions. Clearing the native trees to make space for the palms is projected to add more than 558 million tons of carbon dioxide into the atmosphere by 2020—an amount greater than all of Canada's current fossil fuel emissions.

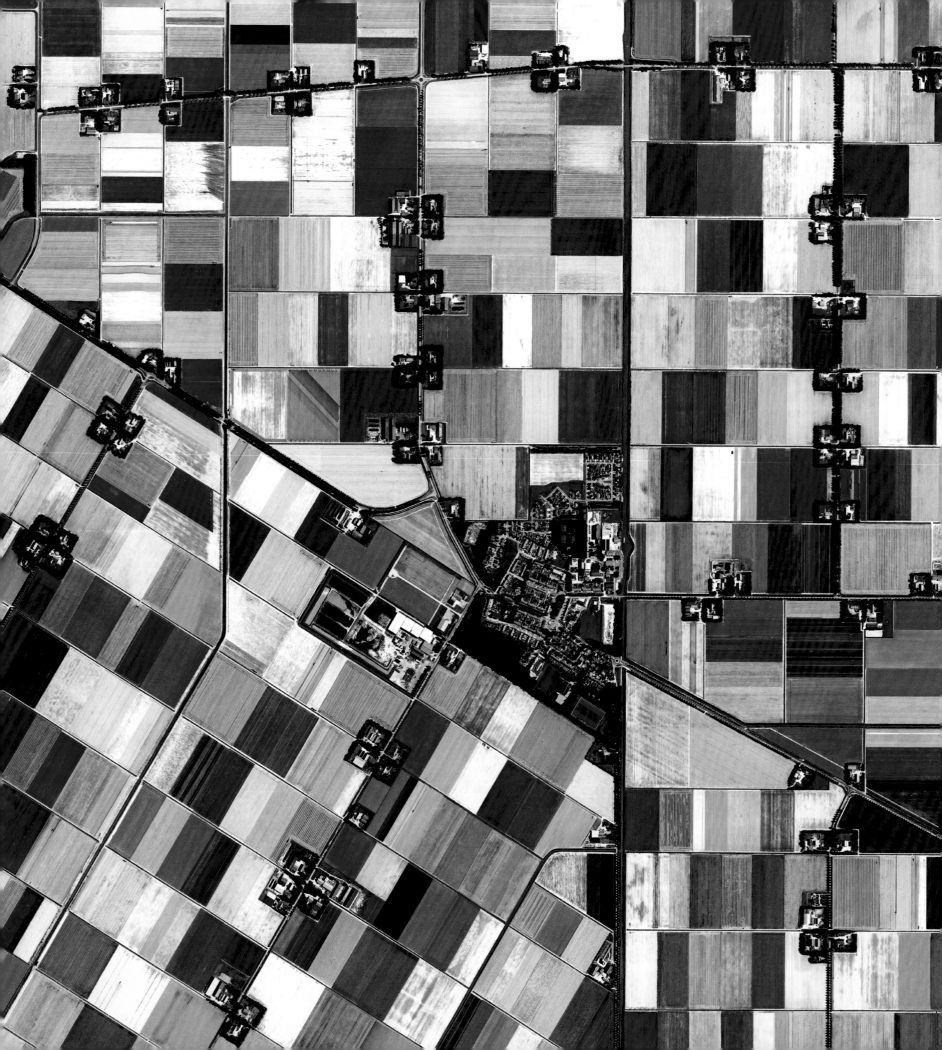

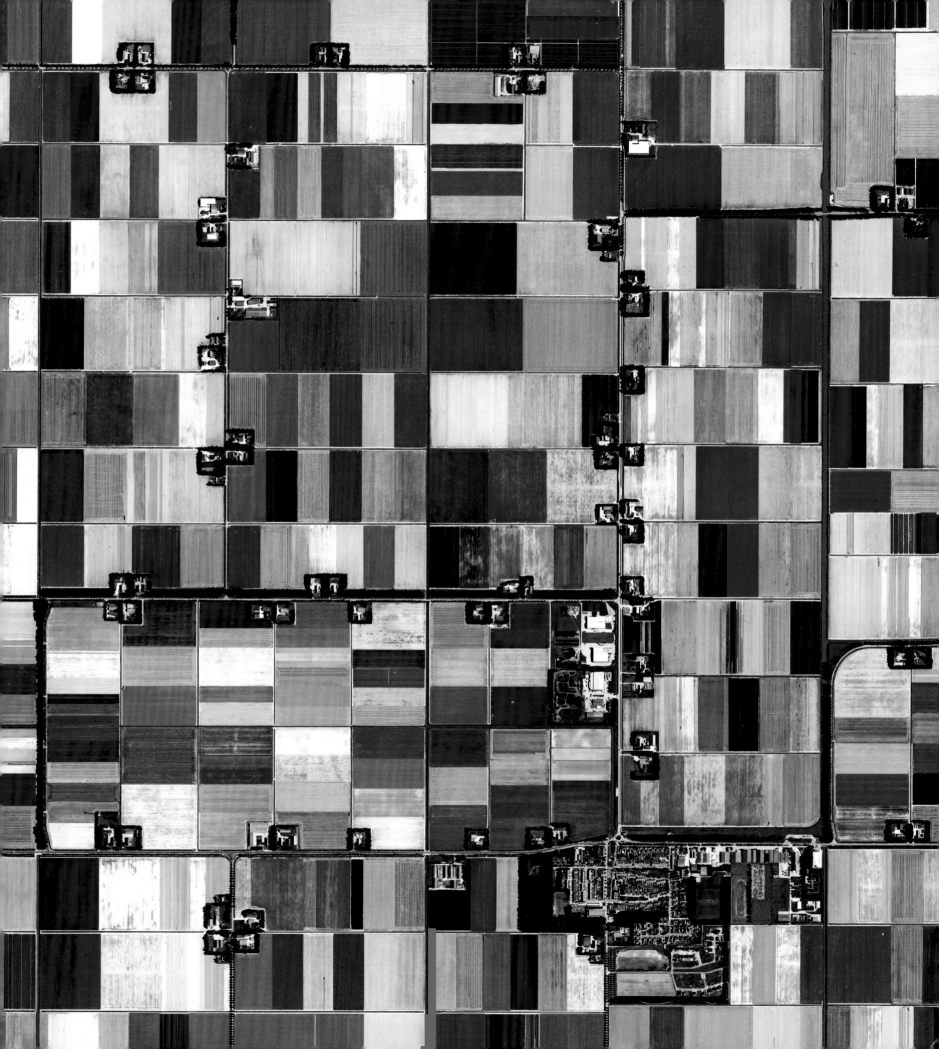

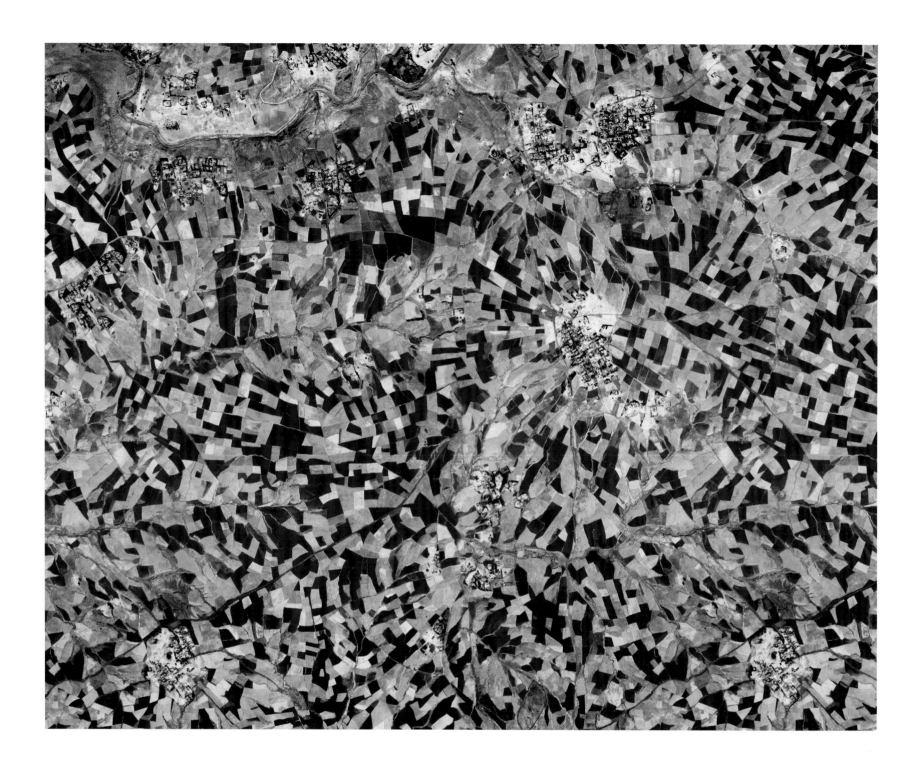

PREVIOUS PAGE

FLEVOLAND

52.724169°, 5.641978°

Farms in the province of Flevoland, Netherlands,
specialize in the growth of flower bulbs. Flevoland
was created by the Zuiderzee Works—a coordinated
reconstruction of dams and dikes, land reclamation,
and water drainage. The reclaimed land now covers
375 square miles (970 square kilometers), making
Flevoland the largest artificial island in the world.

ABOVE

ADDIS ABABA

8.904953°, 38.869170°

Agricultural development is seen on the outskirts of
Addis Ababa, Ethiopia. Both the capital and the largest
city in the country, Addis Ababa has a population of
approximately 3.4 million. Despite the significant role
urban agriculture has played in the history of the city,
this activity is facing challenges due to rapid urbanization
and the subsequent competitive demand for land.

RIGHT

ALMERIA

36.715441°, −2.721485°

Greenhouses—also known as plasticulture—
cover approximately 50,000 acres of land
(20,000 hectares) in Almeria, Spain. The use
of plastic covering is designed to increase
produce yield and size, and shorten growth
time. For a sense of scale, this Overview shows
roughly 3.5 square miles (9 square kilometers).

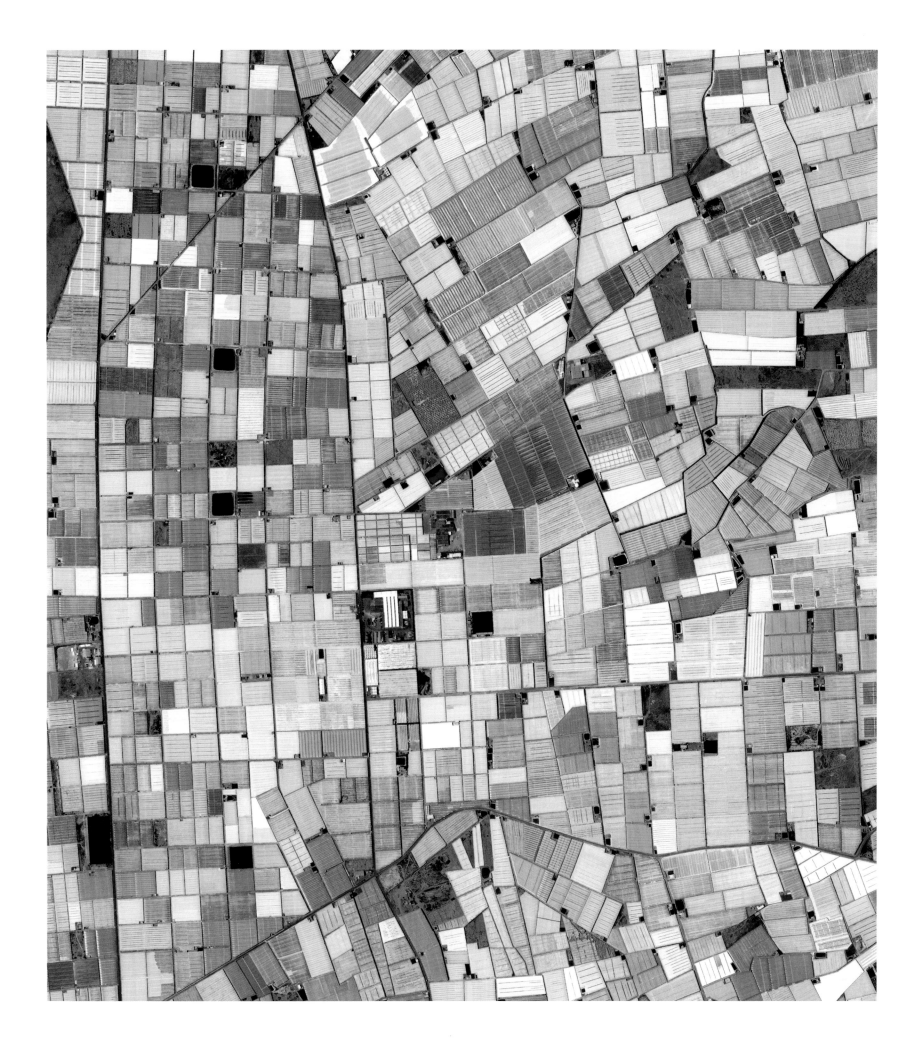

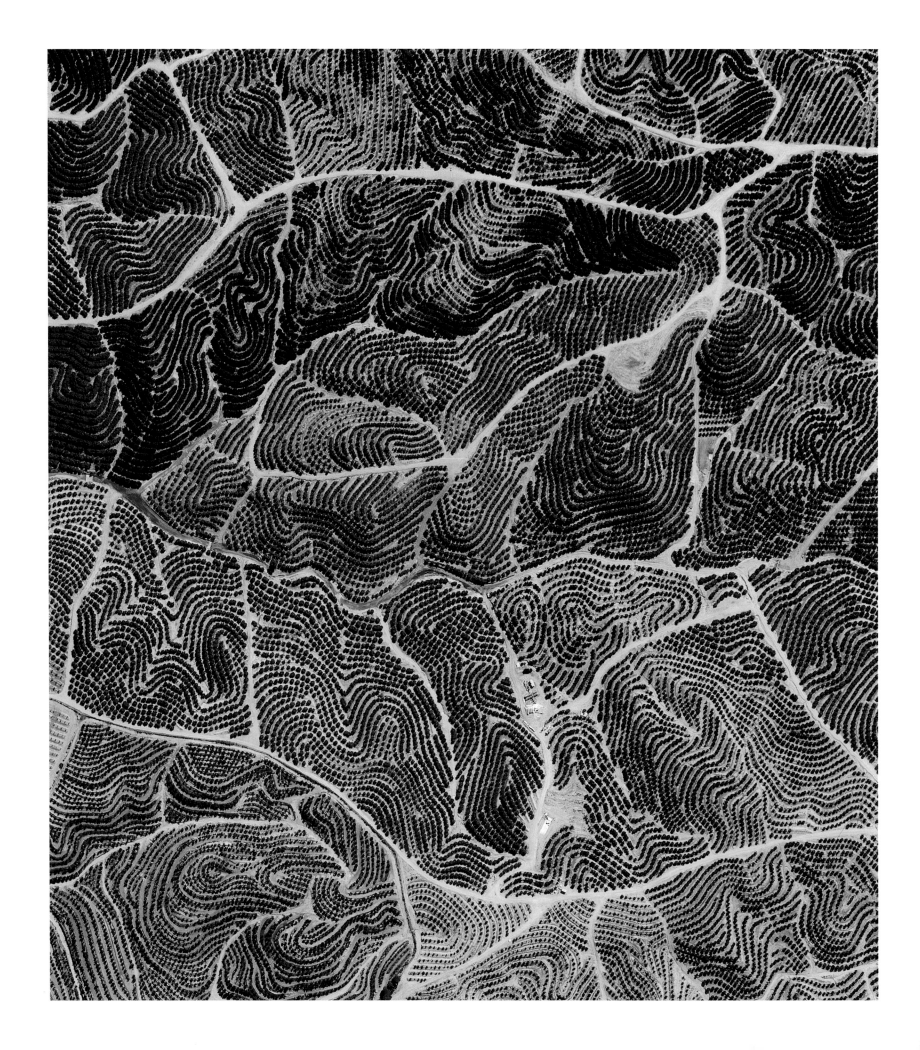

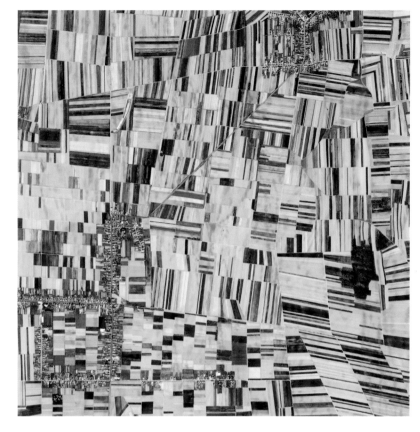
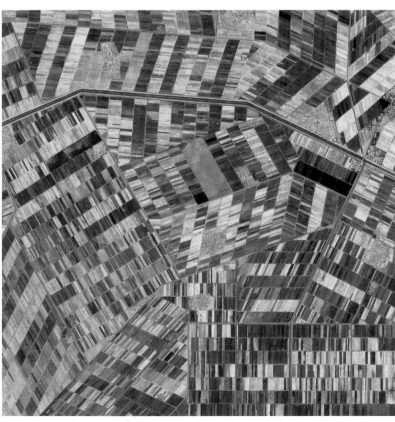
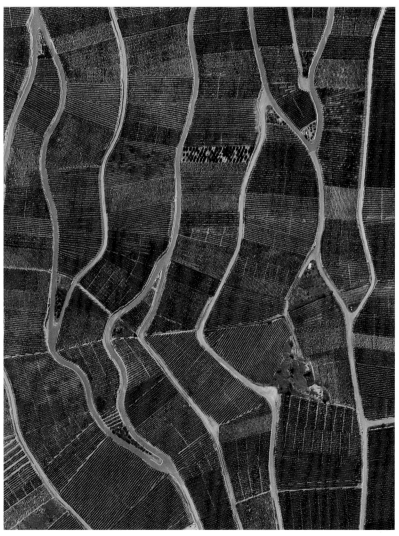

PREVIOUS PAGE, CLOCKWISE FROM LEFT

CITRUS FRUIT

37.714546°, –6.532834°

Citrus trees cover the landscape in Isla Cristina, Spain. The climate is ideal for this growth, with an average temperature of 64°F (18°C) and relative humidity between 60 and 80 percent.

PECANS

31.972467°, –110.948875°

A massive grove of pecan trees is seen here in Sahuarita, Arizona, USA. Historically, the southwest region of the United States has had the perfect climate for growing the pecan nut. However, in recent years, the pecan supply has been dramatically decreased and prices have shot up due to prolonged drought, marauding animals, and unusually high demand for the nut generated by the growing middle-class population in China.

CORN

46.422810°, 16.467788°

Corn is the primary crop grown in Međimurje County, Croatia. Of the county's total area of 280 square miles (730 square kilometers), nearly half—100 square miles (260 square kilometers)—is used for agricultural purposes.

GRAPES

49.982265°, 7.035582°

Step vineyards climb the hills of Ürzig, Germany. Wine production started in the region more than two centuries ago by the Celts and the Romans. Today, winemakers primarily grow grapes to produce Riesling wines.

COTTON

14.500005°, 33.164478°

The Gezira Scheme is one of the largest irrigation projects in the world, situated at the confluence of the Blue and White Nile Rivers near the city of Khartoum, Sudan. Because the soil slopes away from the rivers, water naturally flows through 2,700 miles (4,350 kilometers) of irrigation canals with gravity. The primary crop cultivated here is cotton.

RIGHT

PIVOT IRRIGATION FIELDS

30.089890°, 38.271806°

Center pivot irrigation is used throughout the Wadi As-Sirhan Basin of Saudi Arabia. Water is mined from depths as great as 0.6 miles (1 kilometer), pumped to the surface, and evenly distributed by sprinklers that rotate 360 degrees. Spurred by a government effort to strengthen its agricultural sector, cultivated land in Saudi Arabia grew from 400,000 acres (162,000 hectares) in 1976 to more than 8 million acres (3.2 million hectares) by 1993. For a sense of scale, the total area shown in this Overview is approximately 32,000 acres (13,000 hectares).

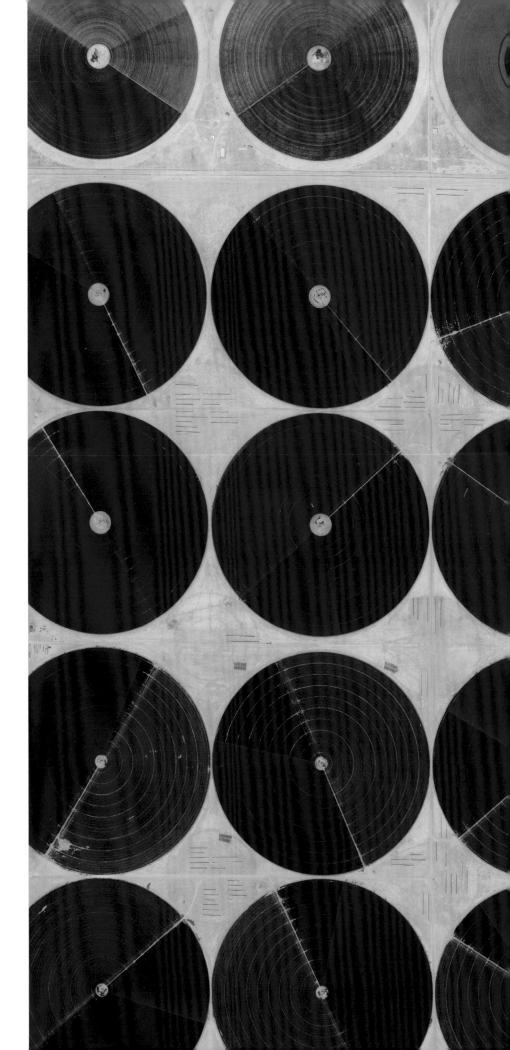

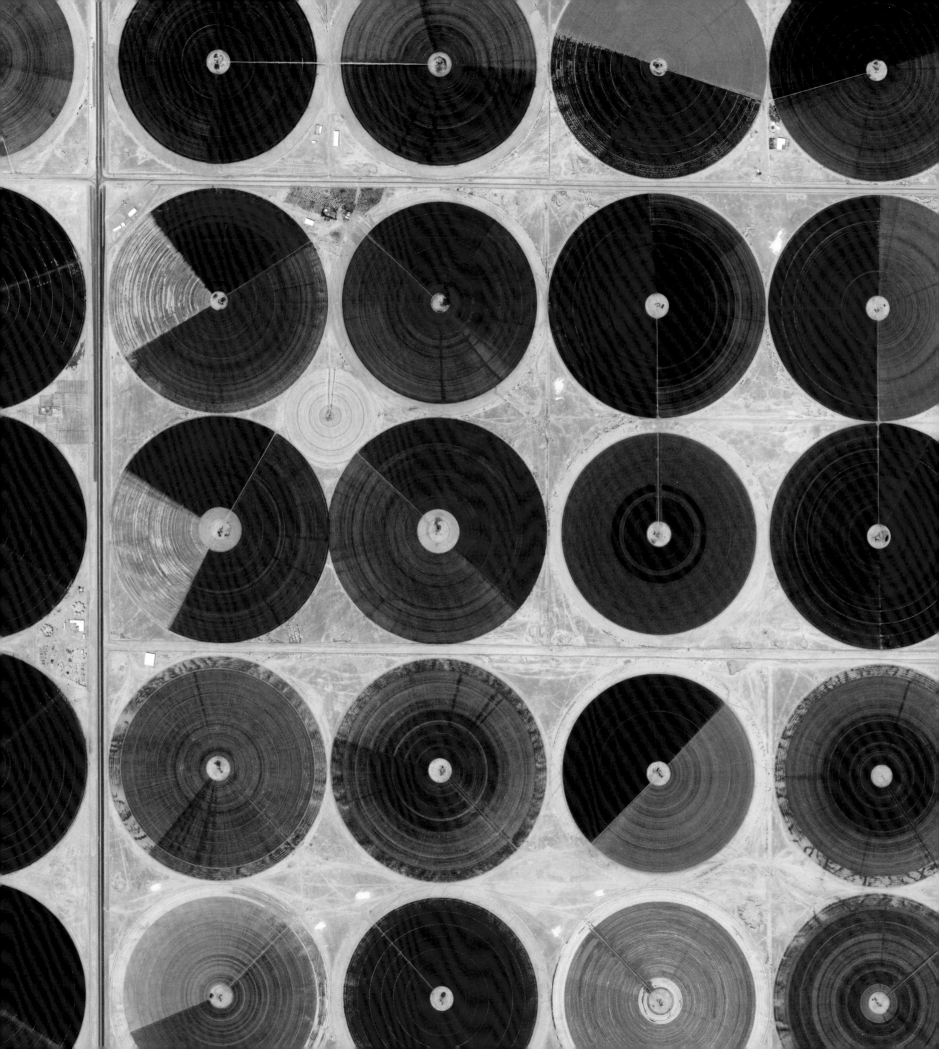

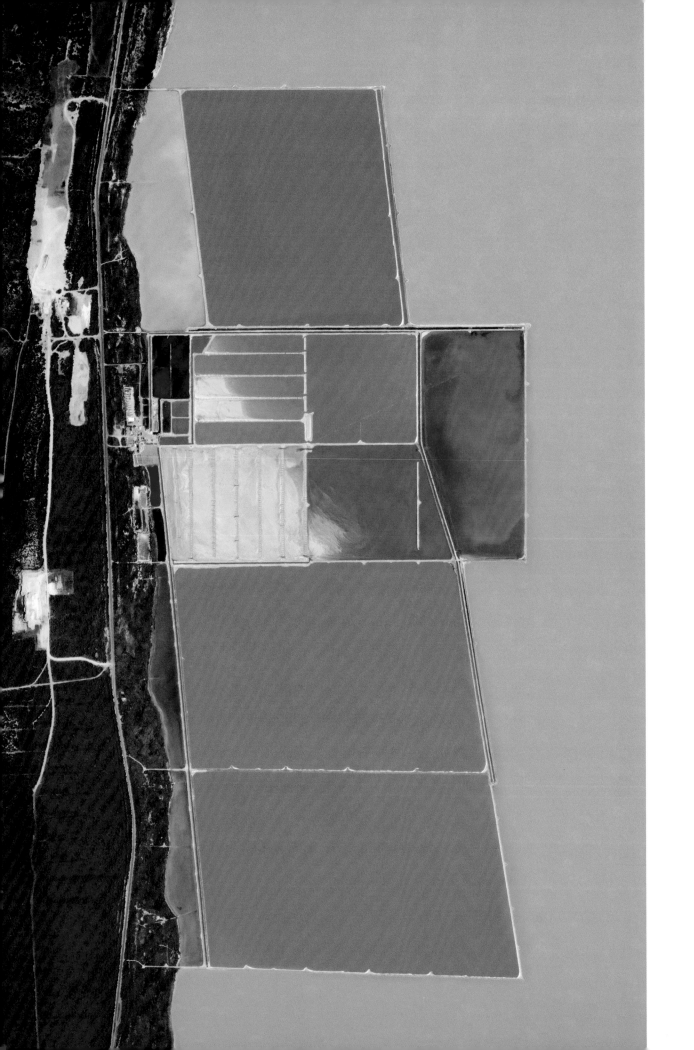

ALGAE

−28.172005°, 114.261002°

Hutt Lagoon is a massive lake in Western Australia that gets its color from a particular type of algae, *Dunaliella salina*. The lagoon contains the world's largest microalgae production plant, where the algae is farmed for its beta-carotene (used as a food-coloring agent and source of vitamin A).

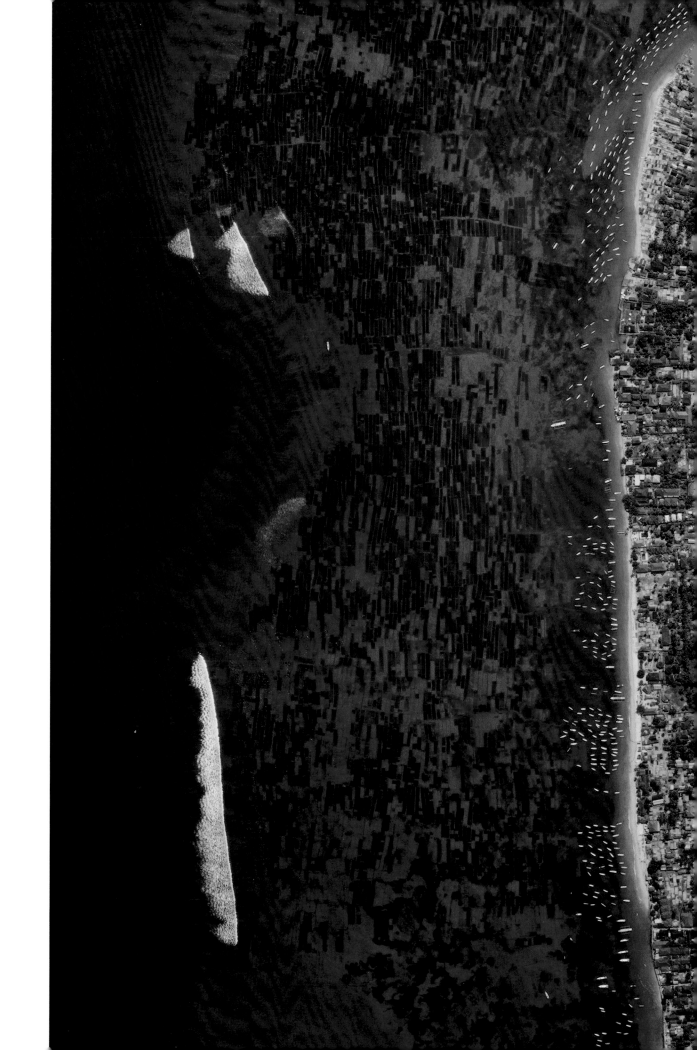

SEAWEED

-8.668518°, 115.441209°

Seaweed farms on Nusa Lembongan—
a small island located southeast of Bali,
Indonesia—have an average harvest
of 50,000 pounds (23,000 kilograms) per
month. Once the seaweed is extracted
from the water, it is then dried by the
sun for three to seven days, depending
on the season.

PREVIOUS PAGE
CANOLA FLOWERS

24.857405°, 104.353534°

Canola flower fields cover the mountainous landscape of Luoping County, China. The crop is grown for the production of oil, which is extracted by slightly heating and then crushing the flower seeds. Canola oil is primarily used as a source of biodiesel.

RIGHT
BEET SUGAR

32.905407°, −115.565693°

The Spreckles Beet Sugar Factory is located in Brawley, California, USA. After machines extract sugar from sugarbeet roots, the leftover, colorful beet pulp is dried on a massive paved area next to the factory. The pulp is then used as a major ingredient in dairy feed.

FAR RIGHT
SUGARCANE

26.658467°, −80.530493°

From October to April, farmers in Palm Beach County, Florida, USA, burn their sugarcane fields in order to remove the sugarless, leafy portions of the plant that surround its stalks. Once the fires die down, machines chop down these stalks and take them to sugar mills for processing. The region's annual harvest has grown to a total of nearly 17 million tons, which can be processed into more than 2 million tons of sugar. Environmental advocates are concerned that these purposeful fires pollute the air and have created health problems across the region.

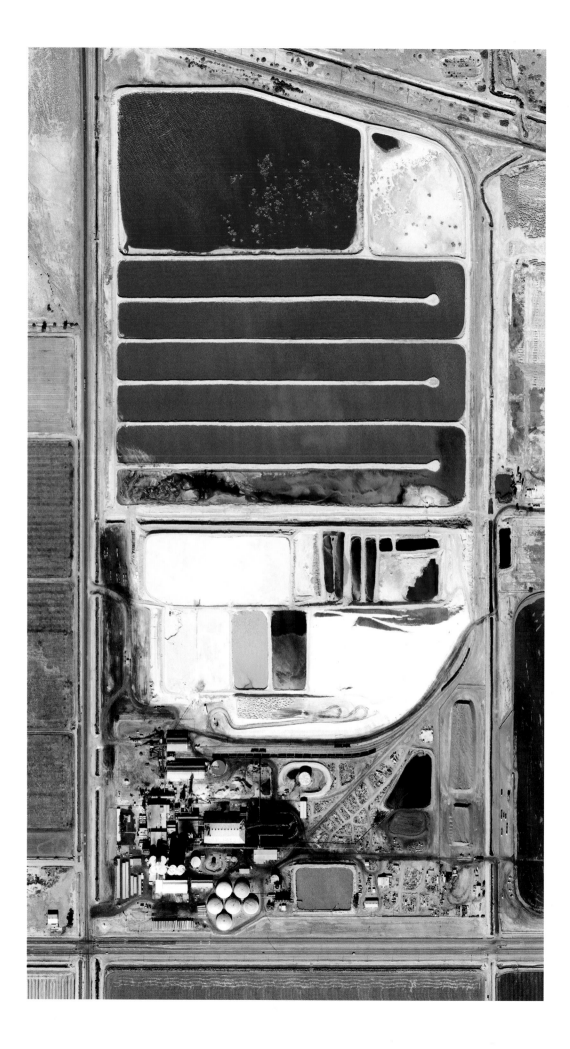

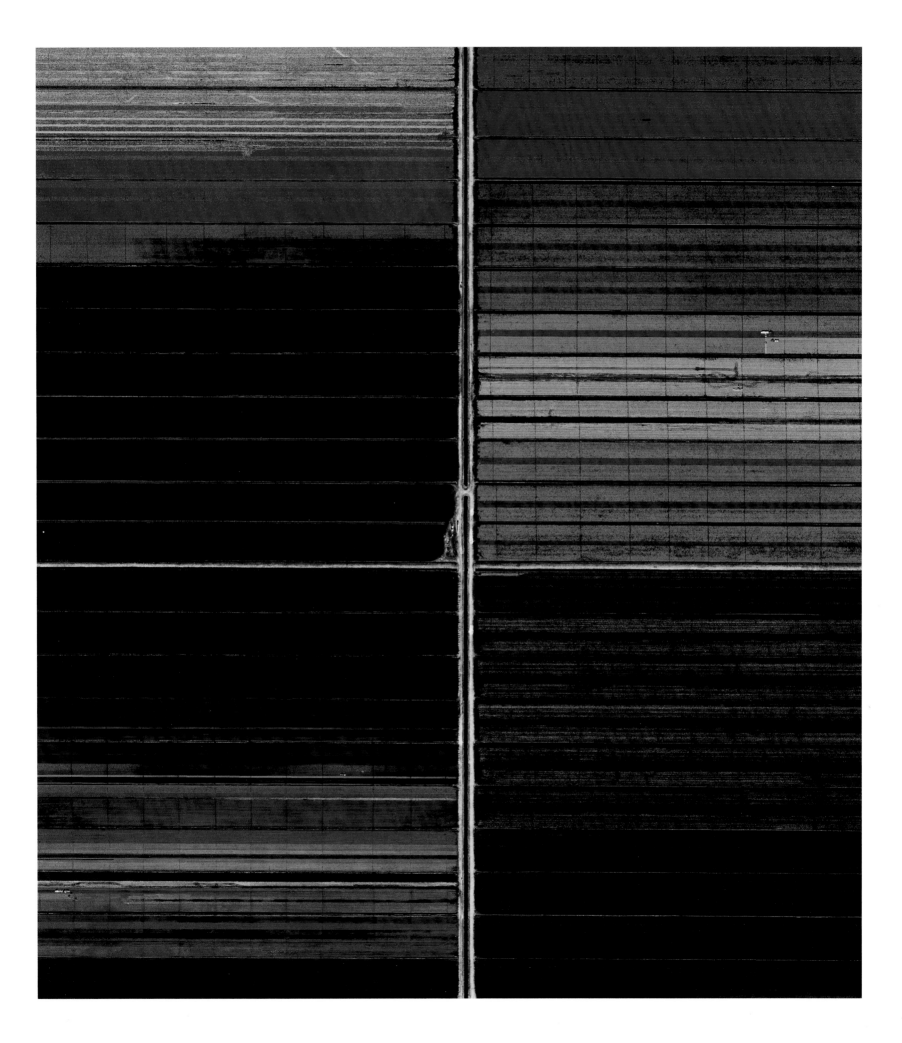

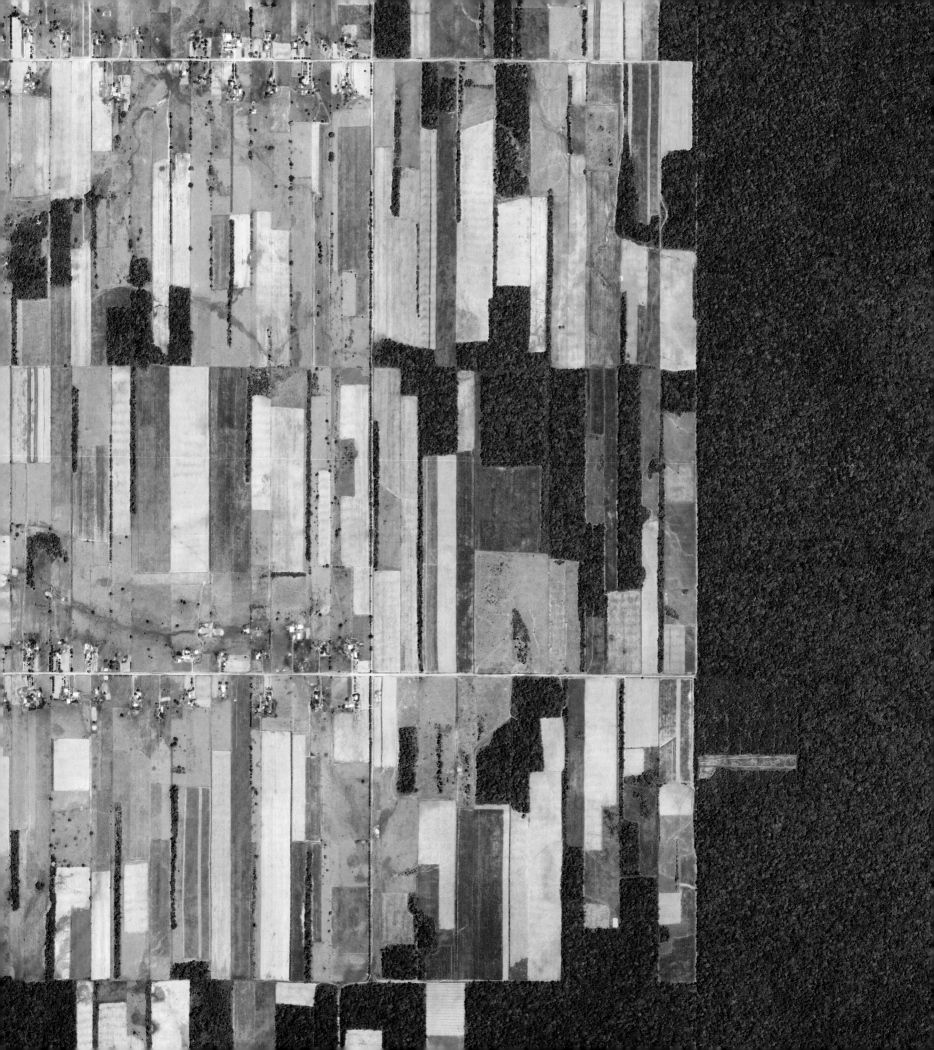

PREVIOUS PAGE

DEFORESTATION IN BOLIVIA

–17.387750°, –60.562130°

Deforestation of the rainforest is visible in Santa Cruz, Bolivia— immediately adjacent to untouched tracts of forest. Deforestation in the country has primarily been driven by the expansion of mechanized agriculture and cattle ranching. This Overview highlights the country's struggle to expand food production in order to meet the needs of its growing population and the sacrificial destruction of its forests that has taken place to do so. While deforestation rates are now relatively stable at about 494,000 acres (200,000 hectares) a year, it is estimated that Bolivia lost 4.5 million acres (1,820,000 hectares) of forests from 2000 to 2010.

ABOVE

DEFORESTATION IN BRAZIL

–3.792333°, –53.868947°

Clearcutting operations in the Amazon Rainforest of Para, Brazil, branch out from one of the state's central roads. Deforestation of the Amazon accelerated significantly between 1991 and 2004, reaching its highest annual forest loss rate of 10,588 square miles (27,423 square kilometers) in 2004. Though the rate of deforestation has been slowing since, the remaining forest cover still continues to decrease. The Amazon represents over half of the planet's remaining rainforests, and accounts for the most biodiverse tract of tropical rainforest in the world.

RIGHT

BRATSK PULP MILL

56.113654°, 101.602842°

Timber is frozen in the Angara River by a pulp mill in Bratsk, Russia. A pulp mill is a manufacturing facility that converts felled trees and wood chips into thick fiber board that is shipped to a paper mill for further processing. The facility in Bratsk handles a capacity of 540,000 cubic yards (413,000 cubic meters) of wood per year.

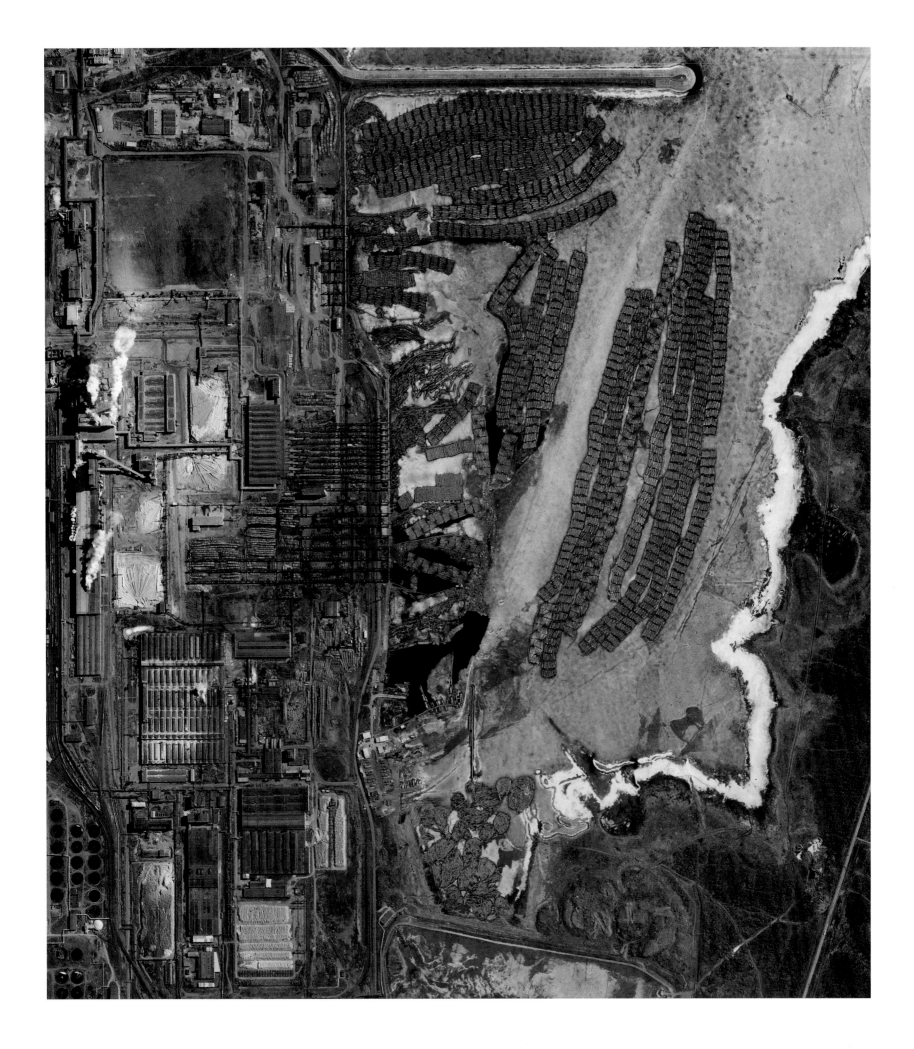

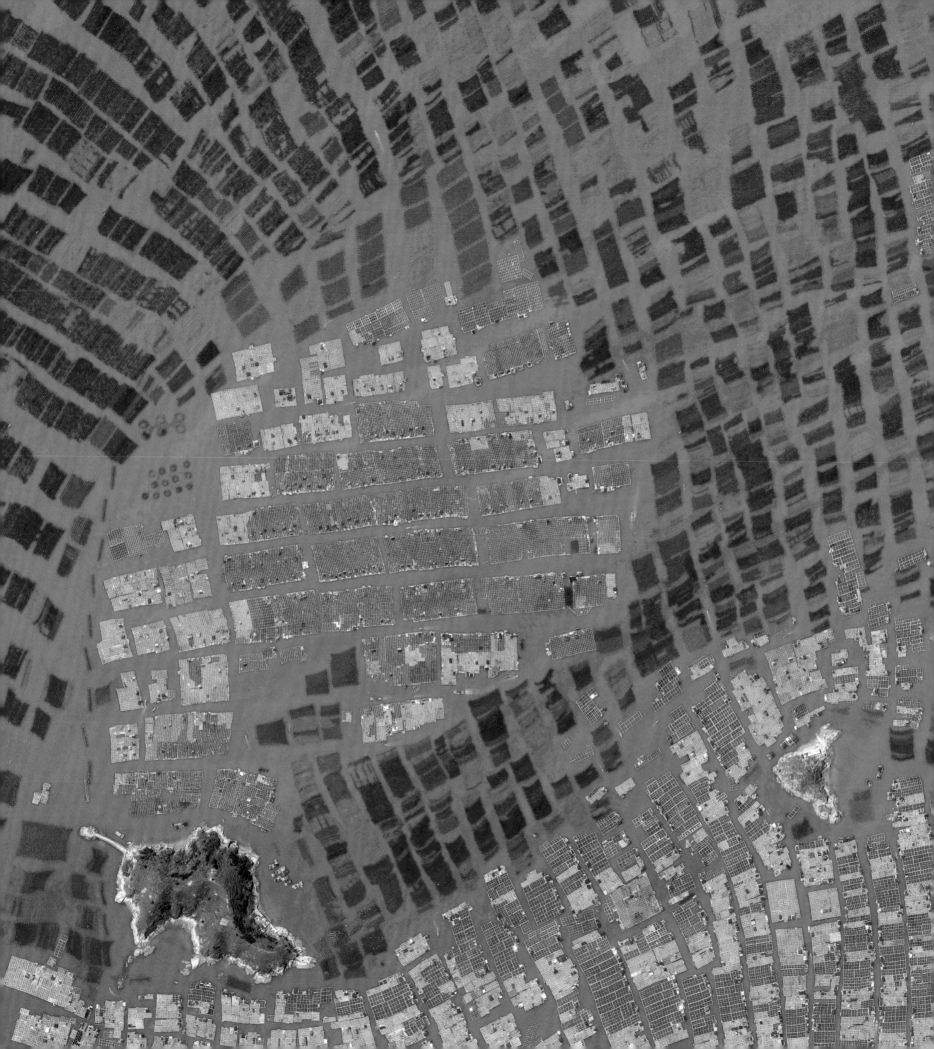

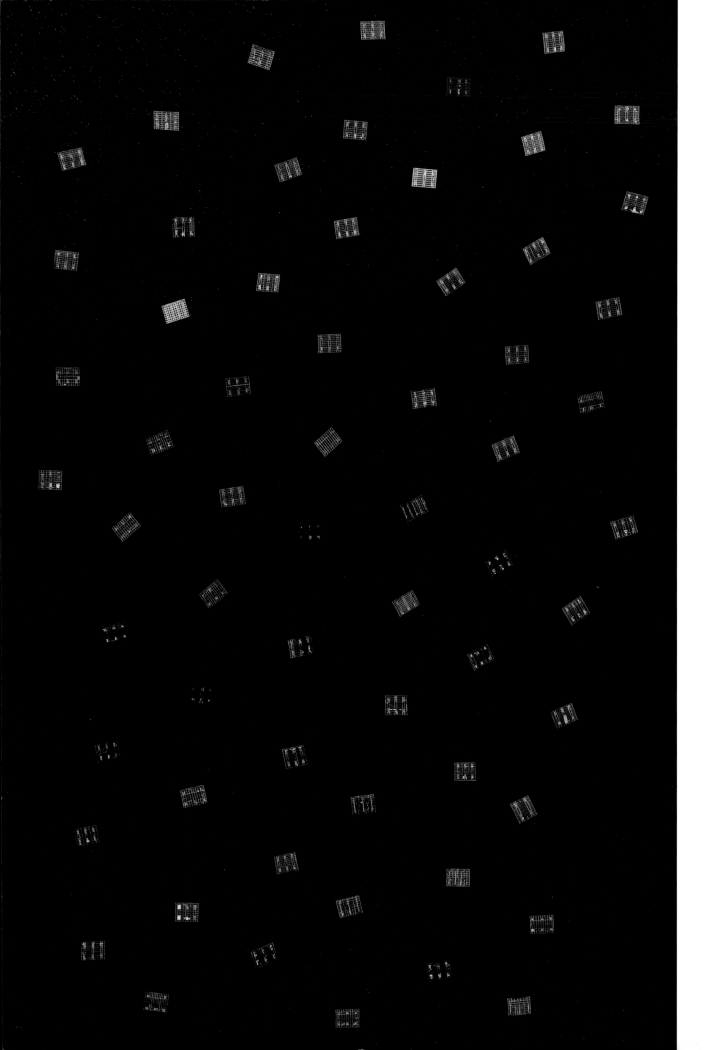

PREVIOUS PAGE
AQUACULTURE
26.408924°, 119.741132°
Seafood farms cover the surface
of Luoyuan Bay in the Fujian
province of China. Underneath the
water is a vast network of lines,
cages, and nets for the growth of
various seafood species, including
crabs, lobsters, scallops, and carp.
For a sense of scale, this Overview
shows approximately 2.3 square
miles (6 square kilometers).

LEFT
MUSSELS
42.576312°, −8.859047°
Mussel cultivation in the Ría de
Arousa saline estuary off the coast
of Galicia, Spain, is the highest in
the world. Floating rafts contain
the nurseries where the mollusks
grow on ropes until they are
large enough to harvest. Mussel
production has thrived here
because there is an usually high
concentration of phytoplankton in
the water, providing the mussels
with a protein-rich diet.

SHRIMP

28.587725°, −111.732473°

Shrimp pools are located on the
coast of Sonora, Mexico. In these
massive ponds, the crustaceans
are grown to marketable size with
advanced statistical methodology
and high-protein diets.

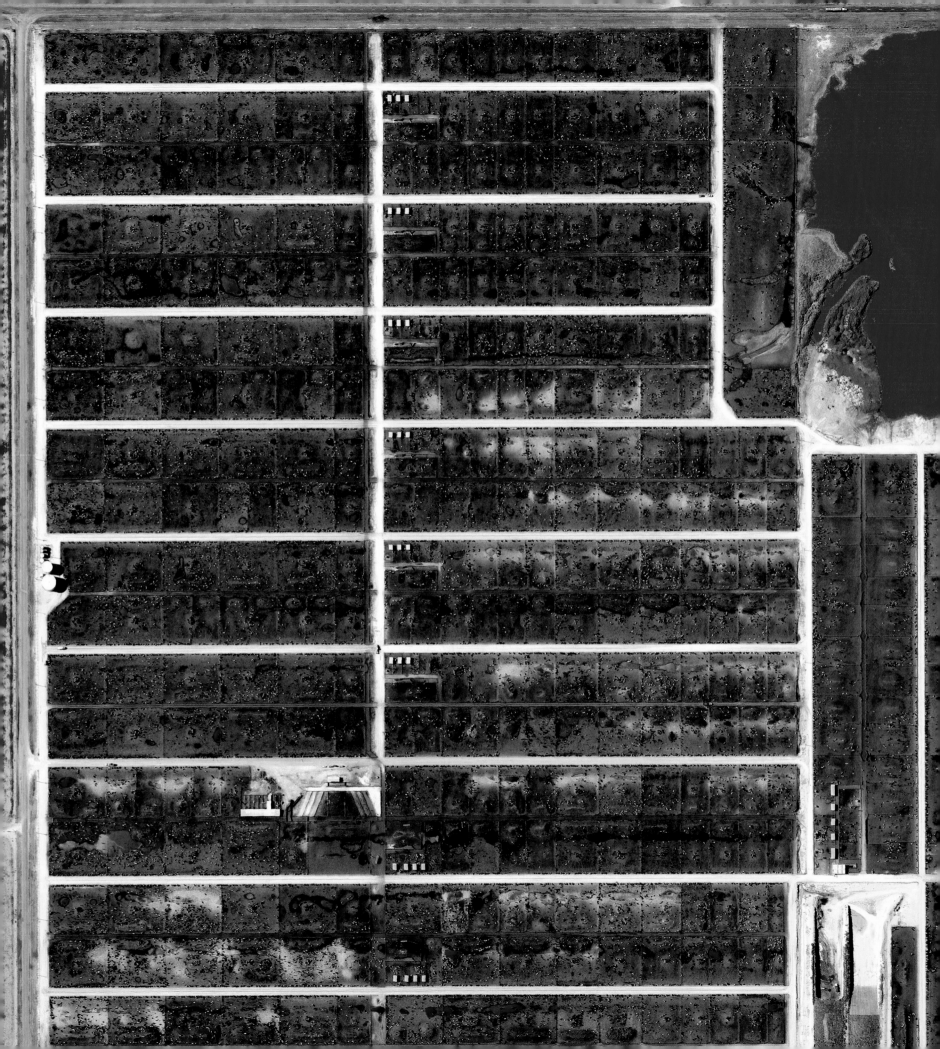

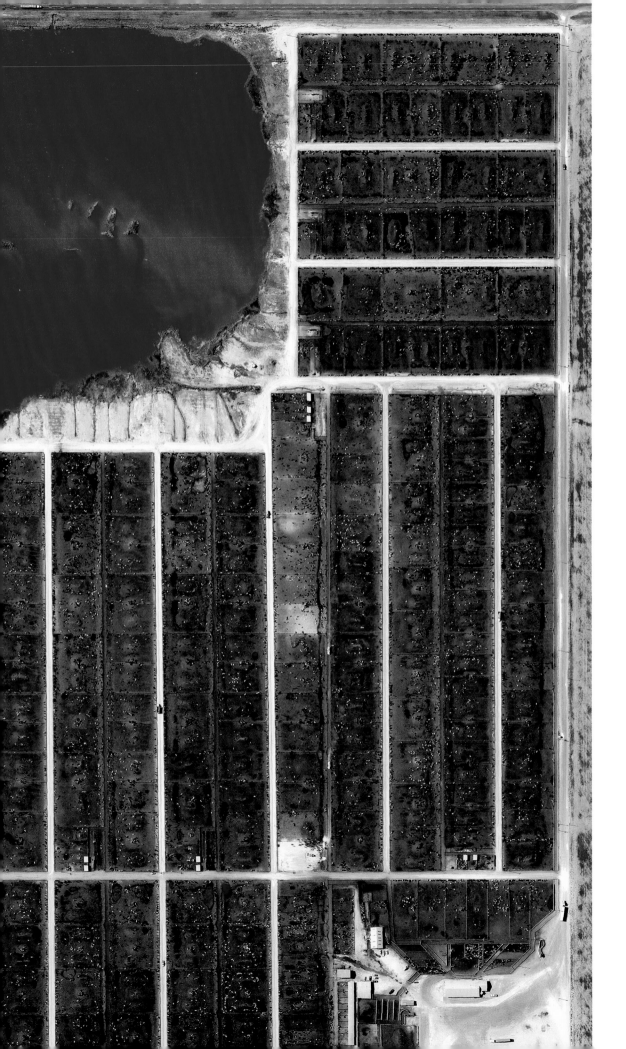

CATTLE FEEDLOT

34.715427°, -102.507400°

Cattle are visible at a feedlot in Summerfield, Texas, USA. Once the animals reach a weight of 650 pounds (295 kilograms), they are moved to these facilities and placed on a strict diet of specialized animal feed. Over the next three to four months, the cows gain up to 400 pounds (180 kilograms) before they are shipped off to slaughter. The lagoon seen at the top of this feedlot gets its glowing color from manure and the presence of algae that grows in the stagnant water.

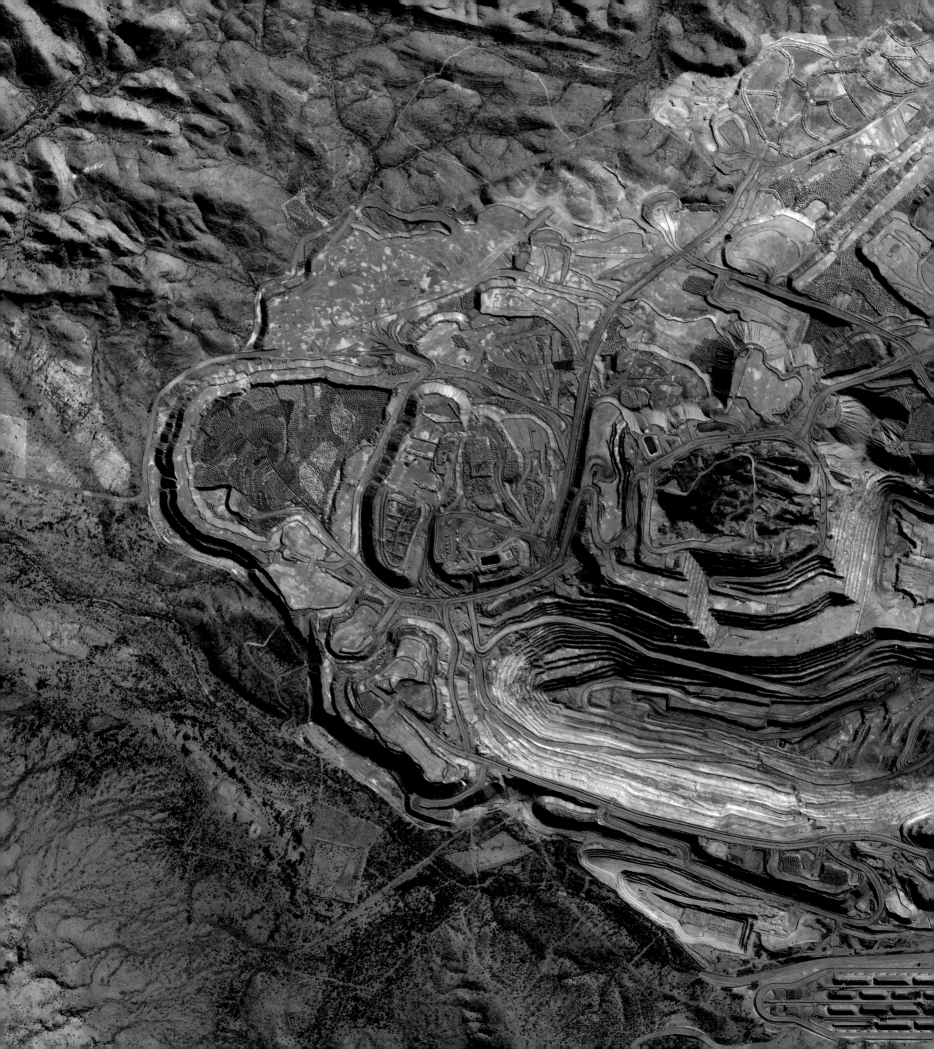

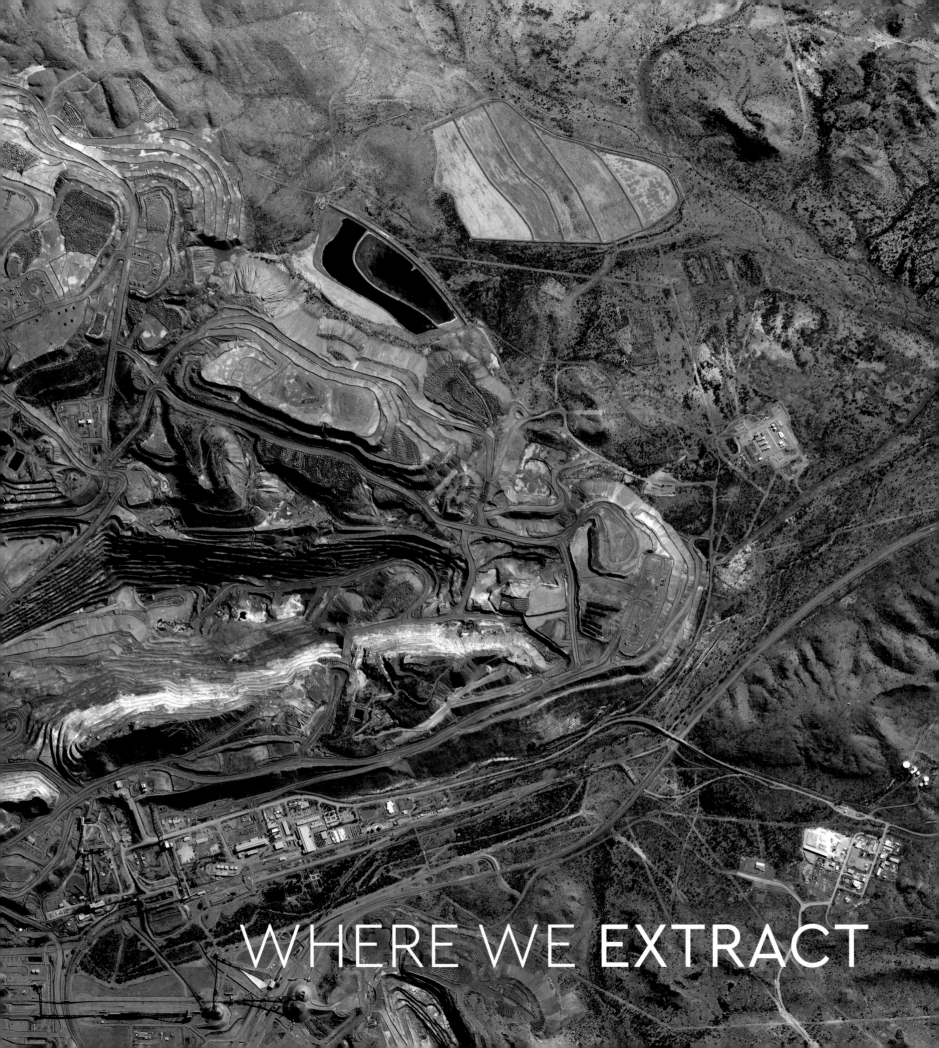

WHERE WE EXTRACT

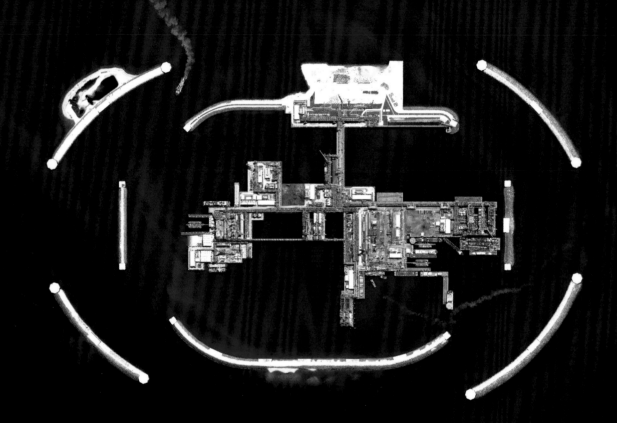

"We can, if need be, ransack the whole globe, penetrate into the bowels of the earth, descend to the bottom of the deep, travel to the farthest regions of this world, to acquire wealth."

William Derham, *Physico-Theology* (1713), cited in Naomi Klein's *This Changes Everything* (2014)

WHERE WE **EXTRACT**

There are natural resources within the Earth that we simply cannot manufacture or grow in a lab. So we dig, pump, strip, frack, and use whatever method we have invented to extract what we need. These resources are then shipped elsewhere around the world to be refined, processed, melted, made into goods, or used as key ingredients in other products. Yet how and where we extract is itself an evolving intersection between people and machines—between insatiable human demand and the technology we have created to supply these needs. Looking at where we extract forces us not only to consider how we use the Earth to drive our development but also to wonder at our ingenuity as creators.

The places where we extract are some of the most visible human-made landmarks that can be seen from space. Digging and stripping the Earth leaves scars and artificial colors rarely seen elsewhere, and yet, we are literally just scratching the surface. In 2016, mining companies reported mines with reserves of up to 75 years. These figures do not include the mines or minerals that are yet to be discovered.

With supply and demand driving our mining, we should realize that we have the power to shift this "demand," and that the future of extraction lies in our hands. Let us use fossil fuels as an example; because the power of human ingenuity has made greater extraction possible with new and improved techniques, waiting until we run out of oil is no longer an option. We must prioritize the shift to more sustainable energy sources if we want to do what is best for our planet, and an important place for this shift to begin is with our awareness. In this chapter, let us consider the things that we consume—how are they made, what they are made of, and what powers them.

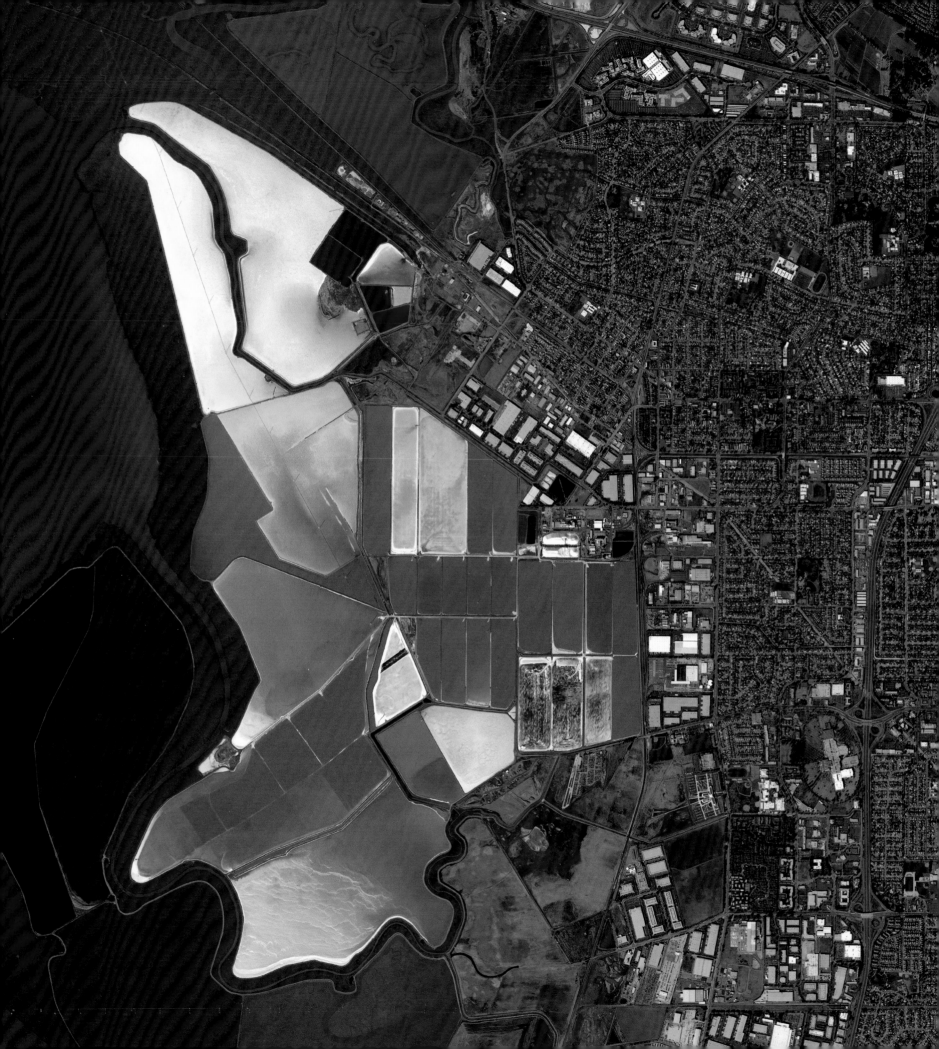

SAN FRANCISCO SALT PONDS
37.504215°, –122.036887°

A recent figure estimates that 80 percent of the
San Francisco Bay wetlands area in California,
USA—approximately 16,500 acres (6,700 hectares)—
has been developed for salt mining. Water is
channeled into large ponds and exits through
natural evaporation. The salt that remains can
then be collected. The massive ponds get their
vibrant colors from the algae that live there
and the species' tolerance to salinity.

LEFT

RECESSION OF THE DEAD SEA

31.2367202°, 35.378043°

In recent decades, the water level of
the Dead Sea has been dropping at
more than 3 feet (1 meter) per year due
to the extraction of raw materials and
the diversion of water to the north.
The Dead Sea level drop has been
followed by a groundwater level drop,
causing mineral-rich brines—water with
a high percentage of dissolved salts—
which previously occupied underground
layers near the shoreline, to be flushed
out by freshwater. Consequently, in
December 2013, Israel, Jordan, and
the Palestinian Authorities signed
an agreement to lay a water pipeline
that will link the Red Sea with the
Dead Sea in an attempt to replenish
devastated areas.

RIGHT

SOQUIMICH LITHIUM MINE

−23.481939°, −68.333027°

The Soquimich Lithium Mine is located
in the Atacama Desert of Chile. With no
historical record of rainfall in parts of
the region, it is considered to be one of
the driest places on Earth. Mineral-rich
brines are pumped via underground
wells into large, shallow ponds that
are colored to speed the evaporation
process. The subsurface brines of
the Atacama are particularly rich in
lithium salts, an essential component
of batteries and some medicines.

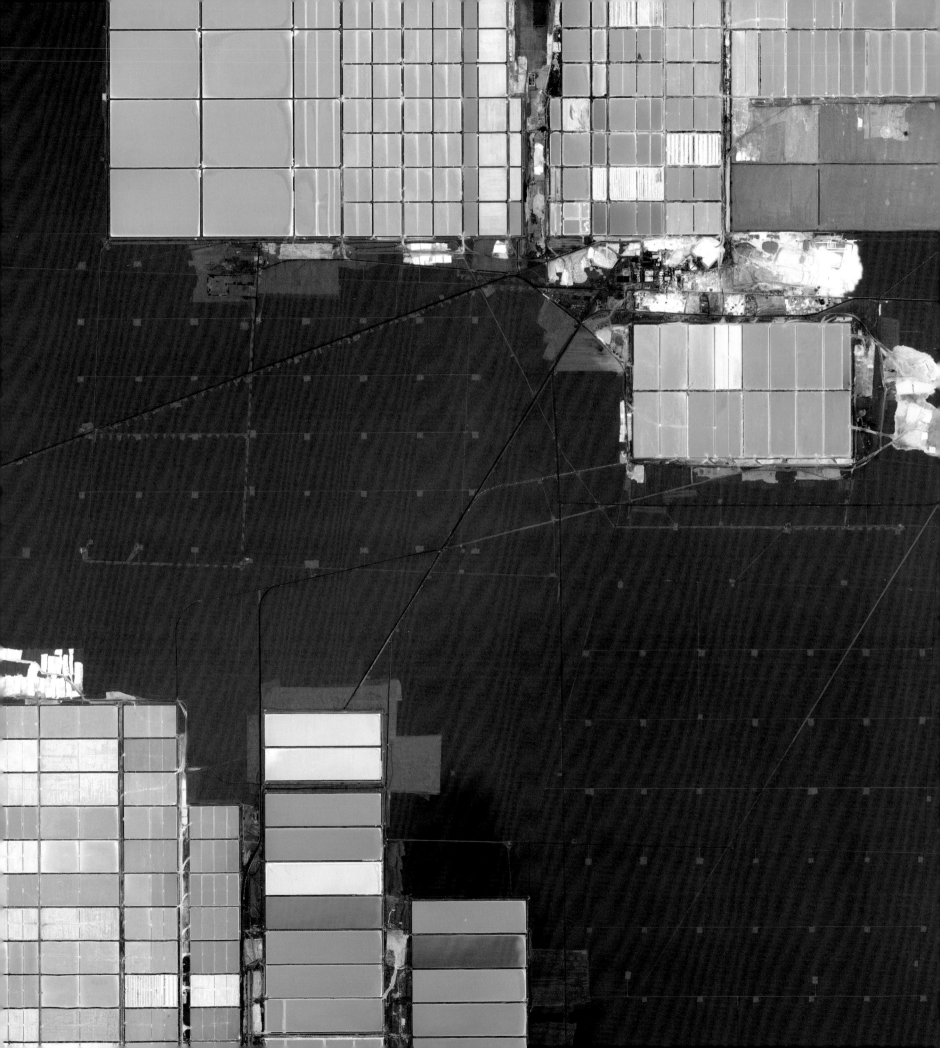

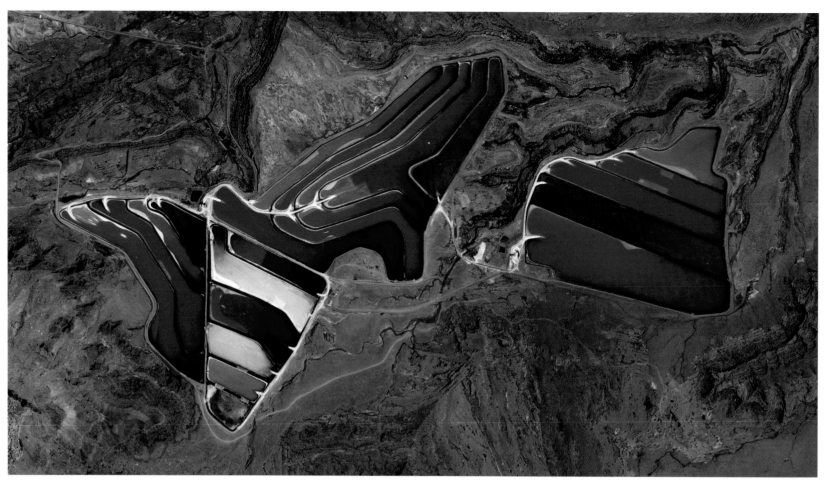

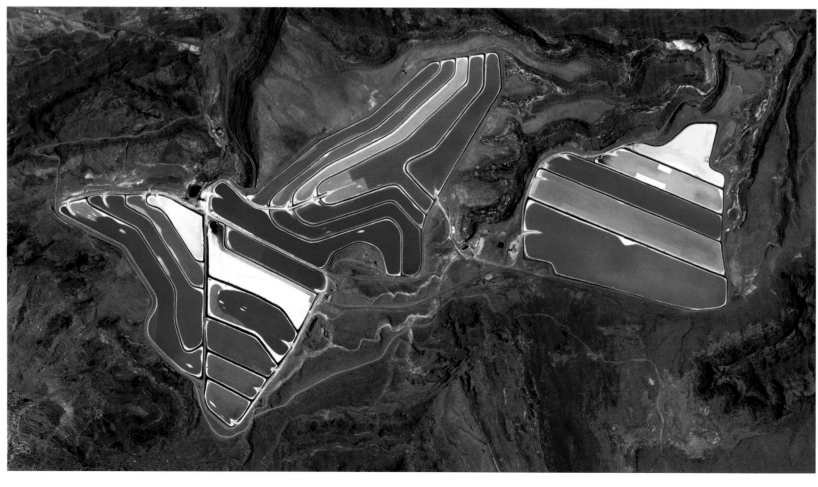

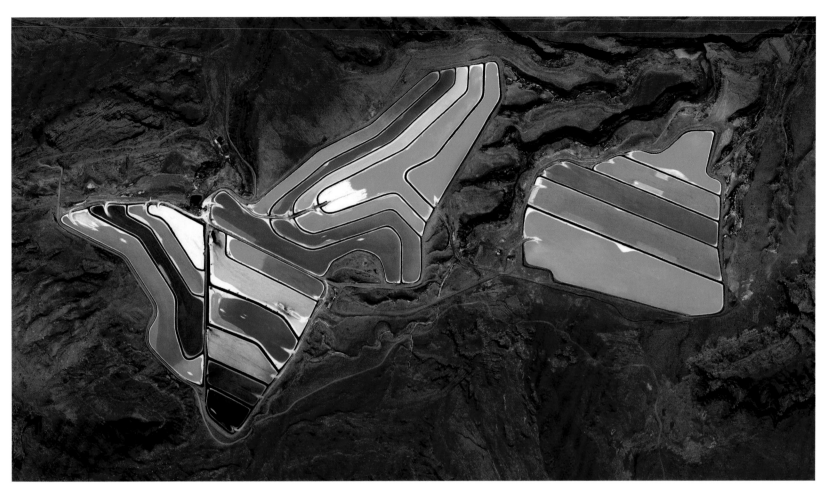

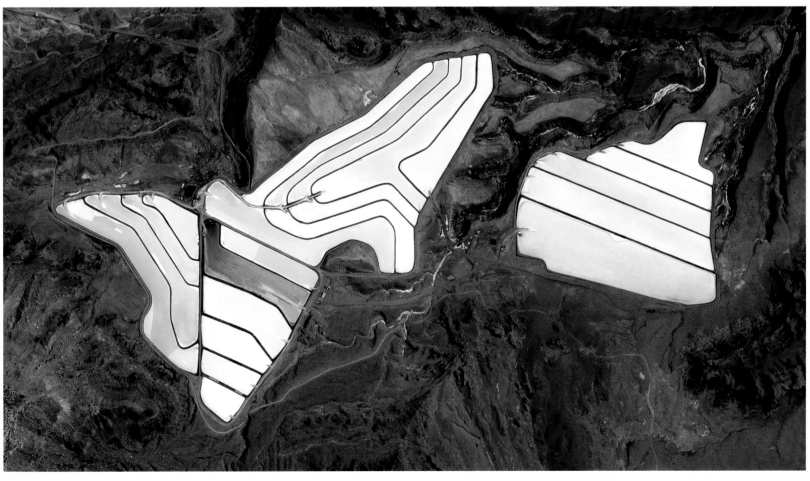

PREVIOUS PAGE

MOAB POTASH EVAPORATION PONDS

38.485579°, −109.684611°

Evaporation ponds are visible at the potash mine in Moab, Utah, USA. The mine produces muriate of potash, a potassium-containing salt that is a major component in fertilizers. The salt is pumped to the surface from underground brines and dried in massive solar ponds that vibrantly extend across the landscape. As the water evaporates over the course of 300 days, the salts crystallize out. The variation of colors that are seen here occur because the water is dyed a deep blue, as darker water absorbs more sunlight and heat, thereby reducing the amount of time it takes for the water to evaporate and the potash to crystallize. Over time, the intensity of the color dissipates as some of the water evaporates.

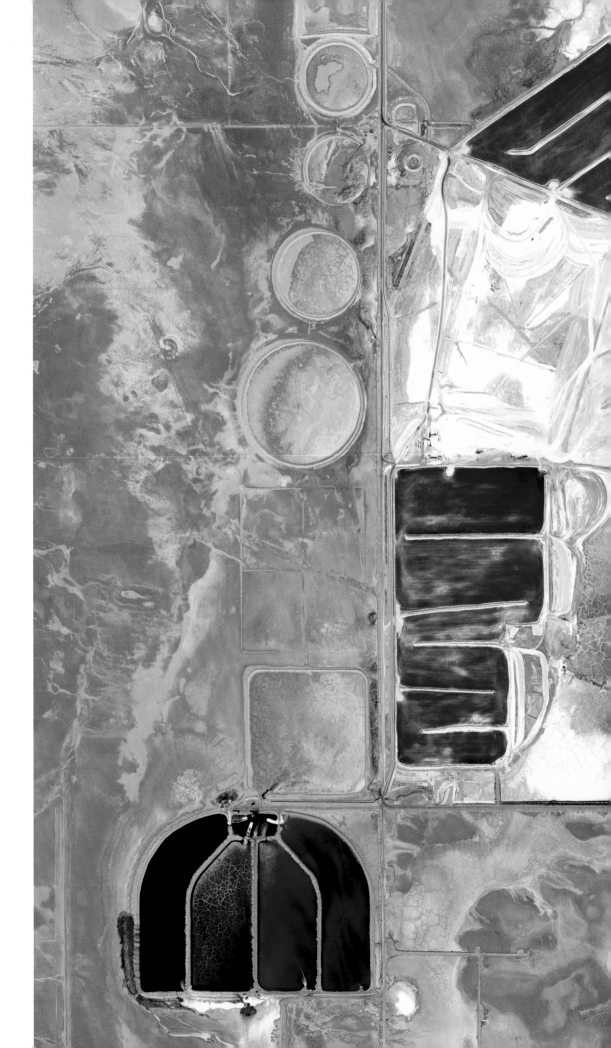

RIGHT

SEARLES LAKE

35.711209°, −117.361819°

Searles Lake is a 12-mile-long (19-kilometer), evaporated basin in the Mojave Desert of California, USA. The brine wells here tap into 4 billion tons of sodium and potassium mineral reserves in order to produce the essential ingredients for products such as detergents, cosmetics, and insecticides.

PORTO TROMBETAS BAUXITE MINE EXPANSION −1.688161°, −56.489029° AUGUST 2005

The Porto Trombetas Mine opened in 1979. As witnessed in this Juxtapose, the facility has continued to
expand and is now the largest bauxite mine in Brazil, with an annual output of 18 million tons. Aluminum

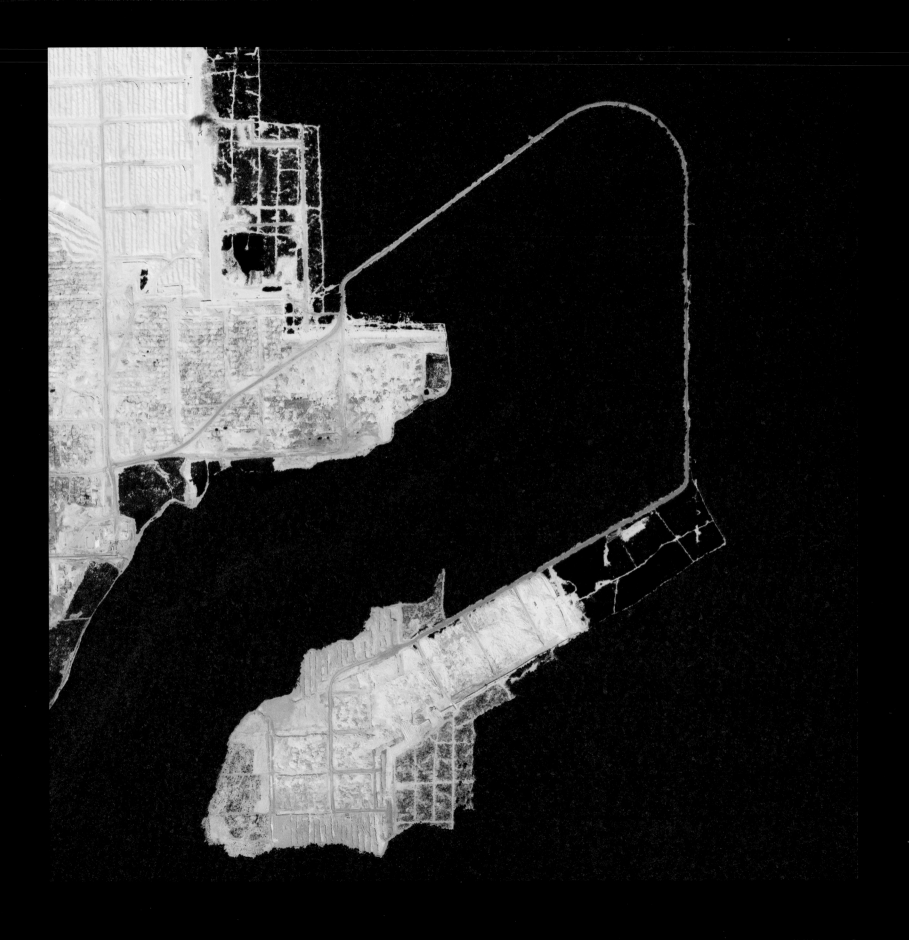

The first step in producing aluminum is mining its ore—bauxite. Then, aluminum manufacturing takes place in two phases: the Bayer Process to refine the bauxite ore in order to obtain aluminum oxide, and the Hall-Héroult Process to smelt the aluminum oxide in order to release pure aluminum.

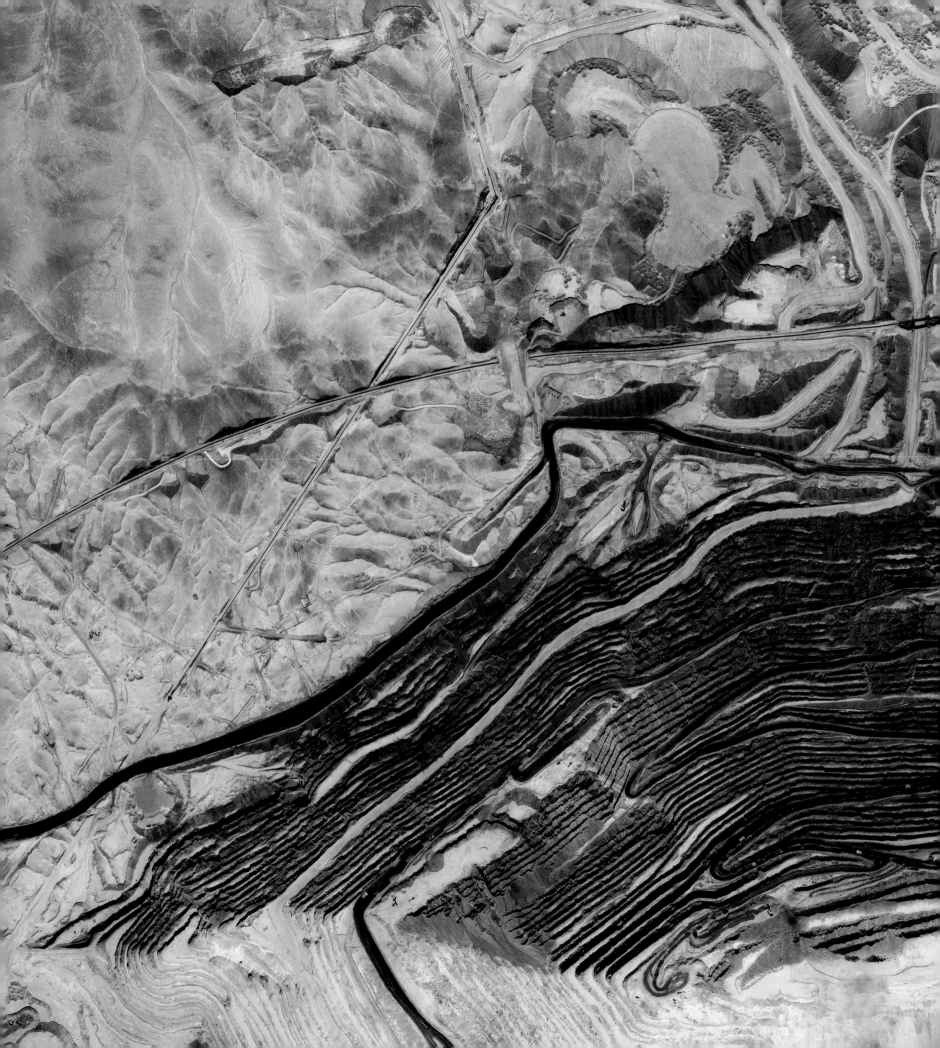

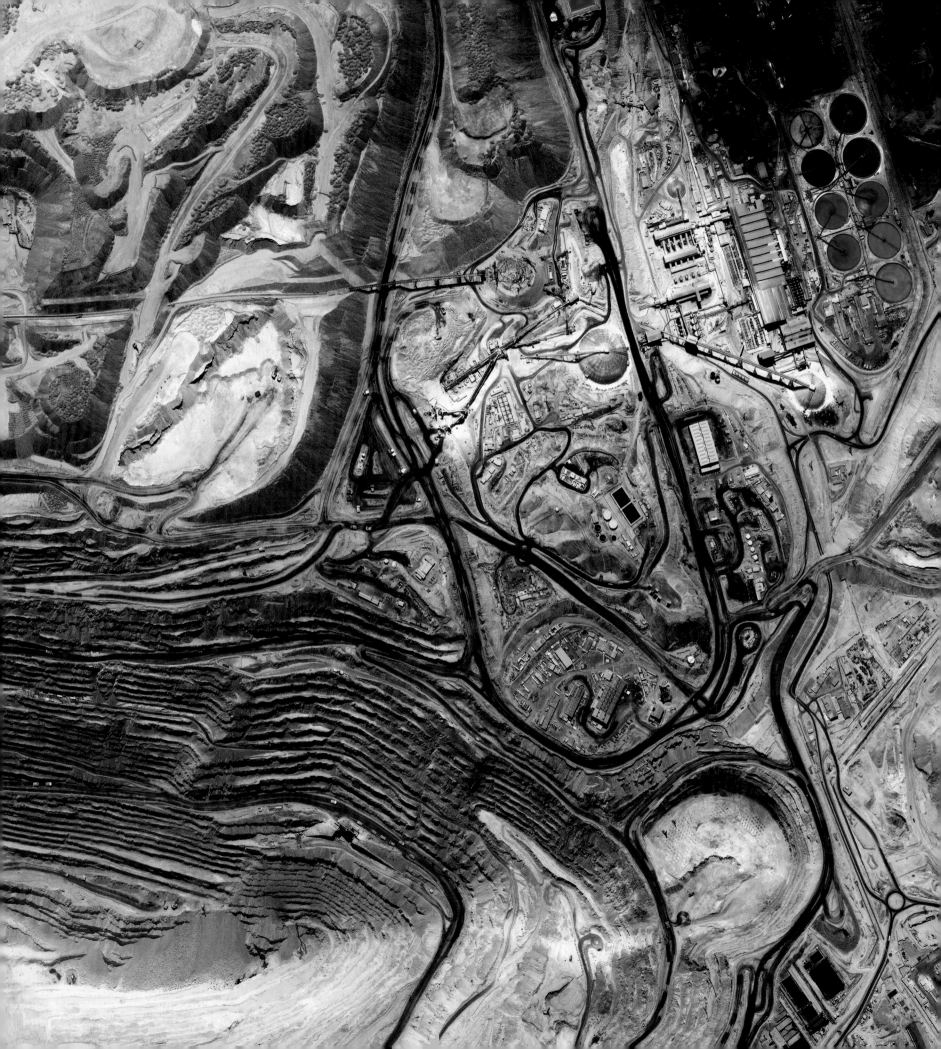

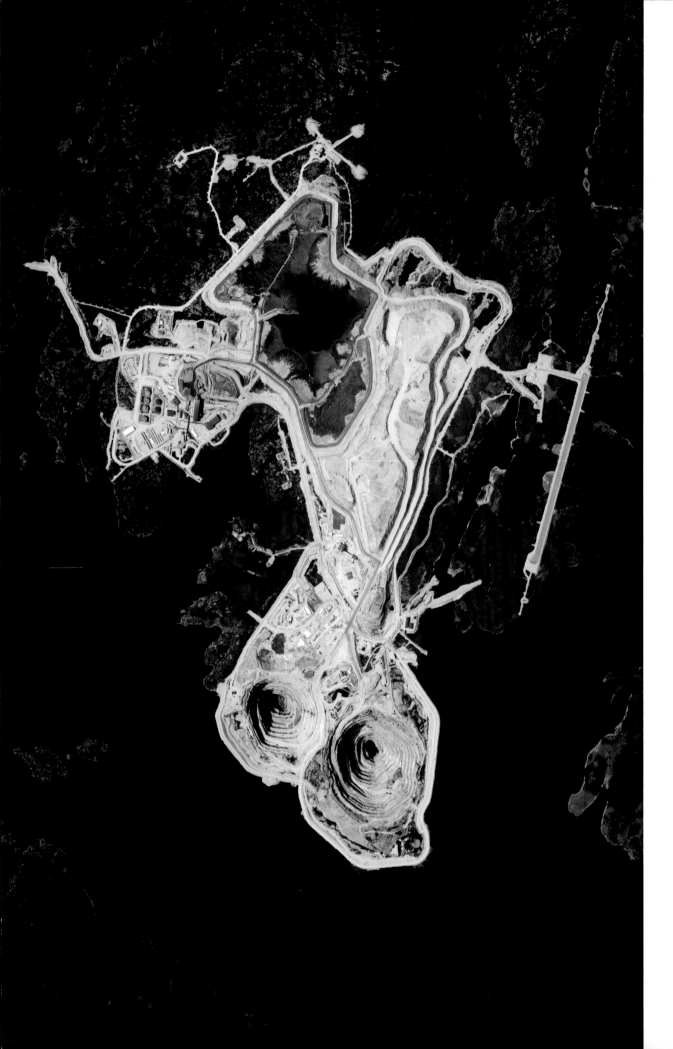

PREVIOUS PAGE
CHUQUICAMATA COPPER MINE
−22.288964°, −68.896753°
Chuquicamata is the largest open-pit
copper mine in the world. Located
in the Antofagasta Region of Chile,
the 2,790-foot-deep (850-meter) site
has enabled the extraction of more than
29 million tons of copper. The major
applications of copper are in electrical
wires (approximately 60 percent of total
use), roofing and plumbing (approximately
20 percent) and industrial machinery
(approximately 15 percent). Copper is
also combined with other elements to
make alloys (approximately 5 percent)
such as brass and bronze.

LEFT
DIAVIK DIAMOND MINE
64.496111°, −110.273333°
The Diavik Diamond Mine is located on the
Lac de Gras in the Northwest Territories
of Canada, 120 miles (193 kilometers) south
of the Arctic Circle. The mine produces
approximately 7.5 million carats of
diamonds each year. In standard weight,
that's an annual output of 3,300 pounds
(1,500 kilograms).

RIGHT
JWANENG DIAMOND MINE
−24.523050°, 24.699750°
The Jwaneng Diamond Mine in Botswana
is the richest diamond mine in the world,
with an annual output of approximately
15.6 million carats. Mine richness takes into
account the rate of diamond extraction
combined with the quality of the diamonds
that are mined (sale price per weight).
To extract the diamonds, the facility
produces 9.3 million tons of ore and an
additional 37 million tons of waste rock
per year.

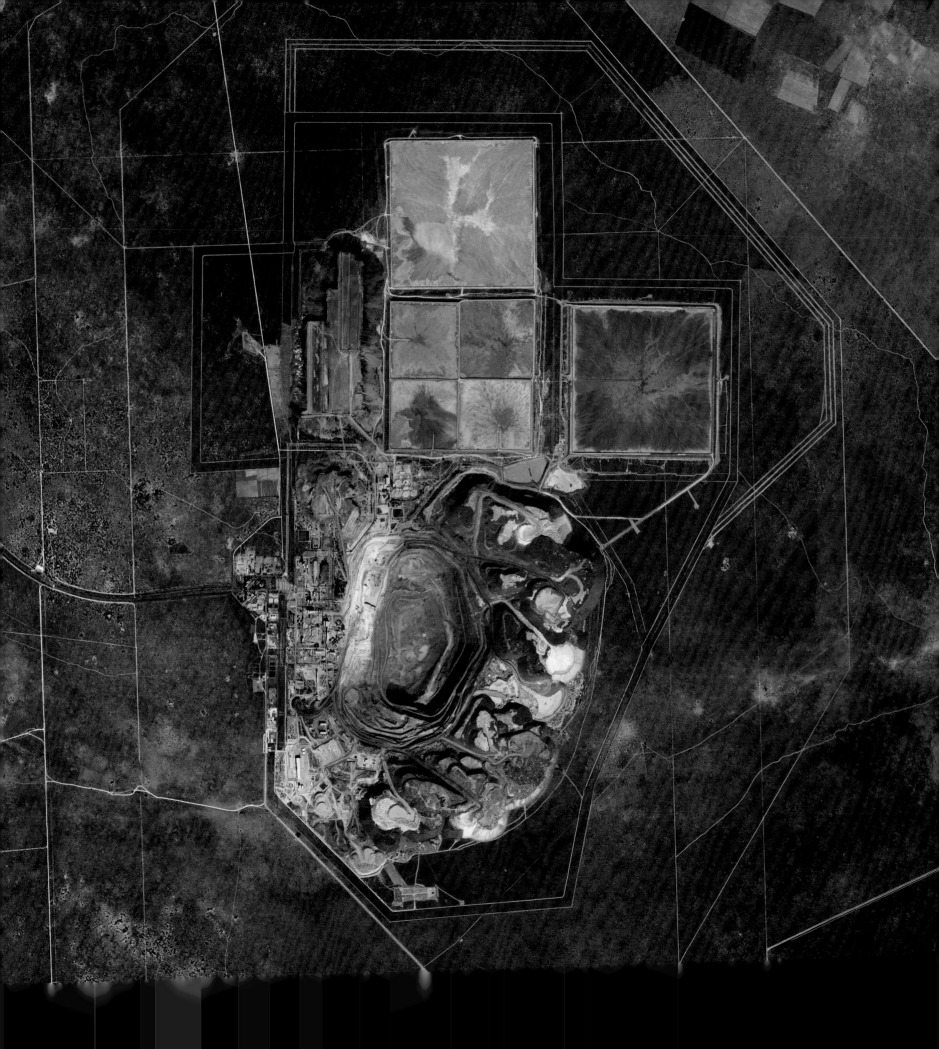

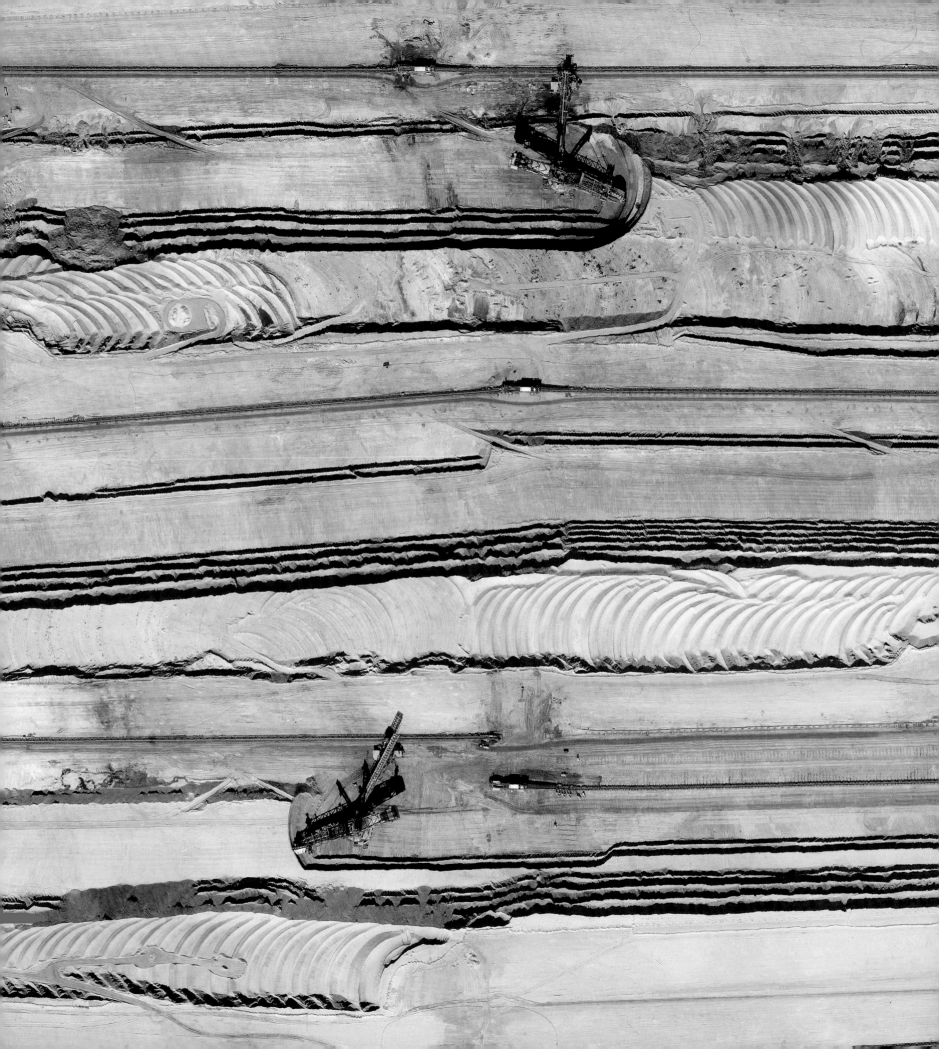

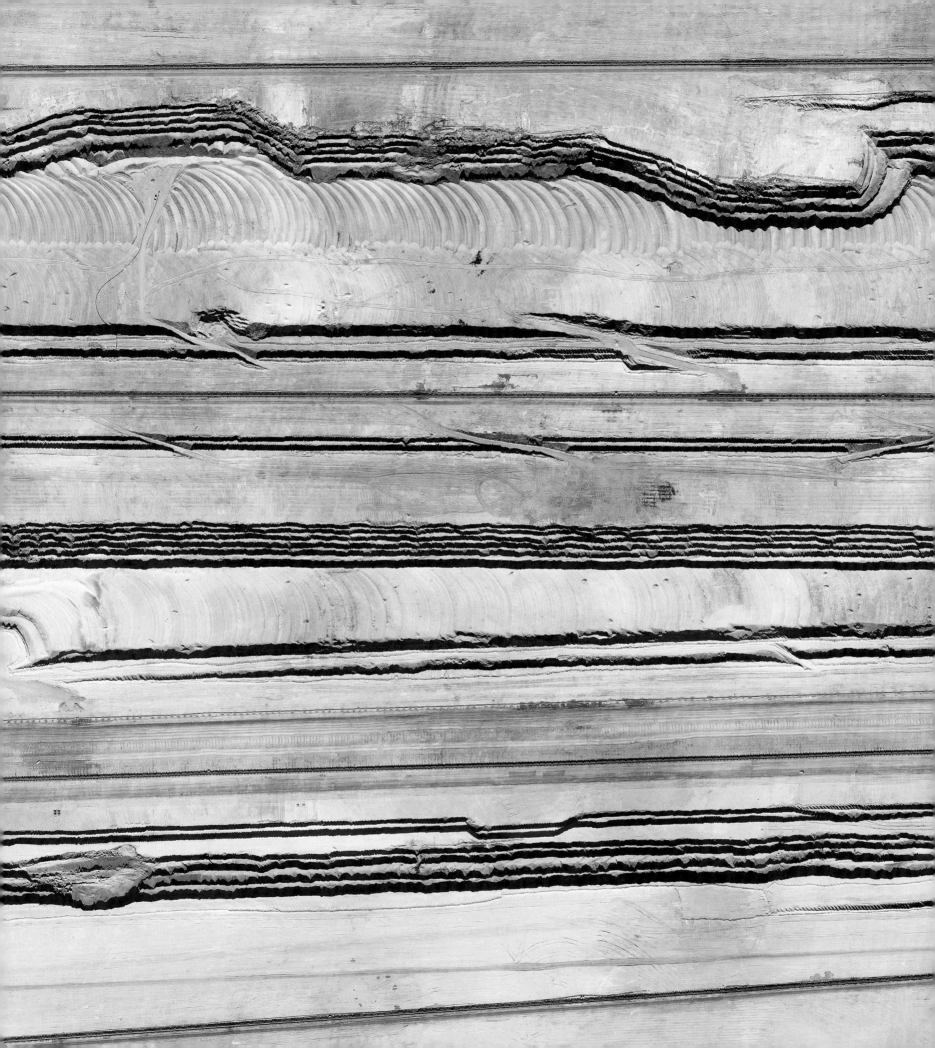

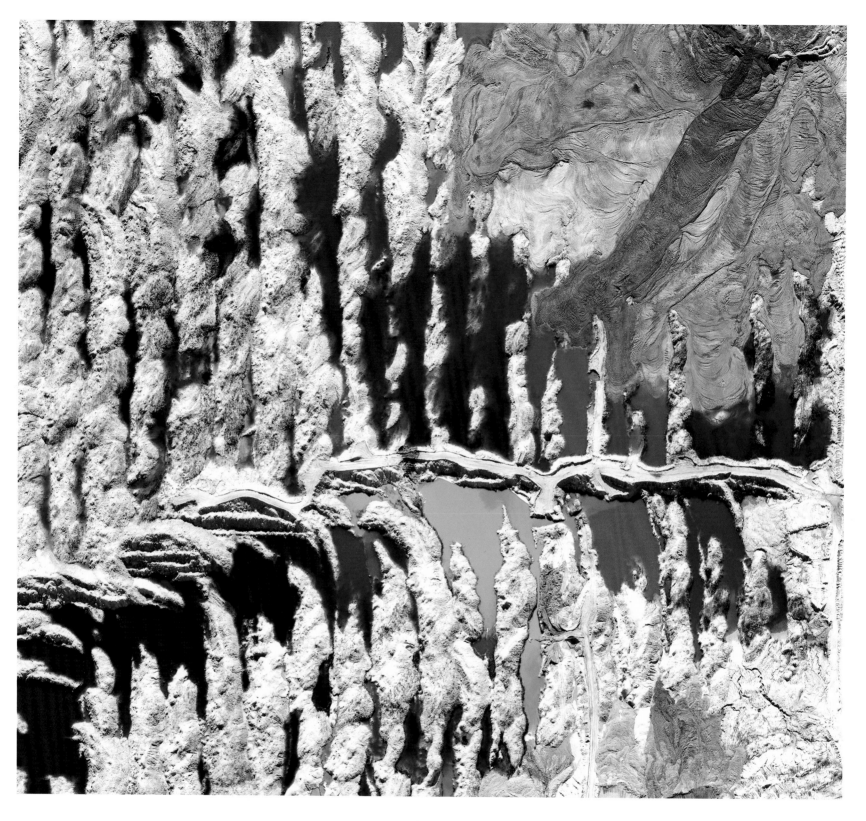

PREVIOUS PAGE

TAGEBAU HAMBACH SURFACE MINE

50.911368°, 6.547357°

Bucket-wheel excavators run on tracks at the Tagebau Hambach open-pit mine in Etzweiler, Germany. These massive vehicles—considered to be the largest land machines in the world at 315 feet (96 meters) tall and 730 feet (223 meters) long—continuously scoop materials from the surface in order to extract lignite. Lignite, often referred to as "brown coal," is a soft, combustible sedimentary rock that is formed from naturally compressed peat and is used as a fuel for steam-electric power generation.

ABOVE

AURORA PHOSPHATE MINE

35.375614°, −76.785105°

The Aurora Phosphate Mine in Aurora, North Carolina, USA, is the largest integrated phosphate mining and chemical plant in the world. The facility produces 6 million tons of phosphate and 1.2 million tons of phosphoric acid every year. Phosphate is used to create fertilizers and animal feed supplements, while phosphoric acid is an ingredient in food and beverage products, as well as metal treatment compounds.

RIGHT

ARLIT URANIUM MINE

18.748570°, 7.308219°

The Arlit Uranium Mine is located in Arlit, Niger. French nuclear power generation, as well as the French nuclear weapons program, are both dependent on the uranium that is extracted from the mine—more than 3,400 tons per year.

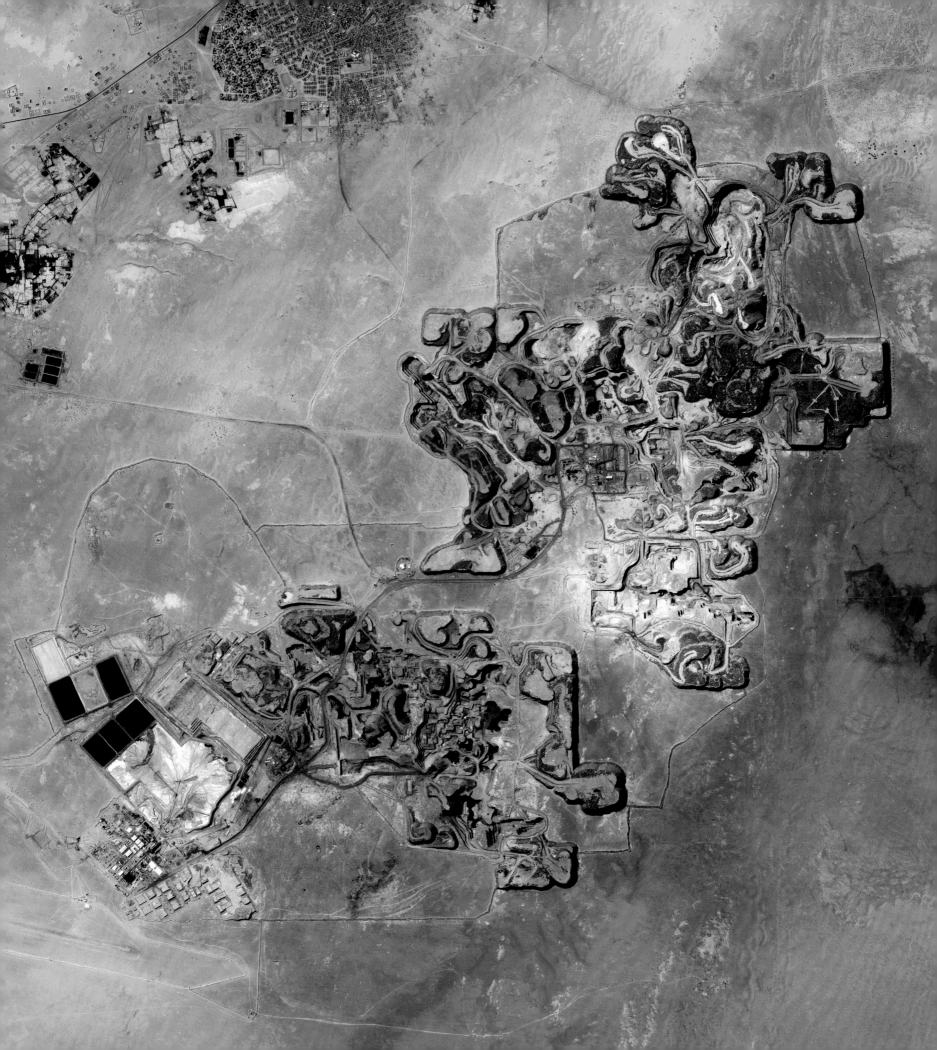

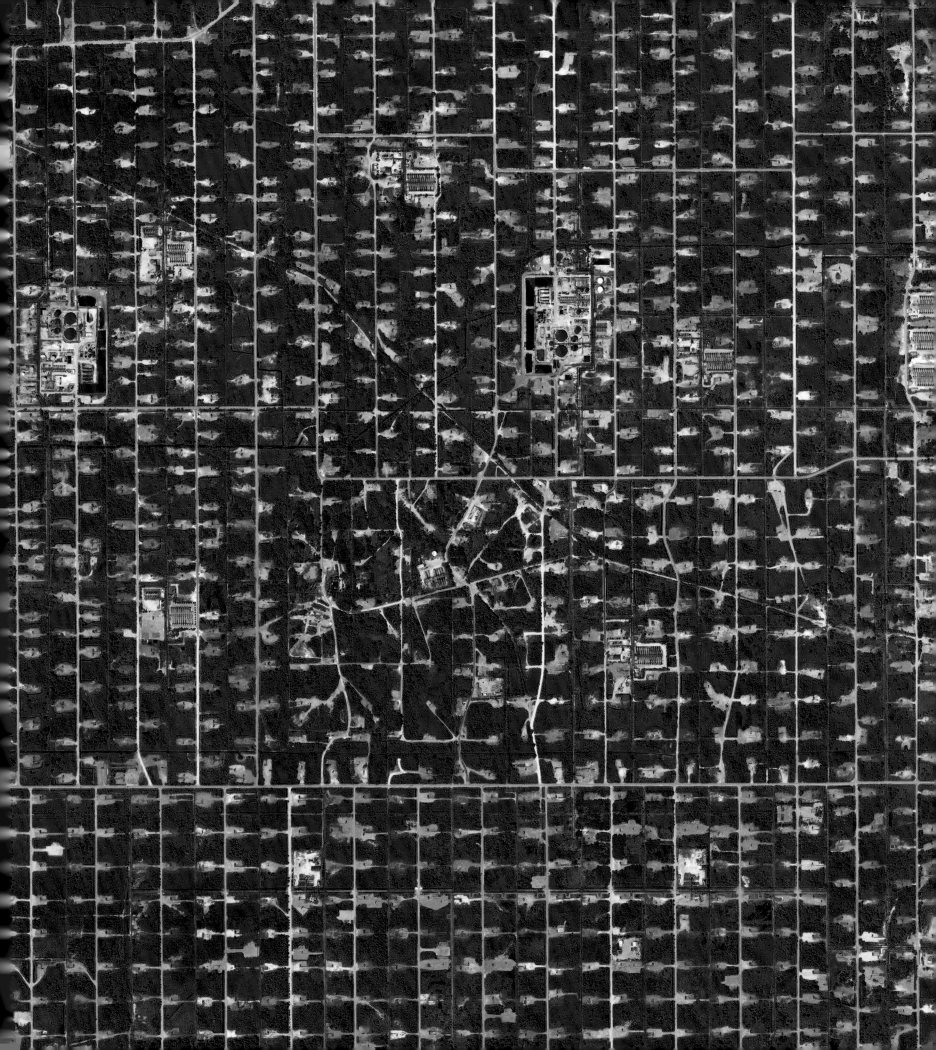

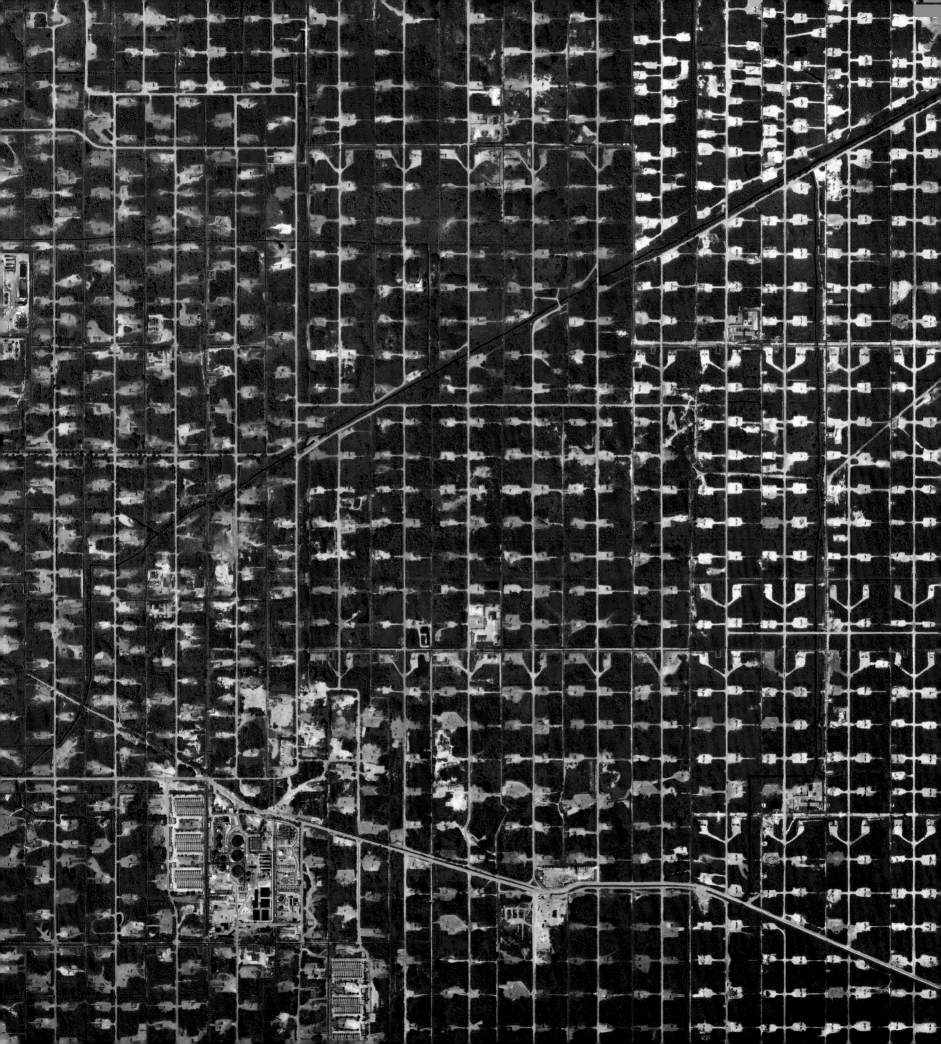

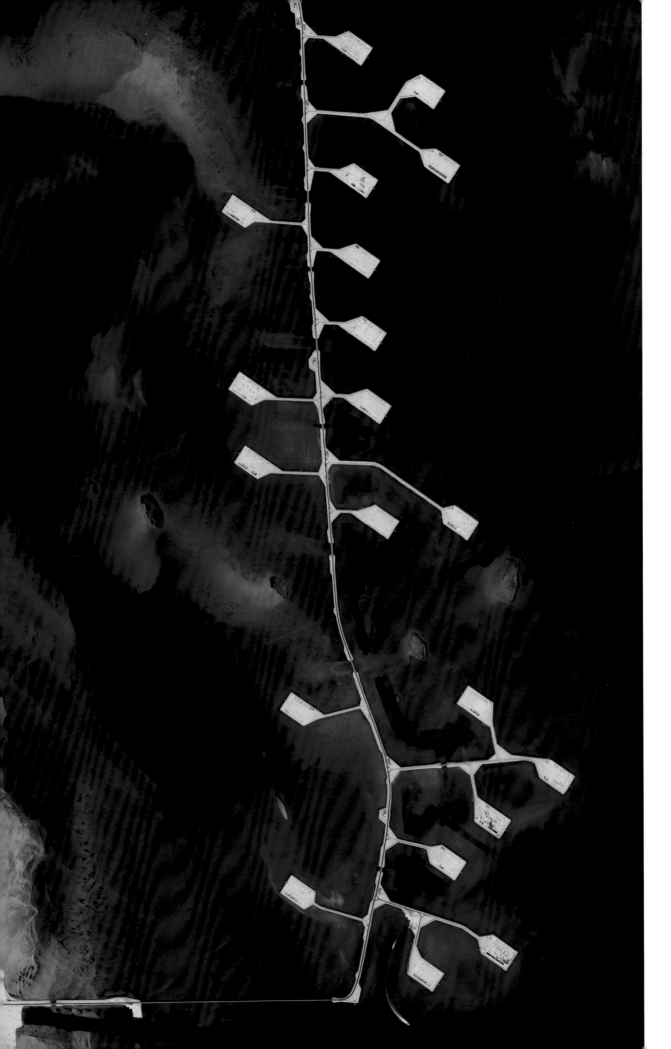

PREVIOUS PAGE

DURI OILFIELD

1.336220°, 101.228242°

The Duri Oilfield is located in the
Riau Province of Sumatra, Indonesia.
In operation since 1954, Duri now
covers approximately 125 square miles
(324 square kilometers), and produces an
average of 185,000 barrels of oil per day.

LEFT

MANIFA OILFIELD

27.639937°, 49.030375°

Pumping facilities are constructed on
artificial islands above the Manifa Oilfield
in Saudi Arabia. The field is considered
to be the fifth largest in the world, with
a pumping capacity of 900,000 barrels of
crude oil per day. Due to the shallow water
location of the field, access to offshore
drilling rigs would not have been possible
without extensive dredging. Accordingly,
a 13-mile (21-kilometer) causeway with
25 offshoot islands was constructed with
52 million cubic yards (40 million cubic
meters) of sand and 10 million tons of rock.
Each drilling island, approximately
1,100 feet by 850 feet (340 meters by
260 meters) in size, serves as a platform
to extract oil from beneath the surface.

RIGHT

PRIRAZLOMNOYE OIL RIG

69.251946°, 57.340583°

The Prirazlomnoye Oil Rig is the world's
first Arctic-class ice-resistant oil platform,
and took more than a decade to construct.
The Prirazlomnoye Oilfield—where
the structure is located in the Pechora
Sea, south of Novaya Zemlya, Russia—
has reserves of 610 million barrels of oil.
Environmentalists have actively criticized
the facility for not being adequately
prepared for a potential spill and the threat
it would cause to wildlife in the Arctic.

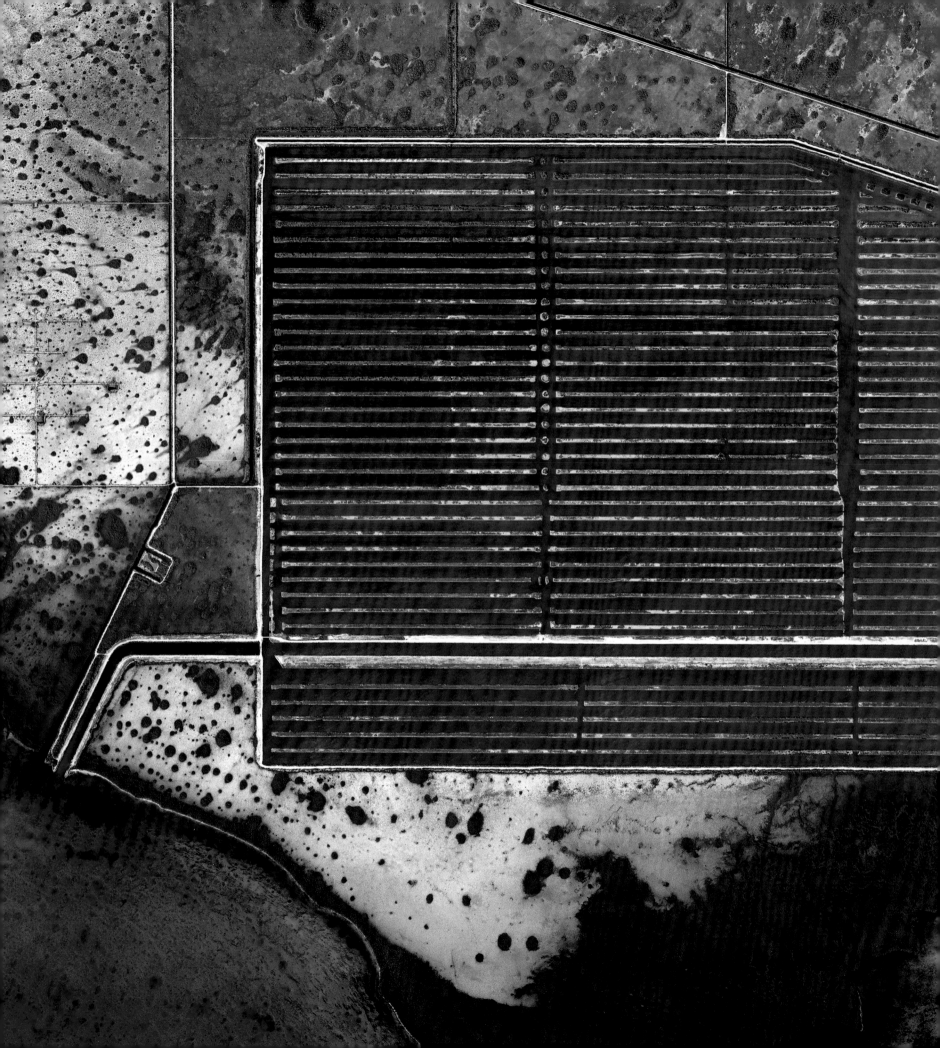

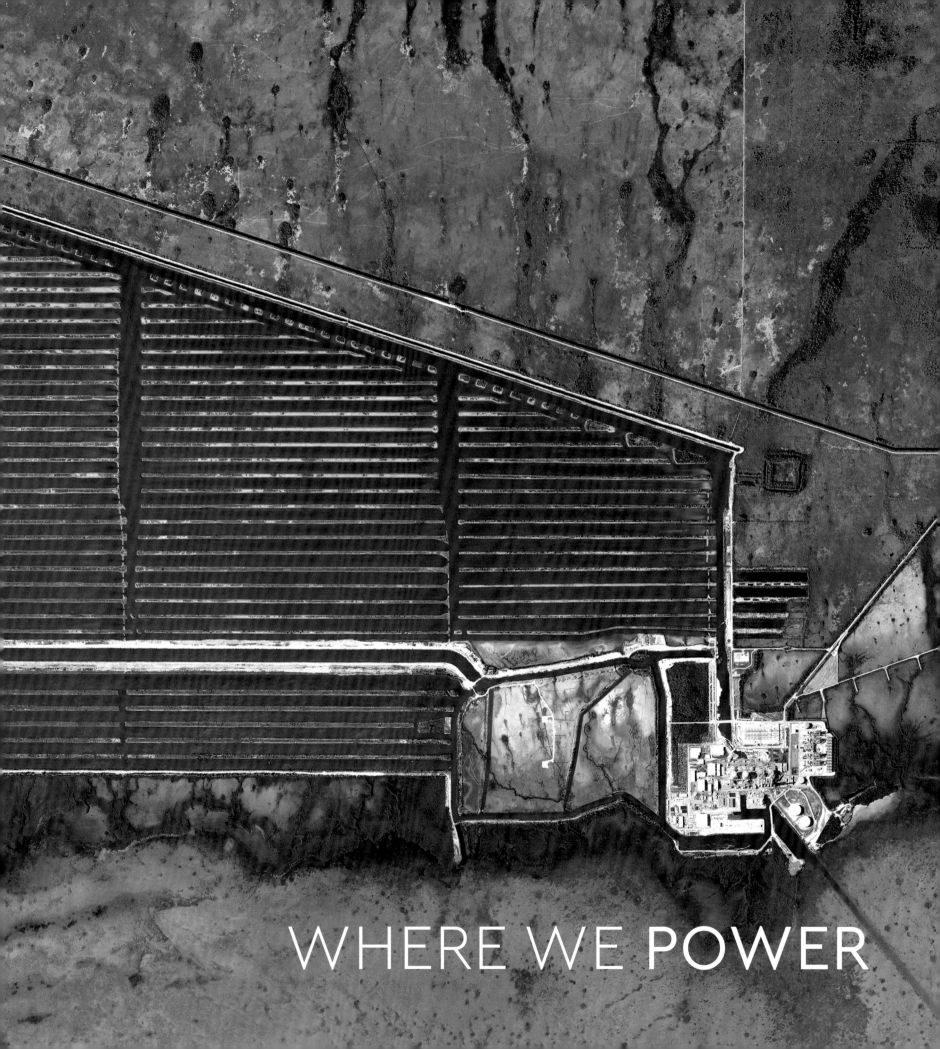

WHERE WE POWER

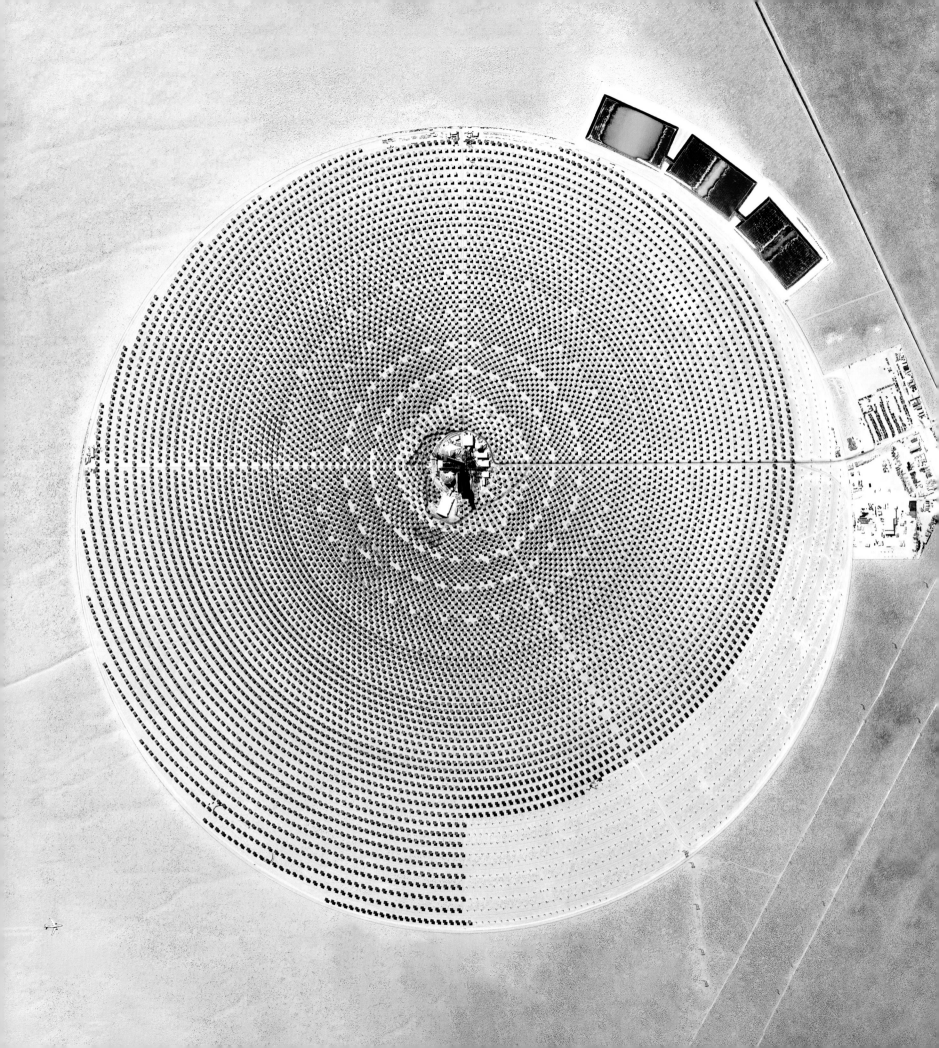

WHERE WE **POWER**

PREVIOUS PAGE

**TURKEY POINT NUCLEAR
GENERATING STATION**

25.394189°, −80.346119°

The Turkey Point Nuclear Generating Station
in Homestead, Florida, USA, is surrounded by an
extensive network of cooling canals. Water used to
cool the nuclear reactors is sent on a two-day journey
from the plant (seen here in the lower right) through
the 168-mile (270-kilometer) canal system before
it is circulated back for reuse. Because the water
in the canals is extremely warm and salty, the area
has become a preferred habitat and refuge for the
North American crocodile.

LEFT

CRESCENT DUNES SOLAR ENERGY PROJECT

38.238992°, −117.363770°

Seen here during its construction, the Crescent
Dunes Solar Energy Project near Tonopah, Nevada,
USA, now powers approximately 75,000 homes
during peak electricity periods. The facility uses
17,500 heliostat mirrors to collect and focus the sun's
thermal energy in order to heat molten salt flowing
through a 525-foot-tall (160-meter) solar power tower
at its center. The molten salt then flows from the
tower down to a storage tank, where it is used to
produce steam and generate electricity. For a sense
of scale, see the lower left corner, which shows
a commercial airplane flying over the complex.

Almost everything that we do requires energy. It is wired into our homes,
gives us light, charges our cellphones, washes our clothes, heats our food—
the list is endless. Yet rarely do we know or consider where our energy
comes from. Technological advancements have expanded not only the
number of ways we get our power but also the efficiency with which we
do so, and some of those methods are shown in this chapter.

From above the Earth, we can see where our power is generated,
and the massive spaces that are required to store the natural resources we
have extracted to fuel our power plants. One cannot help but notice how
much more integrated "clean" energy sources are with their surrounding
landscape (for example, wind and solar). And while aesthetics are only
a part of the story, there is no denying that we often find beauty in our
clean energy sources and disapprove of those that are "dirty" (for example,
oil and coal), even before we know the full context of what we are seeing.

Although modern energy has enabled widespread economic
and societal development, it is also one of our greatest environmental
concerns. We read and hear about carbon emissions and greenhouse gases,
but there is an inherent challenge in understanding an often invisible
enemy. Today, in 2016, there is no doubt that fossil fuels remain the
cheapest option for power generation. However, the scientific community
is all but unanimous on the dangers posed by the continued extraction
and burning of these ancient materials. To understand our energy better,
let us consider what it looks like, and where it is coming from.

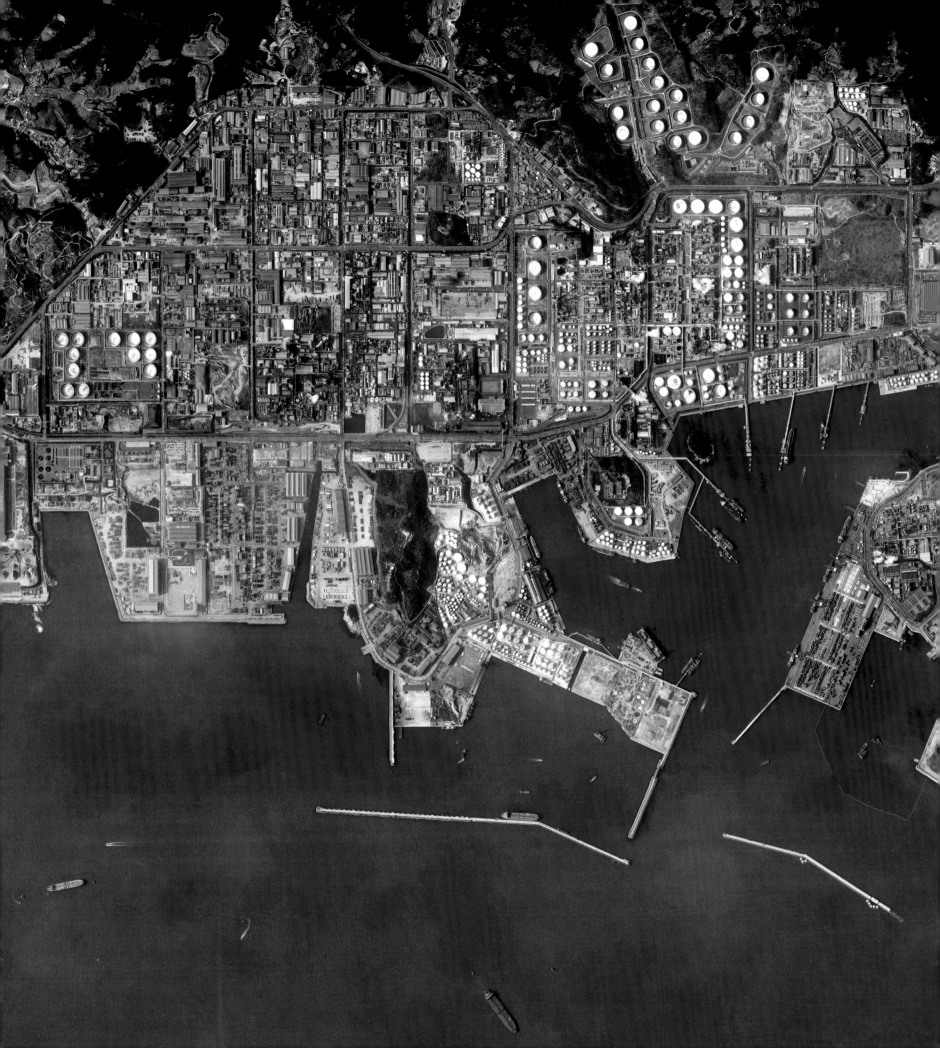

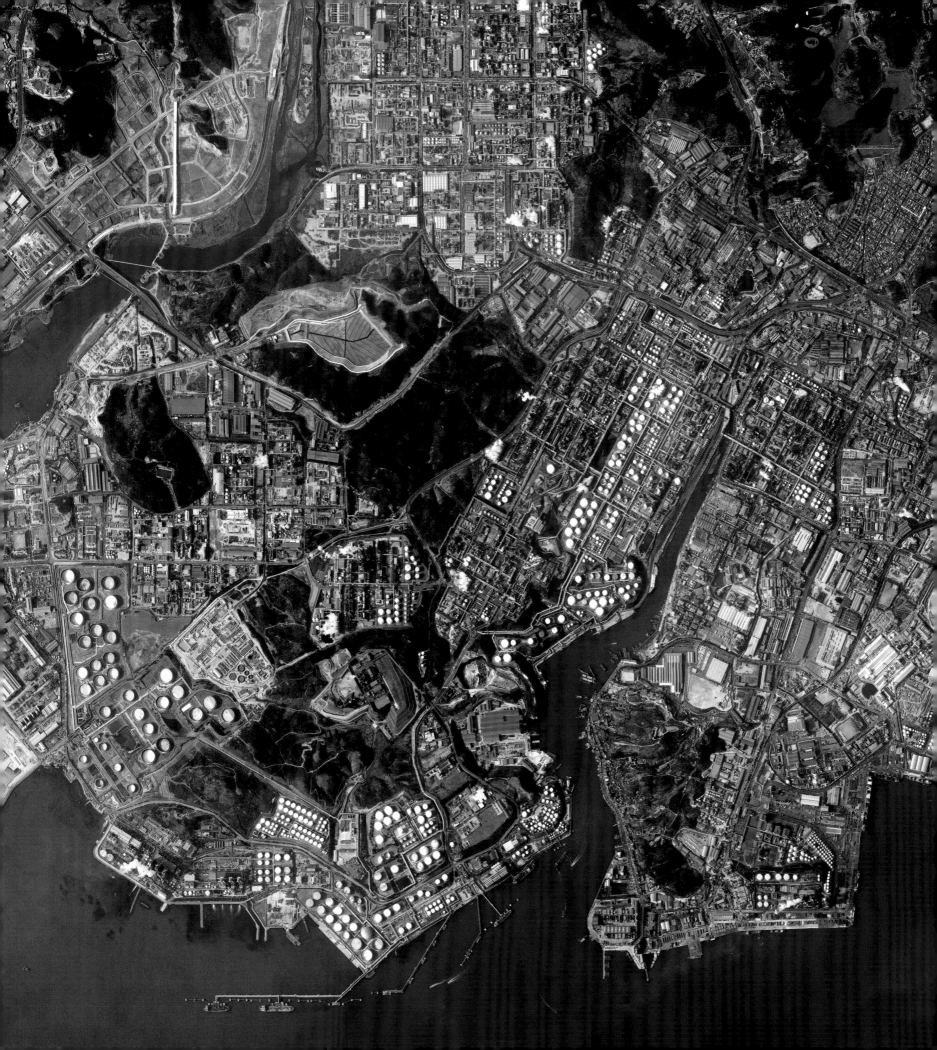

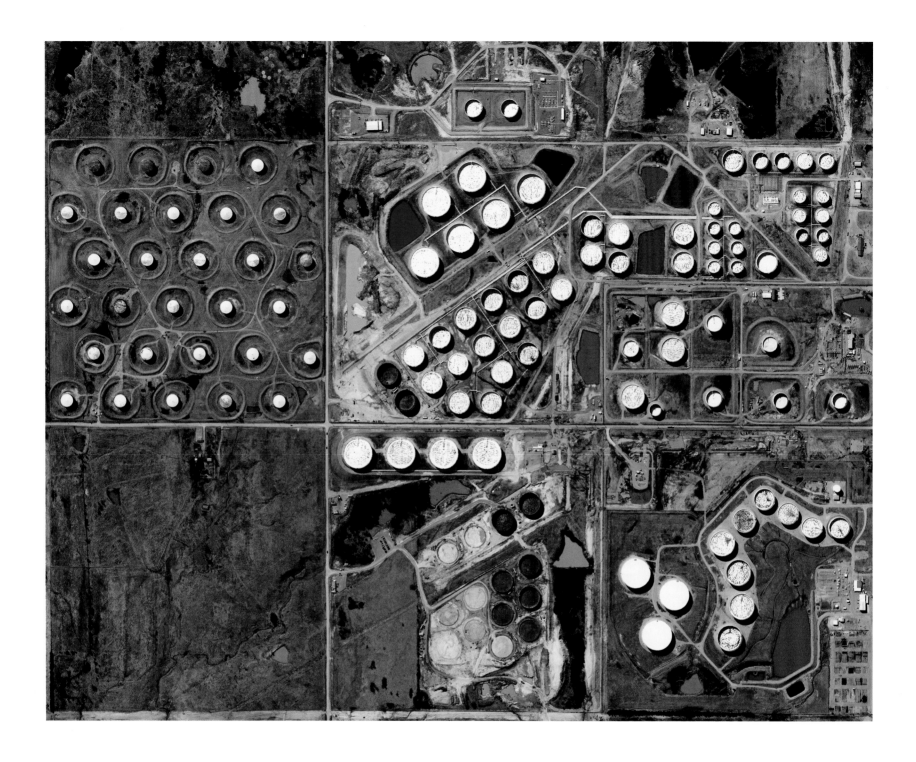

PREVIOUS PAGE
ULSAN REFINERY
35.460962°, 129.353486°
The Ulsan Refinery in Ulsan, South
Korea, is the third largest oil refinery
in the world. Crude oil is carried
here by oil tankers from the Middle
East, South America, and Africa.
The facility has a refining capacity
of 1,120,000 barrels per day and
produces liquefied petroleum gas,
gasoline, diesel, jet fuel, and asphalt.

ABOVE
CUSHING CRUDE OIL STORAGE
35.942624°, −96.752899°
The crude oil storage facilities in Cushing, Oklahoma,
USA—approximately 85 million barrels—are the
largest in the world and represent 13 percent of the
total crude storage capacity in the United States.
The town is strategically located at the intersection
of numerous pipelines, including a vital terminus
point of the Keystone Pipeline that runs south
from the tar sands of Alberta, Canada. The town of
Cushing, Oklahoma, is home to only 2,000 residents.

RIGHT
QINHUANGDAO COAL TERMINAL
39.933622°, 119.683840°
The coal terminal at the Port of Qinhuangdao in China is the largest coal
shipping facility in the country. From here, approximately 210 million tons
of coal are transported to coal-burning power plants throughout southern
China every year. In 2015, new data from the Chinese government revealed
that the country has been burning up to 17 percent more coal each year than
previously disclosed. The sharp upward revision in official figures means that
China has been burning an additional 600 million tons of coal each year,
and has released much more carbon dioxide—almost a billion more tons
per year—than previously estimated.

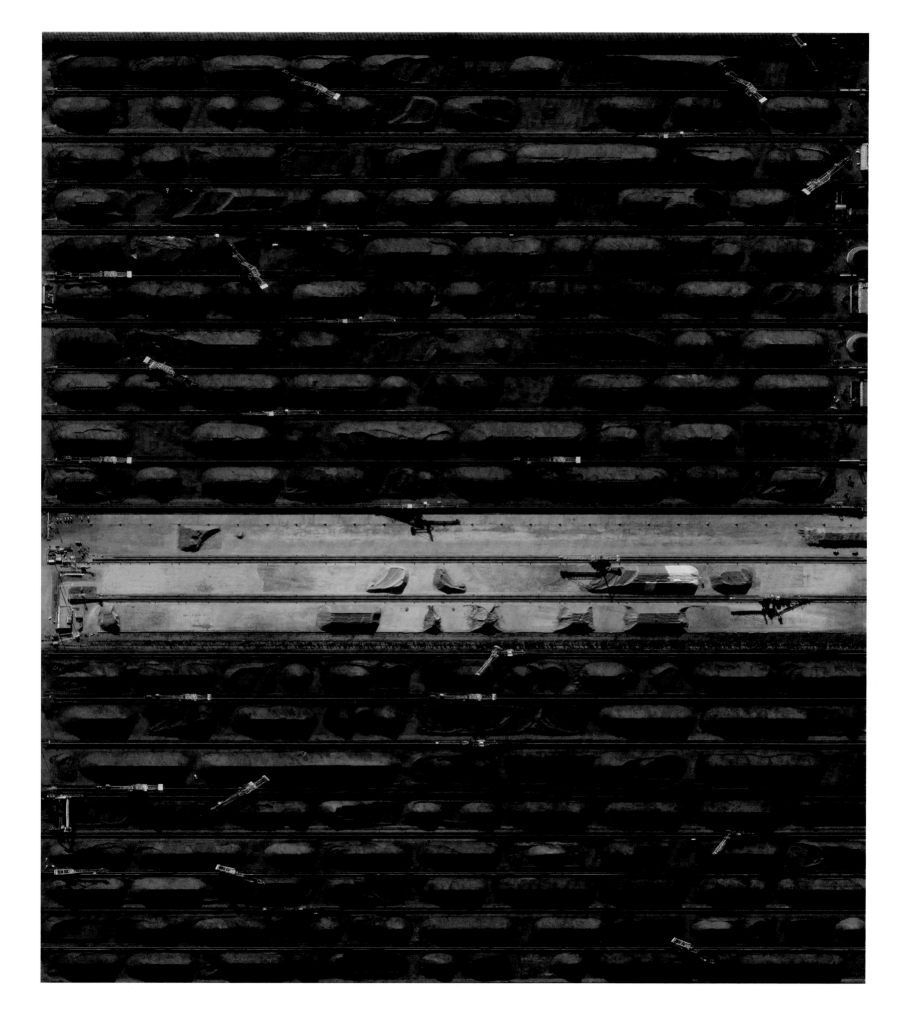

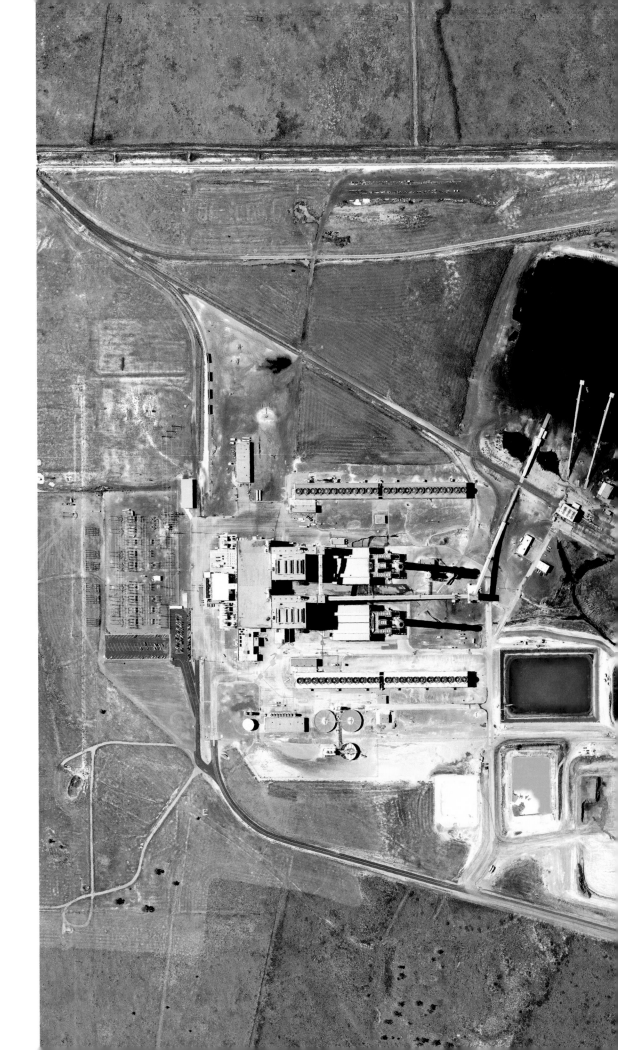

TOLK COAL-FIRED POWER STATION
34.195475°, -102.573681°

Tolk Station is a coal-fired, steam-electric power plant
near Sudan, Texas, USA. Coal, supplied primarily
from Wyoming's Powder River Basin, is unloaded from
railcars into the facility. Coal-fired plants produce
electricity by burning coal in a boiler in order to
produce steam. The steam then flows into a turbine,
which spins a generator to create electricity. The steam
is then cooled, condensed back into water, and returned
to the boiler to start the process over. The sludge and
contaminated water produced during these processes
at Tolk Station are dumped into waste ponds, seen in
the right of this Overview.

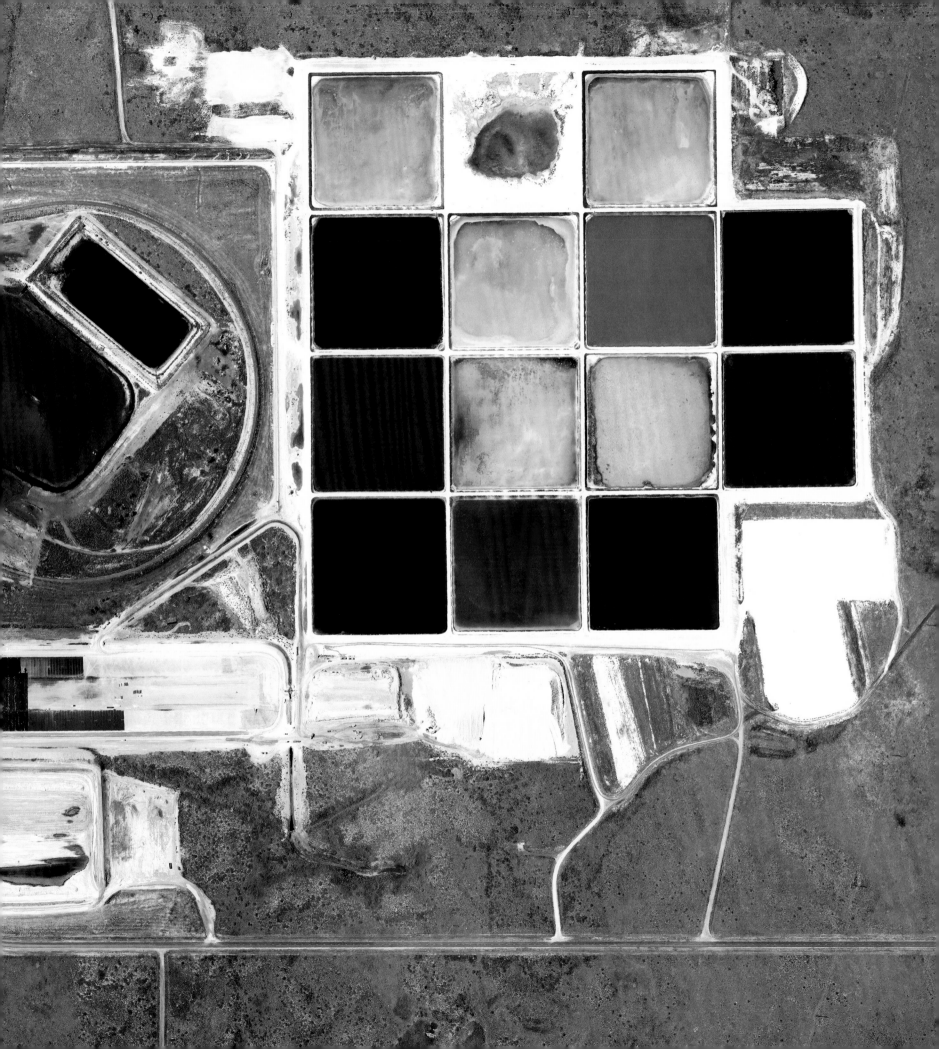

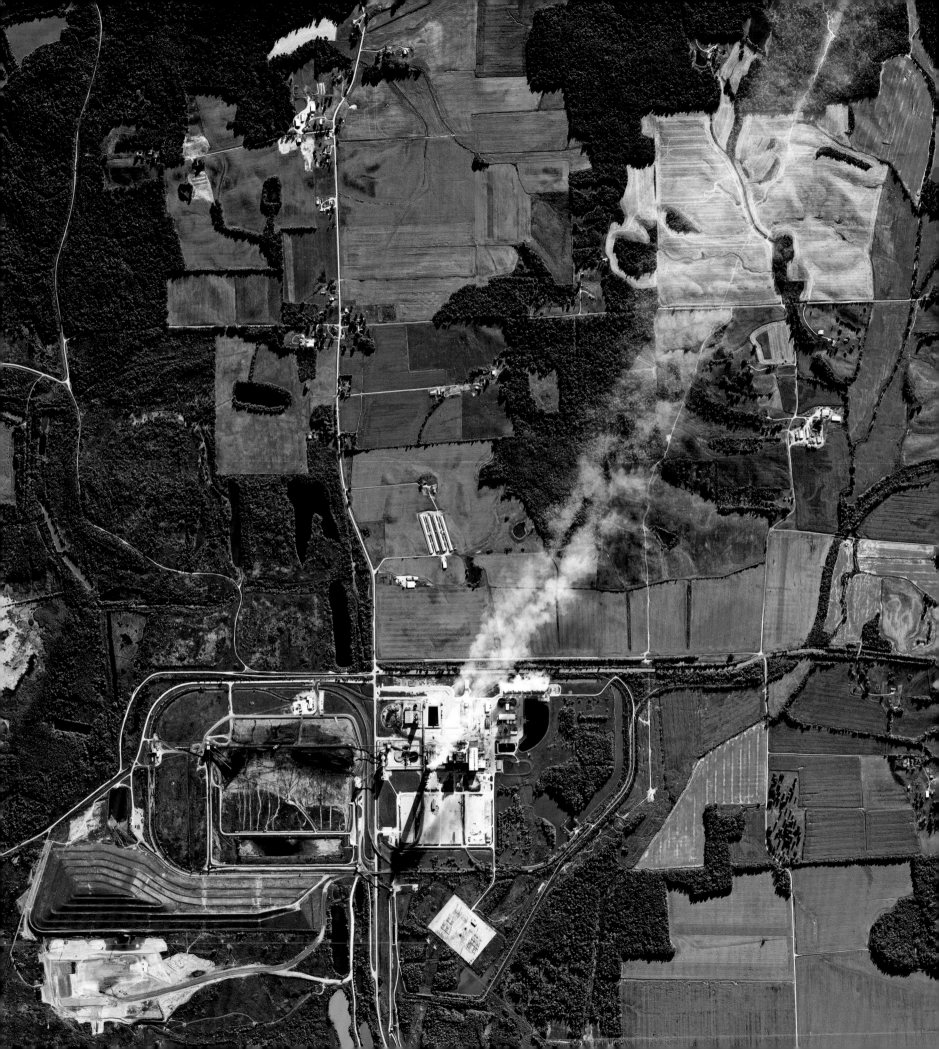

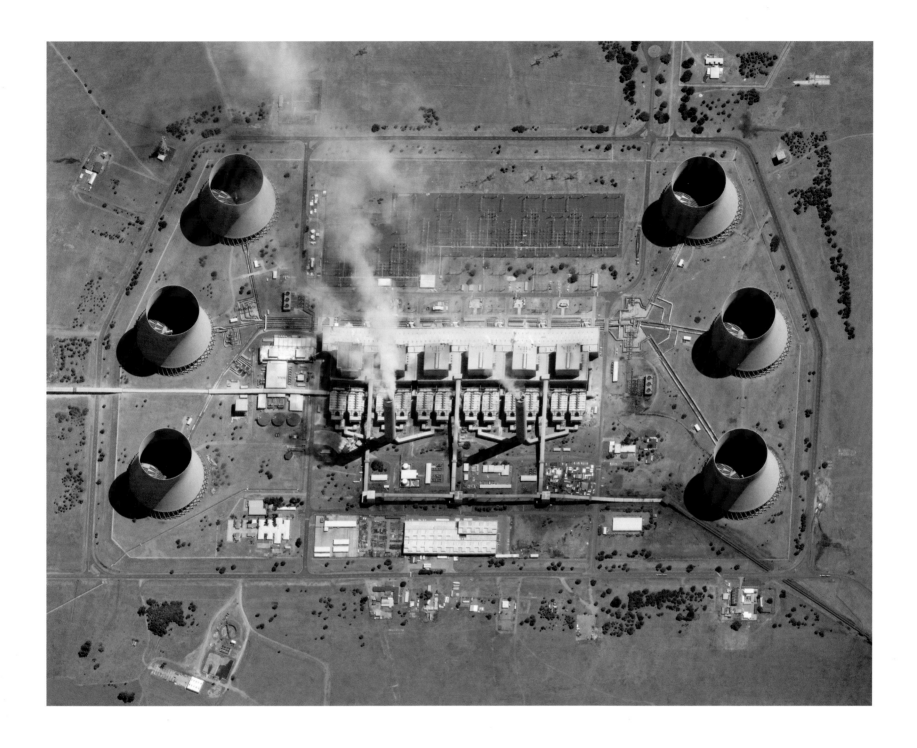

D.B. WILSON COAL-FIRED STATION
37.450255°, –87.084050°

The D.B. Wilson Station is located in Centertown, Kentucky, USA. Coal is the largest source of energy for the generation of electricity worldwide, as well as one of the largest human causes of carbon dioxide release. In 1999, world gross carbon dioxide emissions from coal usage were 8,666 million tons. By 2011, that figure had increased to 14,416 million tons.

KENDAL POWER STATION
–26.089118°, 28.968824°

Kendal Power Station is a coal-fired power station in Mpumalanga, South Africa. The facility uses a dry-cooling system, meaning it uses air instead of water to cool the steam exiting a turbine. While dry-cooled systems can decrease a plant's water consumption by more than 90 percent, they are less efficient and require more fuel to create the same amount of electricity. The station's six cooling towers are the largest structures of their kind in the world, with a height and base diameter of 541 feet (165 meters).

GILA RIVER POWER STATION
32.970997°, –112.708929°

The Gila River Power Station in Gila Bend, Arizona, USA contains eight turbines that are fueled by natural gas. The gas is delivered via a 19-mile (31-kilometer) pipeline and can produce approximately 2,200 megawatts of electrical power. The colorful rectangles seen in the center are the station's cooling ponds.

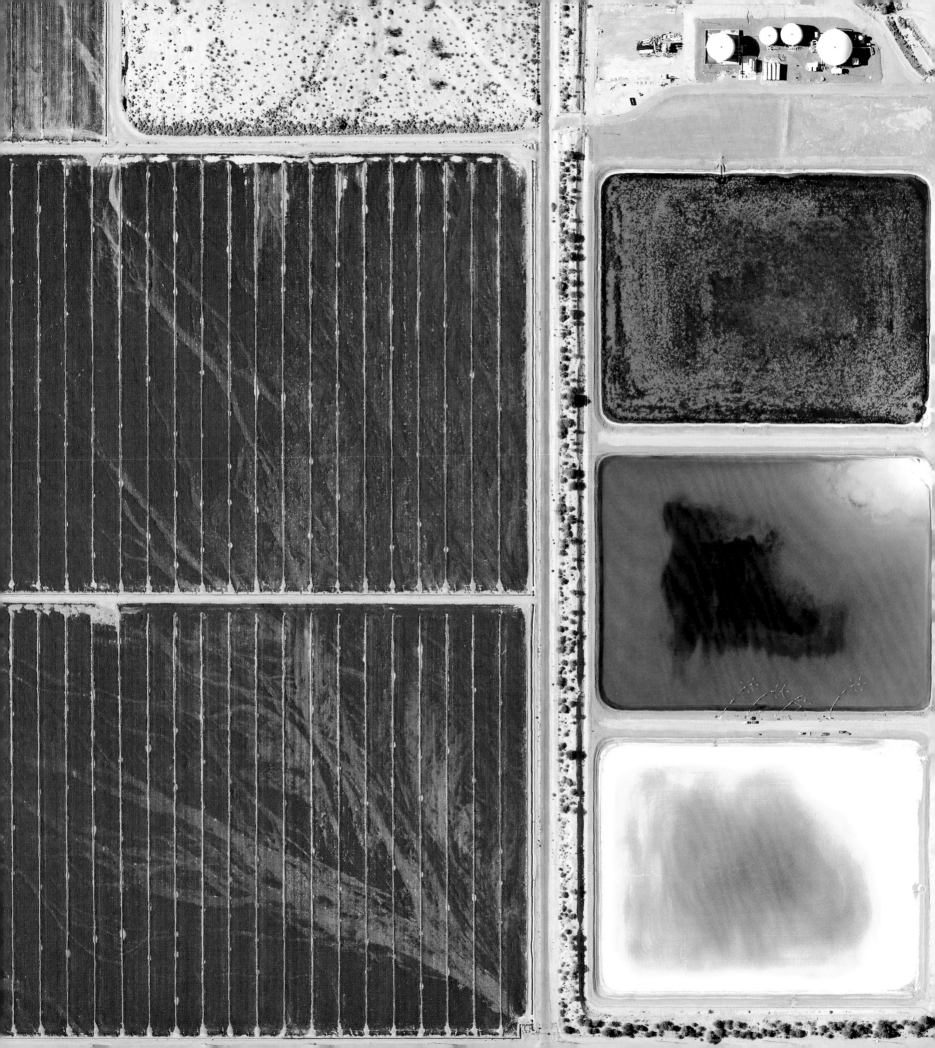

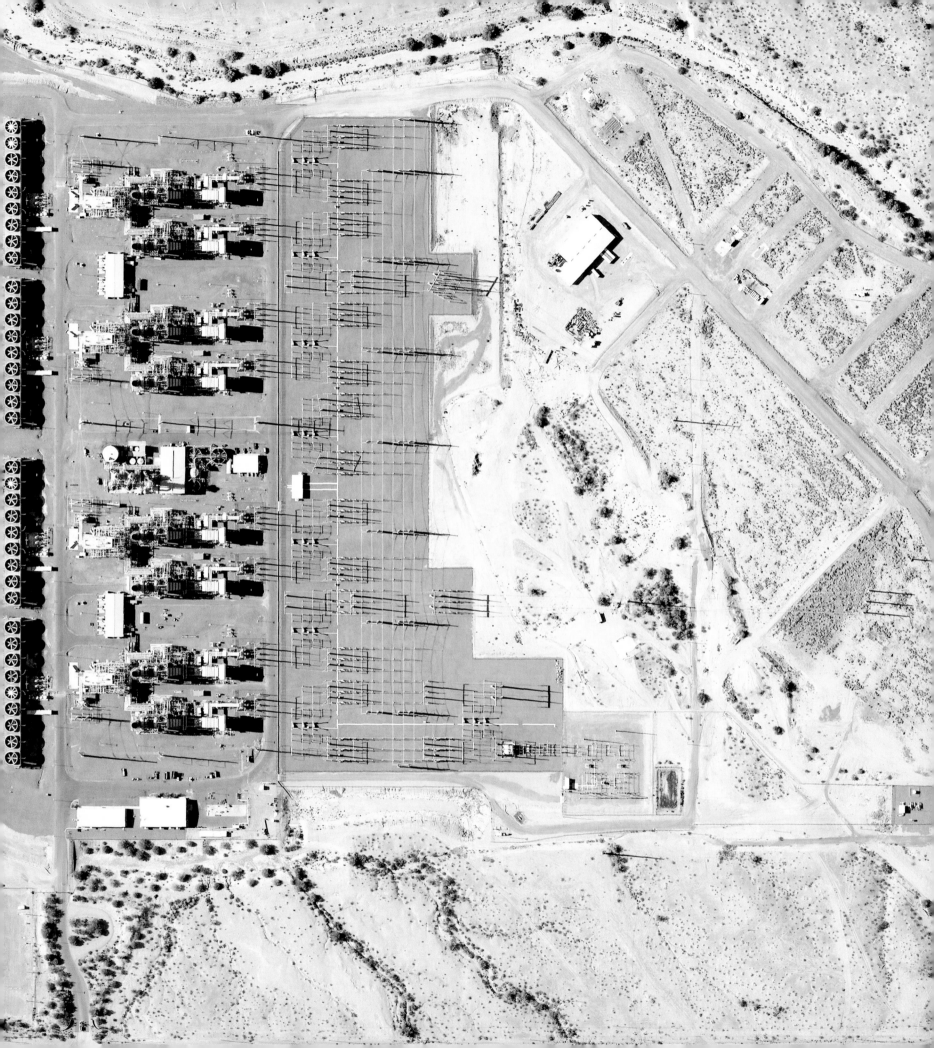

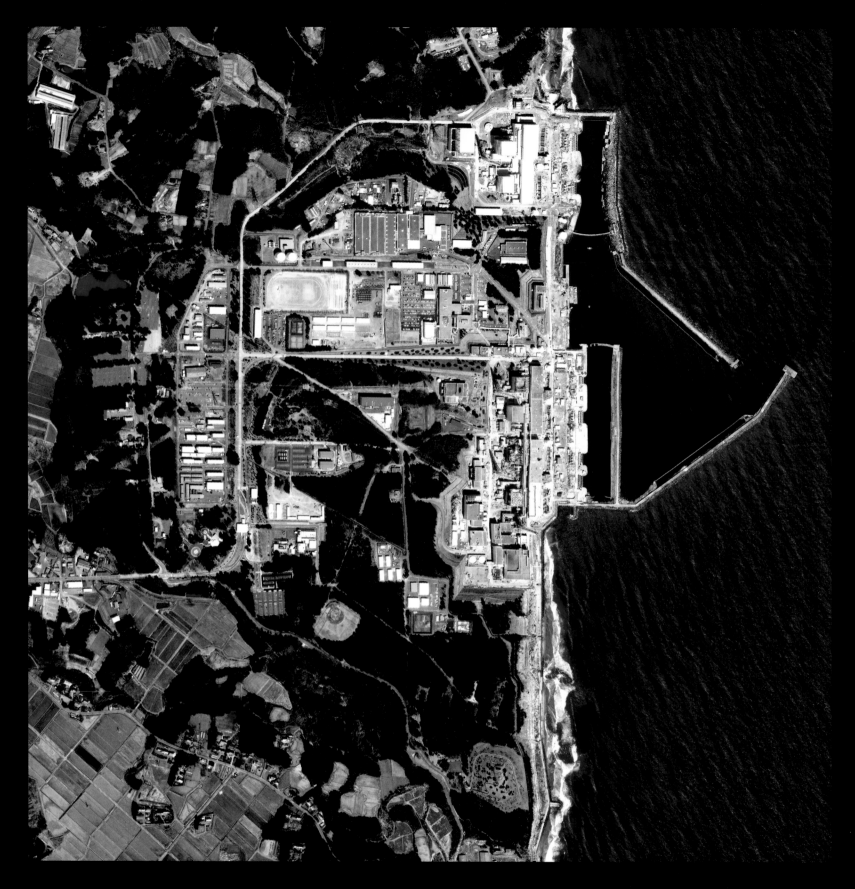

FUKUSHIMA DAIICHI NUCLEAR DISASTER 37.421405°, 141.030850°

On March 11, 2011, an earthquake with a magnitude of 9.0—one of the most powerful earthquakes ever measured—struck off the northeast coast of Japan. The resulting tsunami wreaked massive damage across the country, including violent swells up to 46 feet (14 meters) that rose over the seawalls at the Fukushima Daiichi Nuclear Power Plant. Over the three weeks that followed the earthquake, explosions and partial nuclear meltdowns occurred in reactors 1, 2, and 3 (reactors 4, 5, and 6 were not operating when the quake struck).

APRIL 2011

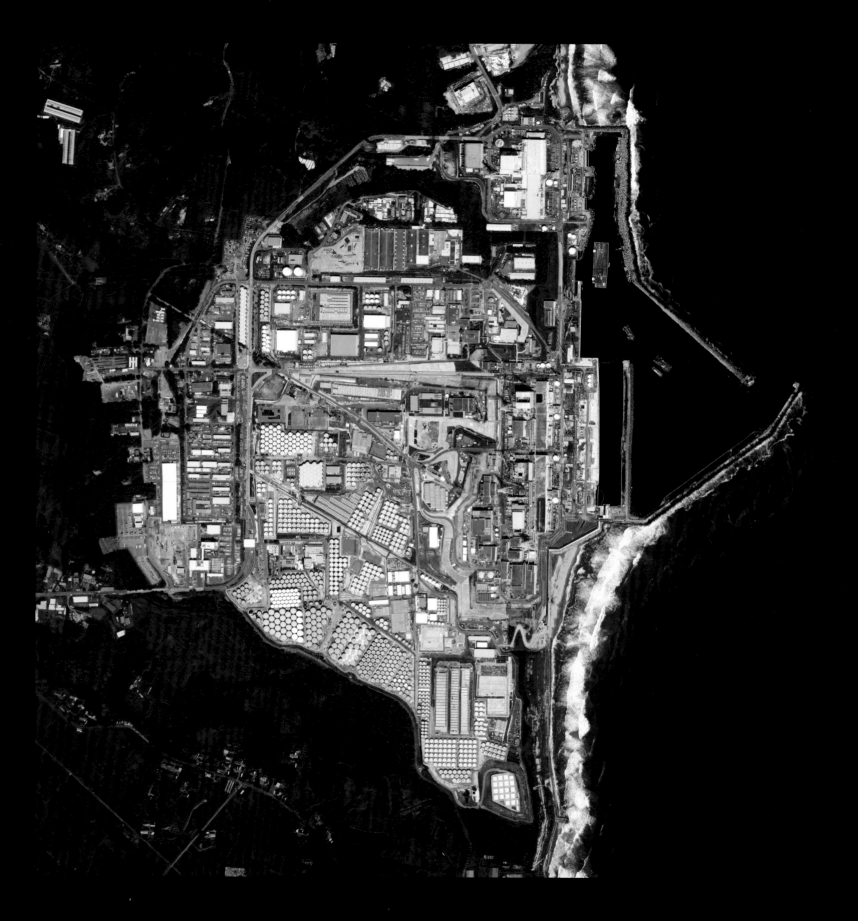

In an effort to contain the water that has been pumped in to cool the melted reactors, thousands of steel barrels (seen primarily in the bottom half of the second Overview) have been constructed at the site to hold approximately 200 million gallons of the contaminated liquid. Yet in 2013, Japanese officials announced that the highly radioactive coolant was leaking into the Pacific Ocean at a rate of 300 tons per day—enough to fill an Olympic swimming pool in a week. The cost for the cleanup effort is estimated at $11 billion USD over the next 40 years.

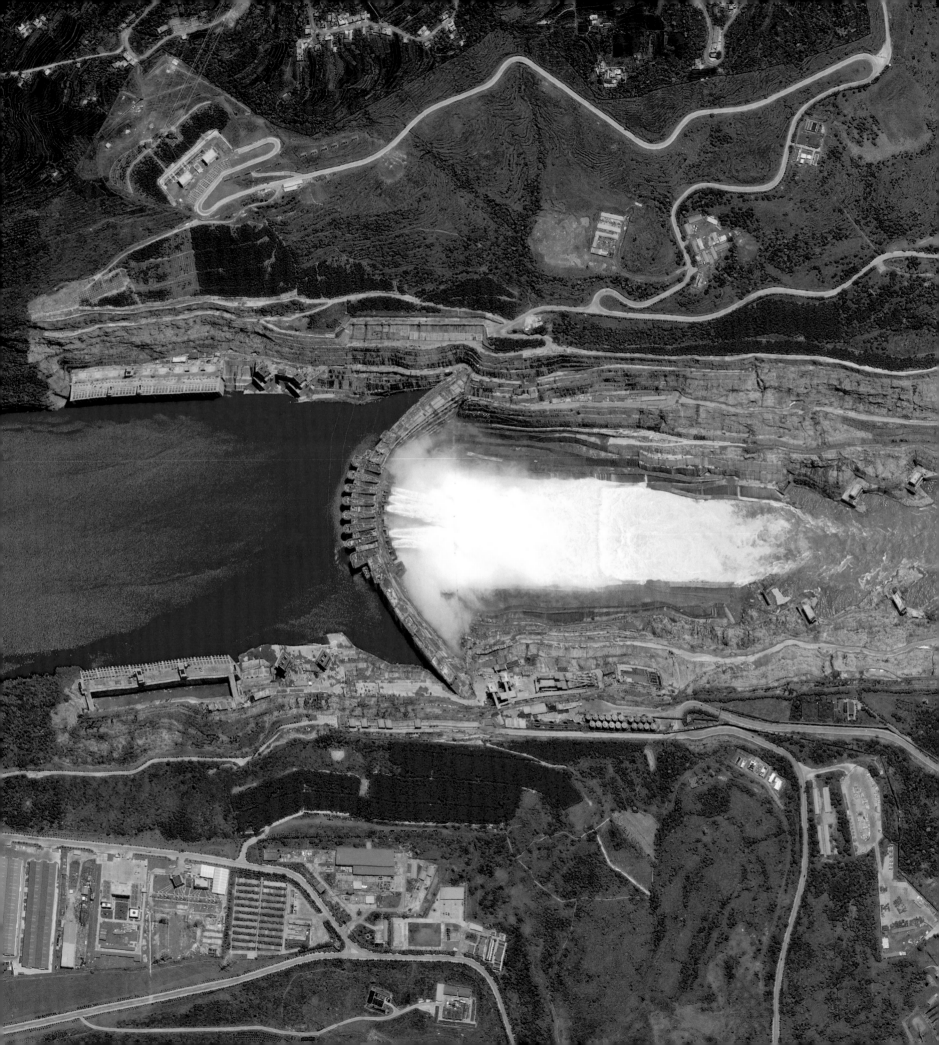

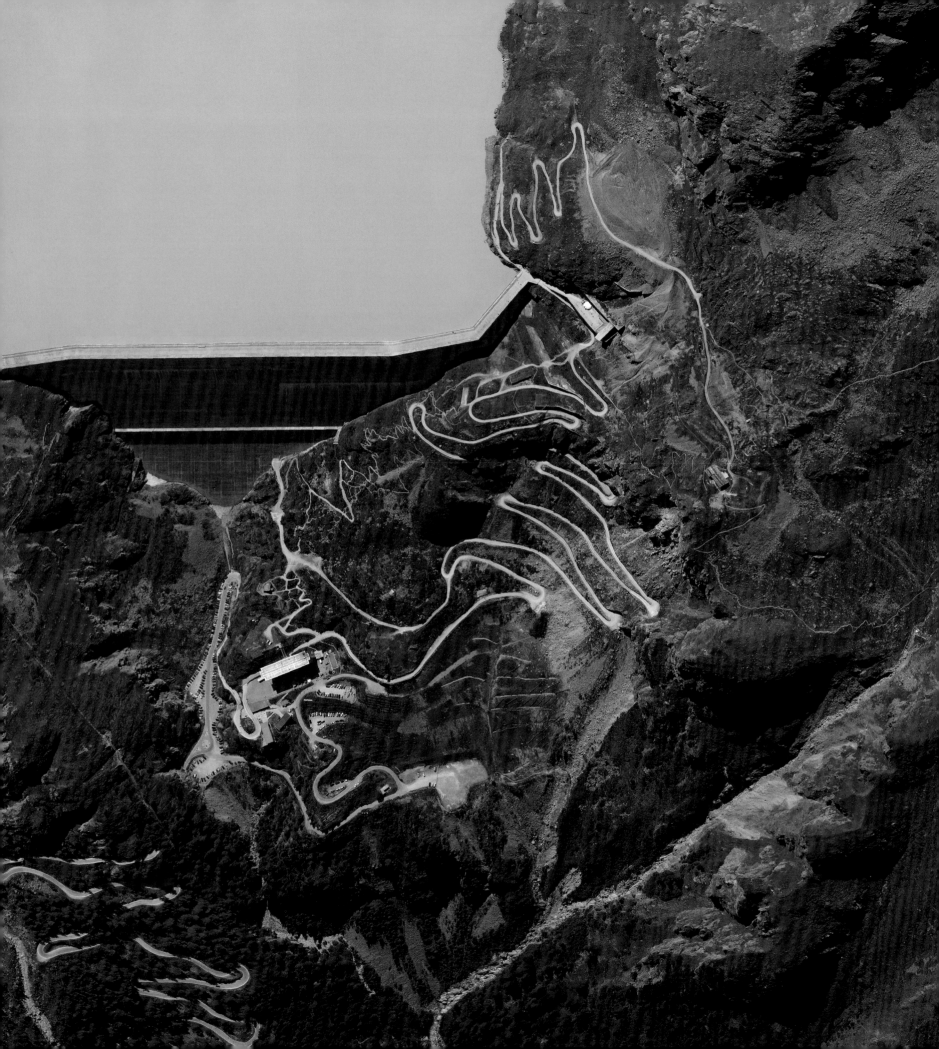

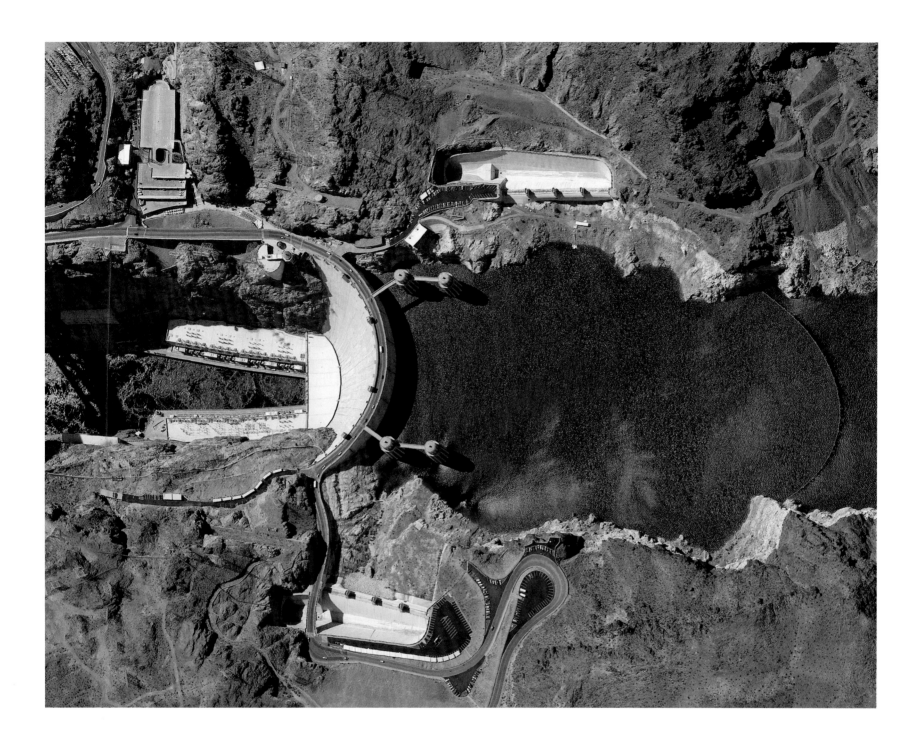

PREVIOUS PAGE

XILUODU DAM

28.259850°, 103.649500°

Water from the Jinsha River surges through the Xiluodu Dam near Xiluodu, China. Arch dams like this one are designed so that the force of the contained water presses against the arch, compressing and strengthening the structure by pushing it into its foundation. At 937 feet (286 meters), the dam in Xiluodu is the fourth tallest in the world, and has a power generation capacity of 13,860 megawatts—that is 20 percent more power than the amount generated by a space shuttle at launch.

LEFT

GRAND DIXENCE DAM

46.080559°, 7.401694°

The Grande Dixence Dam in the canton of Valais, Switzerland, is the tallest gravity dam in the world, with a height of 935 feet (285 meters). A gravity dam resists the horizontal thrust of the contained water, in this case the Dixence River, entirely by its own weight. The dam took 14 years to construct, contains approximately 7.8 million cubic yards (6 million cubic meters) of concrete, and generates power for more than 400,000 Swiss homes.

ABOVE

HOOVER DAM

36.015844°, −114.738804°

Hoover Dam is a 726-foot-high (221-meter), 1,244-foot-wide (379-meter) concrete arch-gravity dam, located on the Colorado River at the border of Arizona and Nevada, USA. Constructed between 1931 and 1936 during the Great Depression, a workforce of approximately 20,000 poured a total of 4.36 million cubic yards (3.33 million cubic meters) of concrete to complete the structure—enough to pave a two-lane highway from San Francisco to New York City.

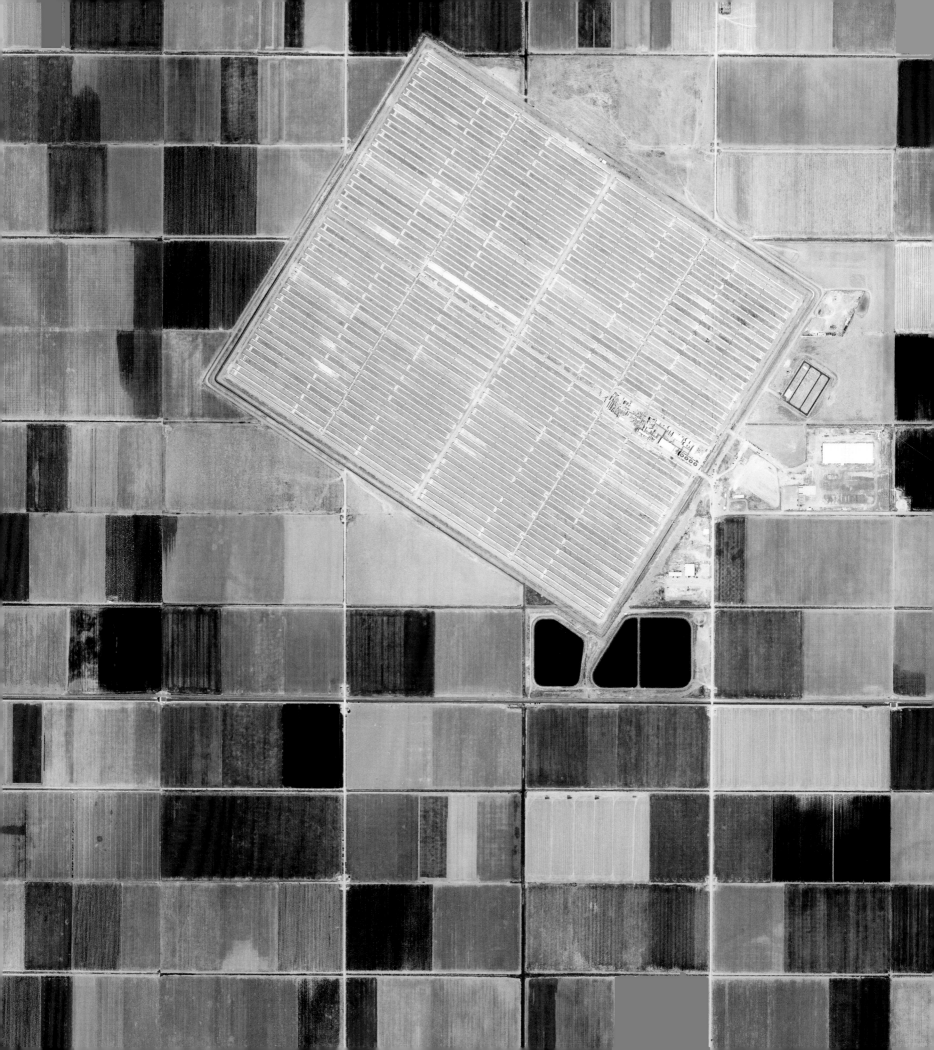

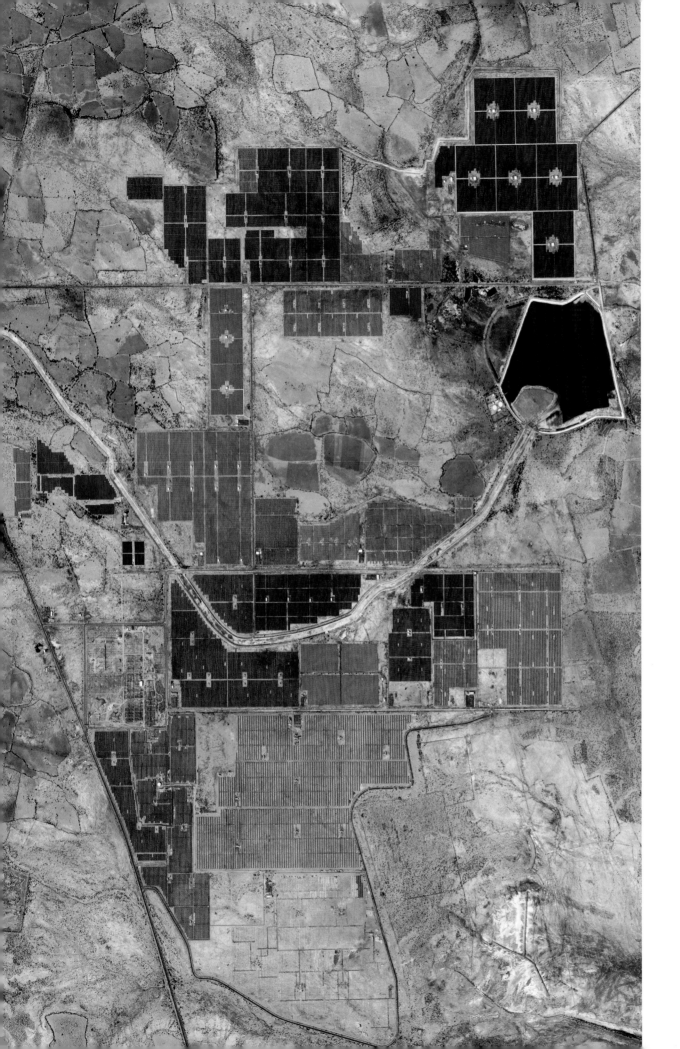

PREVIOUS PAGE
LEBRIJA 1 SOLAR POWER PLANT
37.007977°, −6.049280°

The Lebrija 1 Solar Power Plant is a
solar thermal power plant in Lebrija,
Spain. Solar thermal plants use
mirrors to concentrate solar energy
and heat oil to a temperature around
752°F (400°C). Once heated, the oil
transfers its thermal energy to water,
ultimately producing pressurized
steam. This steam then drives a turbine,
and converts mechanical energy
into electricity through a generator.
The facility in Lebrija is composed
of approximately 170,000 individual
mirrors installed on 6,048 parabolic
troughs. If placed next to one another,
the troughs would extend for 37 miles
(60 kilometers).

LEFT
GUJARAT SOLAR PARK
23.905854°, 71.196795°

The Gujarat Solar Park is a collection
of individual solar facilities in Gujarat,
India. The project is estimated to prevent
approximately 8 million tons of carbon
dioxide from being released into the
atmosphere and will save approximately
900,000 tons of natural gas per year. The
primary components of this particular type
of solar park are solar panels to absorb
and convert sunlight into electricity, and
a solar inverter that changes the electrical
current from direct current (DC) to
alternating current (AC), the form that
is transmitted through the power grid.

RIGHT
DESERT SUNLIGHT SOLAR FARM
33.813087°, −115.400001°

The Desert Sunlight Solar Farm is a
photovoltaic power station located in
the Mojave Desert of California, USA.
With 8.8 million solar modules spread
across 6.2 square miles (16 square
kilometers), the facility is one of the
largest photovoltaic solar farms in
the world.

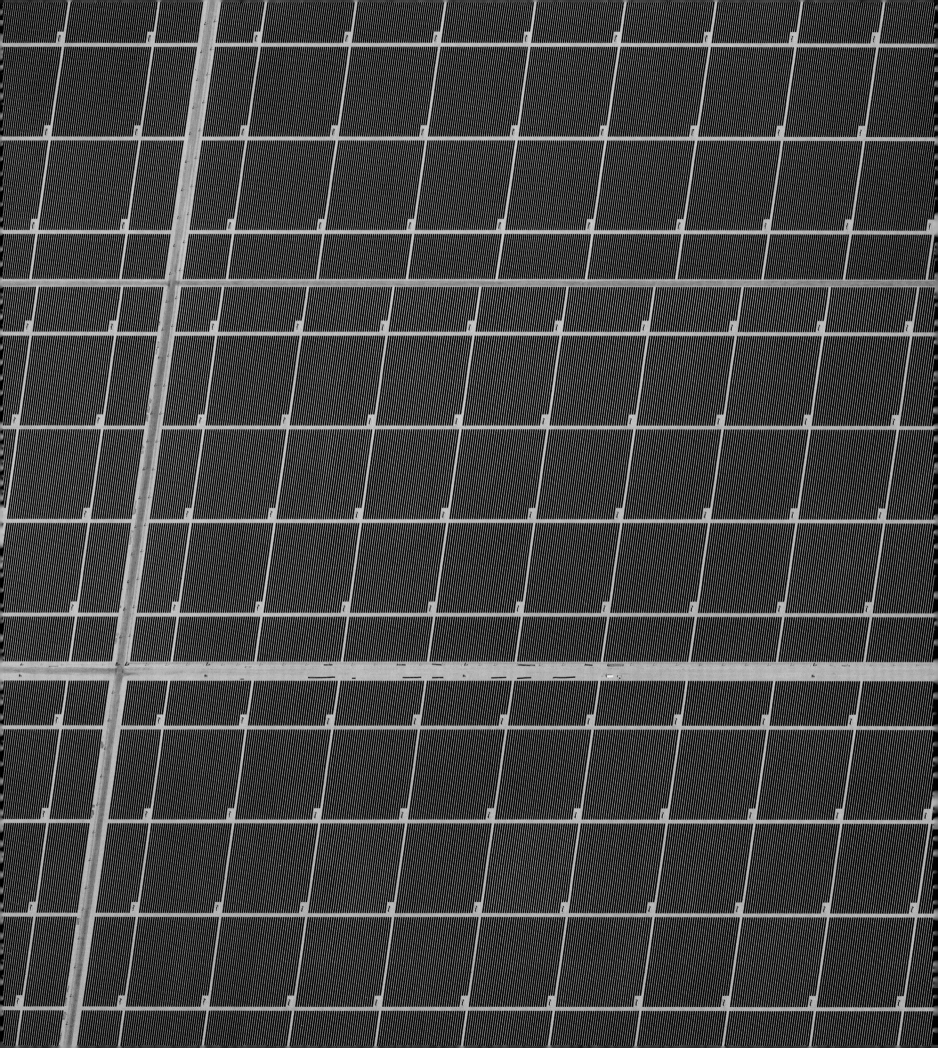

PREVIOUS PAGE

MIDDELGRUNDEN

55.690455°, 12.668373°

Middelgrunden is an offshore wind farm located 2.2 miles (3.5 kilometers) from Copenhagen, Denmark, in the Øresund— the strait that forms the border of Denmark and Sweden. The farm's 20 turbines deliver approximately 4 percent of the power for Copenhagen. When wind blows against the blades of a wind turbine, they slowly rotate. The blades are connected to a drive shaft on the top of the turbine that turns a generator, thereby generating electricity that is carried through underground cables to each site's substation. The turbines operate independently of one another, and each has an internal computer that constantly calculates wind speed and direction. The top of the turbine and its blades can rotate a full 360 degrees, and change the pitch of the blades to always face into the wind and optimize positioning for energy creation.

LEFT

DONGHAI BRIDGE WIND FARM

30.770004°, 121.991800°

With the incoming tide, streaks of sediment form around the turbines of the Donghai Bridge Wind Farm in Shanghai, China. The facility was the first commercial offshore wind farm in China, and has the capacity to power 200,000 homes.

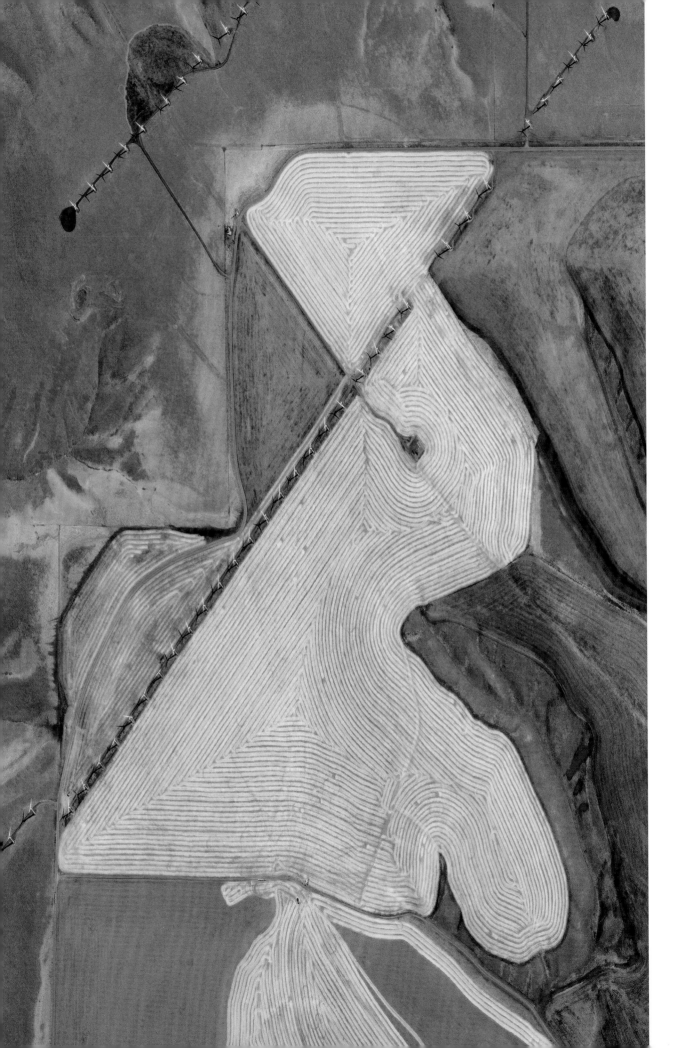

STATELINE WIND FARM

46.029760°, −118.875712°

The Stateline Wind Farm is located on Vansycle Ridge at the border of Washington and Oregon in the United States. With 456 turbines located in an area that maintains average wind speeds of 16 to 18 miles (26 to 29 kilometers) per hour, the facility produces enough energy to power 90,000 homes. Before the facility was constructed, environmental studies determined that the site was not used extensively by birds or other species that are vulnerable to injury from turbines, and the positioning of each tower was designed to minimize perching places for birds.

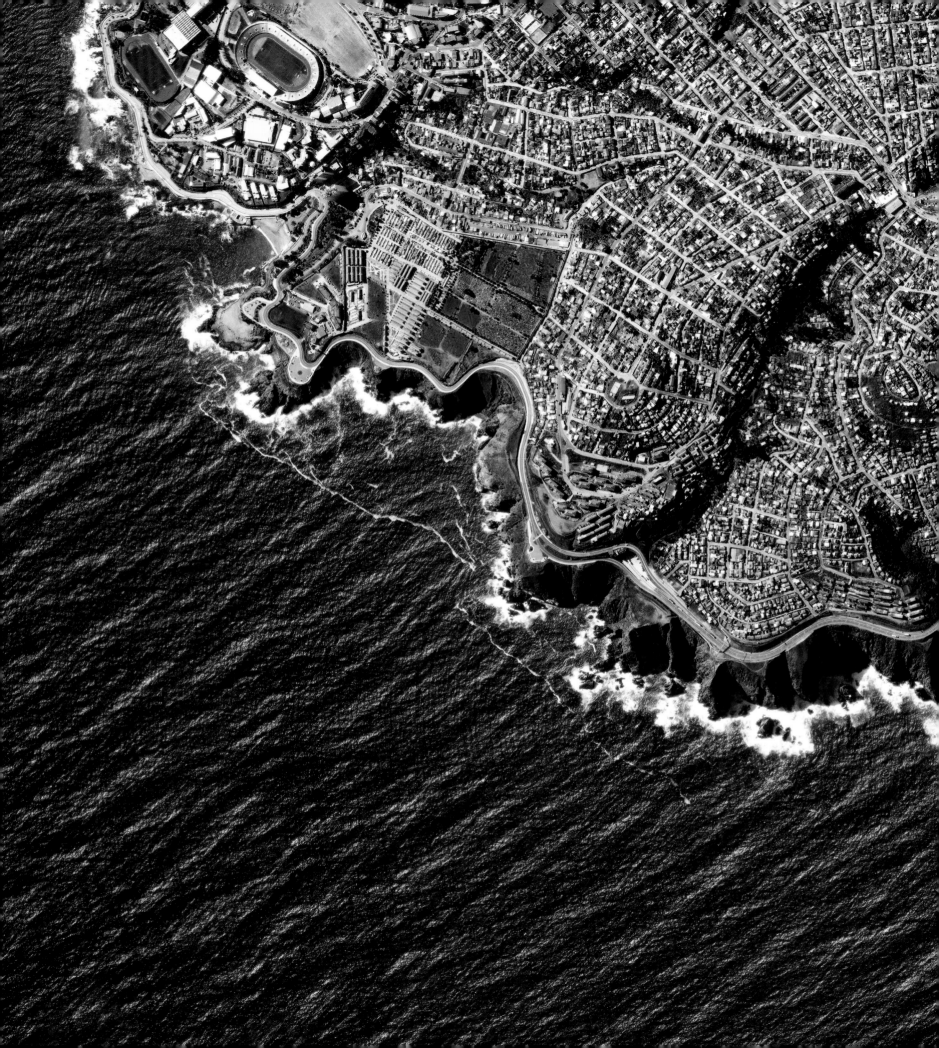

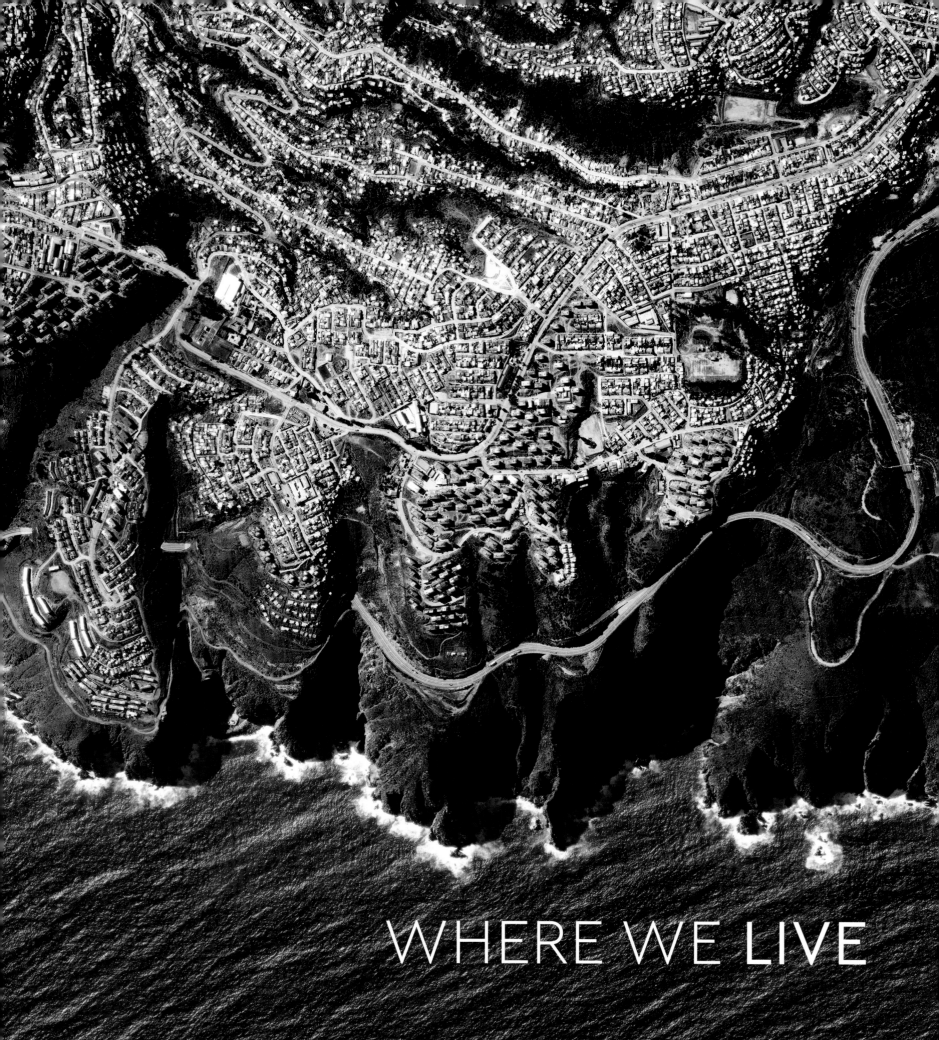

WHERE WE LIVE

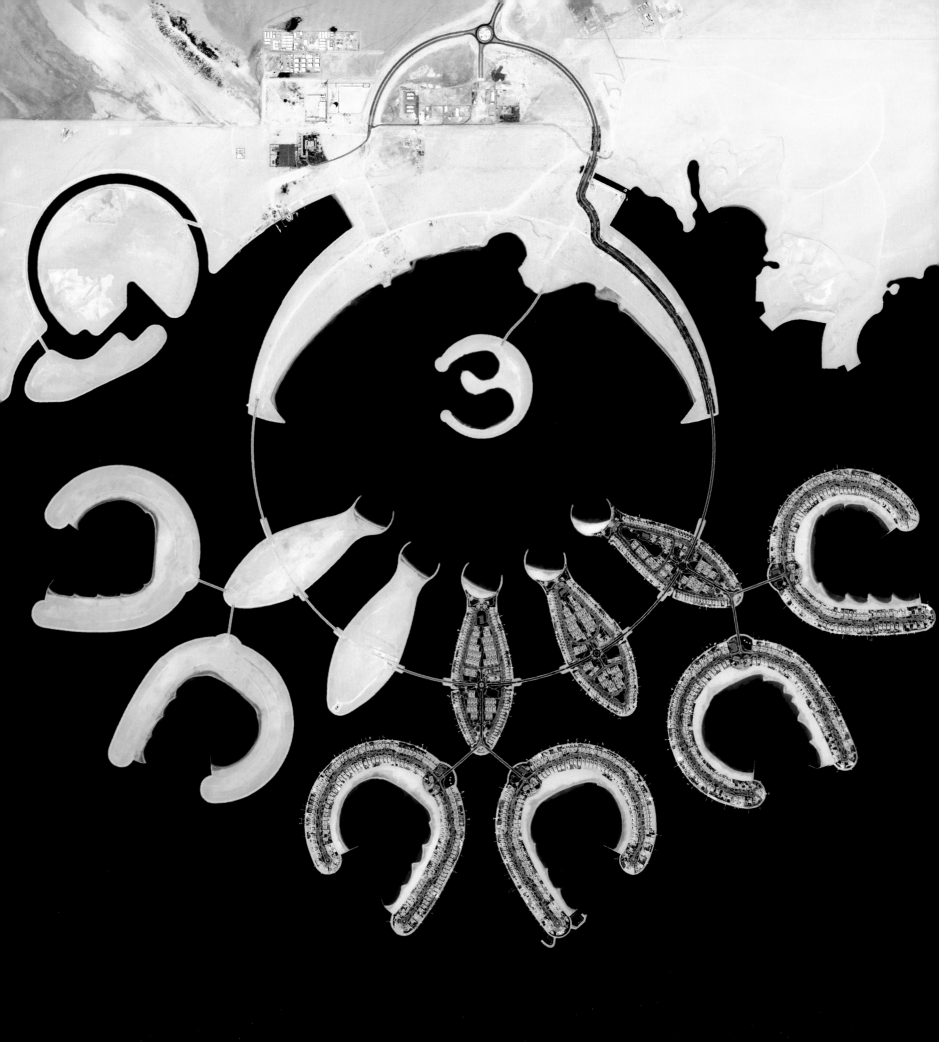

"The ache for home lives in all of us, the safe place where we can go as we are and not be questioned."

Maya Angelou, *All God's Children Need Traveling Shoes* (1986)

WHERE WE **LIVE**

For most of us, where we live is the place that we can always go back to. It may also be a place that is only temporary or a place we can never leave at all. As long as humans have existed, securing a safe space to live has been crucial to our survival. From the caves of Africa to the islands of Dubai, we have come quite a long way.

Since there are untold numbers of dwellings that can be seen from space, the images shown in this chapter are by necessity only a small sample of the many varieties of living spaces that we occupy. In many instances, this chapter is strongly related to the urban planning seen in "Where We Design." However, here the focus is primarily on residential neighborhoods, communities that have been organized in a cohesive scheme. From above, we have the ability to compare the places where we live to far-flung places on the opposite side of the globe, as well as the houses just across the street.

The development of sustainable and affordable housing is a pressing issue for our species. Indeed, the ever-growing need to maximize our living space in order to cope with the influx of humans into cities is deeply connected to the challenges presented later in this book. What we can see from space only tells a piece of the complete story. Nevertheless, from these macro views, we can start to get a better idea of what the conditions might be like on the ground, what is working well, and what we can do to make things better.

PREVIOUS PAGE
VALPARAISO
-33.029093°, -71.646348°
Valparaíso, Chile, is built upon dozens of steep hillsides overlooking the Pacific Ocean. Known as "The Jewel of the Pacific," the city is the sixth largest in the country and is home to approximately 285,000 residents.

LEFT
DURRAT AL BAHRAIN
25.838060°, 50.596236°
Still under construction, Durrat Al Bahrain will consist of 13 artificial islands in the Persian Gulf that will primarily be used for residential development. Construction costs for the project are estimated at $6 billion USD.

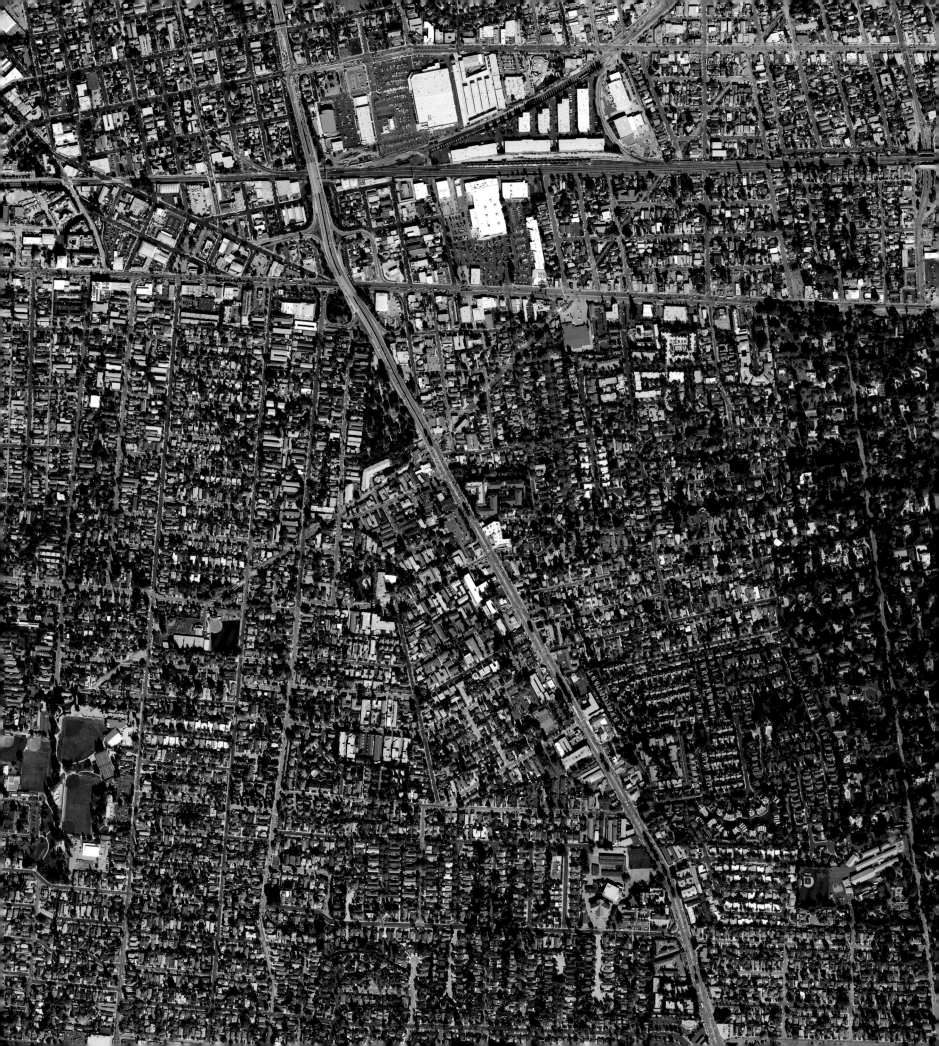

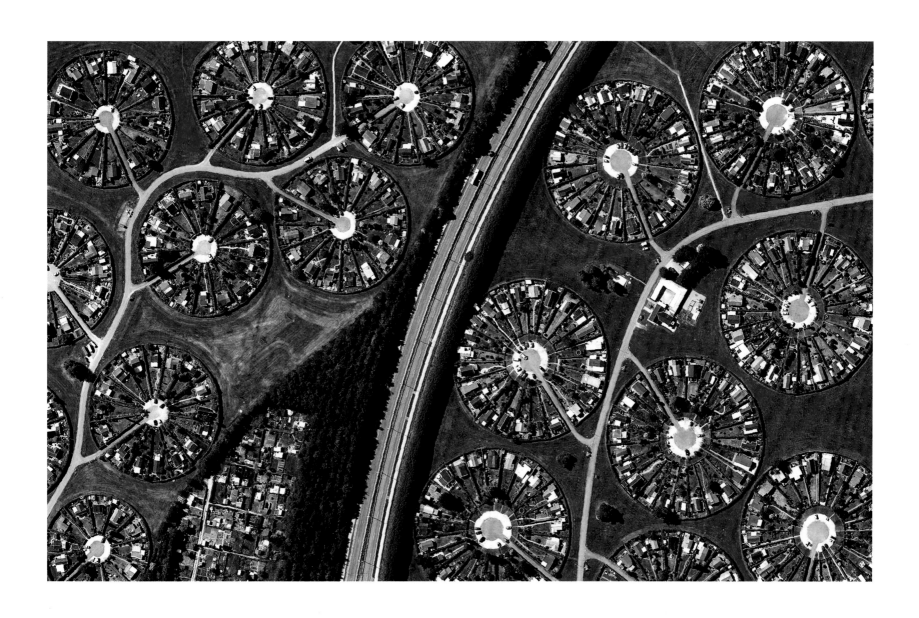

SAN FRANCISCO BAY AREA
37.445583°, −122.147748°
Numerous studies have shown a correlation between the wealth
of a residential area and its total number of trees and the amount of
green space. A particularly striking example of this trend is seen in
the San Francisco Bay Area, California, USA. In this Overview, two
extremely affluent towns—Palo Alto and Atherton—are seen on the
right with extensive green coverage, and the less affluent Redwood
City is seen on the left with significantly fewer trees.

DELHI
28.614656°, 77.057758°
Delhi, India, contains approximately
16 million residents. The neighborhoods
of Santosh Park and Uttam Nagar,
both pictured here, are home to
some of the city's poorest people
and contain its most built-up and
densely populated land.

BRØNDBY HAVEBY
55.637244°, 12.395112°
Brøndby Haveby is a residential community
located just outside Copenhagen, Denmark.
Houses with large front yards are centred
around cul-de-sacs, providing urban dwellers
the opportunity to live outside the city and
grow small subsistence or hobby crops during
the summer months.

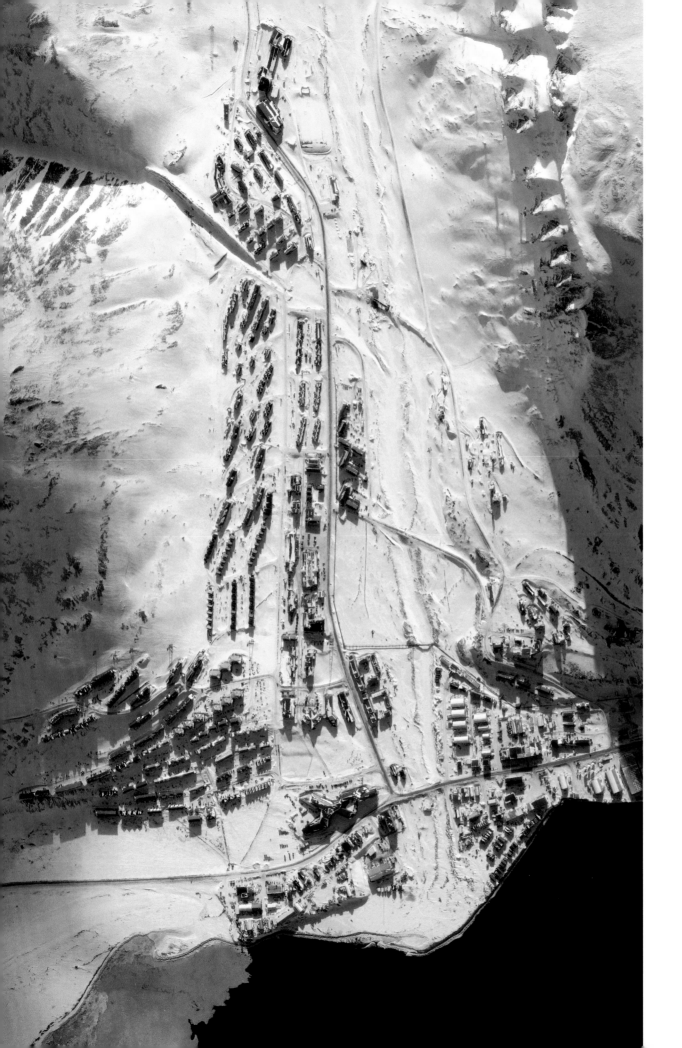

LONGYEARBYEN

78.217583°, 15.630230°

Longyearbyen is a town located on the archipelago of Svalbard, Norway. Situated north of mainland Europe, the islands are located approximately halfway between continental Norway and the North Pole. Longyearbyen has a population of 2,075, making it the world's northernmost settlement of any kind with more than 1,000 permanent residents. The record low temperature here is −51.3°F (−46.3°C).

MARABE AL DHAFRA

23.610424°, 53.702677°

The villas of Marabe Al Dhafra in Abu Dhabi, United Arab Emirates, are home to approximately 2,000 people. Located in one of the hottest regions of the world, the record high temperature here is 120.6°F (49.2°C).

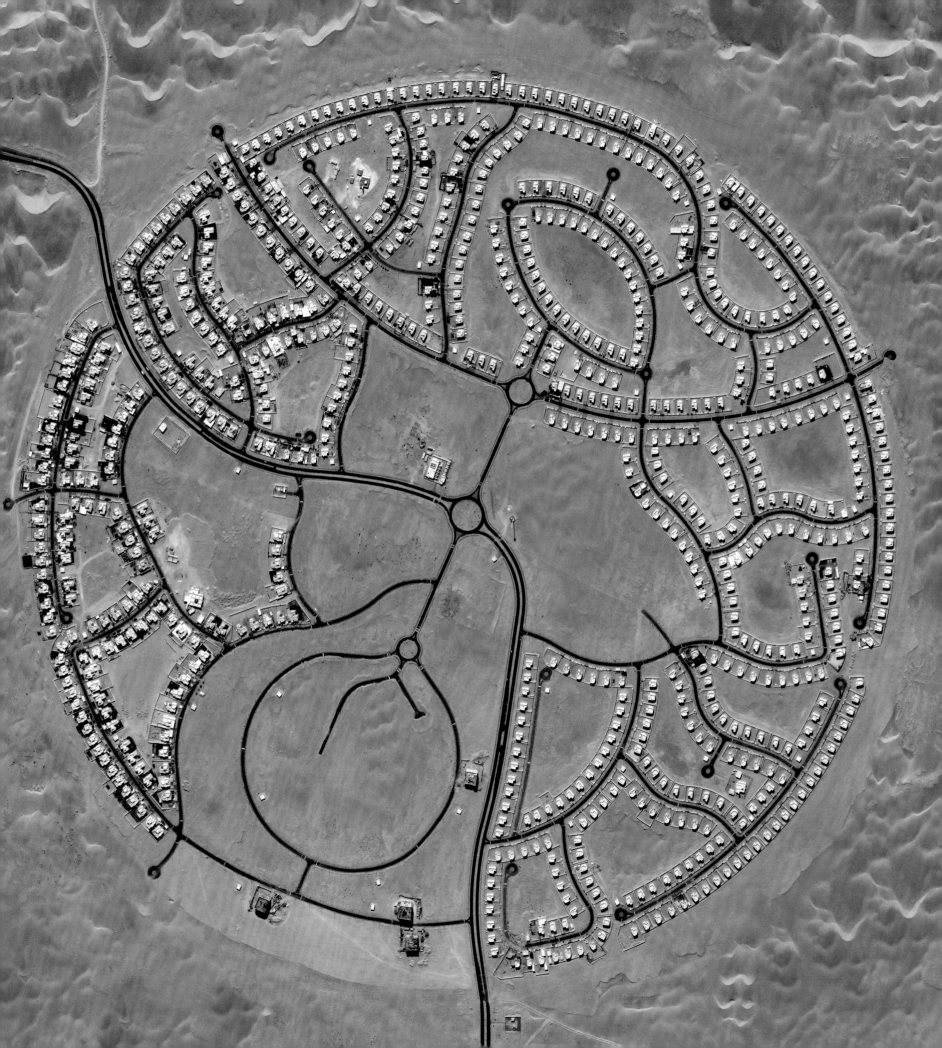

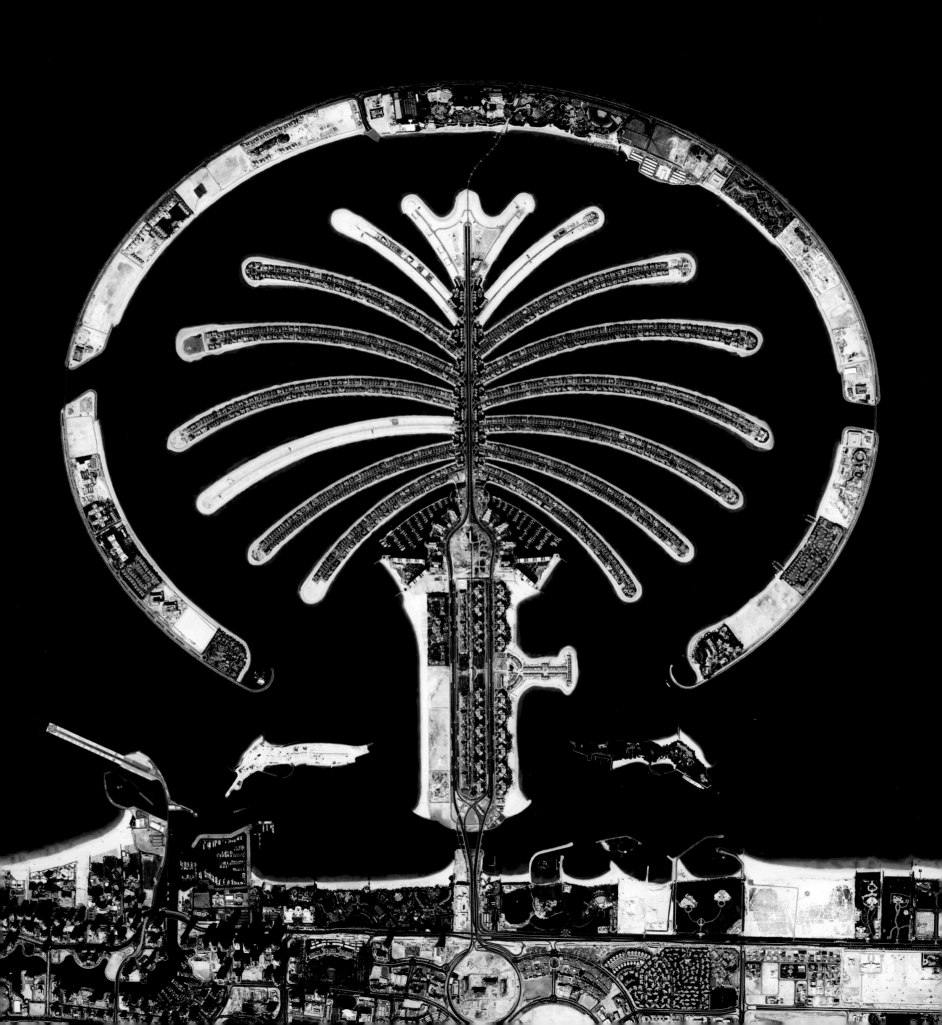

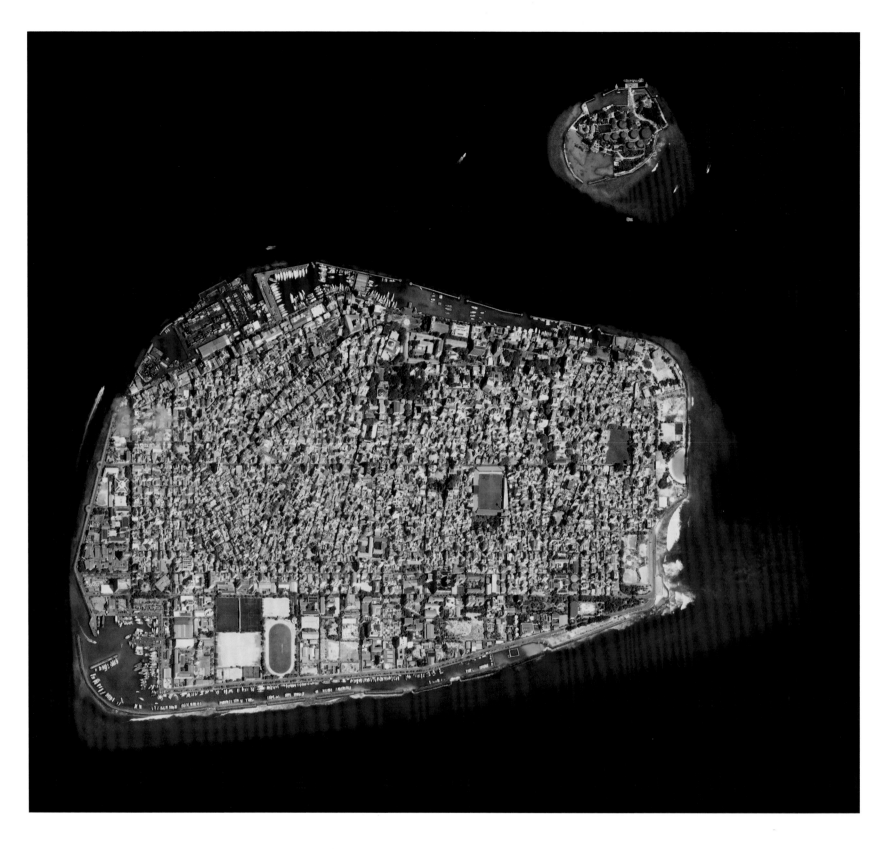

PREVIOUS PAGE

PALM JUMEIRAH 25.119724°, 55.126751°
The Palm Jumeirah in Dubai, United Arab
Emirates, is an artificial island that was
created with 4.3 billion cubic yards
(3.3 billion cubic meters) of sand and
7 million tons of rock. It is estimated that
the island is now home to approximately
26,000 people.

ABOVE

MALÉ 4.175283°, 73.506694°
Malé is the capital and most populous city in the
Republic of Maldives. With more than 120,500
residents per square mile (2.6 square kilometers),
the heavily urbanized city constitutes the fifth
most densely-populated island in the world.
Malé and the other islands of the Maldives are
located 3 feet (1 meter) above sea level.

RIGHT

VENICE 45.440995°, 12.323397°
Venice, home to approximately 265,000 people, is situated upon
118 small islands that are separated by canals and linked by bridges.
With its tide waters expected to rise to perilous levels, the city has
constructed 78 giant steel gates across the three inlets, through which
water from the Adriatic could surge into Venice's lagoon. The panels—
which weigh 300 tons and are 92 feet (28 meters) wide and 65 feet
(20 meters) high—are fixed to massive concrete bases dug into the seabed.

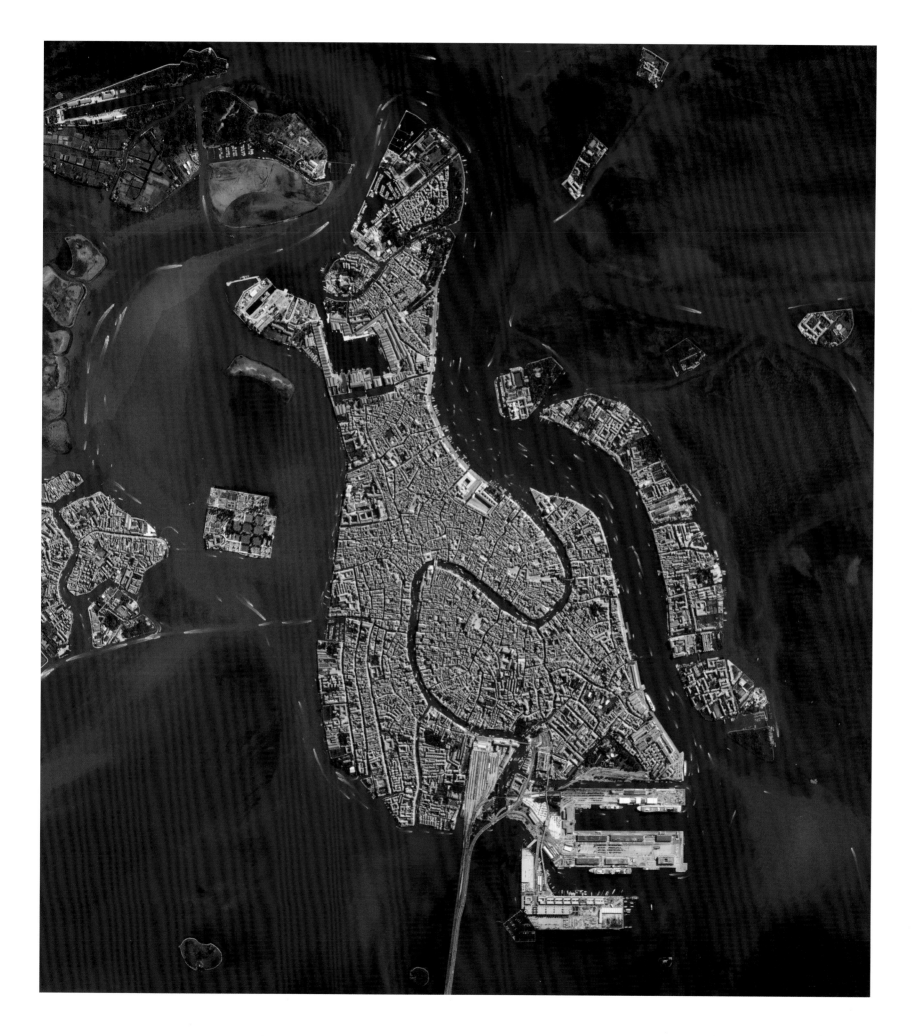

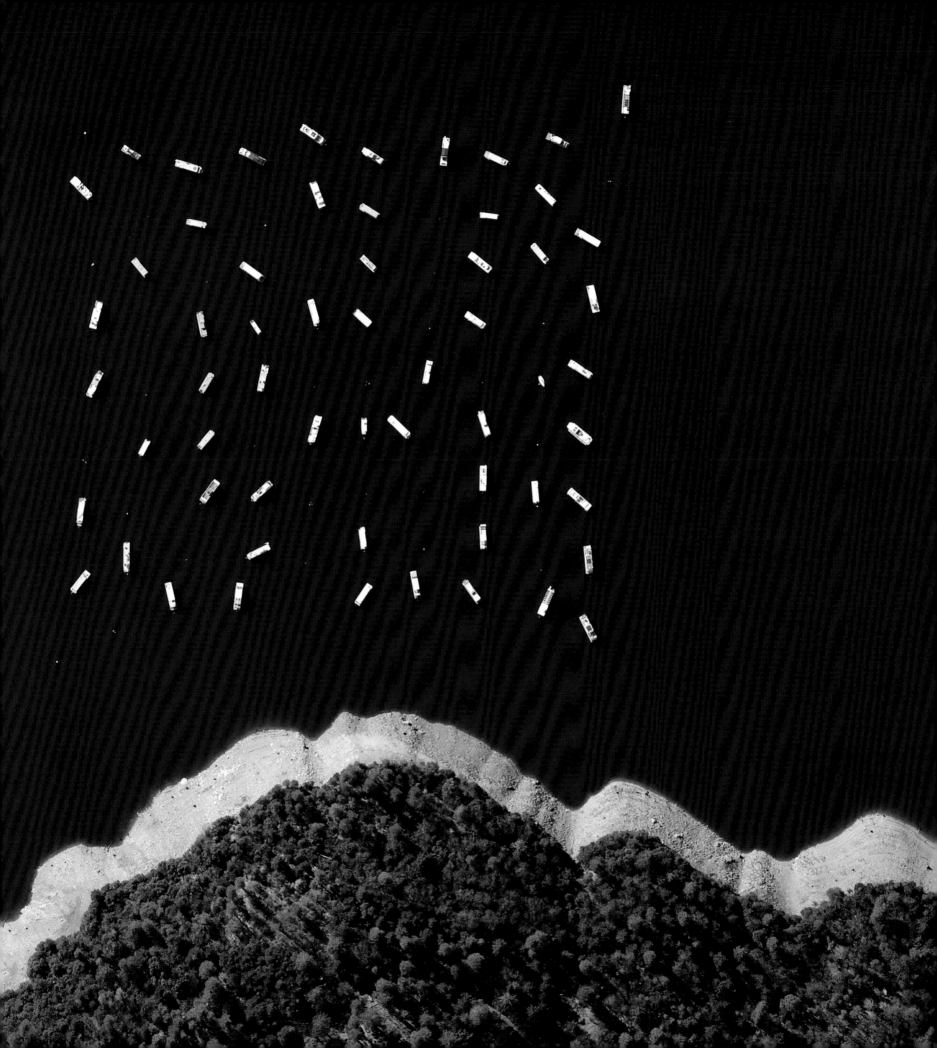

LAKE OROVILLE HOUSEBOATS
39.398691°, −121.139347°
Moored houseboats float peacefully on the New
Bullards Bar Reservoir in Yuba County, California, USA.
Due to a severe drought that has hit the state over the
past four years, there is less space to anchor on the lake
and many houseboats have been moved to a nearby
onshore storage area.

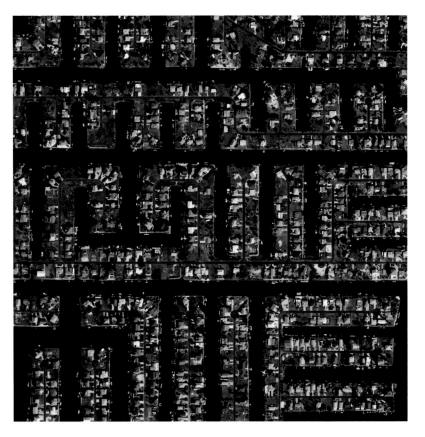

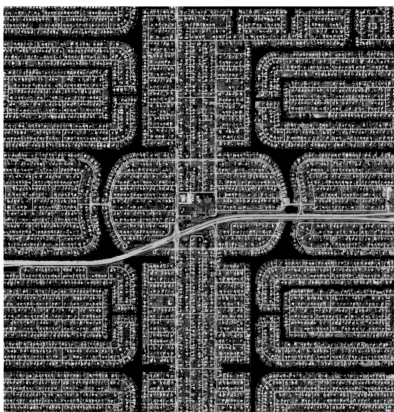

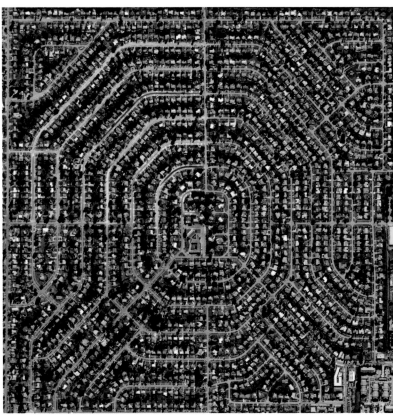

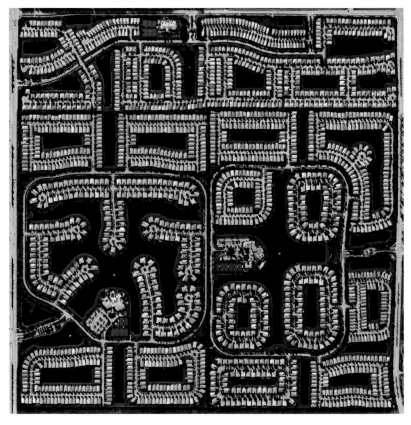

FLORIDA RESIDENTIAL DEVELOPMENTS

Because many cities in the American state of Florida contain master-planned communities, often built on top of waterways in the latter half of the twentieth century, there are a number of intricate designs that are visible from the Overview perspective. A selection of these areas is seen here.

CLOCKWISE FROM TOP LEFT

HERNANDO BEACH, FLORIDA 28.496771°, −82.657945° Total population: 2,185
CAPE CORAL, FLORIDA 26.604391°, −81.958473° Total population: 165,831
DELRAY BEACH, FLORIDA 26.475547°, −80.156470° Total population: 65,055
MELROSE PARK, FLORIDA 26.113889°, −80.193611° Total population: 7,114

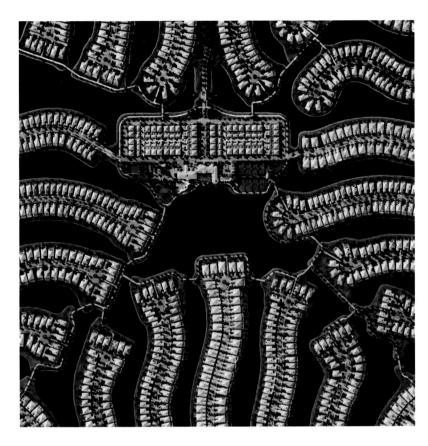

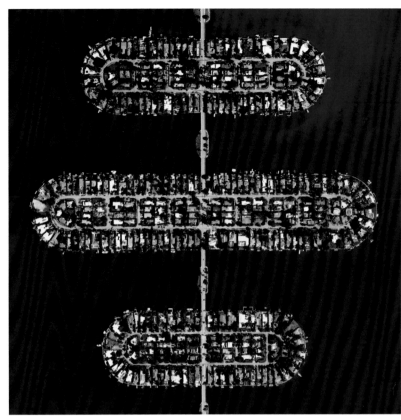

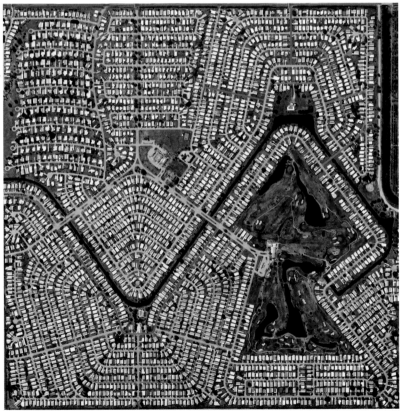

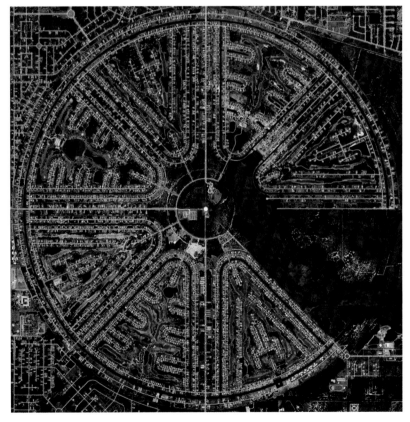

CLOCKWISE FROM TOP LEFT

NAPLES, FLORIDA 26.250632°, −81.711302° Total population: 20,600
MIAMI BEACH, FLORIDA 25.790889°, −80.159772° Total population: 87,779
ROTONDA WEST, FLORIDA 26.893741°, −82.276419° Total population: 8,759
BAREFOOT BAY, FLORIDA 27.887575°, −80.524405° Total population: 9,808

FOLLOWING PAGE

BOCA RATON, FLORIDA 26.386332°, −80.179917° Total population: 91,332

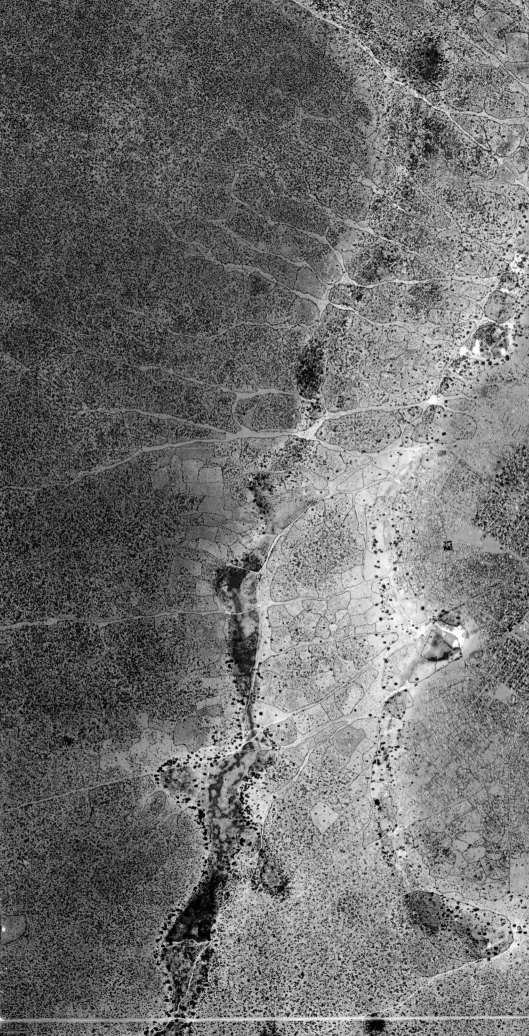
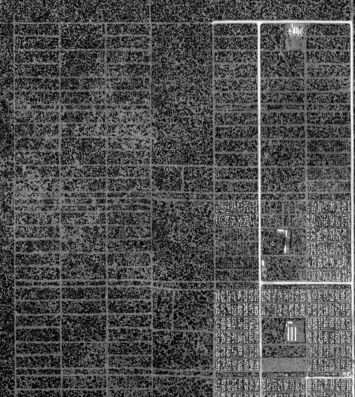
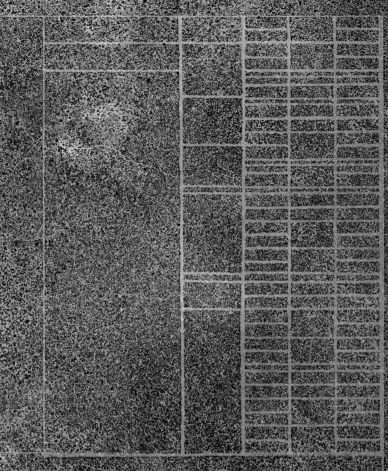

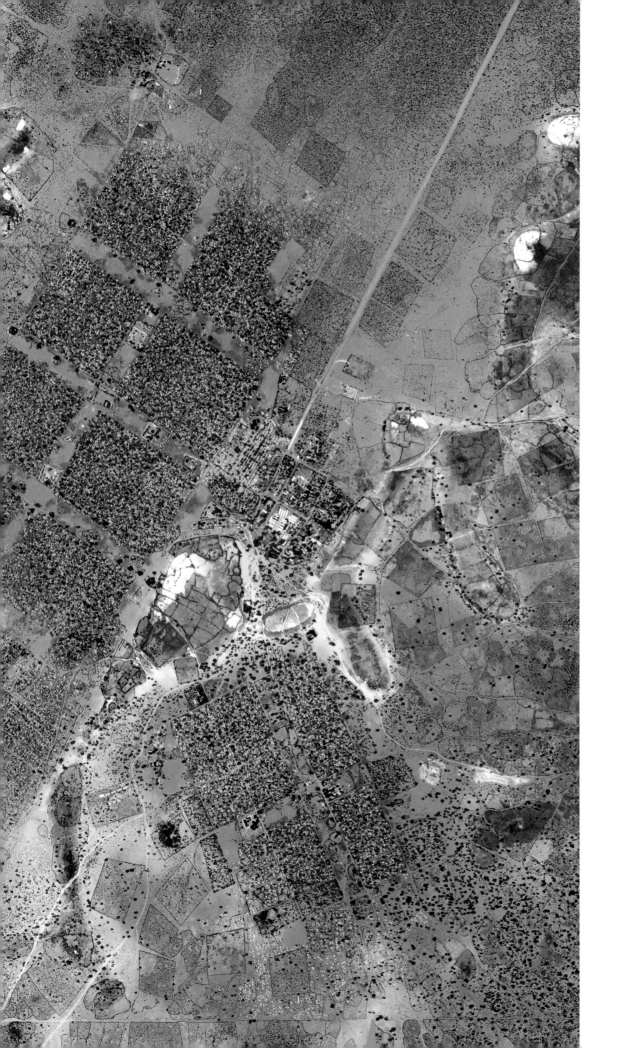

DADAAB REFUGEE CAMP
−0.000434°, 40.364929°

Hagadera, seen here on the right, is the largest section of the Dadaab Refugee Camp in northern Kenya and is home to 100,000 refugees. To cope with the growing number of displaced Somalis arriving at Dadaab, the UN has begun moving people into a new area called the LFO extension, seen here on the left. Dadaab is the largest refugee camp in the world with an estimated total population of 400,000.

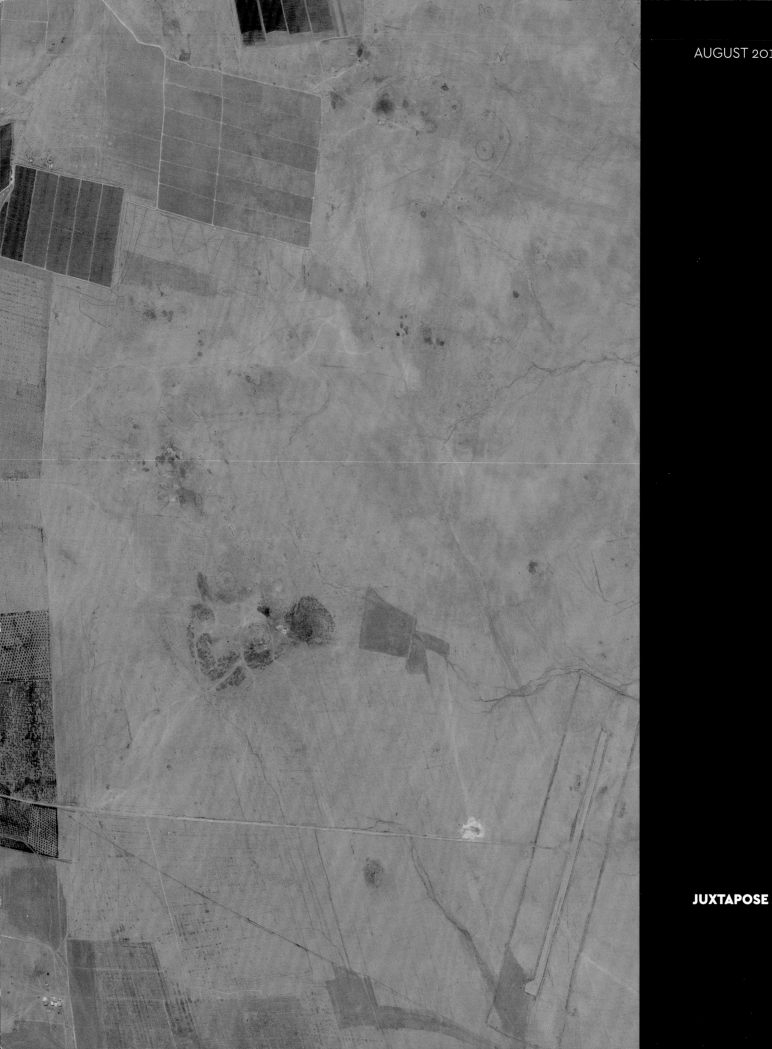

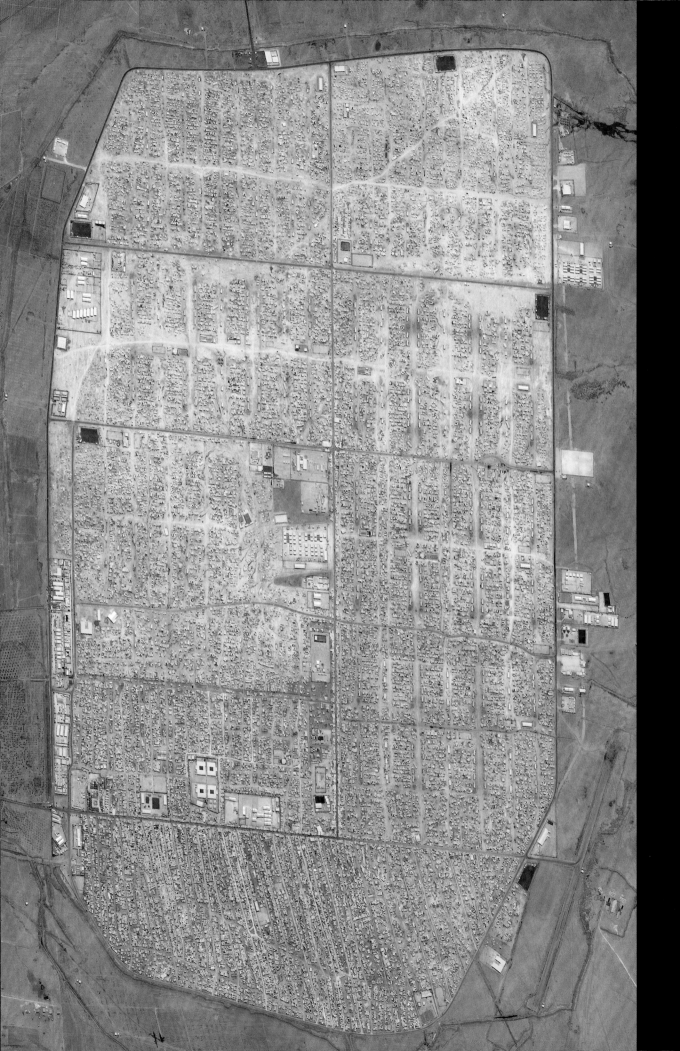

ZAATARI REFUGEE CAMP
32.291959°, 36.325464°
The Zaatari Refugee Camp was constructed in Mafraq, Jordan, and opened in July 2012 to host refugees fleeing the ongoing civil war in Syria. The population of the camp is currently estimated at 83,000.

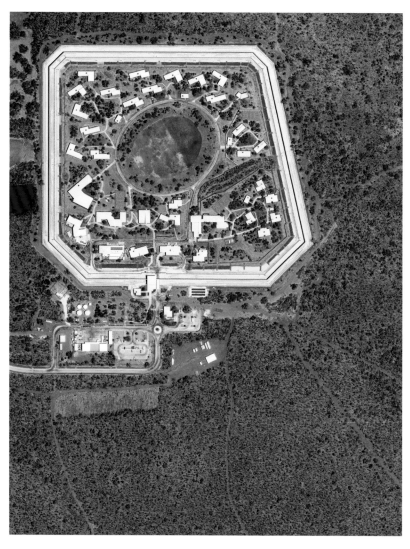
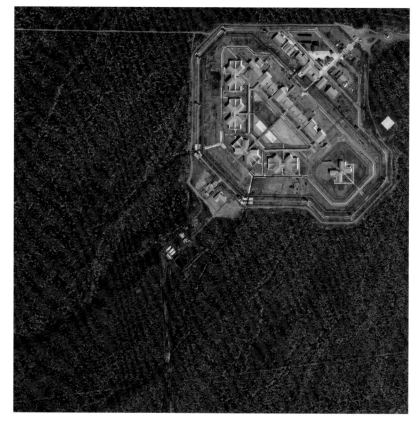

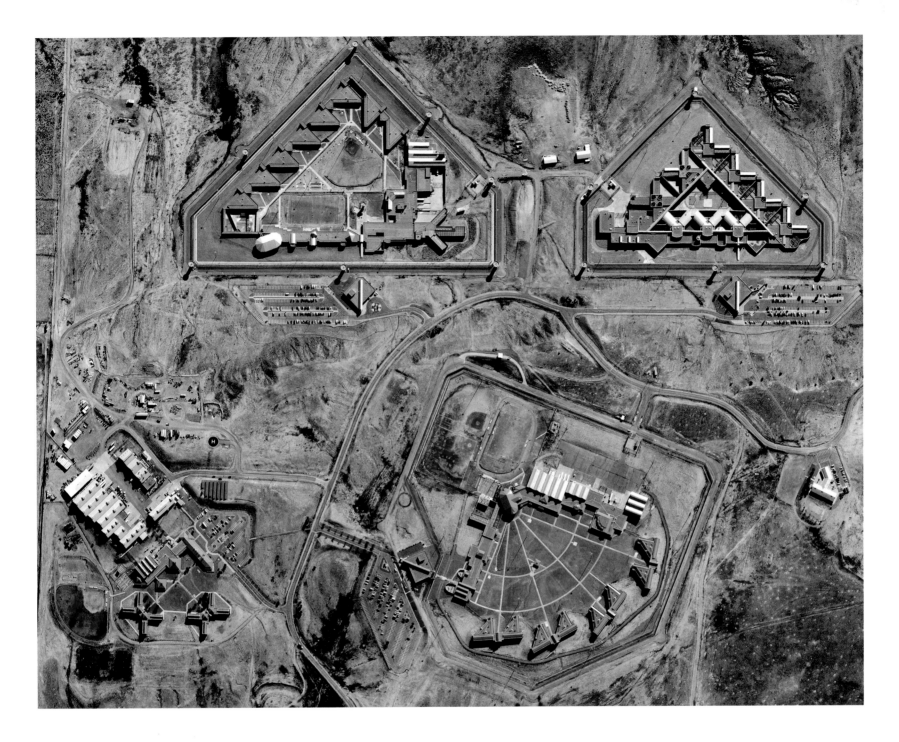

WEST KIMBERLEY REGIONAL PRISON

−17.354186°, 123.675010°

Capacity: 150 male and female inmates.

The West Kimberley Regional Prison in Derby, Australia, consists of 42 buildings, including 22 self-care accommodation units that each hold six or seven prisoners.

ARIZONA STATE PRISON COMPLEX, PERRYVILLE

33.470704°, −112.436855°

Capacity: 2,382 female inmates.

An all-female prison facility, the Arizona State Prison Complex in Perryville, Arizona, USA, houses the state's female death row population.

ALMAFUERTE MENDOZA PRISON

−33.094305°, −69.049702°

Capacity: 940 male and female inmates.

The Almafuerte Mendoza Prison in Mendoza, Argentina, was constructed to help deal with the country's prison overcrowding problem. It has been reported that the facility is home to more than three times its prisoner capacity, frequently leading to five prisoners squeezed into cells with a floorplan of 43 square feet (4 square meters).

GUANTÁNAMO BAY DETENTION CAMP

19.902001°, −75.102790°

The Guantánamo Bay Detention Camp is a United States military prison located at the American naval base, situated on Guantánamo Bay in Cuba. The highly controversial facility was established in 2002 and is still operational despite numerous political efforts to bring about its closure.

ADX FLORENCE
SUPERMAX PRISON

38.358962°, −105.097407°

Capacity: 410 male inmates.

ADX Florence in Fremont County, Colorado, USA, houses the most dangerous inmates in the American prison system. Four building units are situated on the 37-acre (15 hectares) site and are surrounded by 12-foot-high (3.7-meter) razor wire fences, laser-beams, pressure pads, and attack dogs. No prisoners have ever escaped the facility.

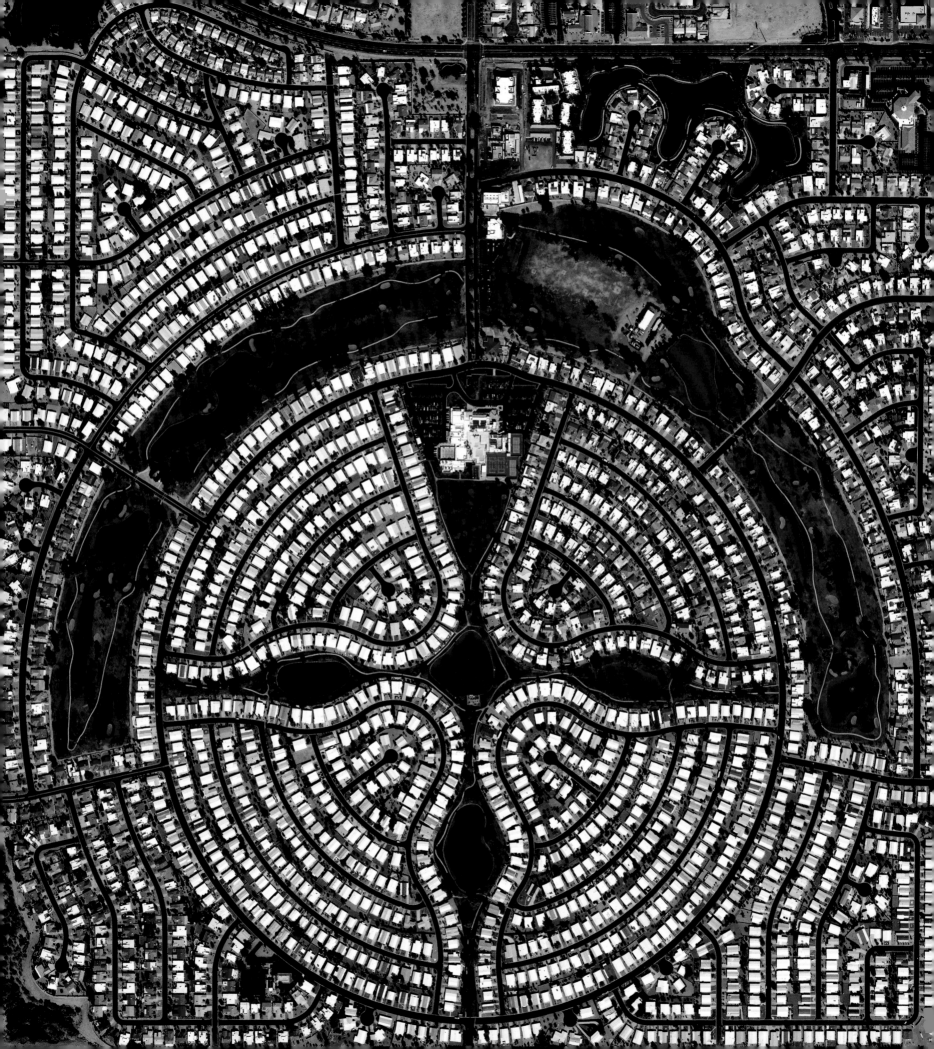

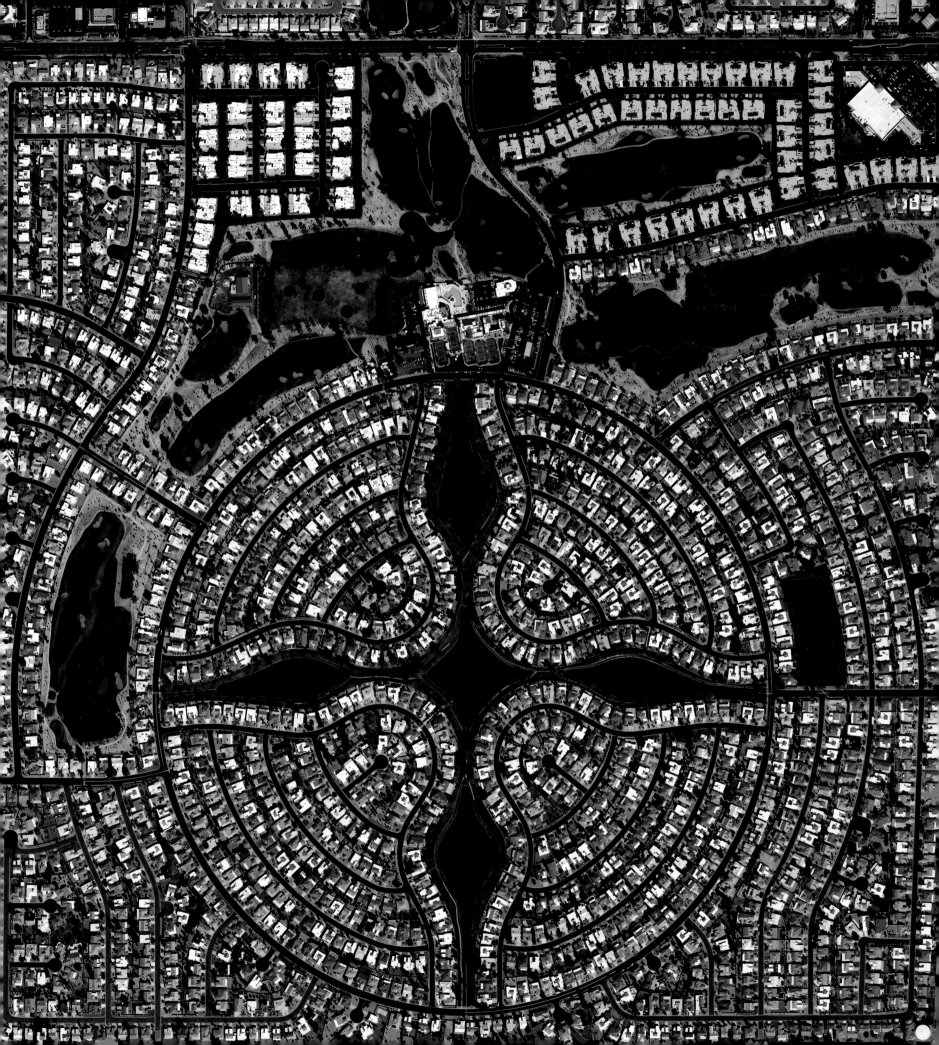

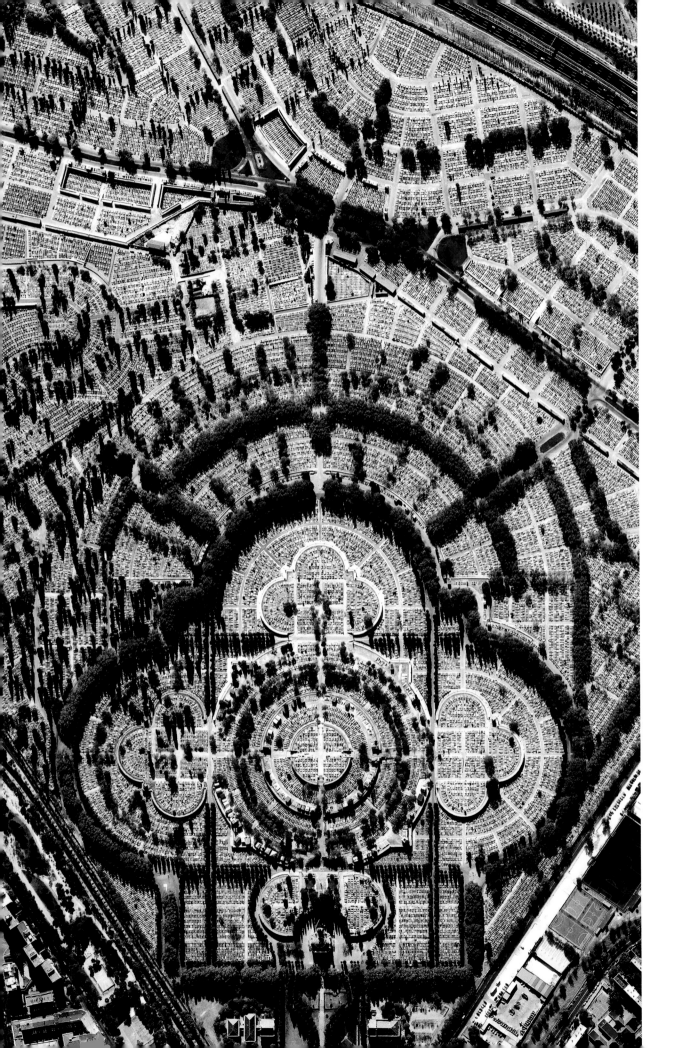

PREVIOUS PAGE
SUN LAKES
33.208518°, –111.876263°
Sun Lakes, Arizona, USA, is a planned community with a population of approximately 14,000 residents, most of whom are senior citizens. According to US Census data, only 0.1 percent of the community's 6,683 households are home to children under the age of 18.

LEFT
OUR LADY OF ALMUDENA CEMETERY
40.419448°, –3.642749°
Our Lady of Almudena Cemetery in Madrid, Spain, is one of the largest cemeteries in the world. The number of gravesites, estimated at 5 million, is greater than the population of Madrid itself.

TSEUNG KWAN O CHINESE PERMANENT CEMETERY

22.296861°, 114.246999°

The Tseung Kwan O Chinese Permanent Cemetery is one of numerous cemeteries in Hong Kong that was constructed on a hillside due to lack of usable land. Because the city's last available burial space was used in the 1980s, the price for a private grave can cost upward of $30,000 USD.

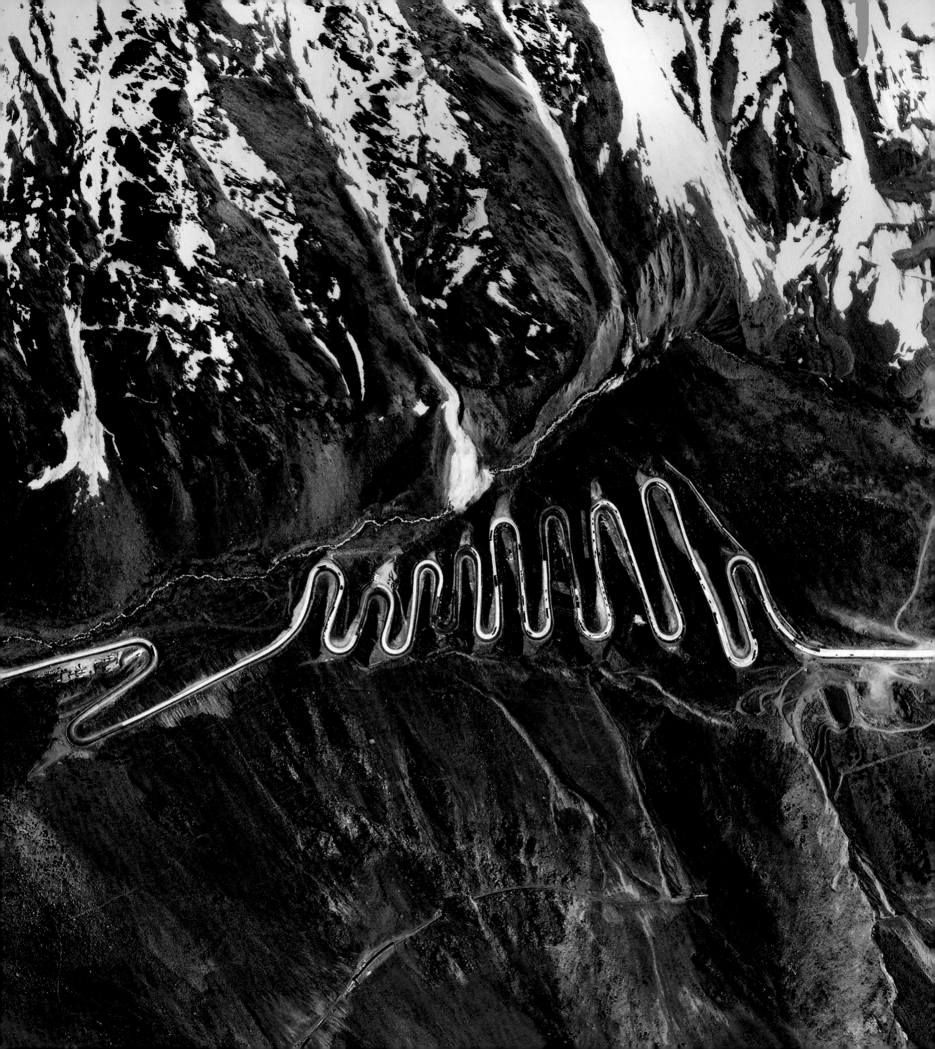

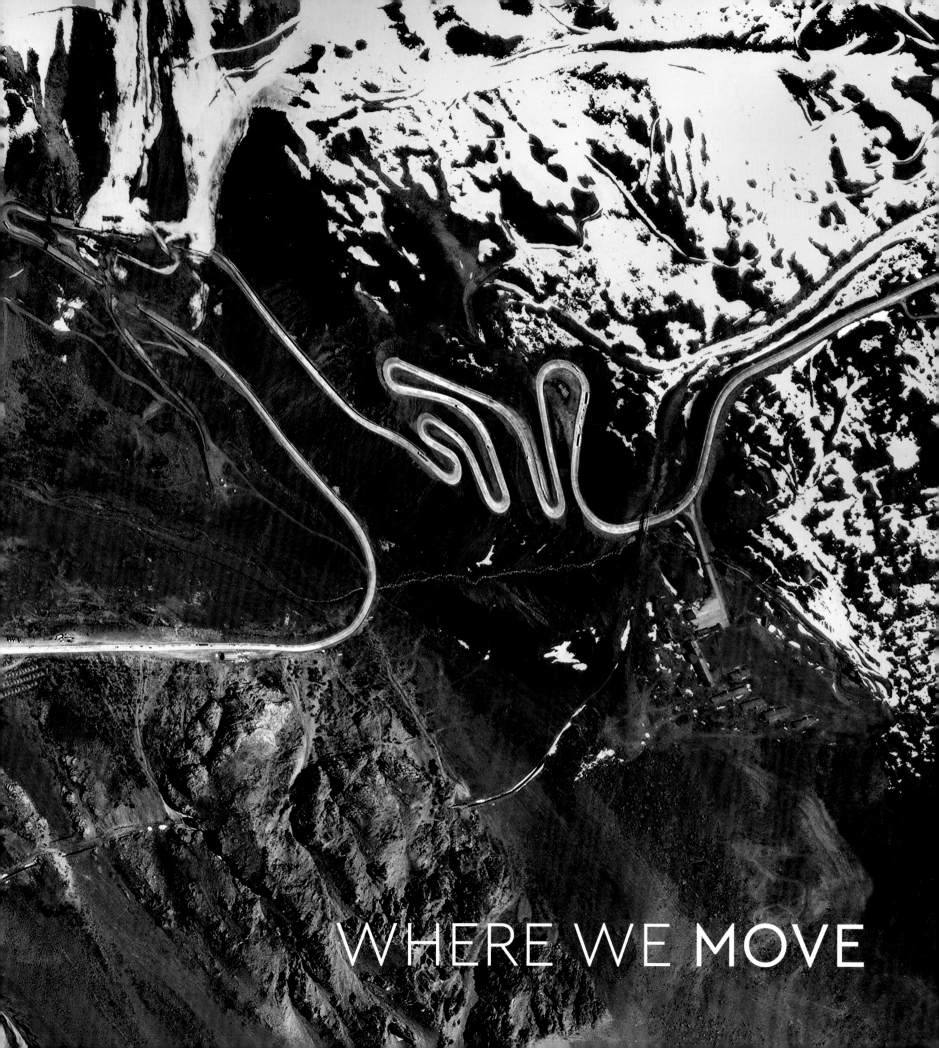

WHERE WE MOVE

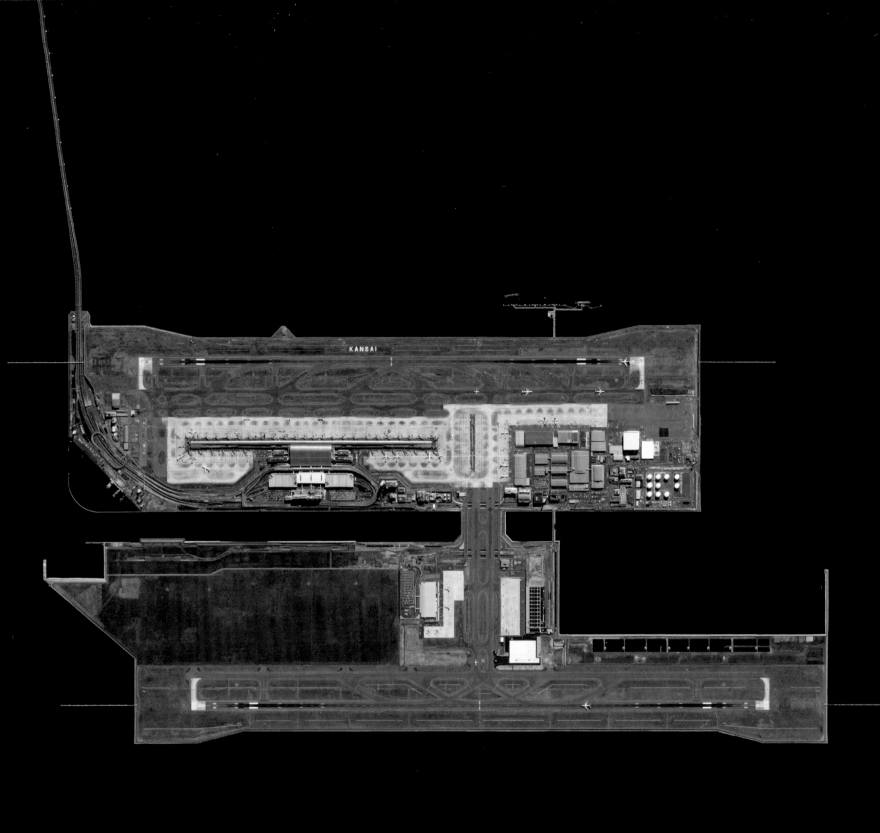

"We shall not cease from exploration
And the end of all our exploring
Will be to arrive where we started
And know the place for the first time."

T.S. Eliot, "Little Gidding" (1942)

WHERE WE **MOVE**

The word *planet* comes from the Greek *planētēs*, meaning "wanderer."
And just as Earth is traveling across the galaxy, we too are in constant
motion—to commute, visit others, transport goods, and explore. As the
efficiency and speed of our transportation has improved, our planet
and galaxy have grown ever smaller and more navigable. And with the
proliferation of cars, trains, commercial aircraft, and seafaring vessels,
transportation has not only become a part of our daily routine, but it is
also often something we seek out.

The landmarks of transportation we can see from space are
primarily our hubs and intersections—the places where we momentarily
come together before we head off in our separate directions. Over the
past few centuries, we have built up an extensive arterial network of
roads, lines, or routes to get us exactly where we need to go, yet our
journeys typically originate at one of these massive gathering sites.

Transportation connects us to new places and new cultures,
supporting our yearning to push our frontiers. However, with this quest
we have left our mark on the landscape of the planet and have released
vast amounts of carbon emissions along the way. Only time will tell
how things will unfold in the conflict between a fossil fuel–driven
transportation system and our undying, ever-growing need to move.
Perhaps the same innovative spirit that led to such far-reaching human
movement will produce the new modes of transport that we will need
to sustain a healthy planet.

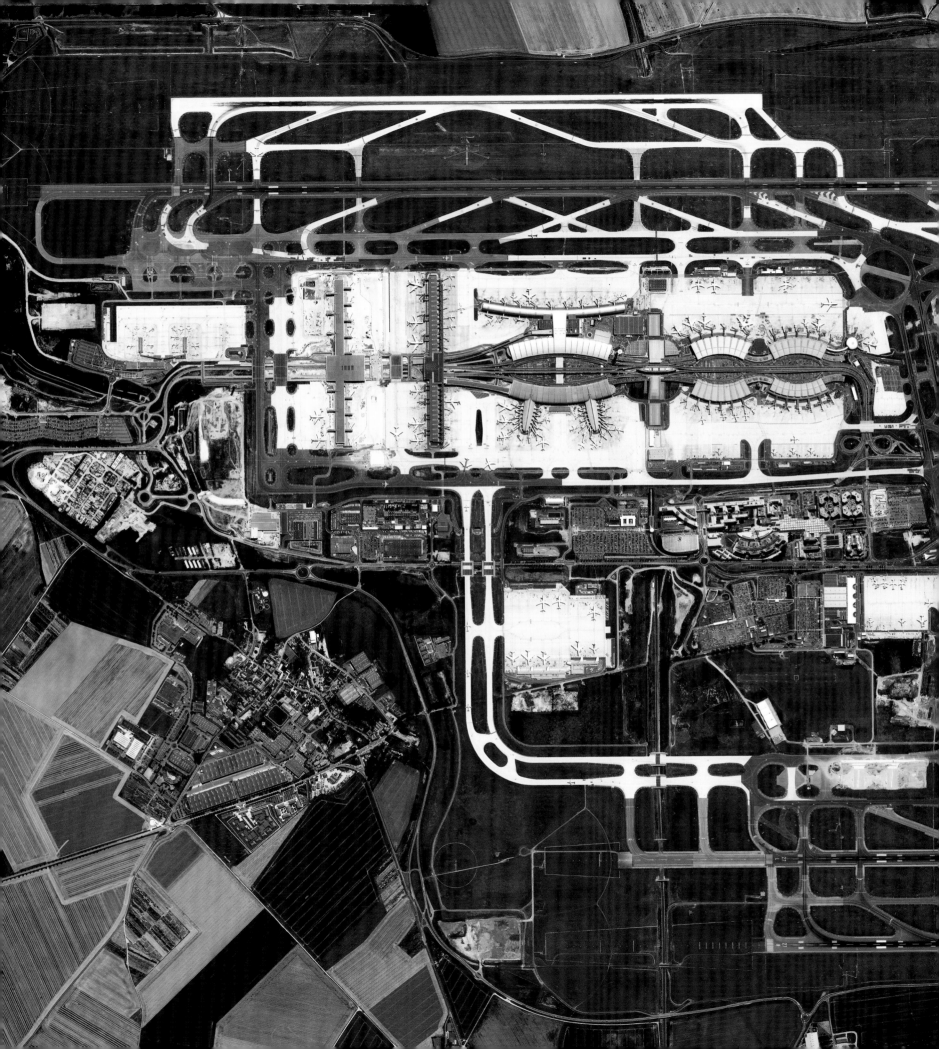

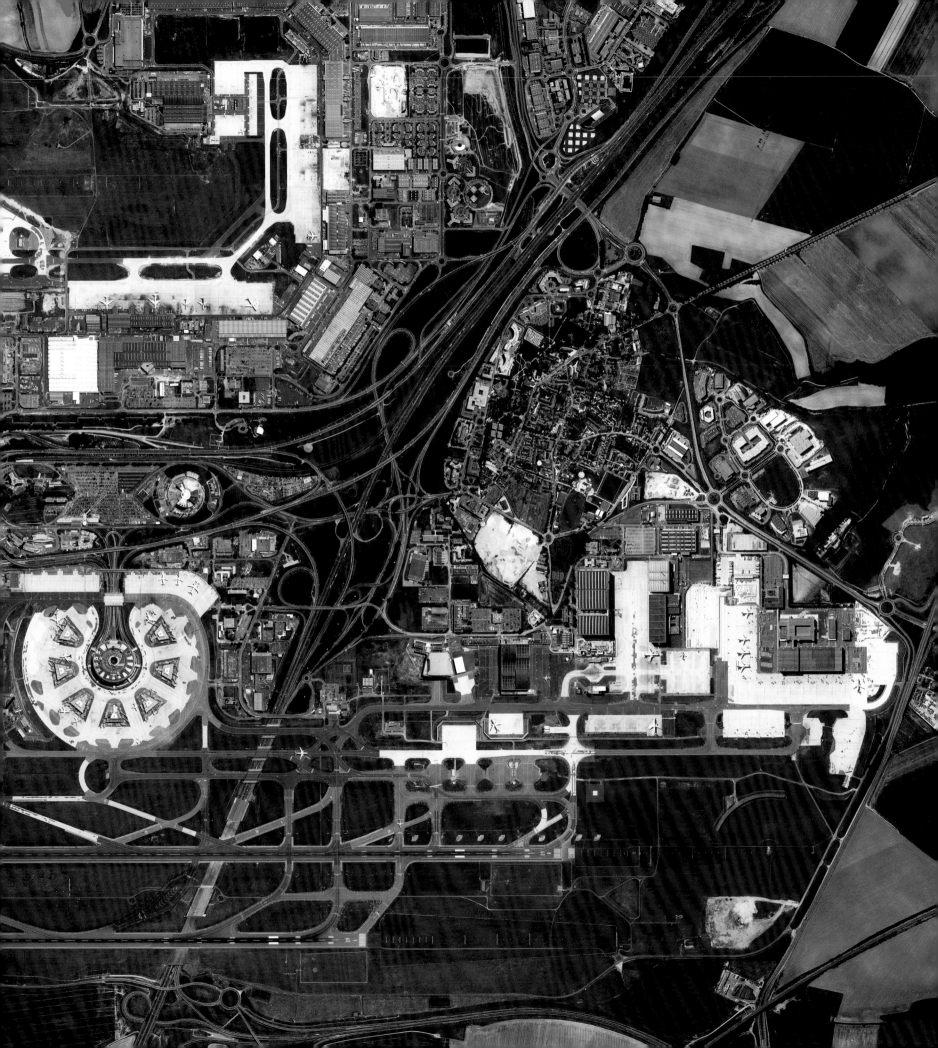

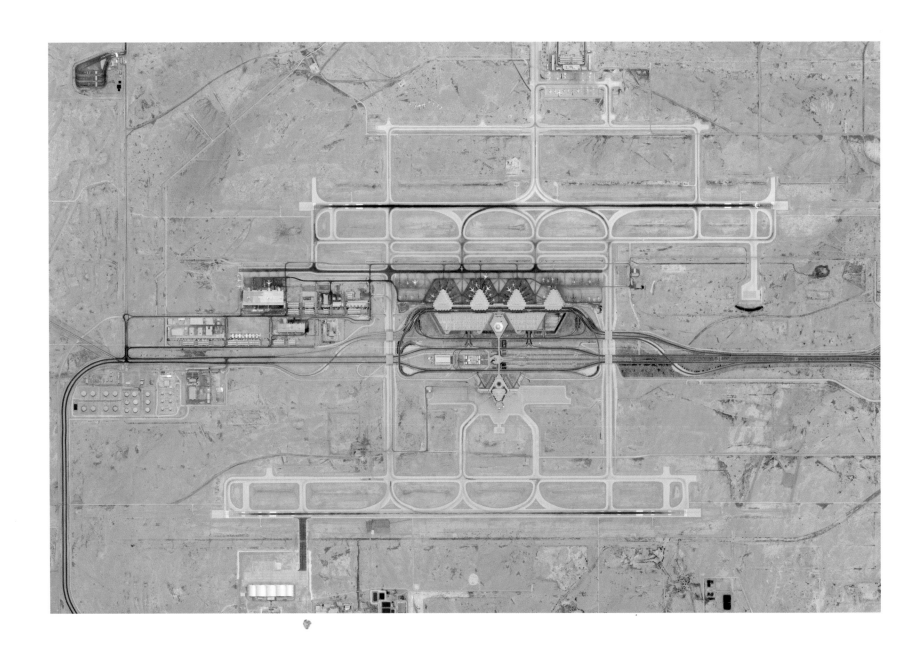

PREVIOUS PAGE

CHARLES DE GAULLE INTERNATIONAL AIRPORT

49.009725°, 2.545583°

Charles de Gaulle Airport is the largest and busiest airport in France, and the ninth busiest in the world, handling more than 65 million passengers each year. The facility has three terminals, including the recognizable, circular layout of Terminal 1 (seen here in the center right). Designed by Paul Andreu in the image of an octopus, the building's center houses key operations such as check-in and baggage claim, while its gates are located in seven satellite buildings connected via underground walkways.

ABOVE

KING KHALID INTERNATIONAL AIRPORT

24.958201°, 46.700779°

King Khalid International Airport is located in Riyadh, Saudi Arabia. The airport consists of four passenger terminals, parking for 11,600 vehicles, a Royal Terminal for distinguished guests and members of the Saudi Royal family, and two parallel runways that are both 13,980 feet (4,260 meters) long.

RIGHT

DALLAS/FORT WORTH INTERNATIONAL AIRPORT

32.897590°, −97.040413°

Dallas/Fort Worth International Airport stretches across 27 square miles (70 square kilometers) in Texas, USA. The facility is the tenth busiest airport in the world by passenger traffic, accommodating more than 64 million passengers each year.

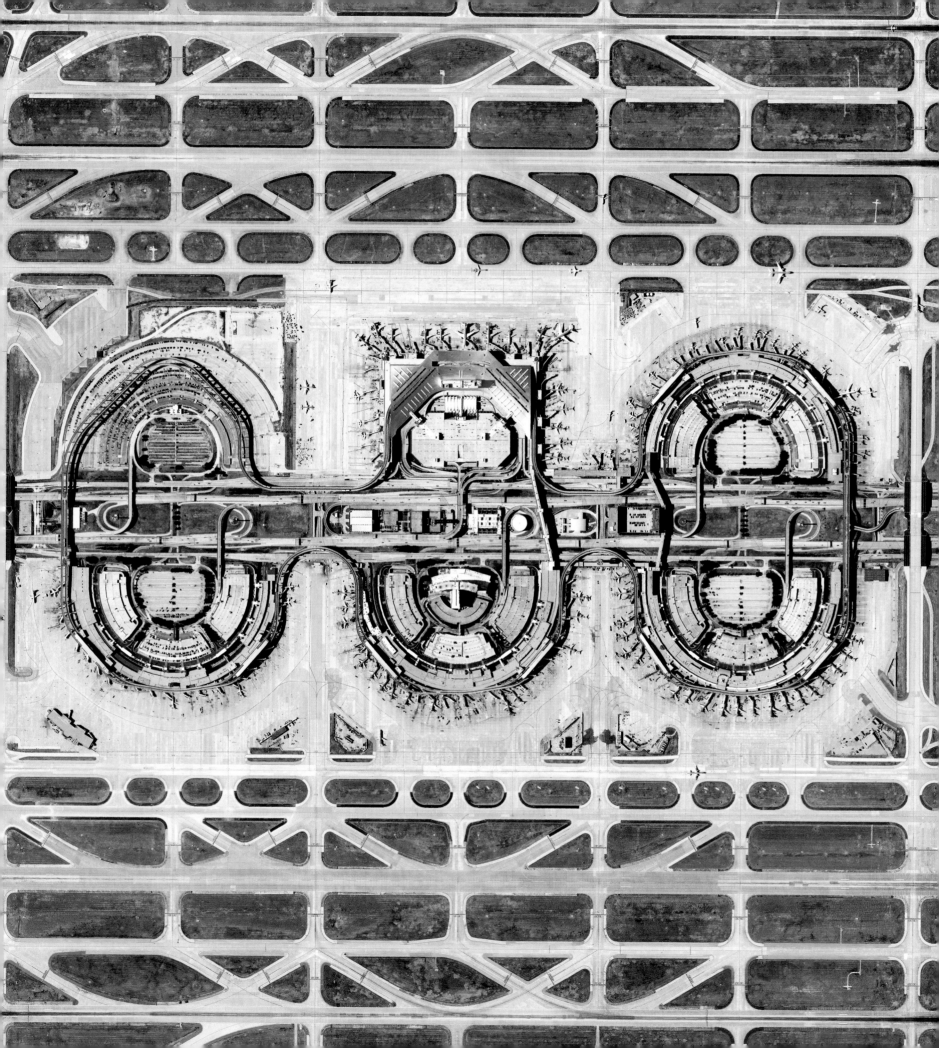

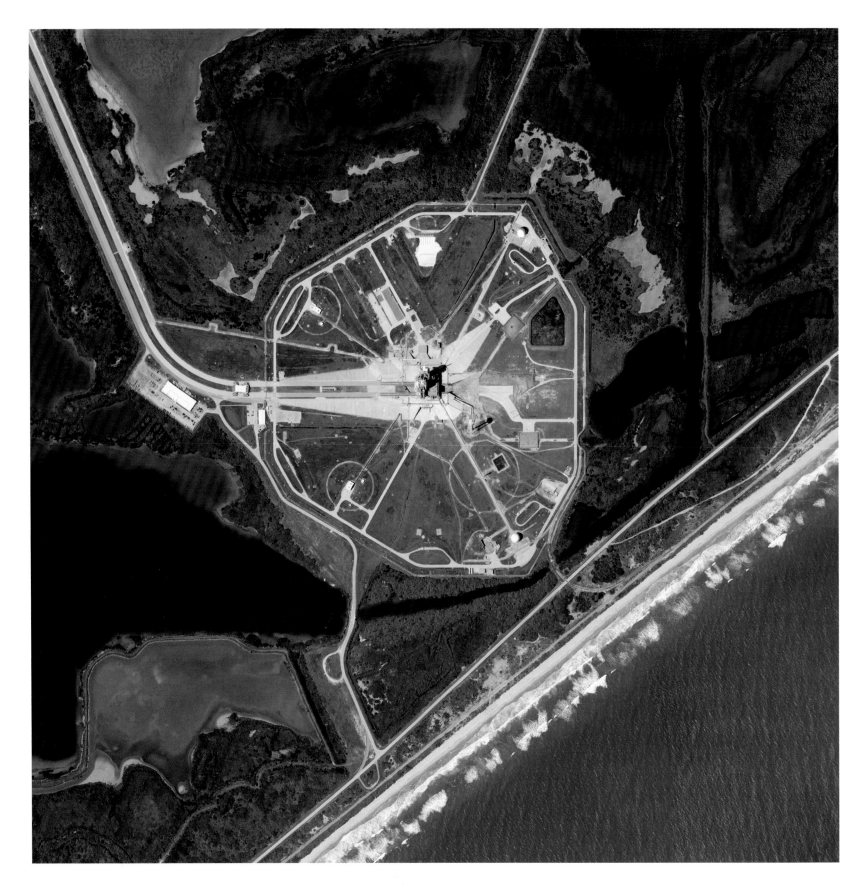

KENNEDY SPACE CENTER

28.607922°, −80.603835°

Launch Pad 39A is seen at the Kennedy Space Center, located in
Merritt Island, Florida, USA. The site has served as the origin for
numerous NASA space travel missions, including Apollo 11—
the first spaceflight that landed human beings on the moon.

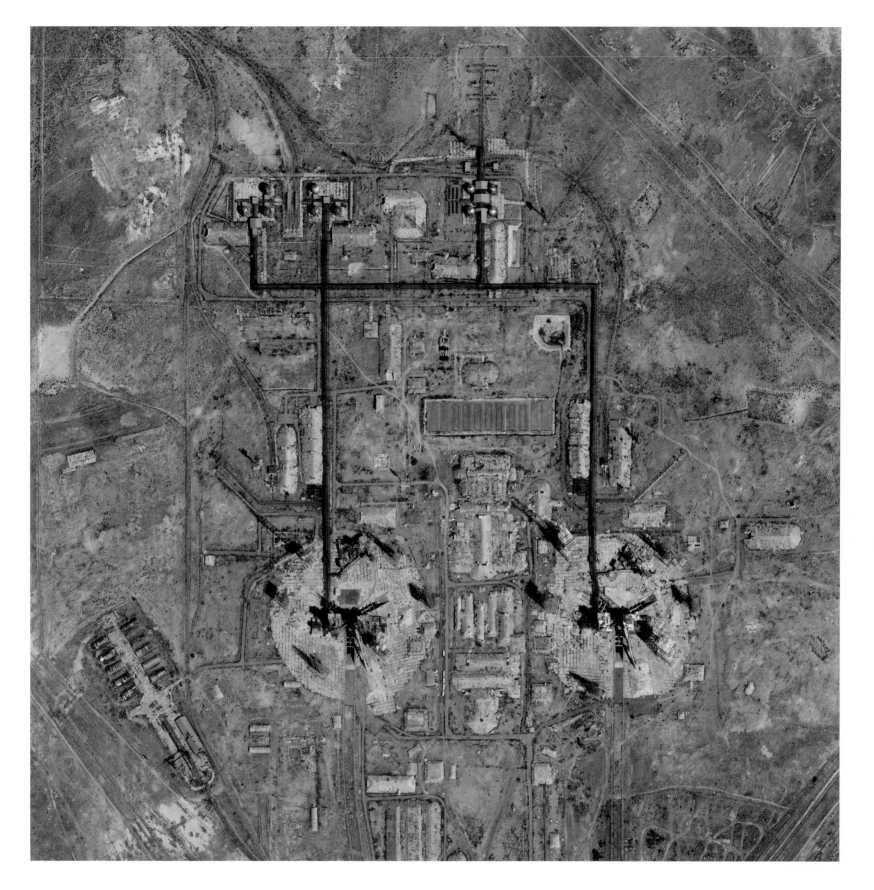

BAIKONUR COSMODROME

45.963775°, 63.307145°

The Baikonur Cosmodrome in Baikonur, Kazakhstan, is the world's first and largest operational space launch facility. The site was built by the Soviet Union in the late 1950s as the base of operations for its space program. Both Vostok 1, the first manned spacecraft in human history, and Sputnik 1, the world's first orbital satellite of any kind, launched from the Cosmodrome.

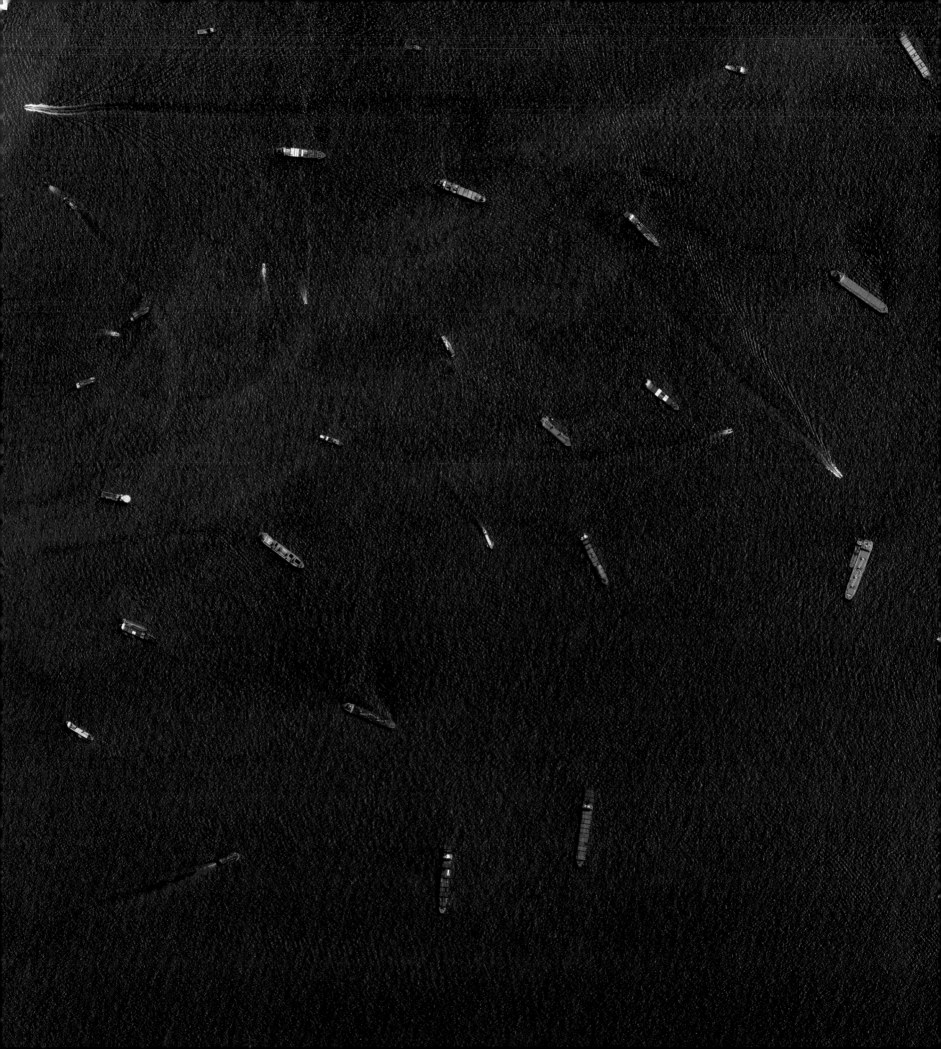

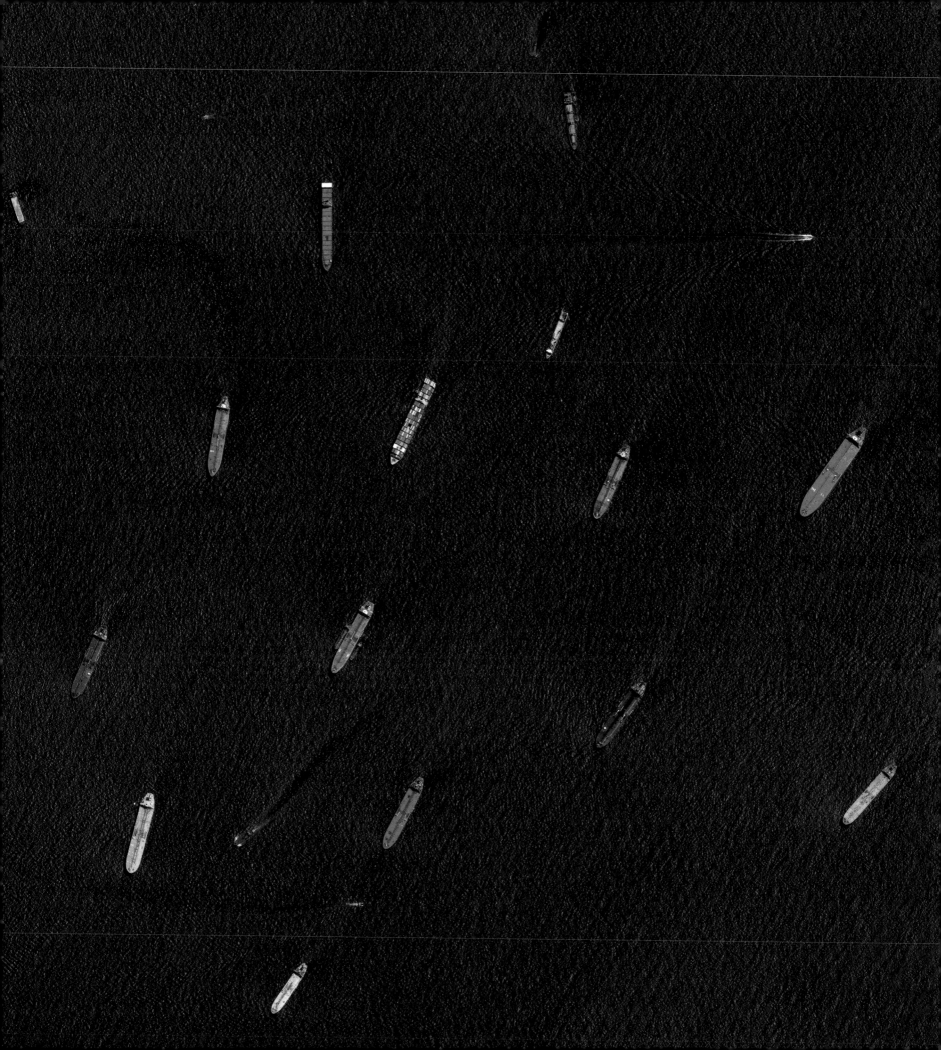

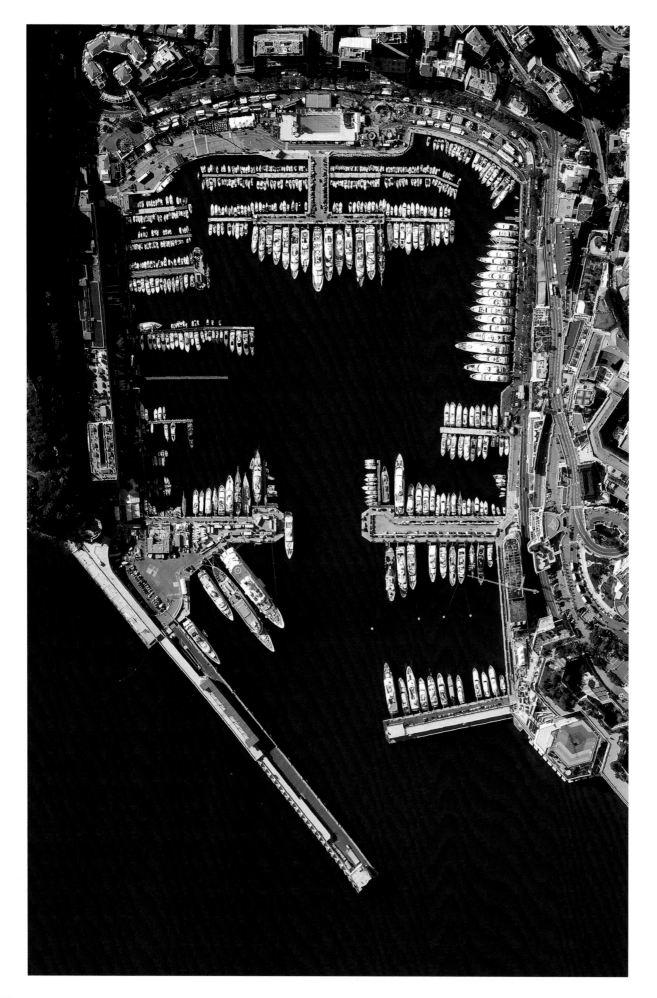

PREVIOUS PAGE

PORT OF SINGAPORE

1.237656°, 103.806422°

Cargo ships and tankers—some weighing up to 300,000 tons—wait outside the entry to the Port of Singapore. The facility is the world's second-busiest port in terms of total tonnage, shipping a fifth of the world's cargo containers and half of the world's annual supply of crude oil.

LEFT

PORT HERCULES

43.734829°, 7.423993°

Port Hercules, the only deep-water port in Monaco, provides anchorage for up to 700 vessels. The area of the port is 0.78 square miles (2.02 square kilometers) and comprises approximately 8 percent of the entire country.

RIGHT

TANJUNG PERAK

−7.181946°, 112.717889°

Cargo ships move through Tanjung Perak, the main port in Surabaya, Indonesia. Expansion and dredging are currently under way here to deepen the waters to 52.5 feet (16 meters) in order to enable a larger fleet of container ships to pass through safely. The facility's principal exports are sugar, tobacco, and coffee.

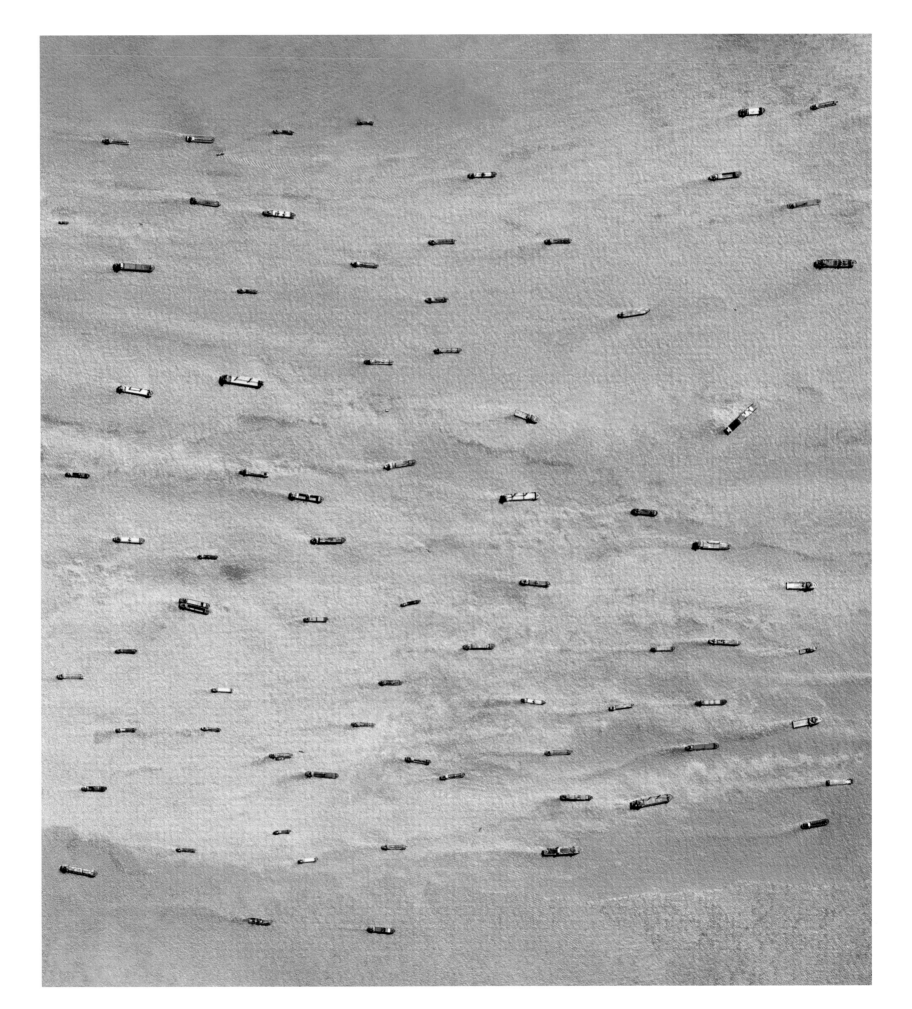

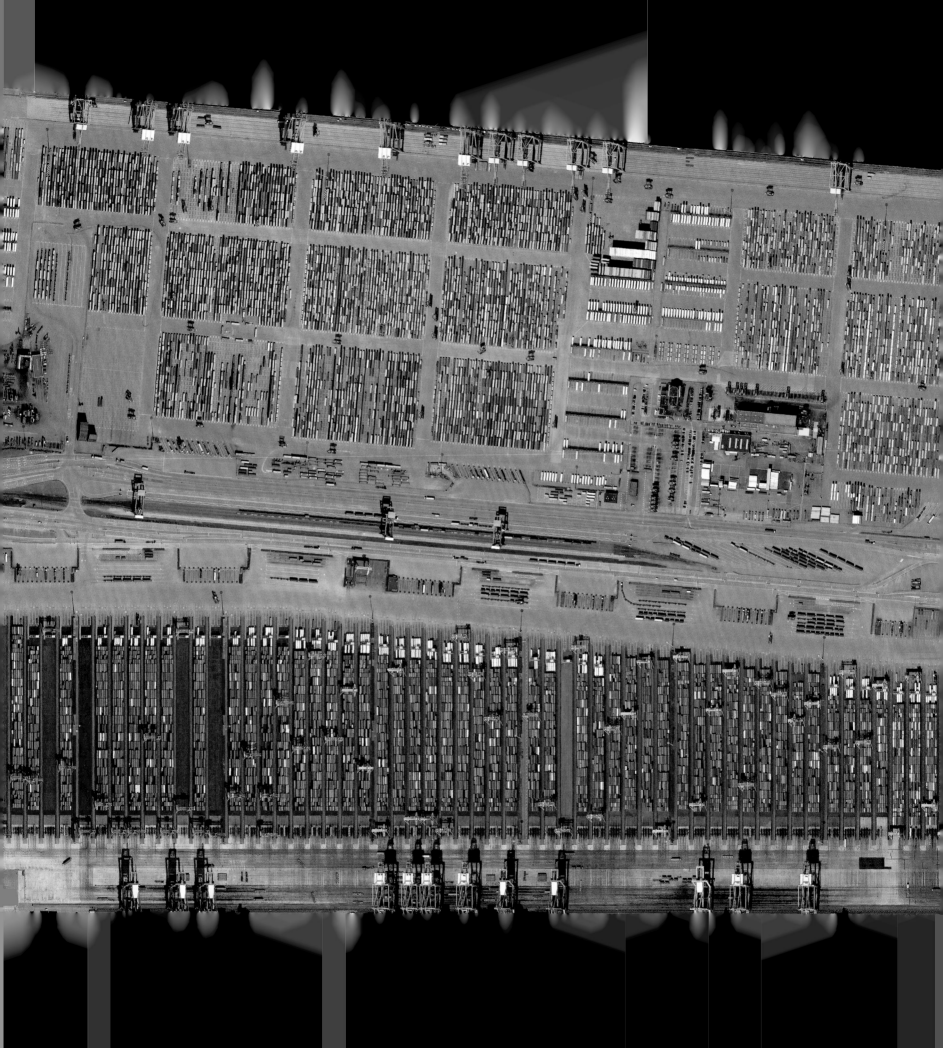

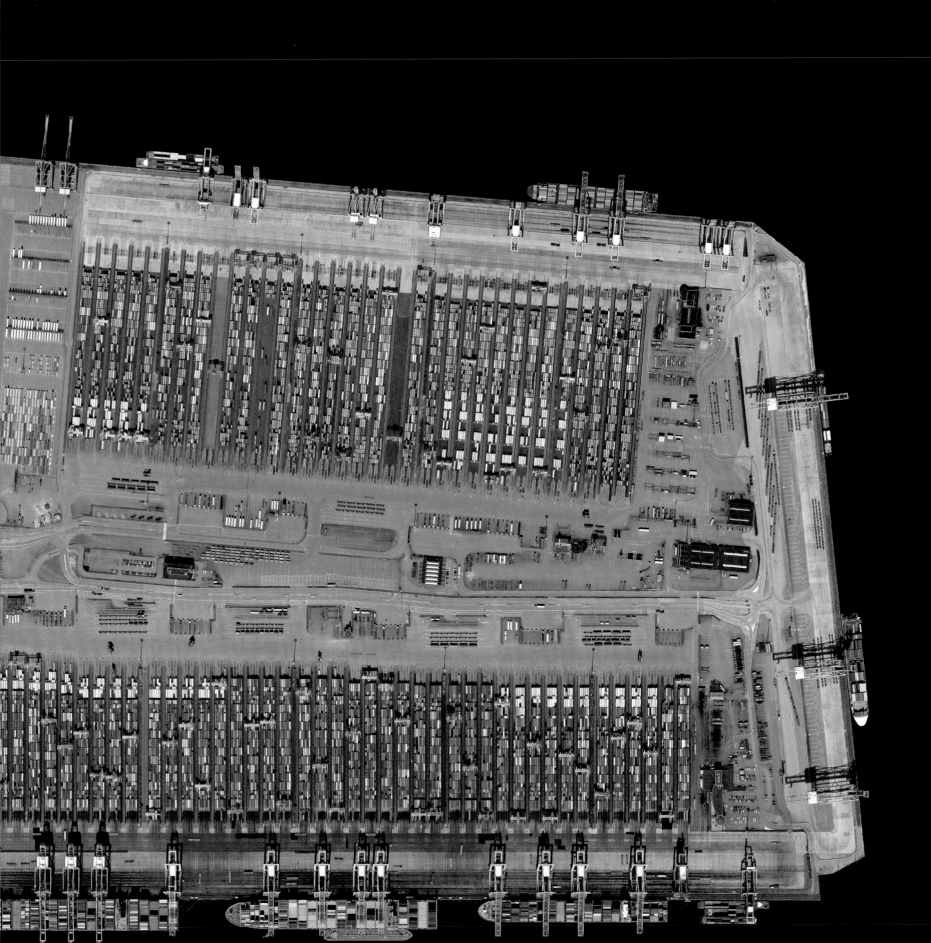

PREVIOUS PAGE

PORT OF ROTTERDAM

51.952790°, 4.053669°

The Port of Rotterdam was the world's busiest port from 1962 until 2002, but has since been surpassed by the Port of Singapore (see pages 148–49) and the Port of Shanghai. The massive docked container ships seen here can weigh up to 300,000 tons and extend up to 1,200 feet (366 meters).

RIGHT

PROGRESO PIER

21.323317°, −89.672746°

The pier in Progreso, Mexico, is the longest in the world, stretching 4 miles (6.5 kilometers) into the Gulf of Mexico. Because the town's shore sits on a limestone shelf that drops off gradually as it gets further into the Gulf, the pier requires this vast length to allow cruise ships to dock here.

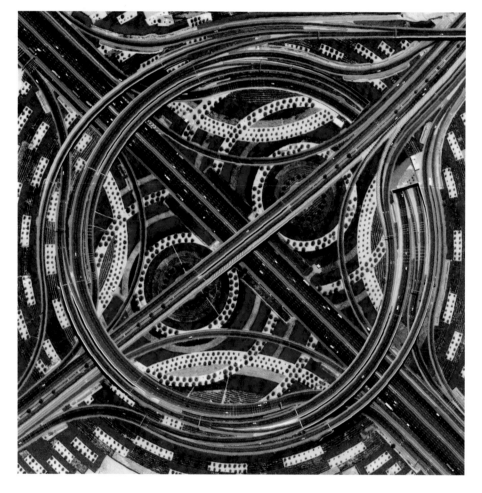

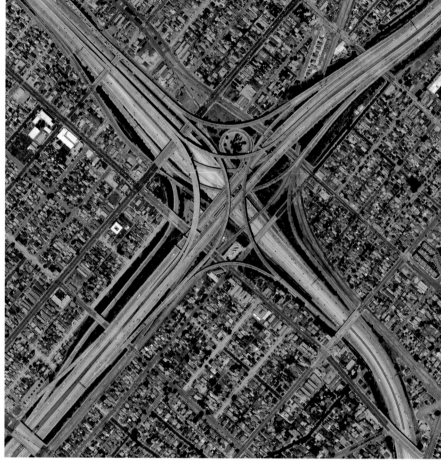

ABOVE LEFT

DUBAI, UNITED ARAB EMIRATES

25.055363°, 55.248780°

A whirlpool interchange connects three highways—including
one with 12 lanes—near the Miracle Garden in Dubai,
United Arab Emirates.

ABOVE RIGHT

LOS ANGELES, CALIFORNIA, USA

33.928700°, −118.281000°

The Judge Harry Pregerson Interchange is a stacked highway interchange
located in Los Angeles, California, USA. The junction is composed of
five levels that scale to a height of more than 132 feet (40 meters).

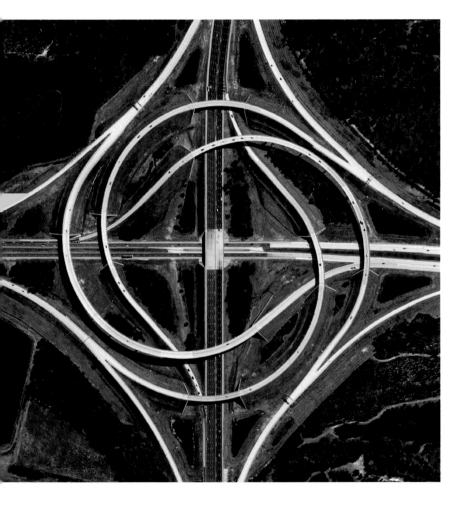

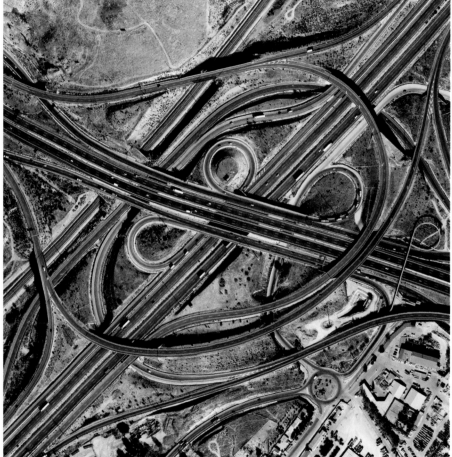

A turbine interchange connects two highways in Jacksonville, Florida, USA. This structure consists of left-turning ramps sweeping around a center interchange, thereby creating a spiral pattern of right-hand traffic.

Two highways come together in an interwoven crossroads southeast of Madrid, Spain. An overlapping interchange like this is often referred to as a "spaghetti junction."

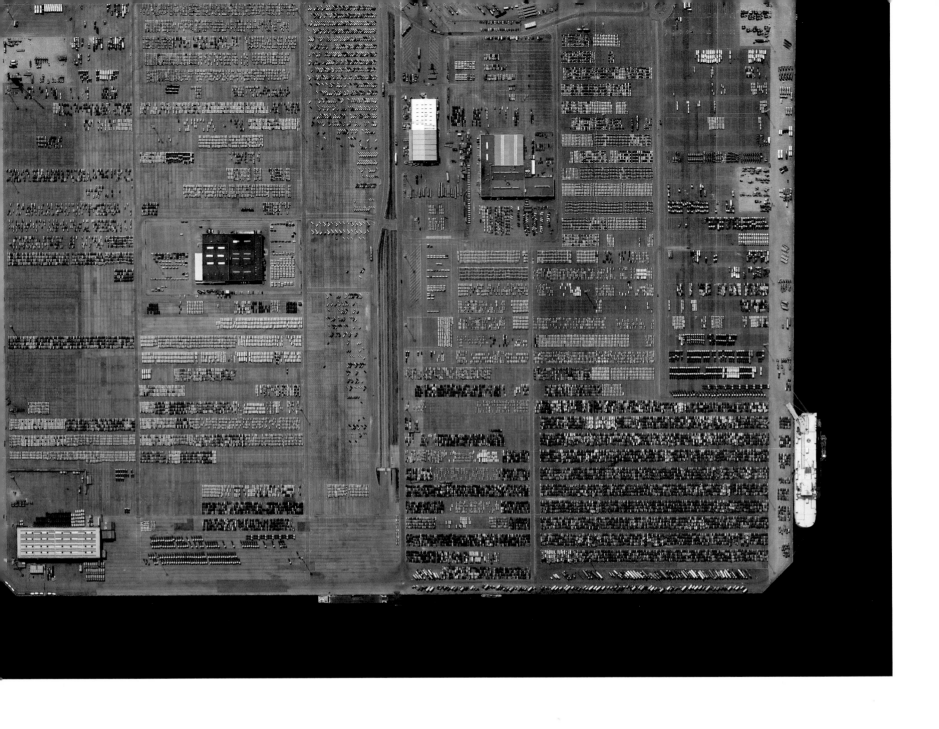

ABOVE

PORT OF ANTWERP

51.269956°, 4.228182°

Automobiles and semitrailer trucks are
unloaded and shipped at the Port of
Antwerp in Belgium. The facility moves
approximately 1.2 million vehicles each year.

RIGHT

O'HARE PARKING LOT

41.987794°, –87.881963°

A massive parking lot is seen at Chicago O'Hare
International Airport in Chicago, Illinois, USA.
Experts estimate that there may be as many as
500 million parking spaces in the United States alone.

FAR RIGHT

SCHOOL BUS ASSEMBLY PLANT

36.189292°, –95.875041°

A school bus assembly plant in Tulsa, Oklahoma, USA,
manufactures 50 to 75 buses a day on average. The standard
American school bus is 45 feet (13.7 meters) long and has
a seating capacity of up to 90 passengers.

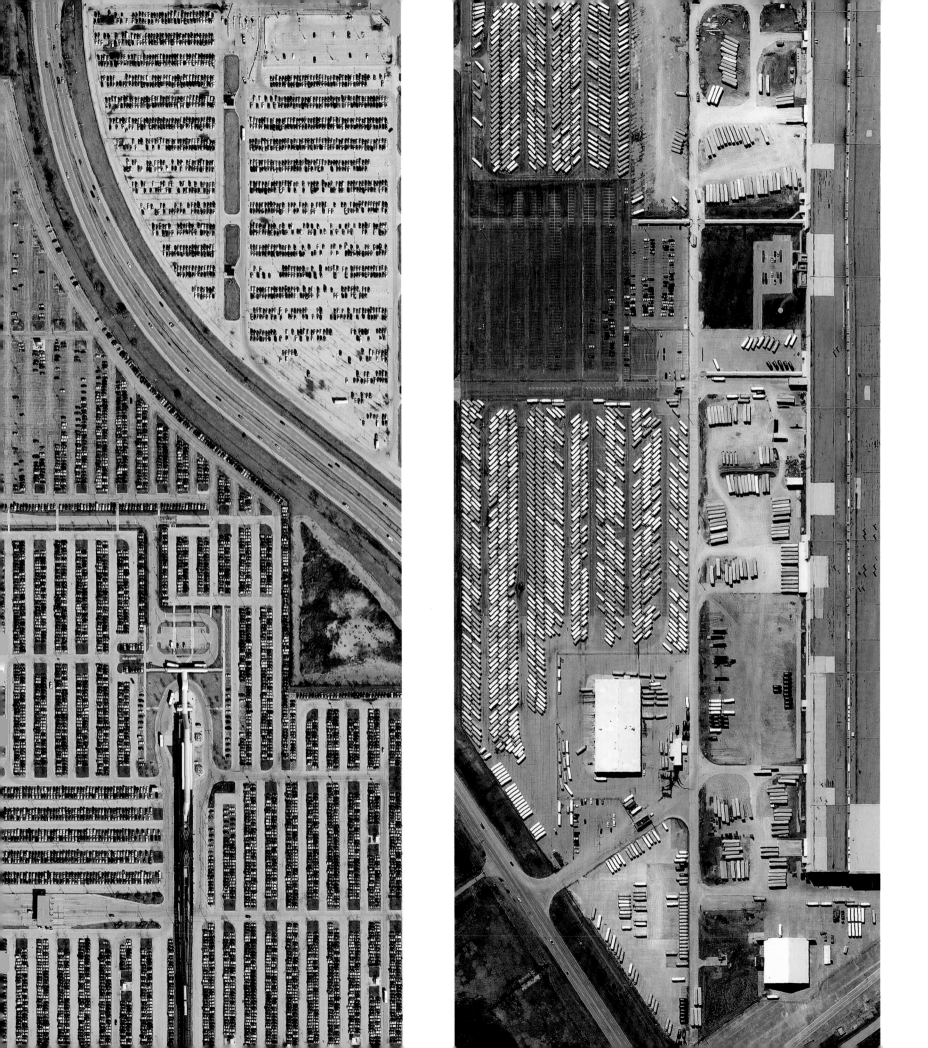

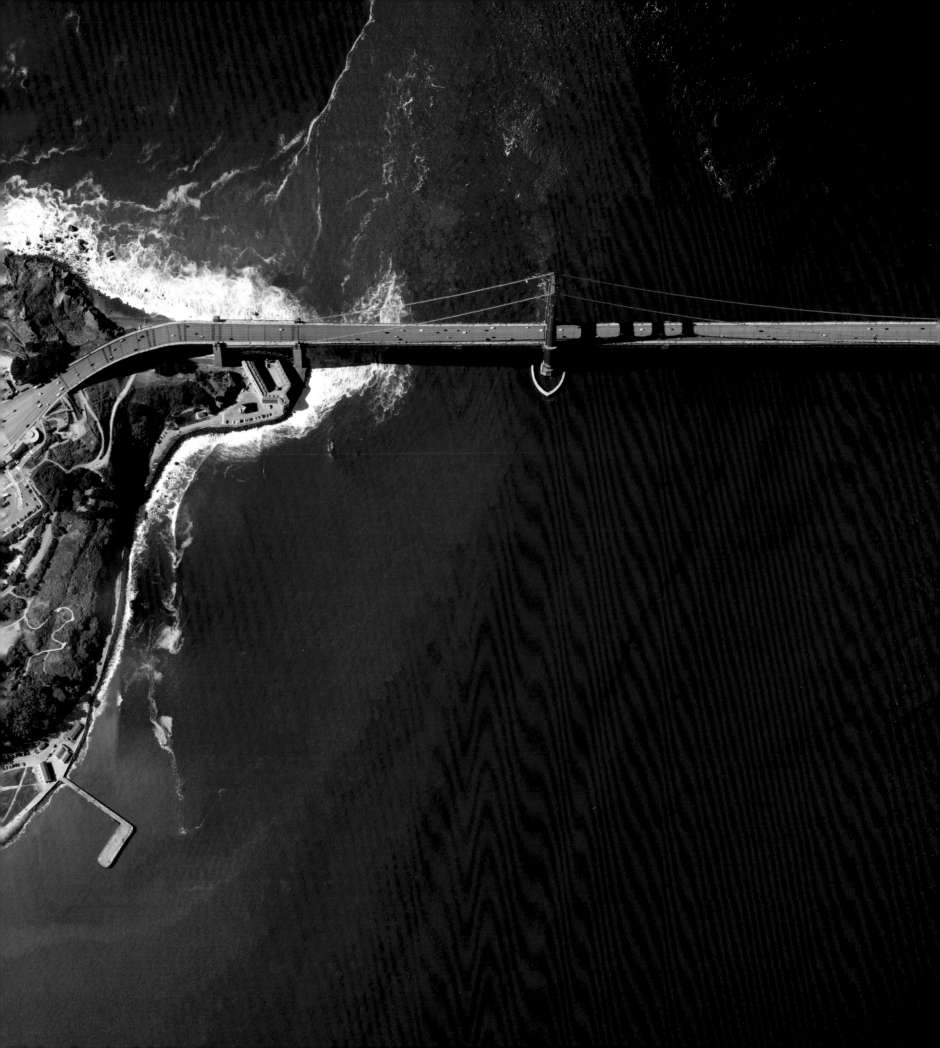

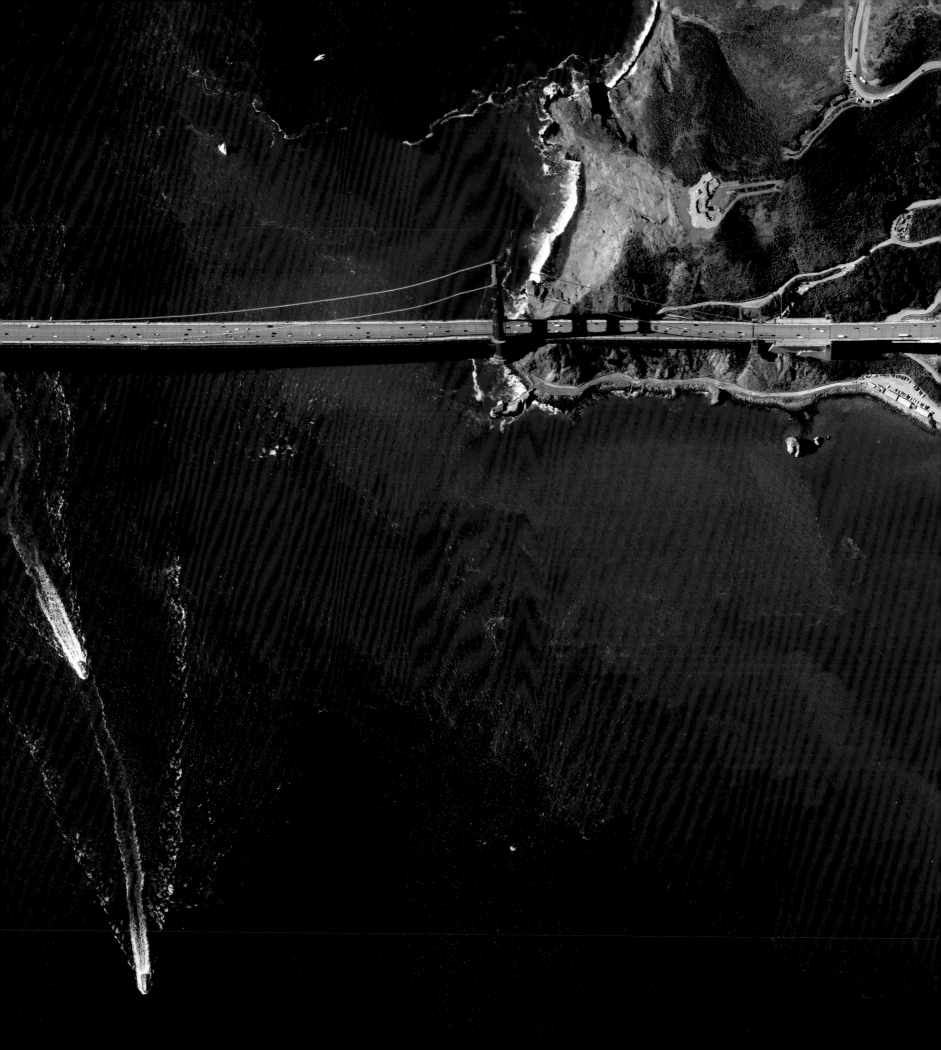

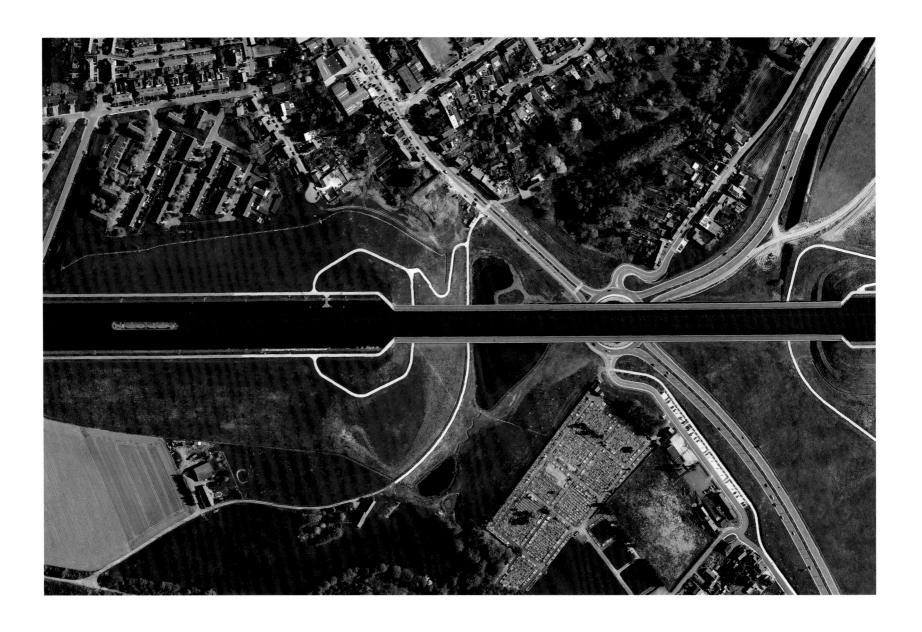

PREVIOUS PAGE

GOLDEN GATE BRIDGE

37.818672°, –122.478708°

The Golden Gate Bridge is a 1.7-mile-long (2.7-kilometer) suspension bridge in San Francisco, California, USA, that spans the Golden Gate Strait—the channel between San Francisco Bay and the Pacific Ocean. The bridge's signature color, known as "international orange." was selected to complement its natural surroundings and enhance its visibility in fog.

ABOVE

PONT DU SART AQUEDUCT

50.493441°, 4.137351°

A barge approaches the Pont du Sart Aqueduct, a navigable water bridge that carries boats over the N55 and N535 roads near the town of Houdeng-Gœgnies, Belgium. The aqueduct weighs 65,000 tons and is supported by twenty eight concrete columns that are 10 feet (3 meters) in diameter.

RIGHT

JUSCELINO KUBITSCHEK BRIDGE

–15.822856°, –47.830000°

The Juscelino Kubitschek Bridge is a steel and concrete bridge that crosses Lake Paranoá in Brasília, Brazil. The main span has four supporting pillars submerged underwater, while the deck weight is supported by three, 200-foot-tall (61-meter) asymmetrical steel arches that crisscross diagonally over the structure.

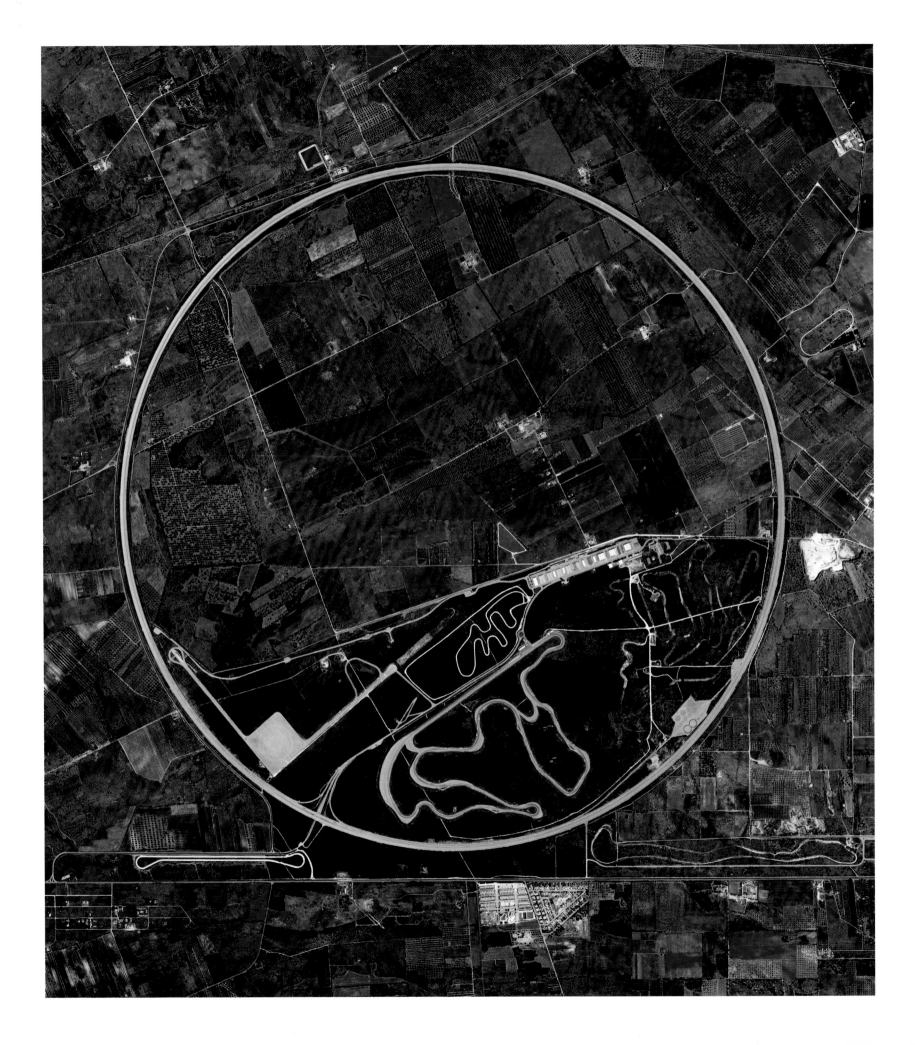

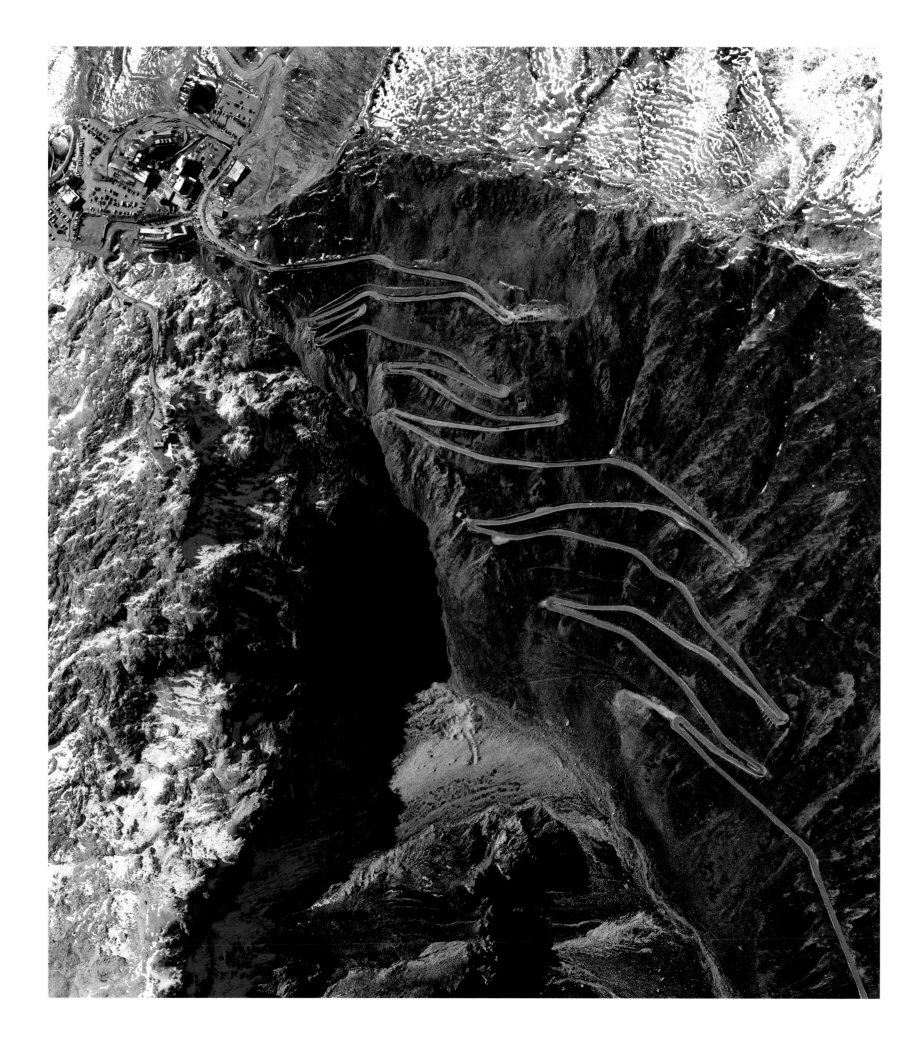

PREVIOUS PAGE LEFT
NARDÒ RING
40.327222°, 17.826111°

The Nardò Ring is a high-speed, 7.8-mile-long (12.6-kilometer) circular test track in Nardò, Italy. Each of the ring's four lanes has a determined "neutral speed" and is banked in such a manner that one can drive as if the road were straight.

PREVIOUS PAGE RIGHT
STELVIO PASS
46.528611°, 10.452777°

The Stelvio Pass in northern Italy is the highest paved roadway in the eastern Alps, with an elevation of 9,045 feet (2,757 meters) above sea level. Only accessible in the summer months, the road and its 75 hairpin turns are sometimes scaled during the famous Giro d'Italia cycling race.

RIGHT
CHANNEL TUNNEL, FRENCH ENTRANCE
50.917395°, 1.809391°

Car-loading ramps and tracks are seen by the entrance to the Channel Tunnel in Coquelles, France—visible in the upper left of this Overview. The tunnel spans 31.4 miles (50.5 kilometers) and contains the longest undersea portion of any tunnel in the world at 23.5 miles (37.9 kilometers). Construction began in 1988, was completed in 1994, and cost approximately $8 billion USD.

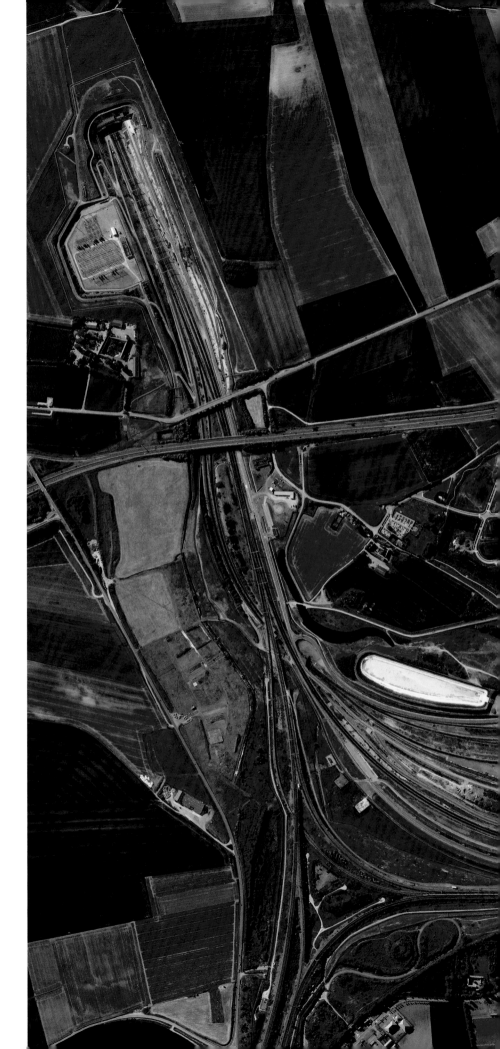

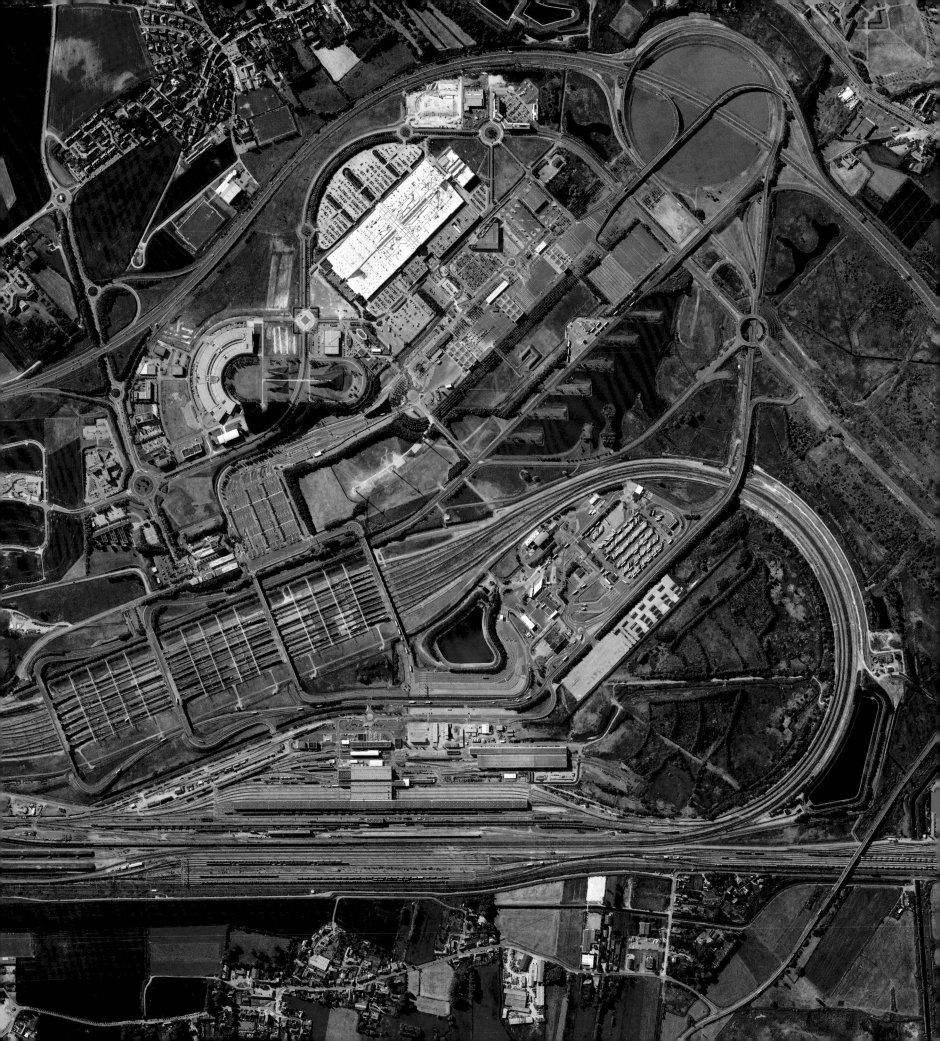

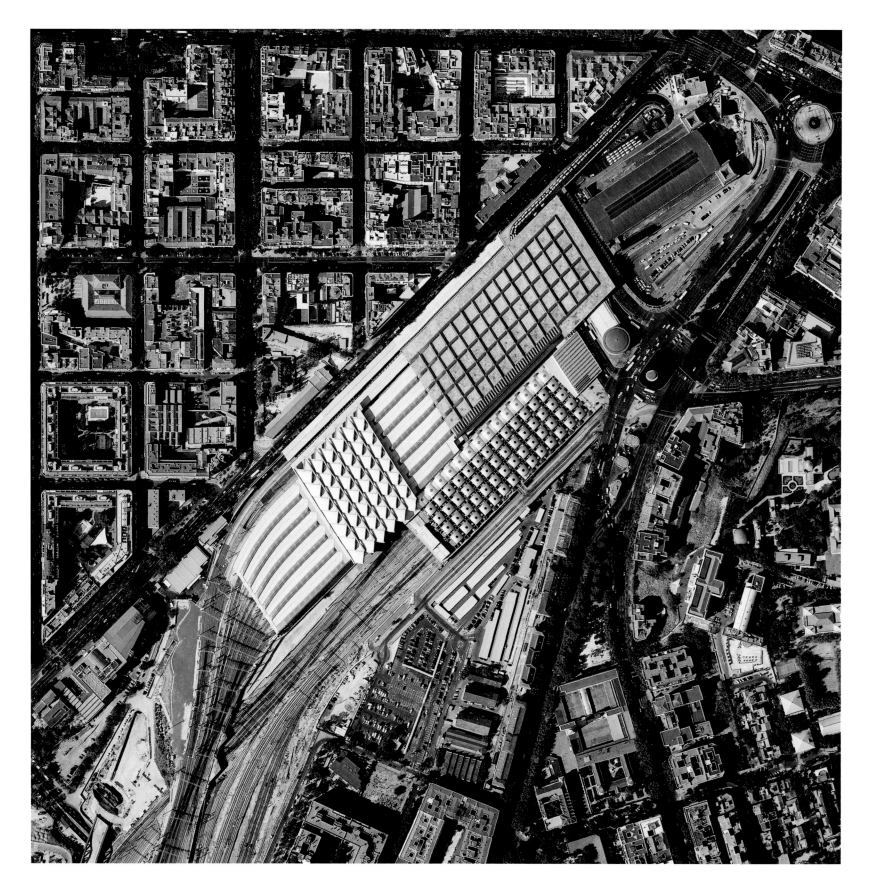

MADRID ATOCHA RAILWAY STATION

40.405419°, −3.689601°

Madrid Atocha Railway Station is the largest train station in Madrid, Spain. The facility serves as a hub for commuter trains, intercity and regional trains from the south, and AVE high-speed trains. In 1992, the station's original terminal building was converted into a concourse with shops, a nightclub, and a 43,055-square-foot (4,000-square-meter) tropical botanical garden.

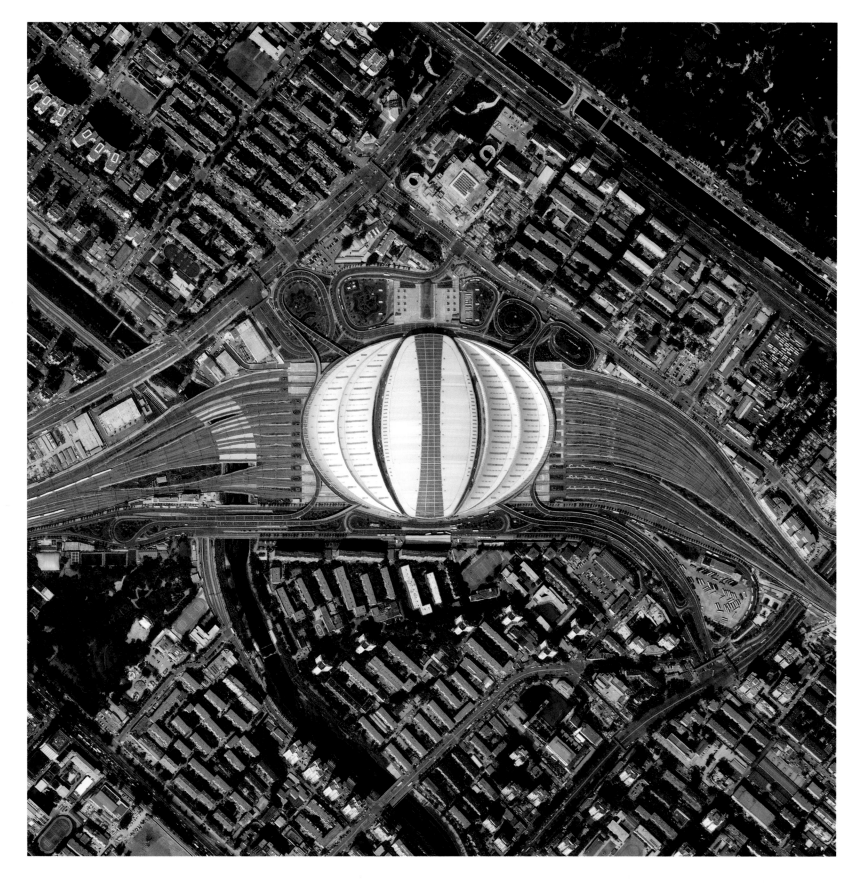

BEIJING SOUTH RAILWAY STATION

39.864688°, 116.378734°

Beijing South Railway Station is the largest train station in the Chinese capital—its 24 platforms have the capacity to dispatch 30,000 passengers per hour, or 241,920,000 per year. The station also serves as the terminus for high-speed routes to Tianjin and Shanghai, on which trains can reach speeds up to 217 miles (350 kilometers) per hour.

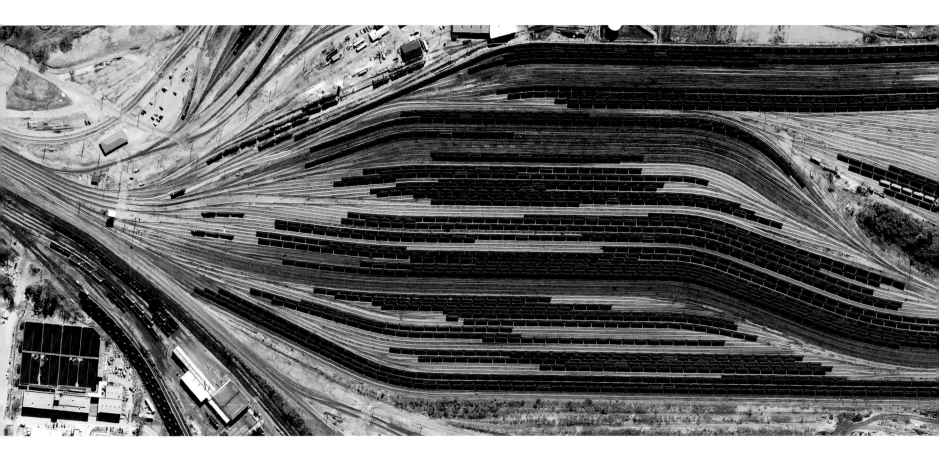

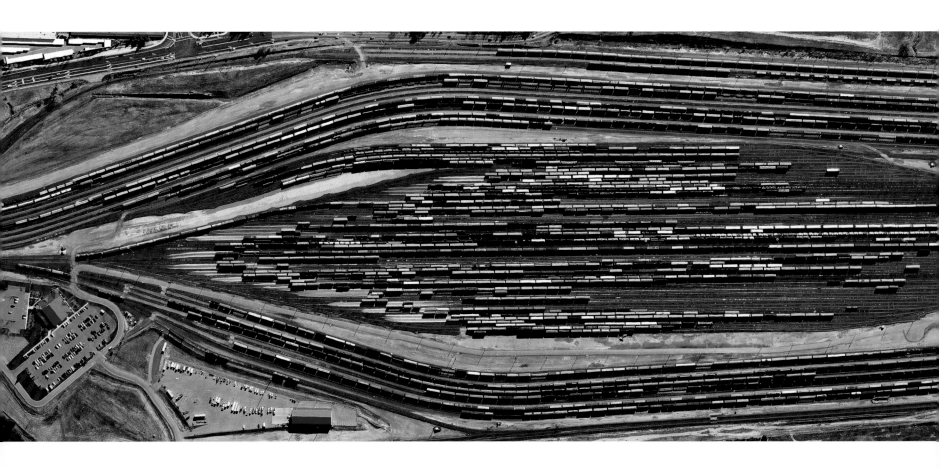

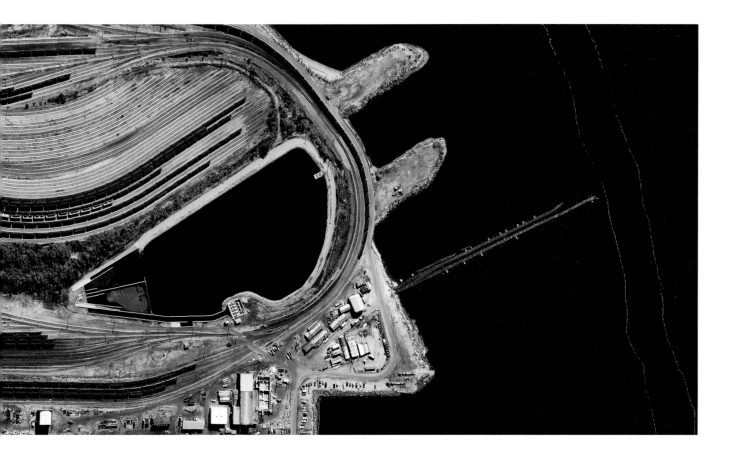

LEFT TOP

LAMBERTS POINT PIER 6

36.875248°, −76.320259°
Train cars filled with
coal are stationed in
Norfolk, Virginia, USA,
at Lamberts Point Pier 6.
The facility is the largest
coal-loading station in the
Northern Hemisphere,
and serves as the depot
for 23,000 coal cars.

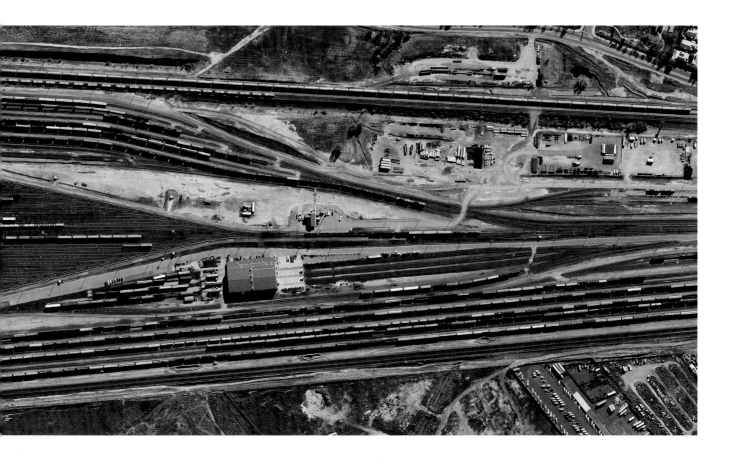

LEFT BOTTOM

ROSEVILLE YARD

38.720556°, −121.316111°
Roseville Yard, located north
of Sacramento, California,
USA, is the largest rail facility
on the West Coast of the
United States. The yard
accommodates approximately
98 percent of all rail traffic
in the north of the state.

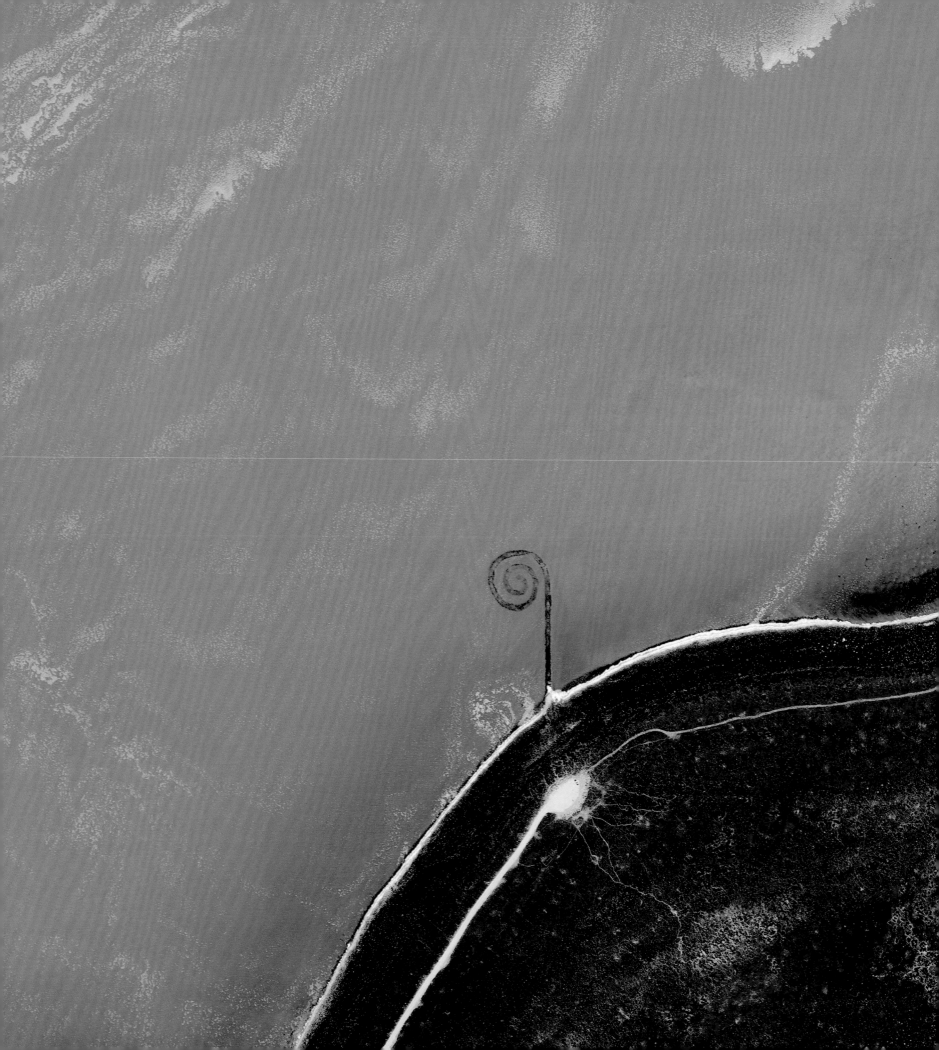

WHERE WE DESIGN

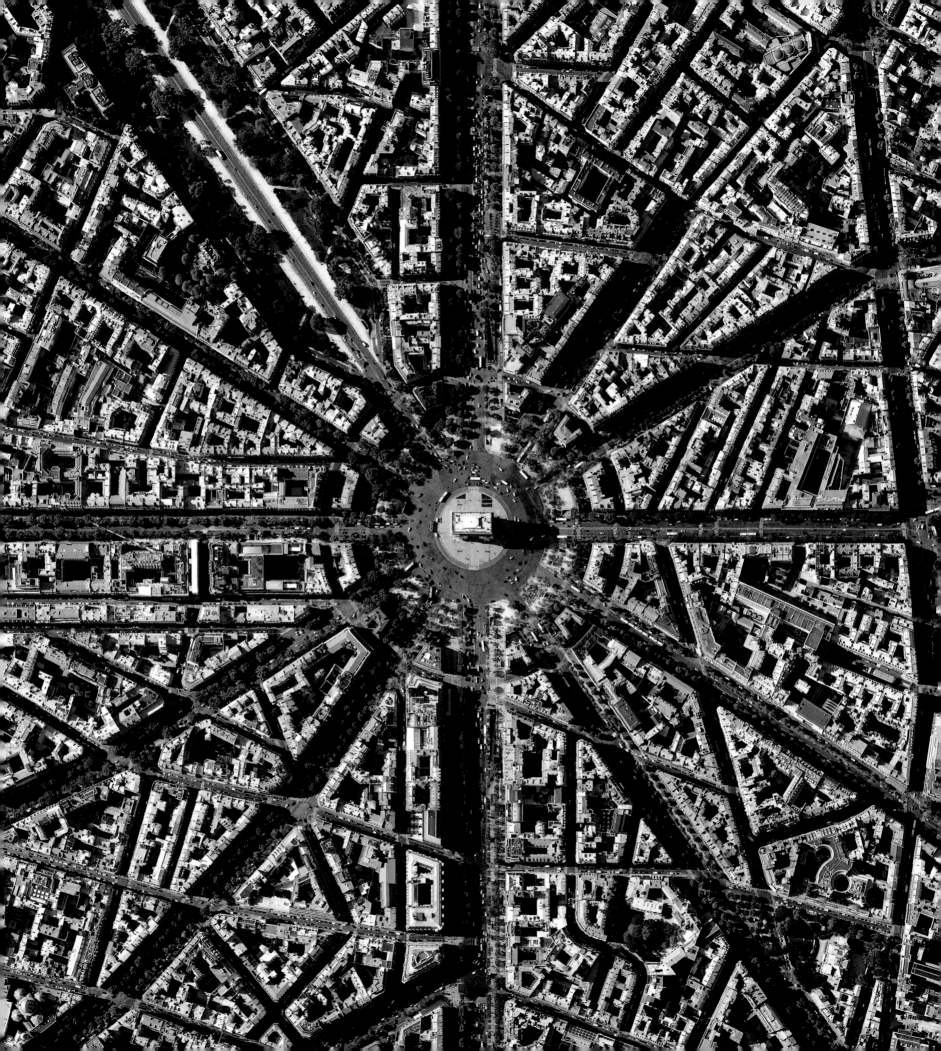

"You can design and create, and build the most wonderful place in the world. But it takes people to make the dream a reality."

Walt Disney

PREVIOUS PAGE
SPIRAL JETTY
41.437932°, −112.668929°
Spiral Jetty is an earthwork sculpture by Robert Smithson, consisting of a 1,500-foot-long (460-meter), 15-foot-wide (4.6-meter) counterclockwise coil jutting from the northeastern shore of the Great Salt Lake in Utah, USA. Smithson reportedly chose this site because of the vibrant colors of the water (salt-tolerant bacteria and algae thrive here in water with 27 percent salinity) and its similarity to the Earth's ancient seas.

LEFT
ARC DE TRIOMPHE
48.873803°, 2.292806°
The Arc de Triomphe is located at the center of 12 radiating avenues in Paris, France. Because of numerous delays, such as the abdication of Napoleon, construction of the arch took nearly 30 years to complete. To see the structure within the full urban plan of Paris, turn to pages 188–89.

WHERE WE **DESIGN**

One could argue that almost all of the images in this book show places where humans have designed something. Nevertheless, planning for the sake of art or design requires our special attention. In this chapter we will explore some of the places where humans have created beauty on a grand scale, either for reasons practical, such as architecture and urban planning, or aesthetic, like land art and gardens. Regardless of the designed area's intended use, seeing human ingenuity manifest itself in a cohesive theme across a vast landscape is something to behold.

A major focus of this chapter is urban planning. There is much to be learned from looking at cities from the Overview perspective. As humanity's population increases, urban living and design will become an increasingly important concern on an ever-crowded planet. City life will become the norm for more of us, and the infrastructure of cities themselves will have to adapt under new strains to serve their residents well. In China alone, the government has an ambitious plan to move 250 million residents from rural areas into massive cities over the next 10 to 13 years. If that plan works, 900 million people will live in Chinese cities in 2025.

The Overview perspective provides us with wonderful examples of how the particular layout of a city can determine where social interaction occurs in a space or how people and transport move through, over, and under the design. We need smart and well-guided minds designing our future cities to solve the problems presented by the aforementioned, imminent population increases. In this case, perhaps there is no better way to prepare for the future than by looking down at the past.

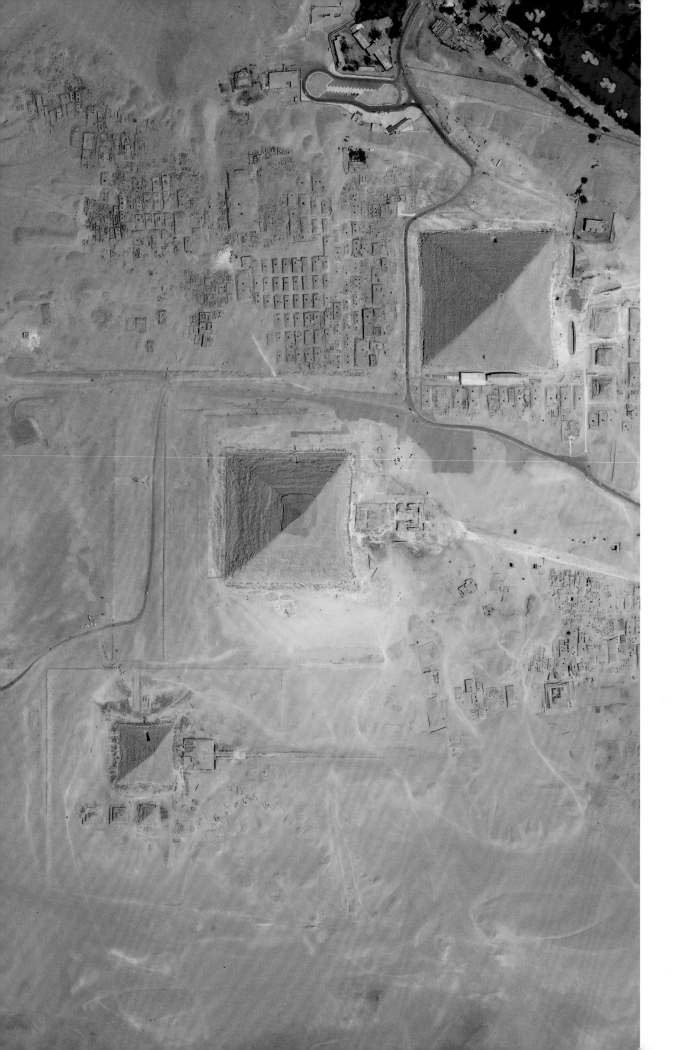

LEFT

PYRAMIDS OF GIZA

29.976115°, 31.130583°

The Great Pyramids of Giza are located on the outskirts of Cairo, Egypt. Dating back to 2580 BC, the Great Pyramid, the largest structure at the site, is the oldest of the Seven Wonders of the Ancient World, and the only one to remain largely intact. With an estimated 2,300,000 stone blocks weighing from 2 to 30 tons each, the 481-foot (147-meter) pyramid was the tallest structure in the world for more than 3,800 years.

RIGHT

ANGKOR WAT

13.412505°, 103.864472°

Angkor Wat, a temple complex in Cambodia, is the largest religious monument in the world (first it was Hindu, then Buddhist). Constructed in the twelfth century, the 8.8 million-square-foot (820,000-square-meter) site features a moat and forest that harmoniously surround a massive temple at its center.

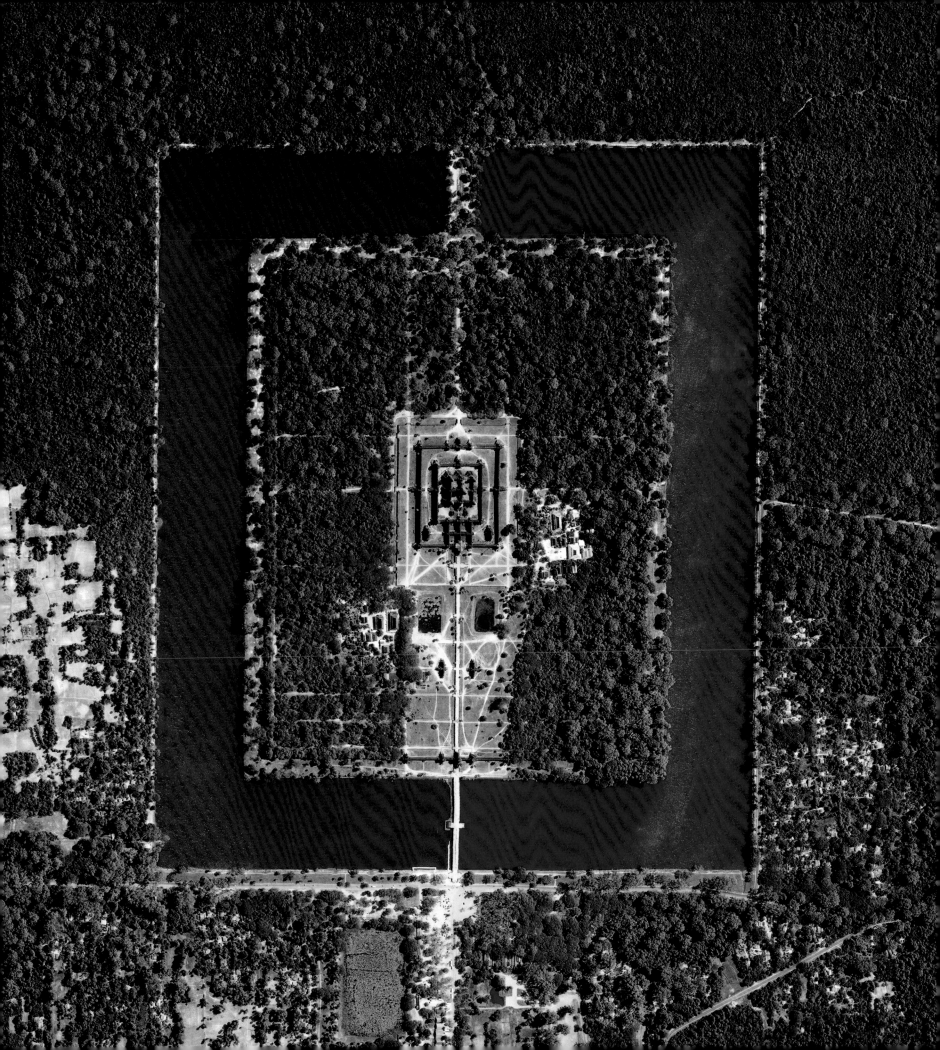

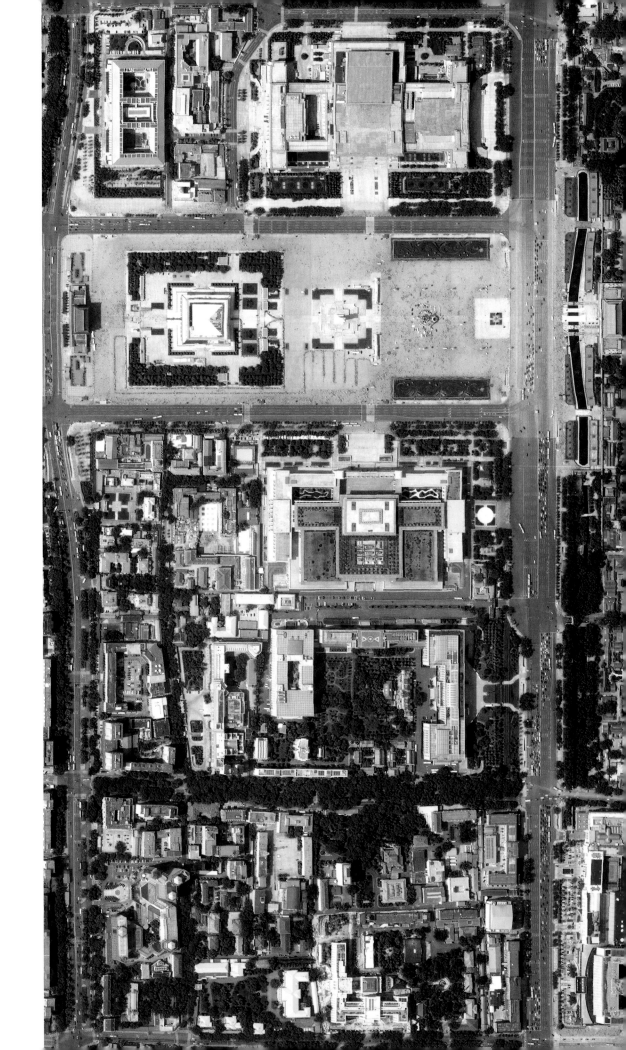

FORBIDDEN CITY
39.914726°, 116.388361°
The Forbidden City in Beijing, China, took 14 years to build (1406 to 1420) and more than 1 million workers were involved in its construction. The palace complex, which contains 9,999 rooms, is surrounded by walls and a moat that are 26 feet (8 meters) high and 171 feet (52 meters) wide, respectively.

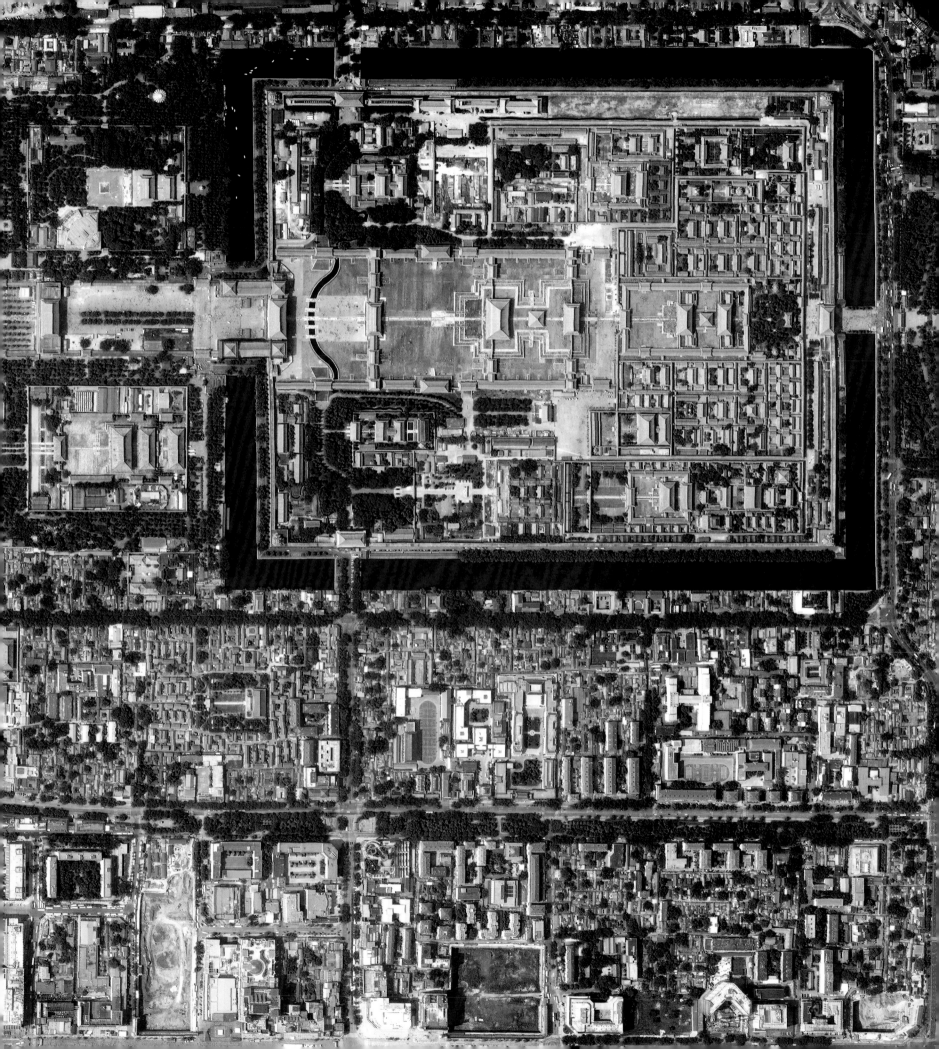

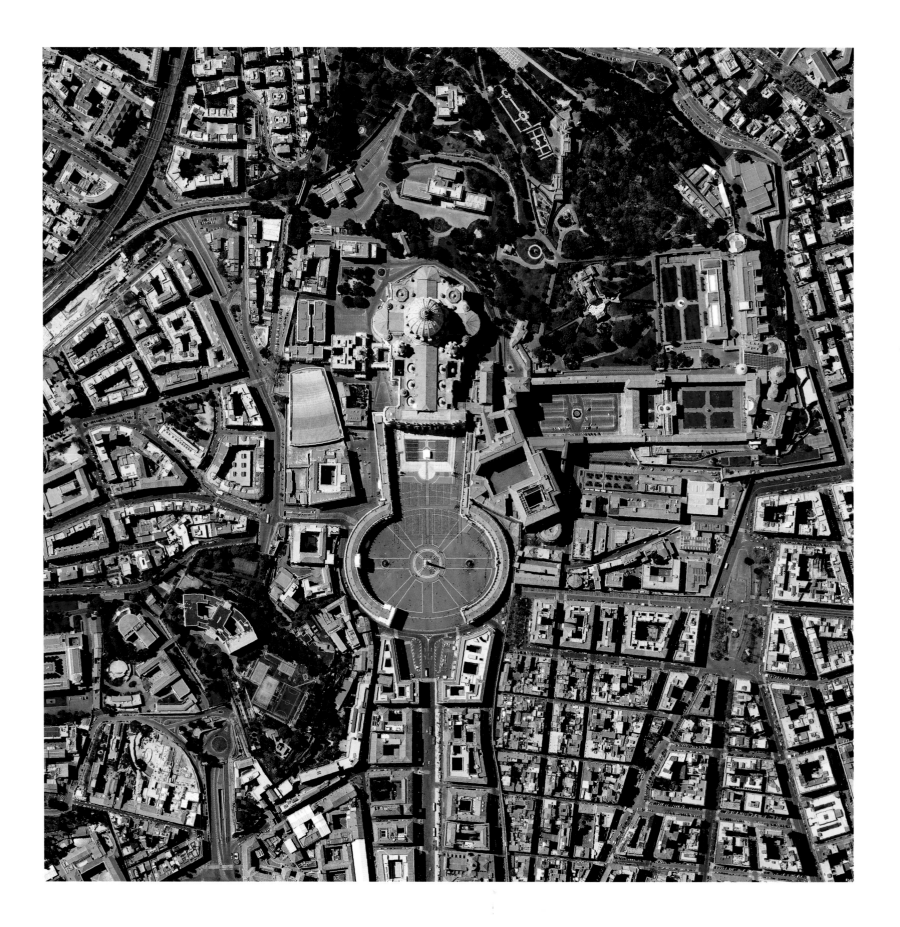

ST. PETER'S BASILICA

41.902170°, 12.451742°

St. Peter's Basilica, located within Vatican City in Rome, Italy, is regarded as one of the holiest Catholic sites and one of the greatest churches in all of Christendom. Construction of the church began in 1506 and was completed in 1626.

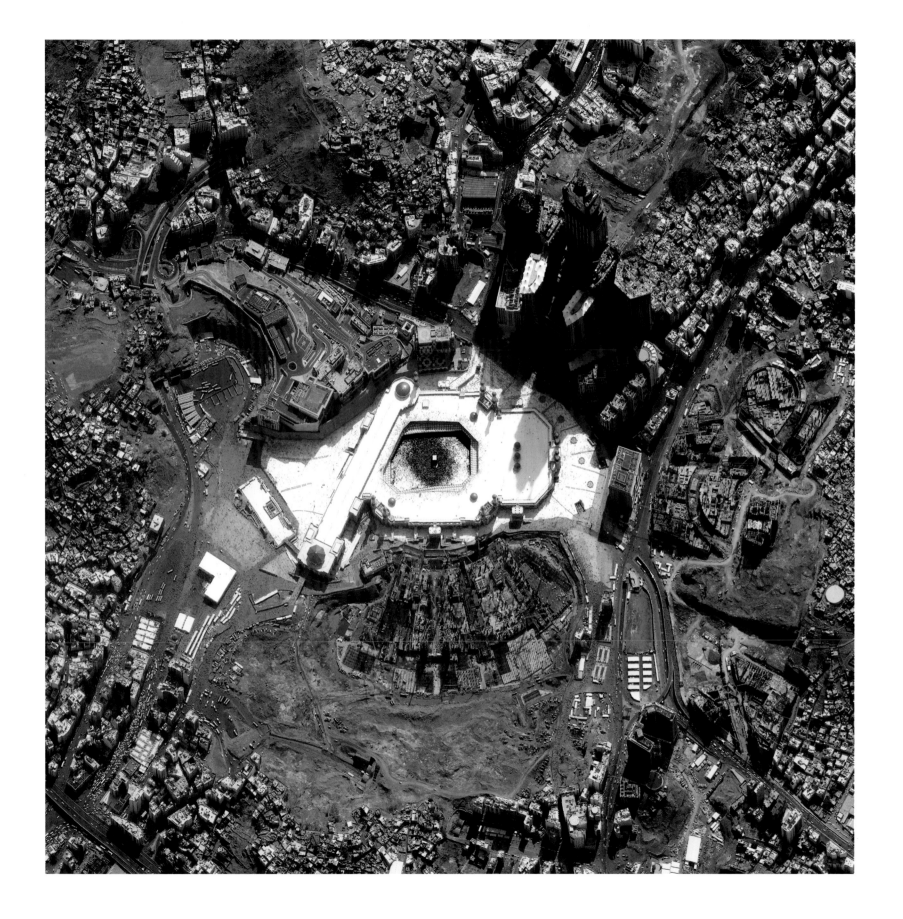

MASJID AL-HARAM

21.423083°, 39.824556°

Masjid al-Haram in Mecca, Saudi Arabia, is the largest mosque in the world. The Kaaba, a granite cuboid structure that stands 43 feet (13 meters) high, is located at its center. During the Hajj, pilgrims gather and circle the Kaaba to pray (seen here in the center) and wherever they are in the world, Muslims are expected to face the Kaaba during daily prayers.

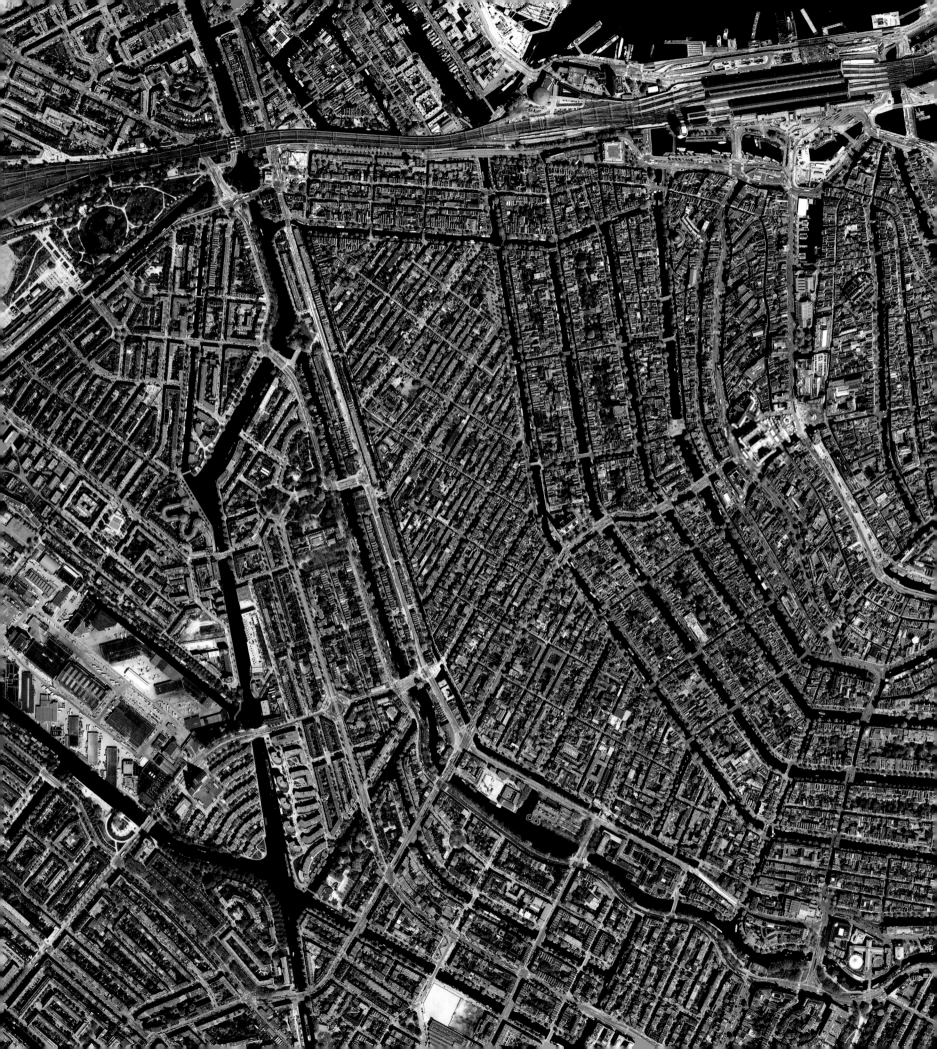

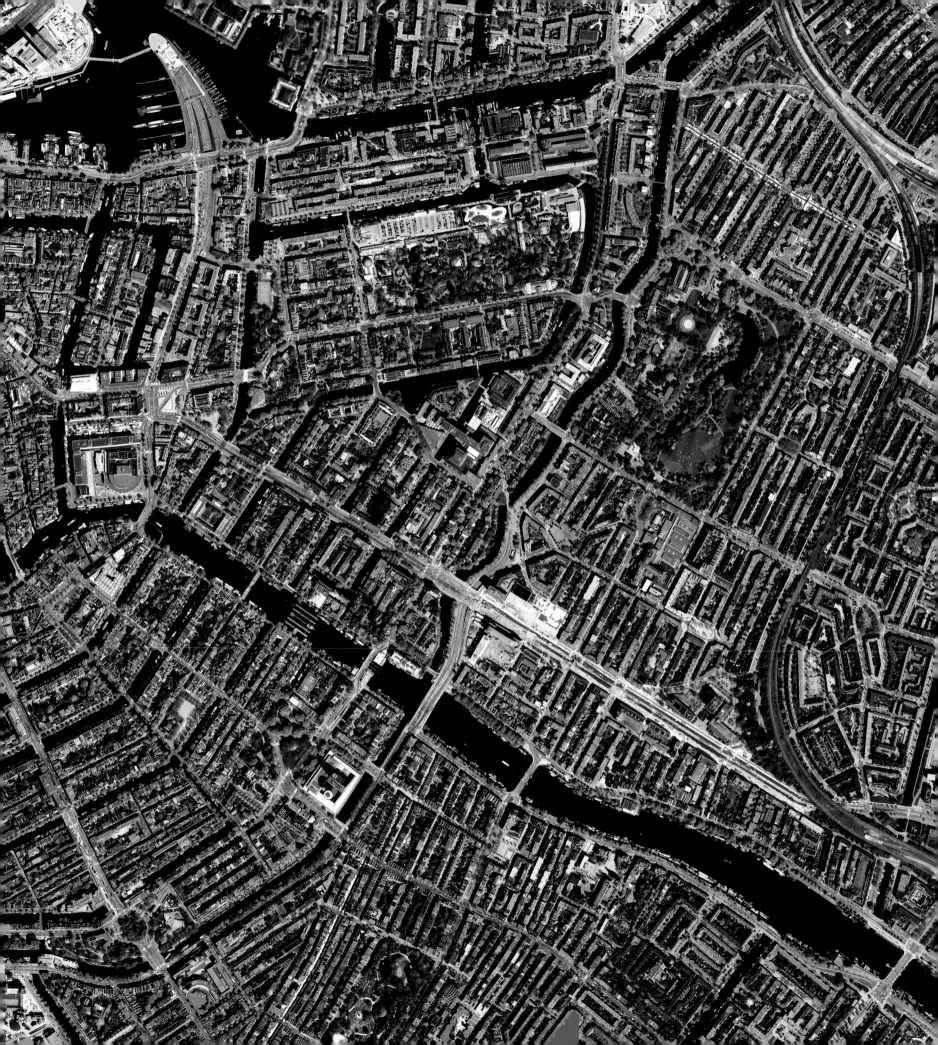

PREVIOUS PAGE

AMSTERDAM

52.370987°, 4.891850°

The canal system of Amsterdam—known as *grachten*—
is the result of conscious urban planning. In the early
seventeenth century, when immigration was at a peak,
a comprehensive plan for the city's expansion was
developed with four concentric half-circles of canals
emerging at the main waterfront (seen at the top of this
Overview). In the centuries since, the canals have been
used for defense, water management, and transport.
They remain a hallmark of the city to this day.

RIGHT

MONT SAINT-MICHEL

48.635150°, −1.513003°

Mont Saint-Michel is a commune built 0.6 miles
(1 kilometer) off the coast of Normandy, France. Over
the past 600 years, the island has functioned as a
prominent monastery (accessible to pilgrims only during
low tide), a French fortification that withstood English
attacks during the Hundred Years' War, and a prison.

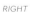

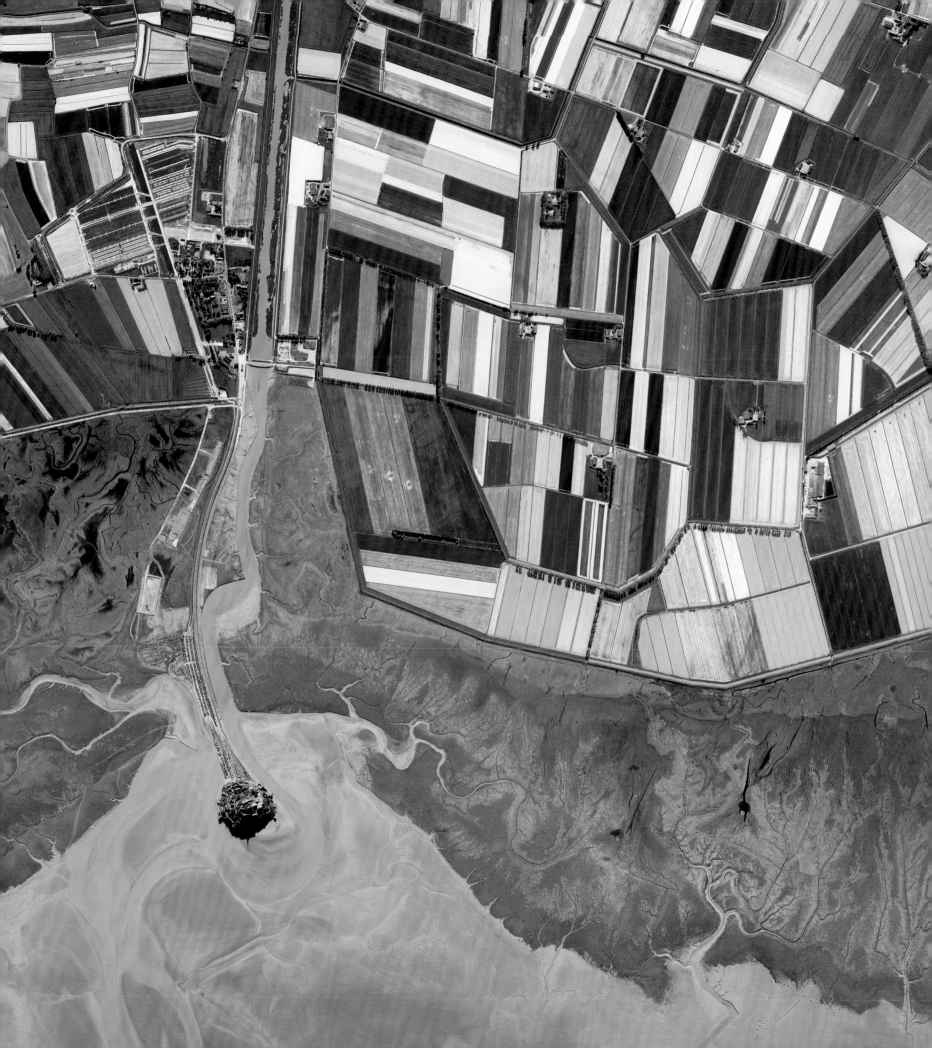

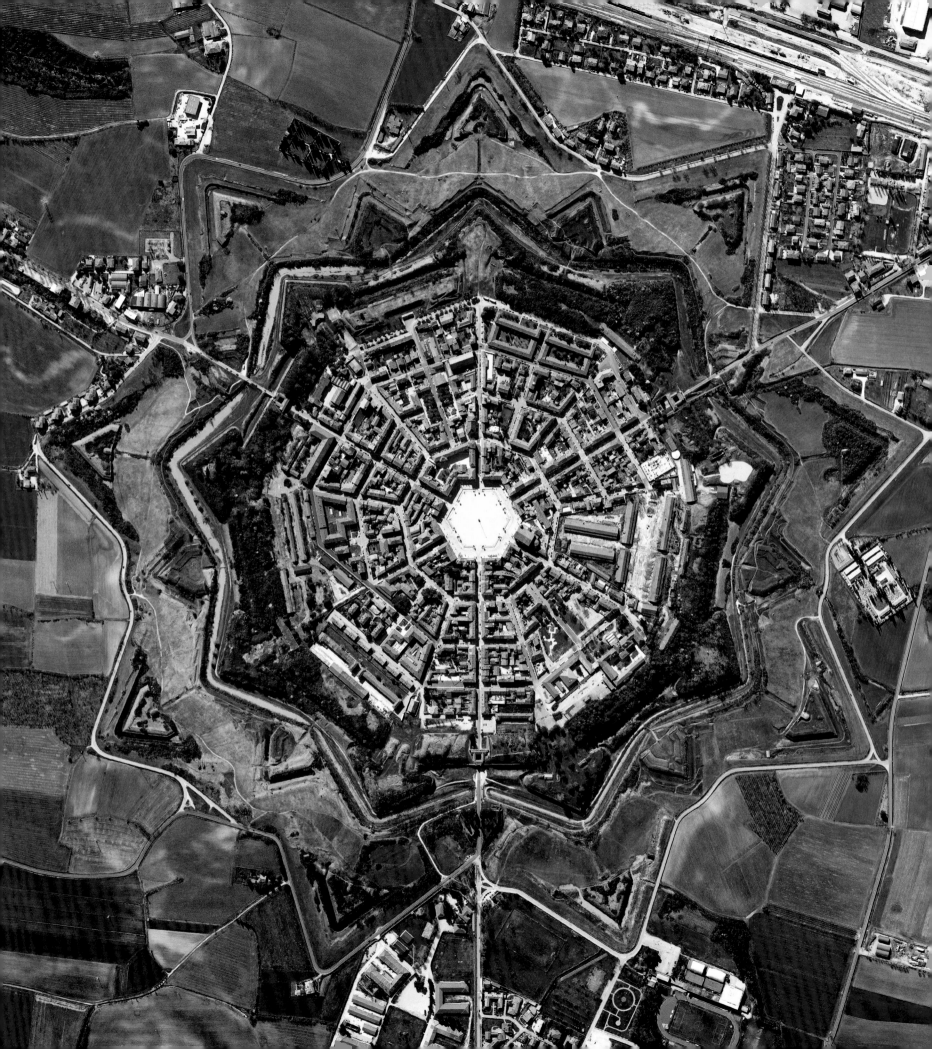

LEFT

PALMANOVA

45.905246°, 13.308300°

Palmanova, Italy is characterized by its star fort layout. The town was constructed in this manner so that an attack on any individual wall could be defended from the two adjacent star points by shooting at the enemy from behind. The three rings that surround Palmanova were completed in 1593, 1690, and 1813.

ABOVE

BOURTANGE

53.006603°, 7.189806°

Bourtange is a village in the Netherlands that was also constructed as a star fort (see description of Palmanova to the left). Today the complex is an open-air museum and has a population of 430 residents.

FOLLOWING PAGE

PARIS

48.865797°, 2.330882°

The street plan and distinctive appearance of central Paris, France, is largely due to the vast public works program commissioned by Emperor Napoleon III and directed by Georges-Eugène Haussmann, between 1853 and 1870. Haussmann's renovation of Paris included the demolition of crowded and unhealthy medieval neighborhoods, and the building of broad, diagonal avenues, parks, squares, sewers, fountains, and aqueducts.

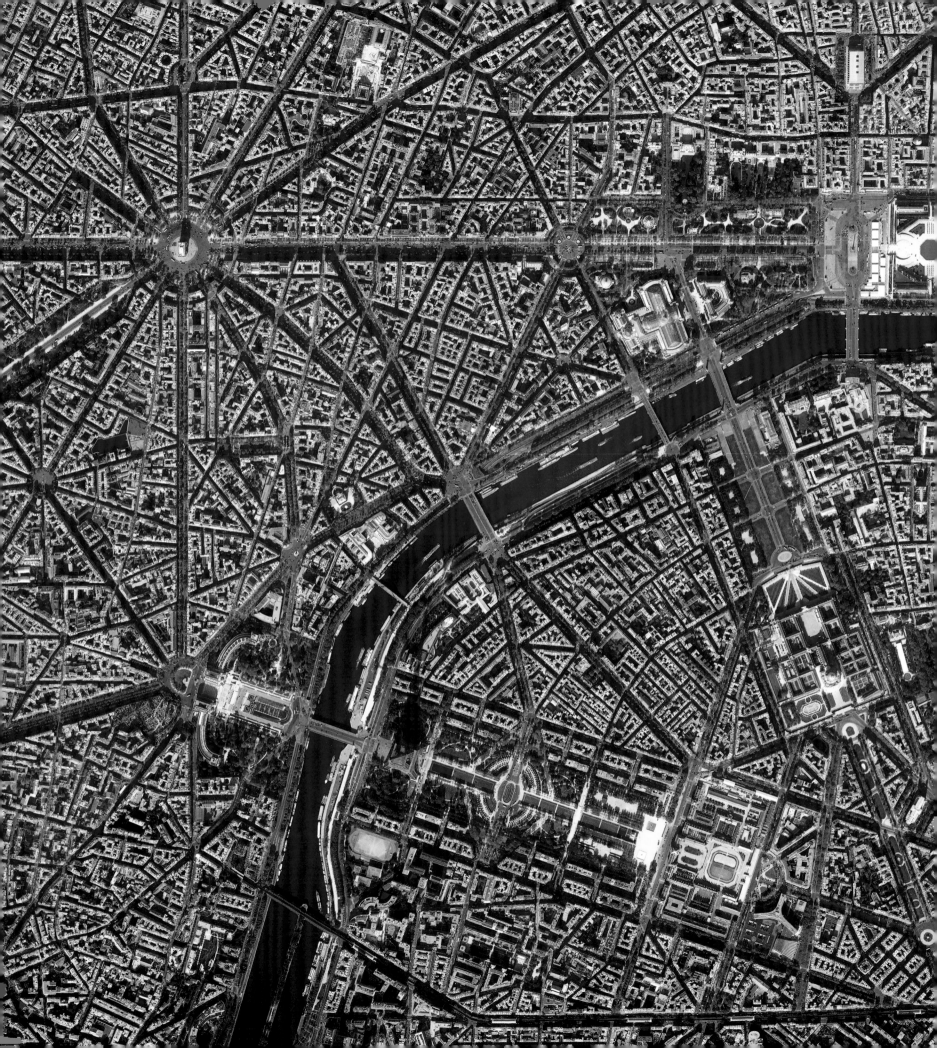

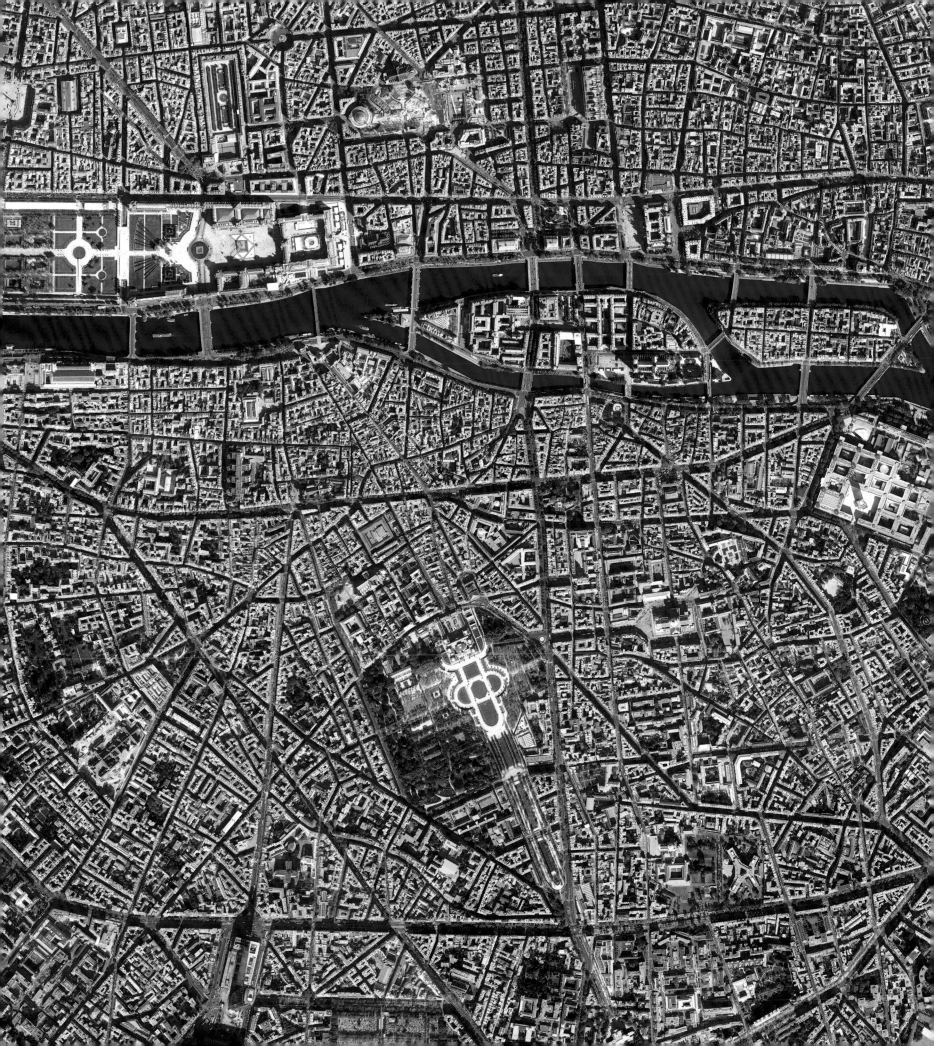

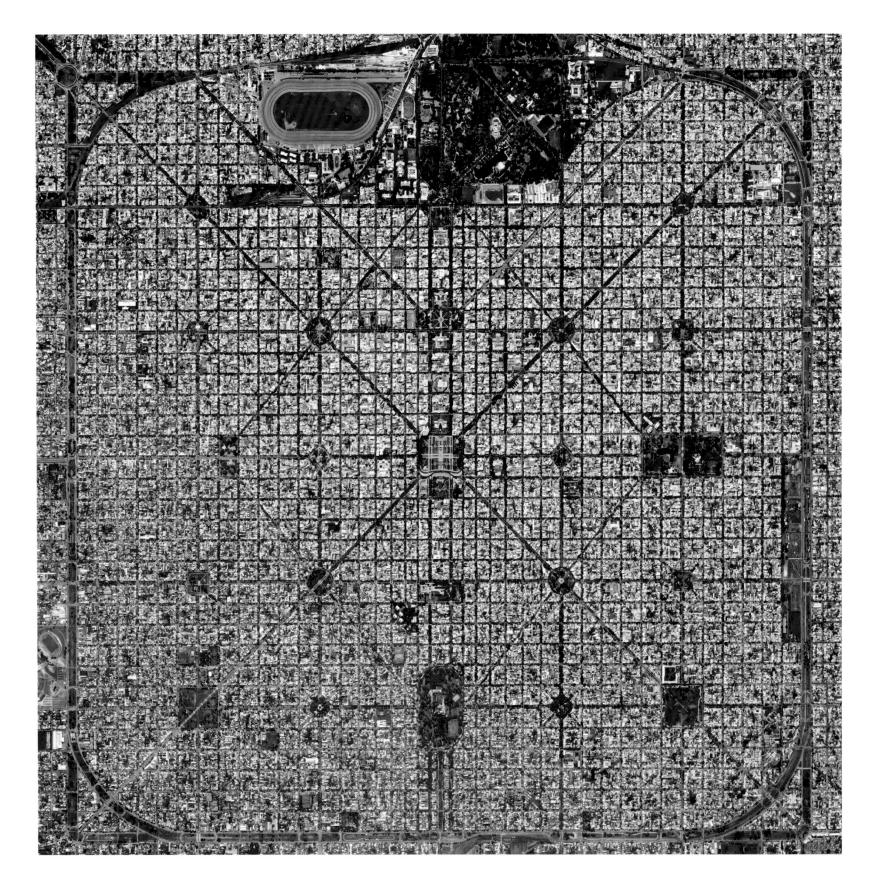

ABOVE

LA PLATA

−34.921106°, −57.956633°

The planned city of La Plata—the capital city of the Province of Buenos Aires, Argentina—is characterized by its strict, square grid pattern. At the 1889 World's Fair in Paris, the new city was awarded two gold medals in the categories "City of the Future" and "Better Performance Built."

RIGHT

BRASILIA

−15.798883°, −47.868855°

Brasilia was founded in 1960 in an effort to move Brazil's capital from the coastal city of Rio de Janeiro to a more central location within Brazil. The city's urban plan—resembling an airplane from above—was developed by Lúcio Costa and prominently features the Modernist buildings of the celebrated architect Oscar Niemeyer at its center.

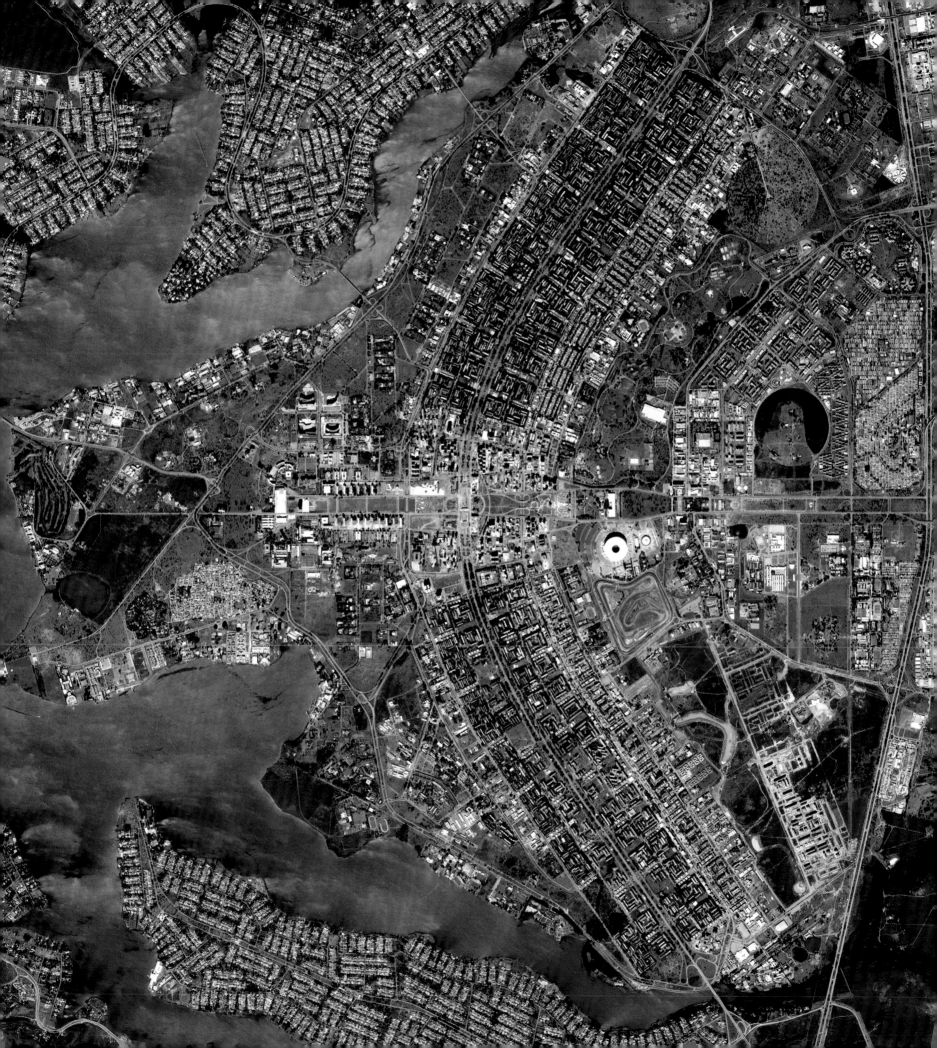

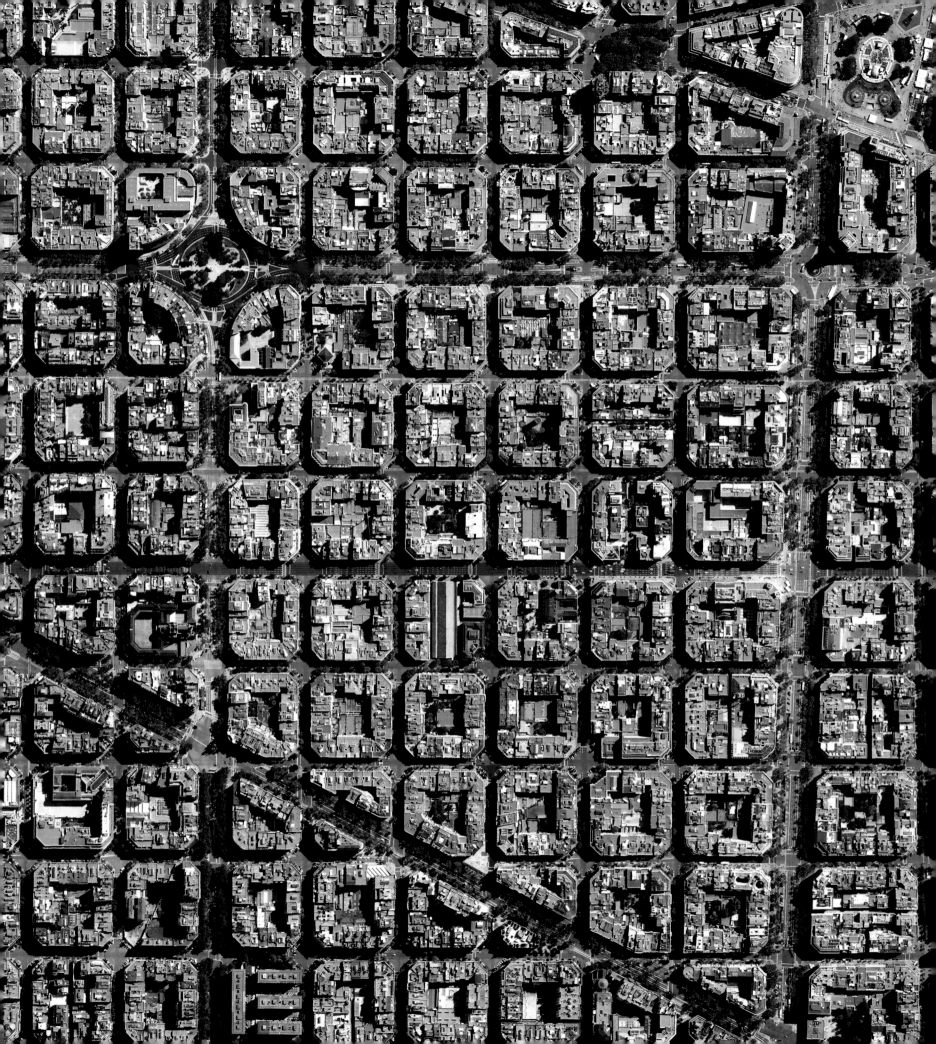

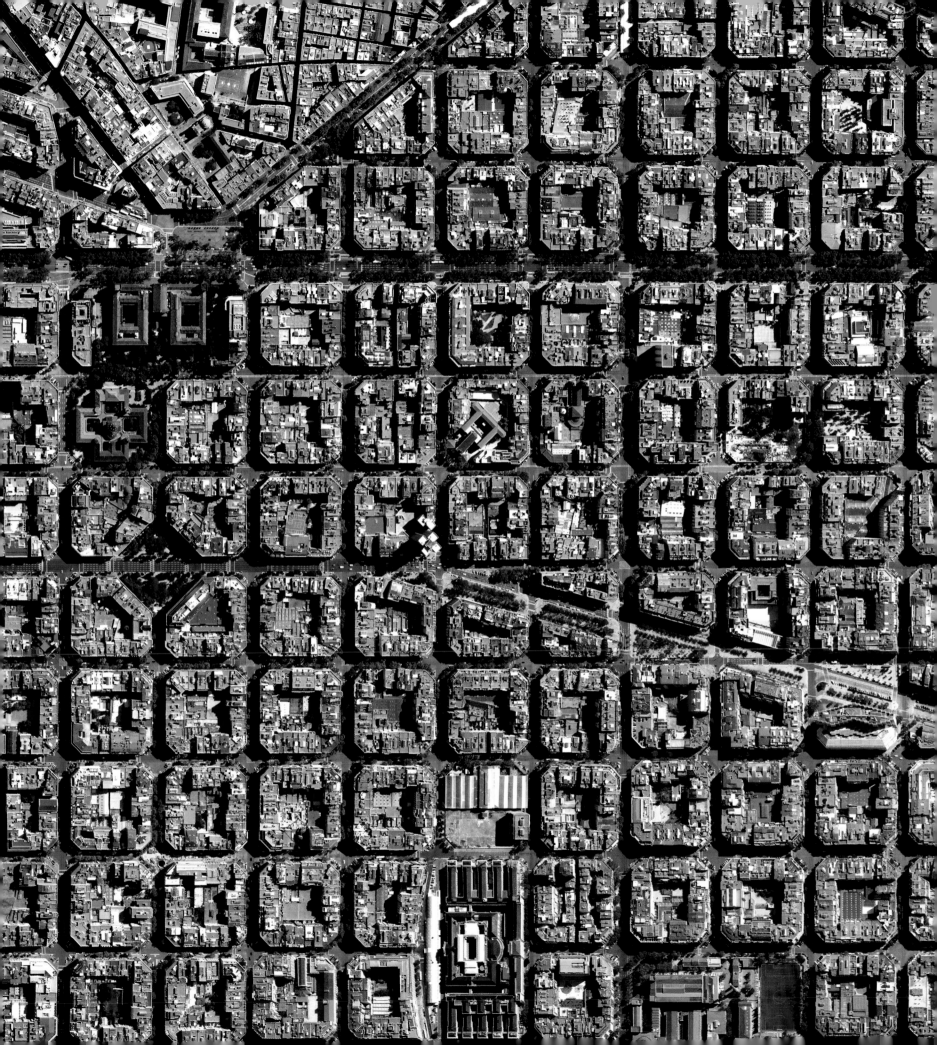

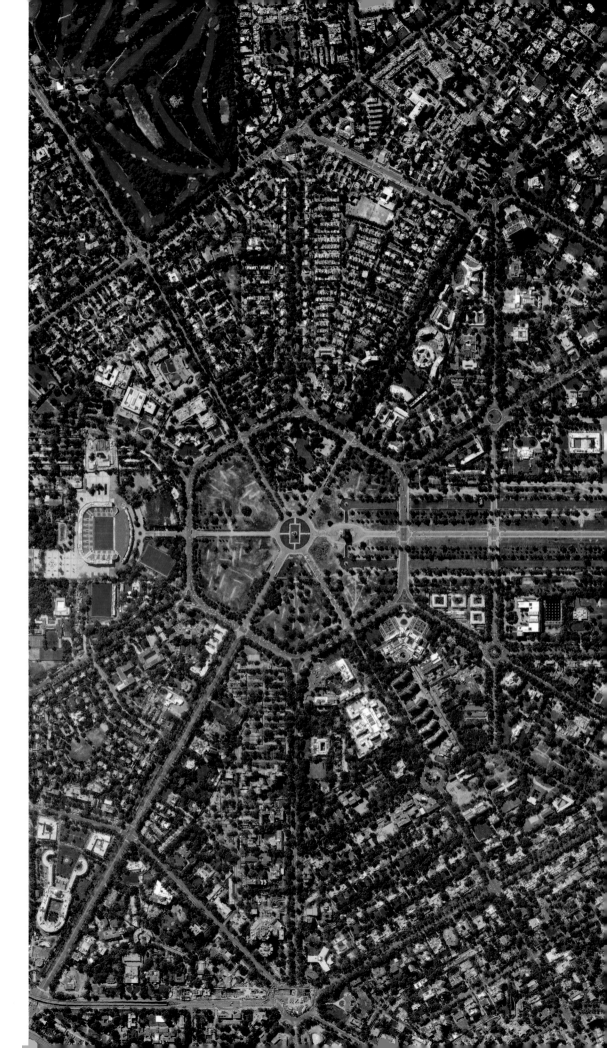

PREVIOUS PAGE

EIXAMPLE

41.393648°, 2.160437°

The Eixample District in Barcelona, Spain, is characterized by its strict grid pattern and apartments with communal courtyards. This thoughtful and visionary design was the work of Ildefons Cerdà (1815–1876). His plan features broad streets that widen at octagonal intersections to create greater visibility with increased sunlight, better ventilation, and more space for short-term parking.

RIGHT

NEW DELHI

28.613219°, 77.223931°

New Delhi, a district of Delhi, India, was planned by British architects Sir Edwin Lutyens and Sir Herbert Baker, and officially inaugurated in February 1931. Their design centered around two promenades— the Rajpath and the Janpath—that run perpendicular to each other and intersect at the center of this Overview.

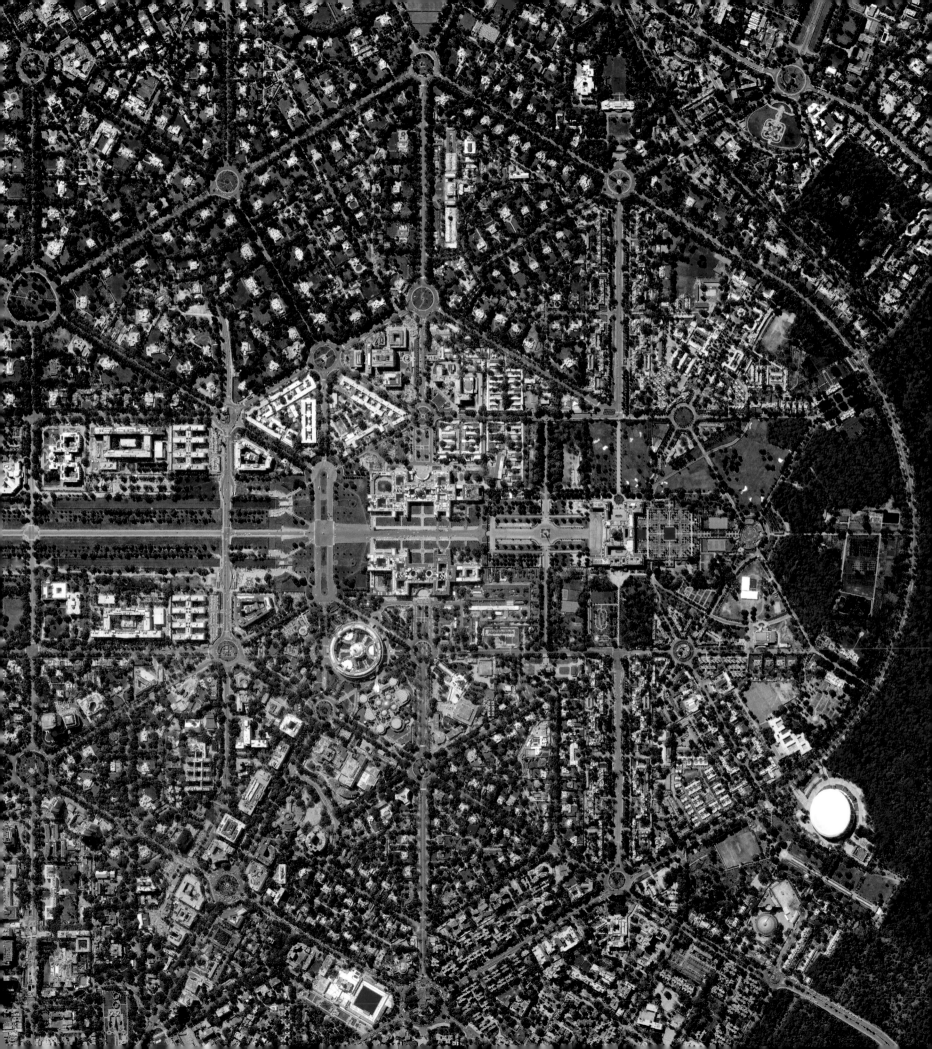

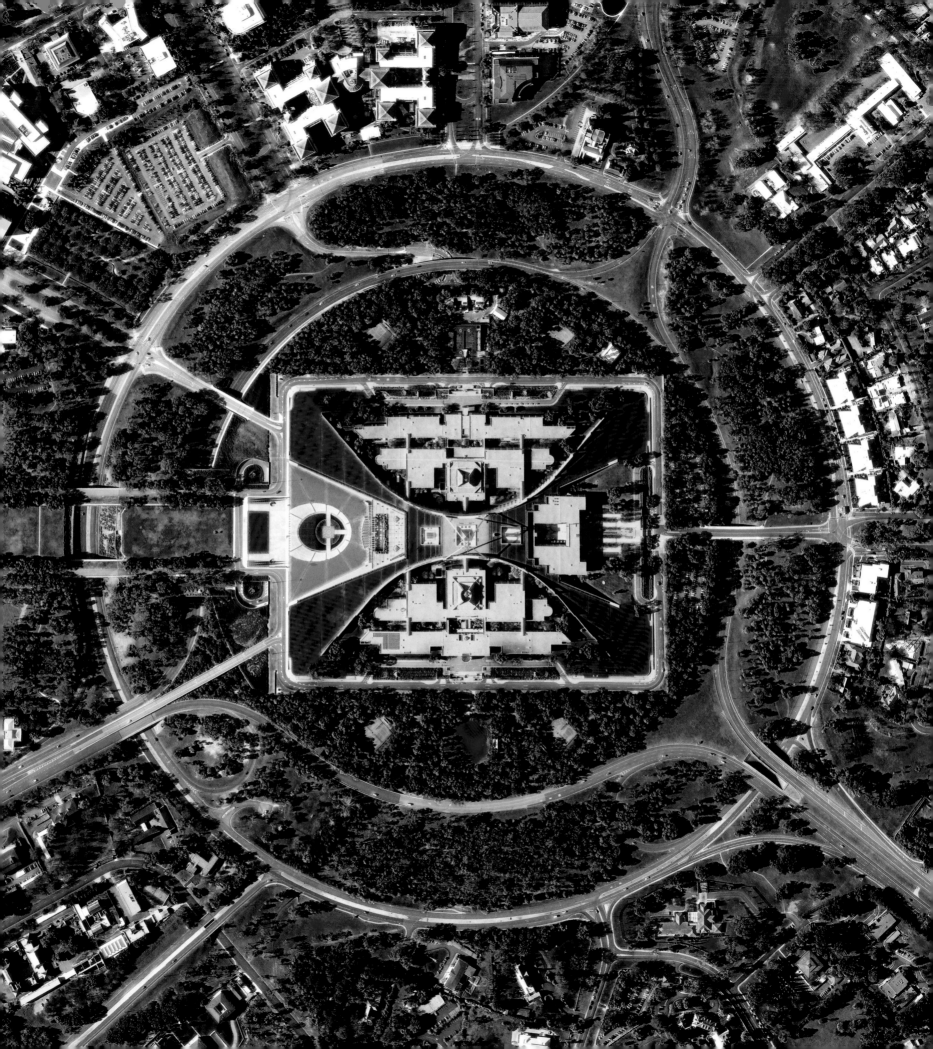

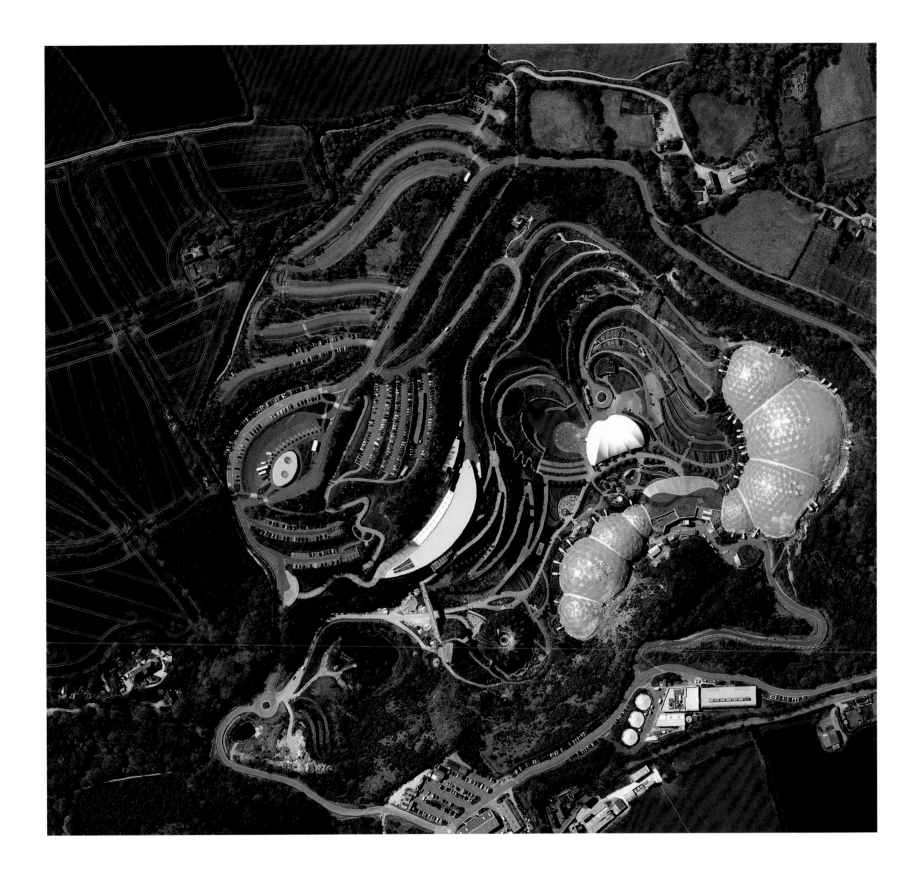

LEFT

CANBERRA PARLIAMENT HOUSE

-35.308219°, 149.122203°

The construction of Parliament House in Canberra, Australia, involved the removal of the top half of Capital Hill (the mound on which the structure was built). After the project was completed, much of the displaced earth was replaced on top of the building, where a lush, green lawn now grows. Opened in 1988, the complex is designed to look like two boomerangs, and contains approximately 4,400 rooms.

ABOVE

EDEN PROJECT

50.361947°, -4.746910°

The Eden Project in Cornwall, England, consists of two massive blue biomes. Opened in 2001, the domes are constructed with hundreds of hexagonal and pentagonal inflated plastic cells that are supported by steel frames. The first biome is designed to simulate a tropical environment, while the other contains species specific to a Mediterranean environment.

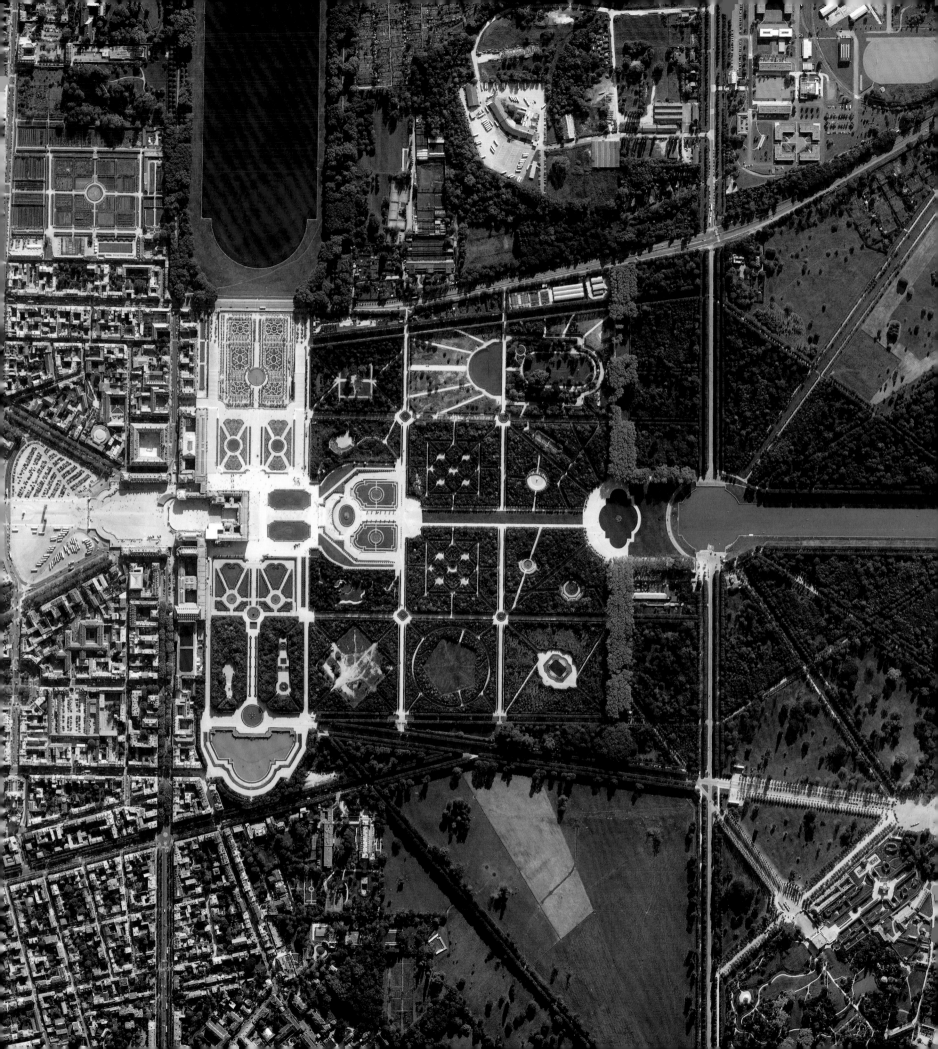

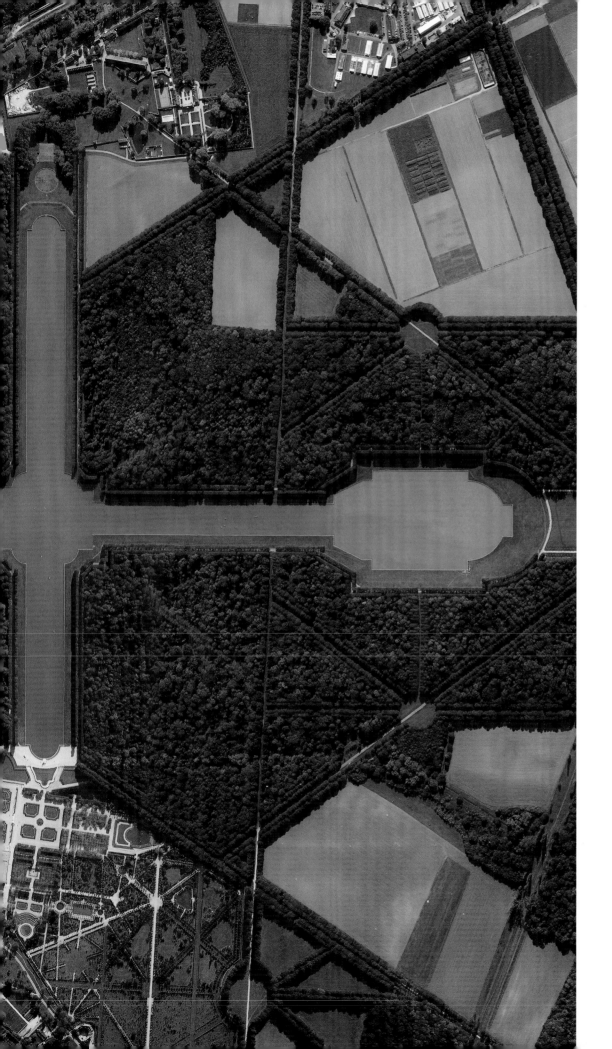

GARDENS OF VERSAILLES

48.804407°, 2.120973°

The Gardens of Versailles are situated across 2,000 acres (800 hectares) of land, behind the Palace of Versailles, 12 miles (19 kilometers) outside of Paris. The grounds are landscaped in the classic French garden style and contain a large body of water at its center—4,900 feet (1,500 meters) wide and 200 feet (62 meters) long—known as the Grand Canal. In addition to its role as a venue for boating parties, the canal collected water drained from the fountains in the gardens above and returned it via pumps back up to these areas for reuse.

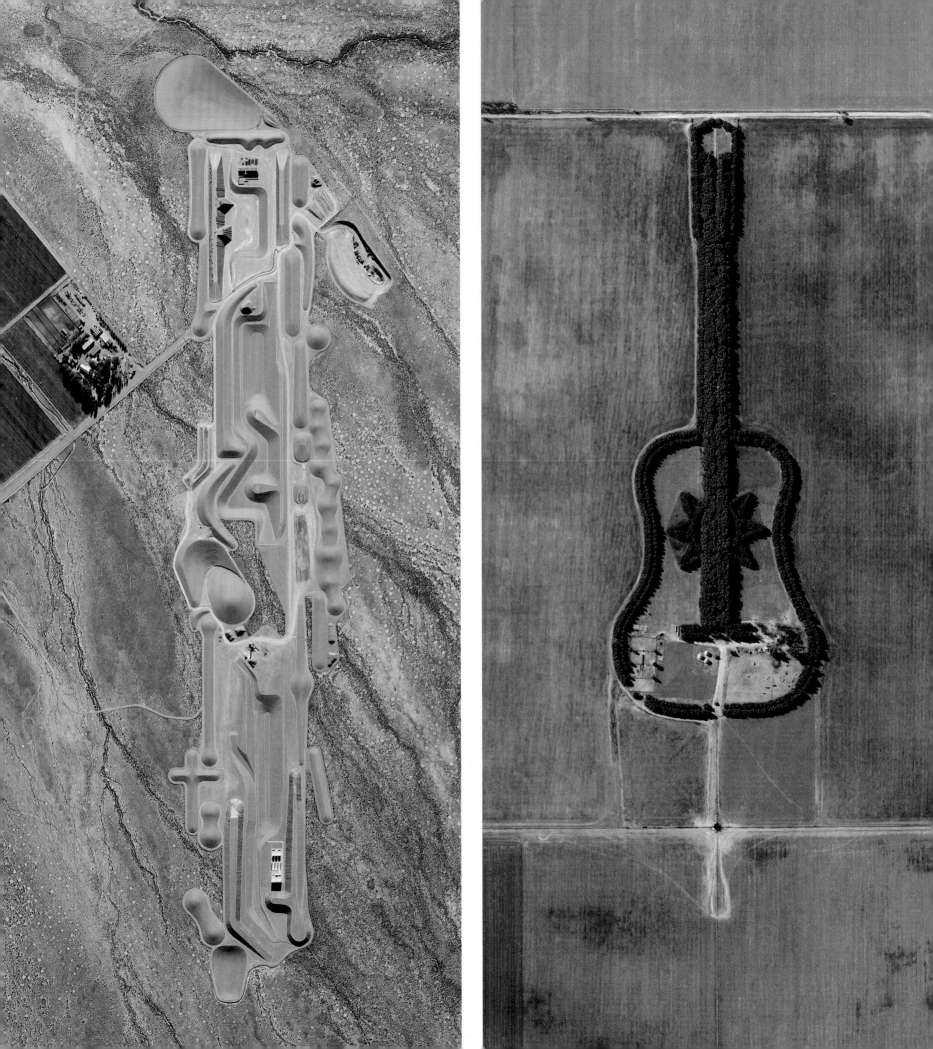

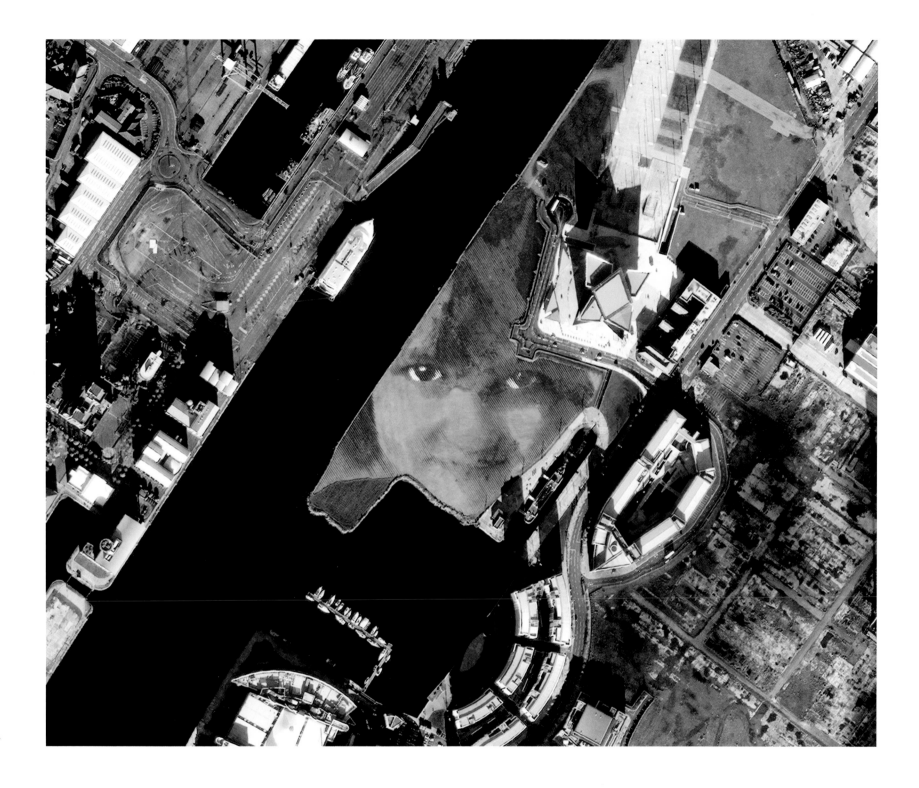

FAR LEFT

CITY 38.030004°, −115.438299°

City is an earth art piece by Michael Heizer located in Garden Valley, Nevada, USA. The piece was started in 1972 and work is still ongoing. Covering a space that is approximately 1.25 miles long (2 kilometers) by 0.25 miles (0.4 kilometers) wide, it is one of the largest sculptures ever created. The work attempts to synthesize ancient monuments, minimalism, and industrial technology across five phases, each consisting of a number of structures referred to as "complexes."

LEFT

GUITAR FOREST −33.868242°, −63.986306°

A guitar-shaped forest—more than 0.6 miles (1 kilometer) in length—is visible outside the city of Laboulaye, Argentina. For years, a married couple by the name of Pedro Ureta and Graciela Yraizoz discussed the idea of creating such a design. However, when Graciela suddenly passed away, Pedro and their four children planted 7,000 cypress (the body of the instrument) and eucalyptus (the strings) trees in her honor. The guitar was Graciela's favorite instrument.

ABOVE

WISH 54.607263°, −5.911726°

Wish is a land-art portrait spanning 4.5 hectares (11 acres) in Belfast, Northern Ireland. Created by artist Jorge Rodriguez-Gerada, the work represents youth's ability to look towards the future. It was constructed of approximately 30,000 wooden pegs, 2,000 tons of soil, 2,000 tons of sand, as well as grass, stones and strings.

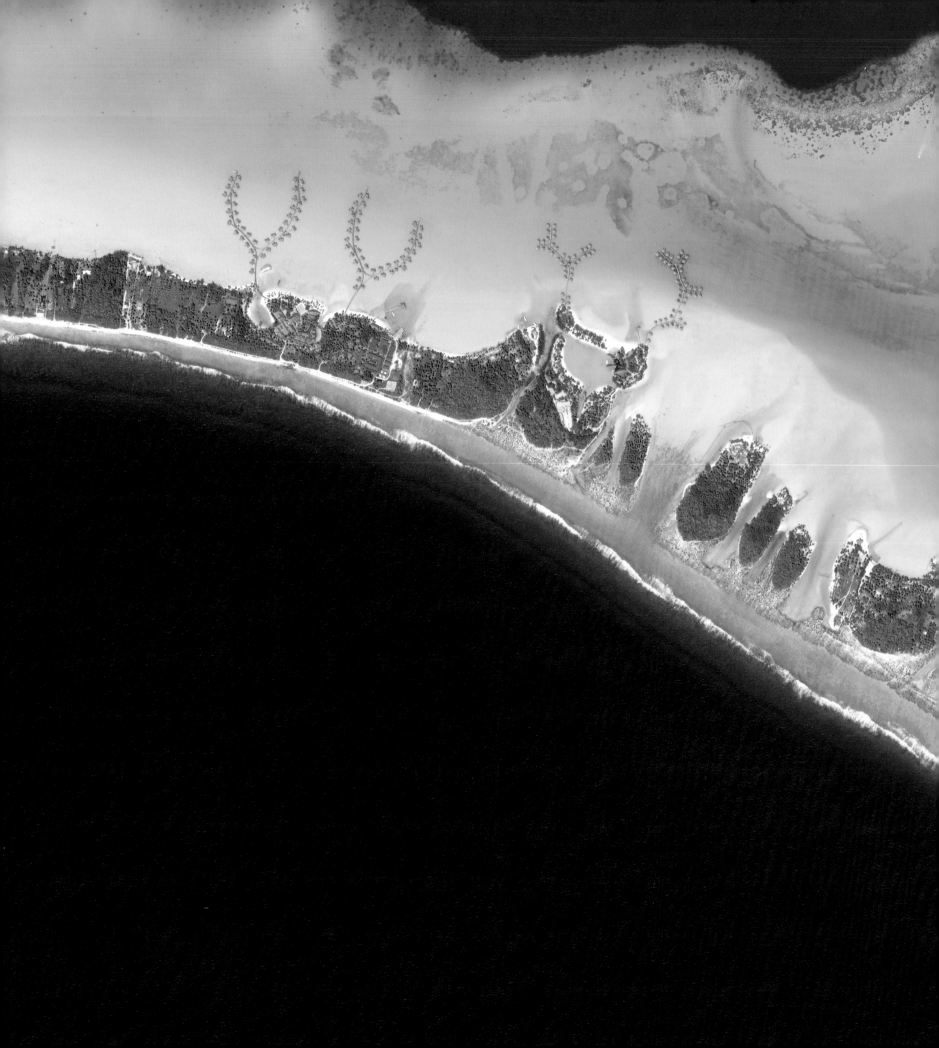

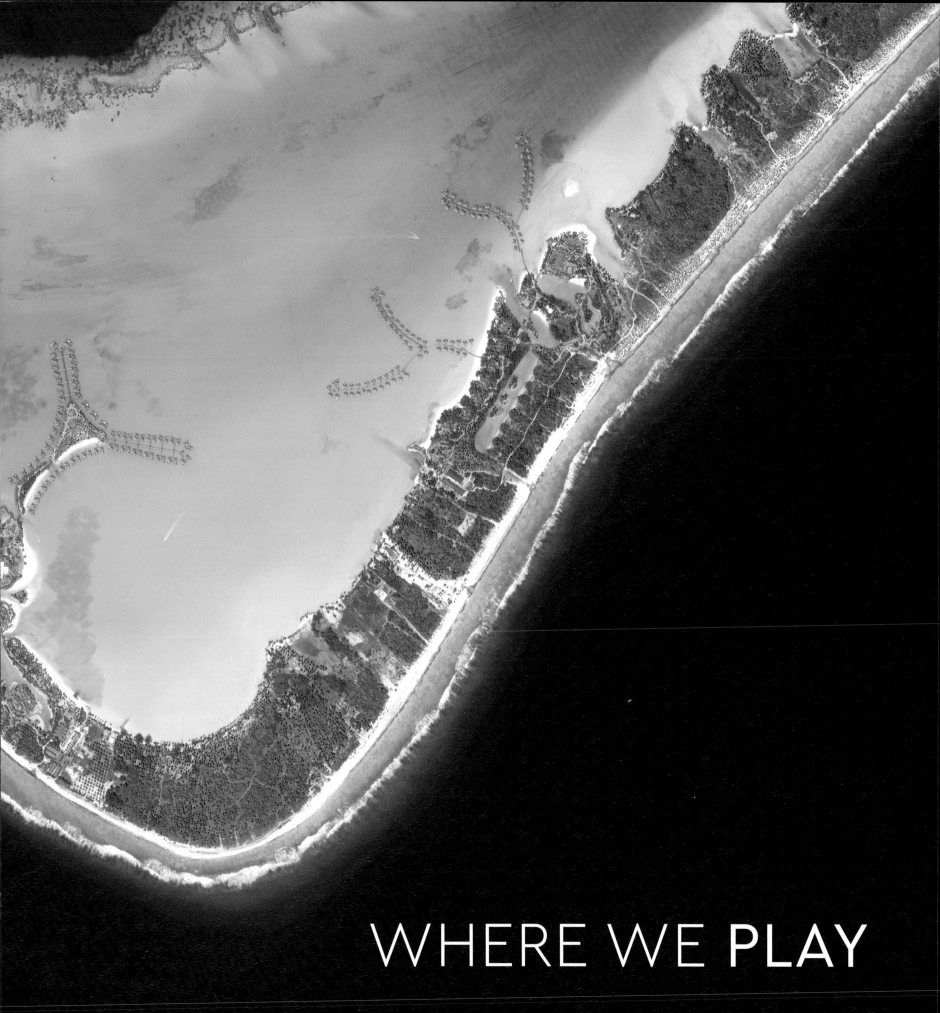

WHERE WE PLAY

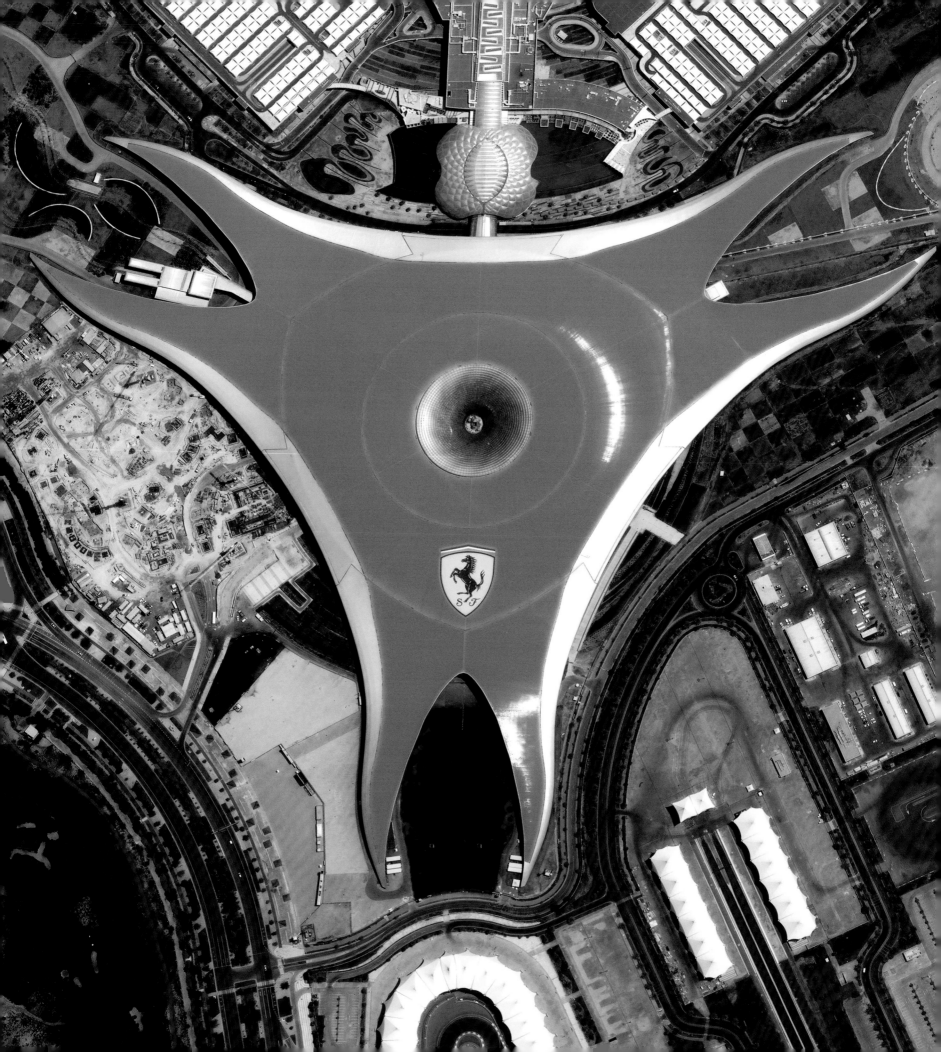

> "Men do not quit playing because they grow old; they grow old because they quit playing."
>
> Oliver Wendell Holmes Sr.

WHERE WE **PLAY**

We are at our freest in the places where we play—the places where we lose ourselves in the beauty of a run, swim, or race, or the pleasure of doing nothing at all. These are the sites we seek out for our own enjoyment, where we create some of our best memories. This chapter brings together an assortment of the buildings, parks, and other structures created expressly to facilitate the enjoyment of mankind.

It is notable that, even when viewed from so far above you cannot make out the human figures at play, seeing these places still elicits a certain joy, a familiar desire to inhabit such a space, if only for a time, and use it for its intended purpose. By appreciating these sites in their larger context—a massive stadium in the center of a city, the vast scale of an amusement park, a long and crowded beach—we can more deeply understand the powerful and universal values that drove their creation.

In keeping with the other chapters in this work, everything presented in this section is human-made. Despite the novelty and often monumental scale of these images, they hearken to the most natural and primitive of our behaviors. We derive much of our pleasure as humans from technologies that we've created. It is imperative, though, that we do not forget the true joy that we can derive from the natural, unmodified world. That topic is explored more thoroughly in the final chapter, "Where We Are Not."

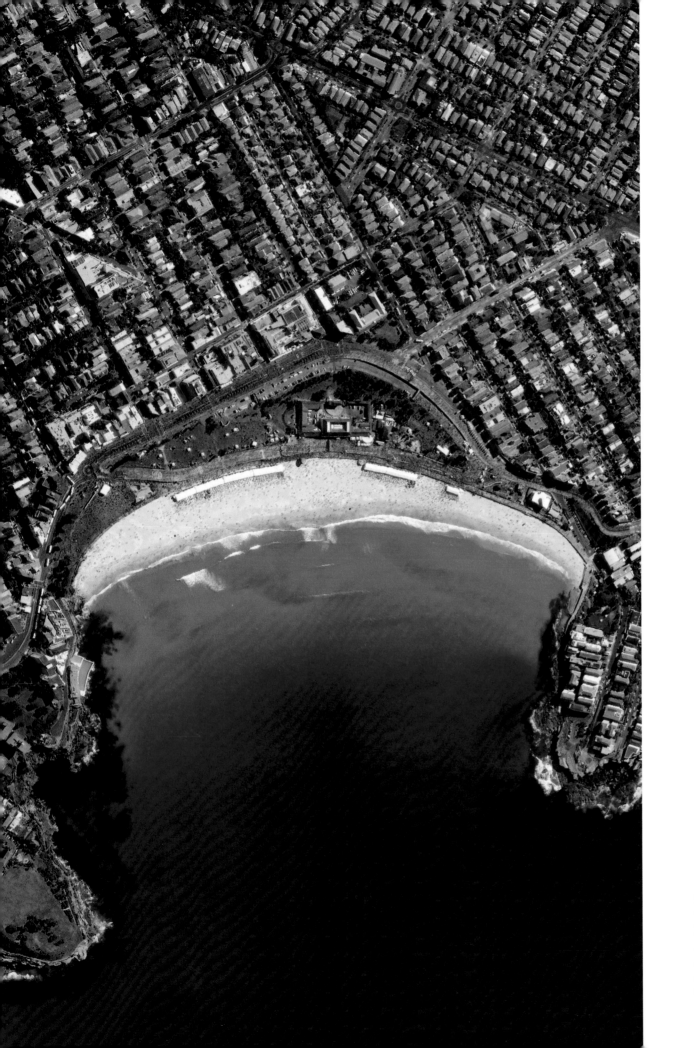

BONDI BEACH
−33.891106°, 151.275583°
Bondi Beach is located in Sydney,
Australia. One of the city's most stunning
and popular destinations, the beach gets
its name from the Aboriginal word *bondi*,
which means "waves breaking over rocks."

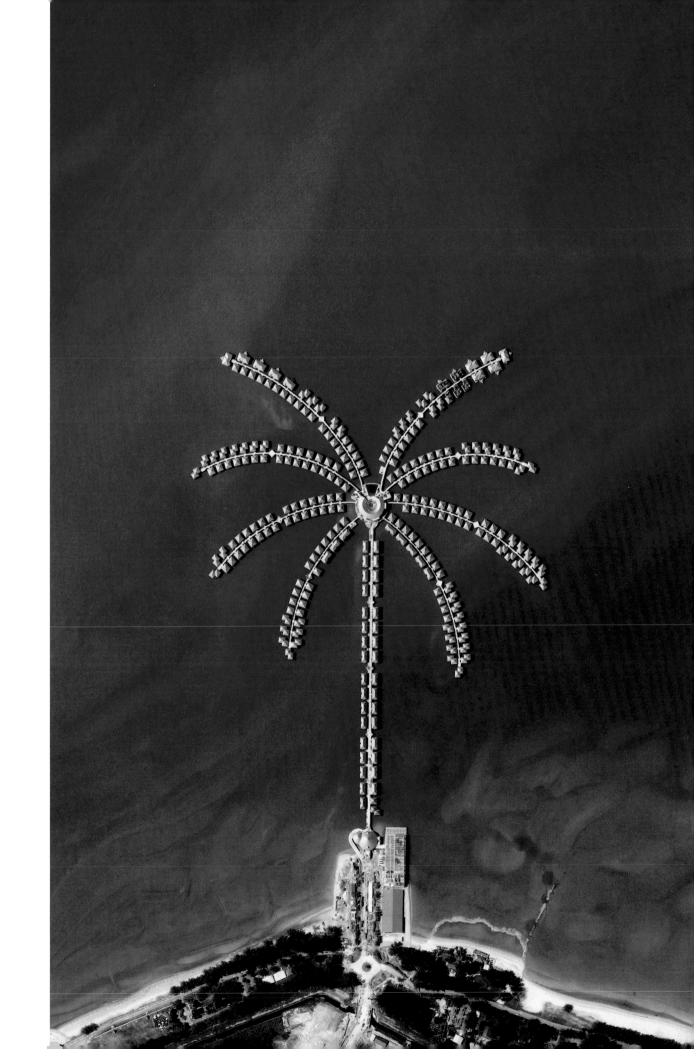

SEPANG GOLDCOAST RESORT
2.598436°, 101.683152°
Sepang Goldcoast Resort is a hotel in
Selangor Darul Ehsan, Malaysia. It features
over-water bungalows that extend out in
a palm-shaped formation into the waters
of the Malacca Straits.

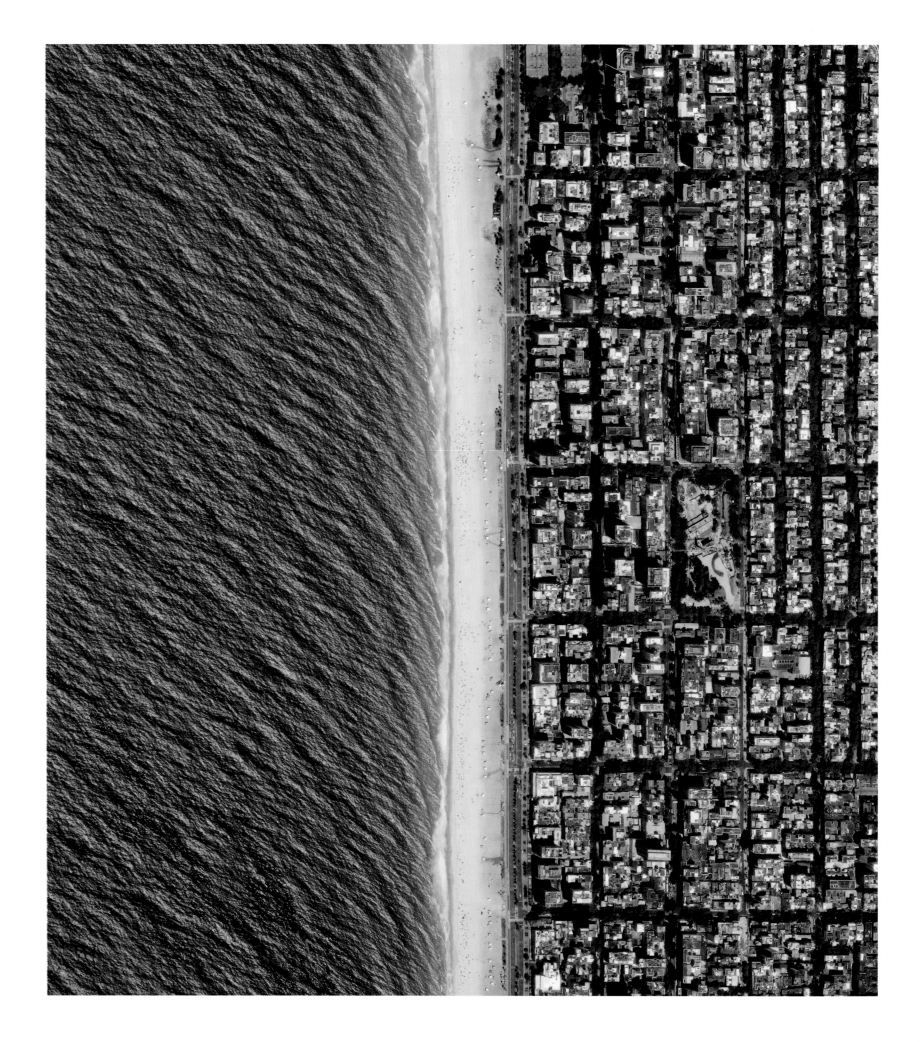

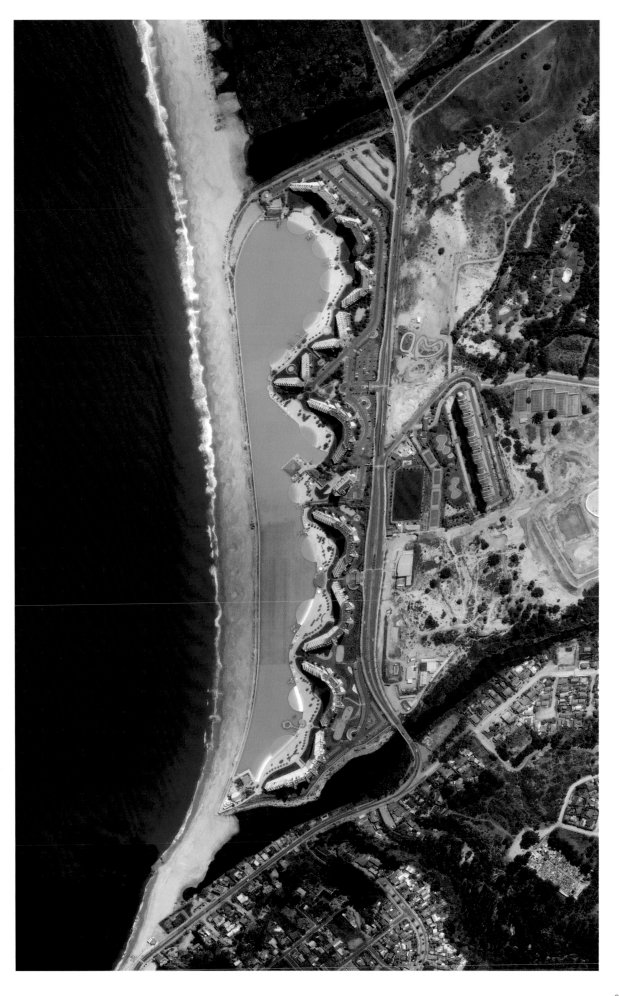

LEFT

IPANEMA BEACH

−22.983606°, −43.206638°

Ipanema Beach is located in the South
Zone of Rio de Janeiro, Brazil. Recognized
as one of the most beautiful beaches in the
world, the sand is divided into segments
by lifeguard towers known as *postos*.

RIGHT

SAN ALFONSO DEL MAR RESORT

−33.350133°, −71.653226°

The swimming pool at the San Alfonso
del Mar Resort in Algarrobo, Chile, is the
largest in the world. The pool is more
than 3,323 feet (1,000 meters) long and
contains approximately 66 million gallons
(250 million liters) of water. The resort
pays roughly $4 million USD each year
to maintain the pool.

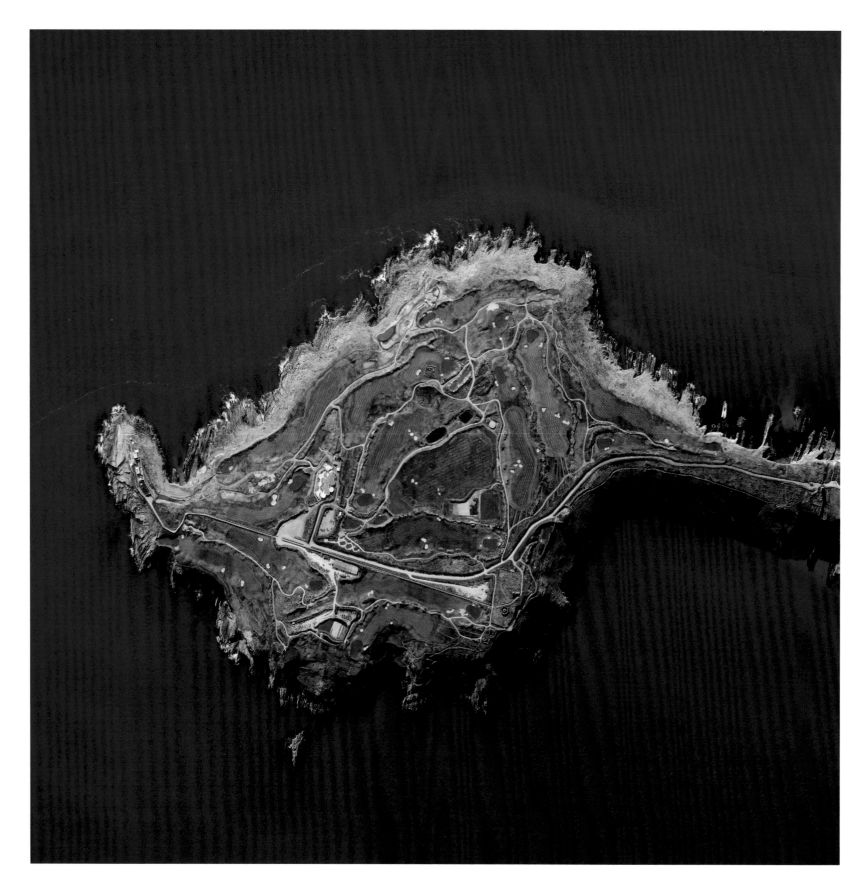

PREVIOUS PAGE

ASPEN SNOWMASS

39.189971°, −106.957611°

Aspen Snowmass is one of four recreational areas at the Aspen winter resort complex in Colorado, USA. This particular mountain has a total skiable area of 1,010 acres (409 hectares), with its longest run extending 3.5 miles (5.6 kilometers) down the mountain.

ABOVE

OLD HEAD GOLF LINKS

51.610825°, −8.537894°

The Old Head Golf Links is an 18-hole golf course in Kinsale, Ireland. The facility is built on a 220-acre (89-hectare) diamond-shaped piece of land that juts out 2 miles (3.2 kilometers) into the Atlantic Ocean, 300 feet (91 meters) above the water's surface.

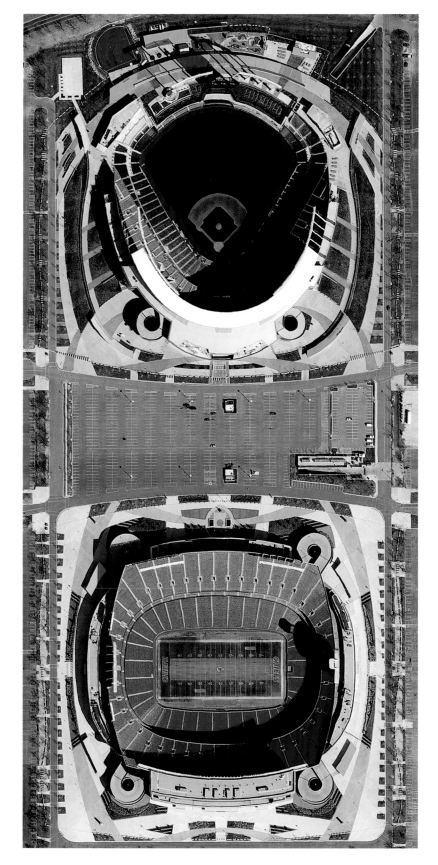

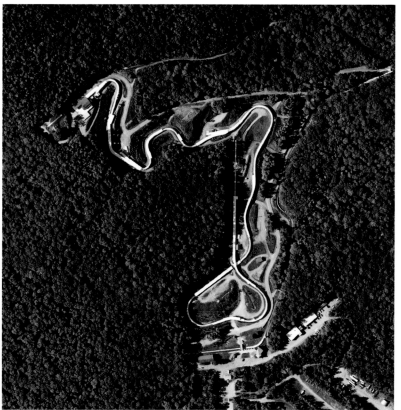

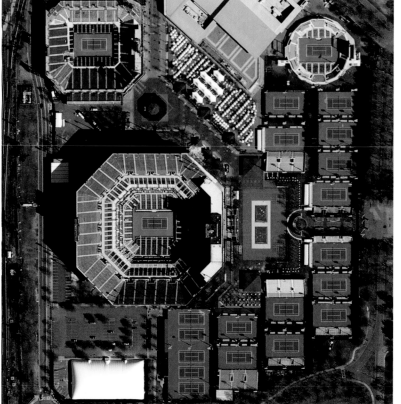

ABOVE **KANSAS CITY STADIUMS**
39.050359°, −94.482511°
Kauffman Stadium (top) and Arrowhead Stadium (bottom)
are home to the Kansas City Royals (baseball) and the
Kansas City Chiefs (American football), respectively.
The combined seating capacity of the stadiums is 114,319.

TOP RIGHT **MT. VAN VOEVENBERG**
OLYMPIC BOBSLED RUN 44.214409°, −73.925450°
The Mt. Van Voevenberg Olympic Bobsled Run is a venue for
bobsled, luge, and skeleton races at the Lake Placid Olympic
Sports Complex in Lake Placid, New York, USA. The facility
was used during the 1932 and 1980 Winter Olympics.

BOTTOM RIGHT **BILLIE JEAN KING TENNIS CENTER**
40.749535°, −73.846886°
The Billie Jean King National Tennis Center is located in New
York City, USA, and hosts the US Open Tennis Championship
each year. The facility contains 22 courts, including its largest
venue, Arthur Ashe Arena, which seats 23,200 spectators.

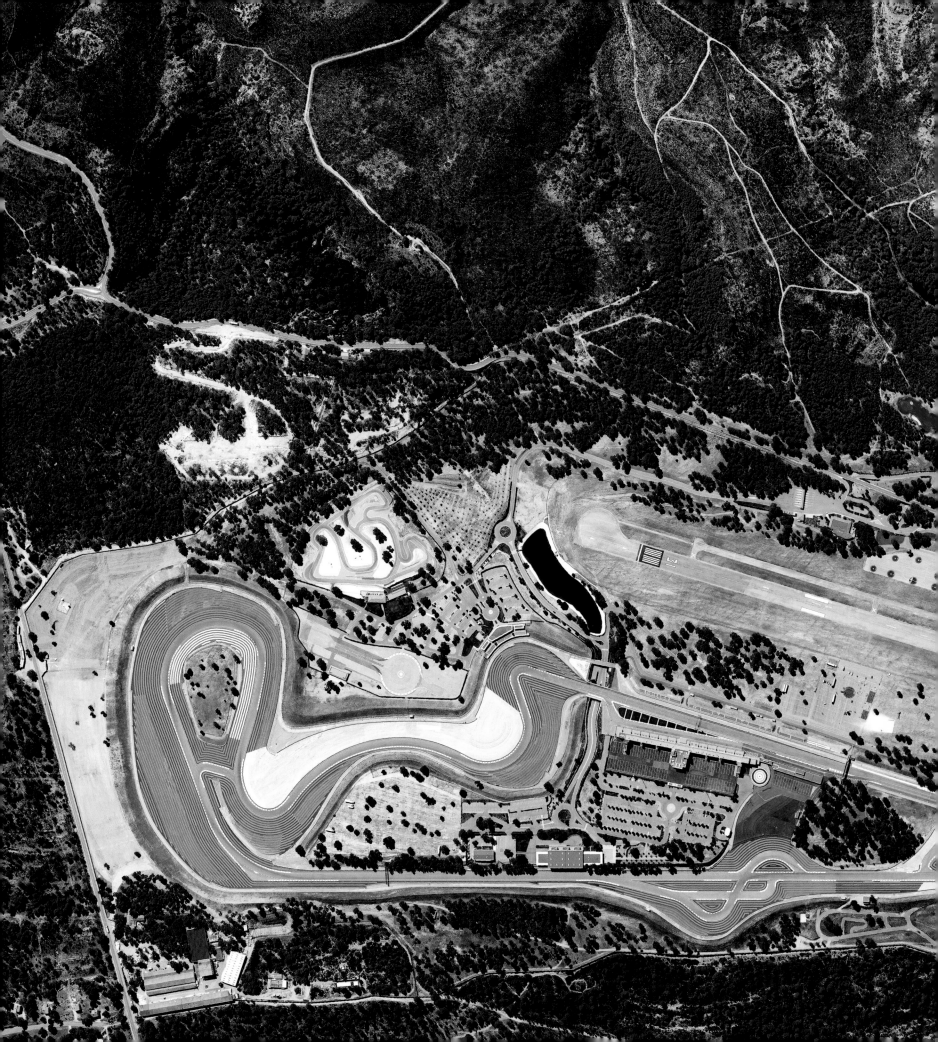

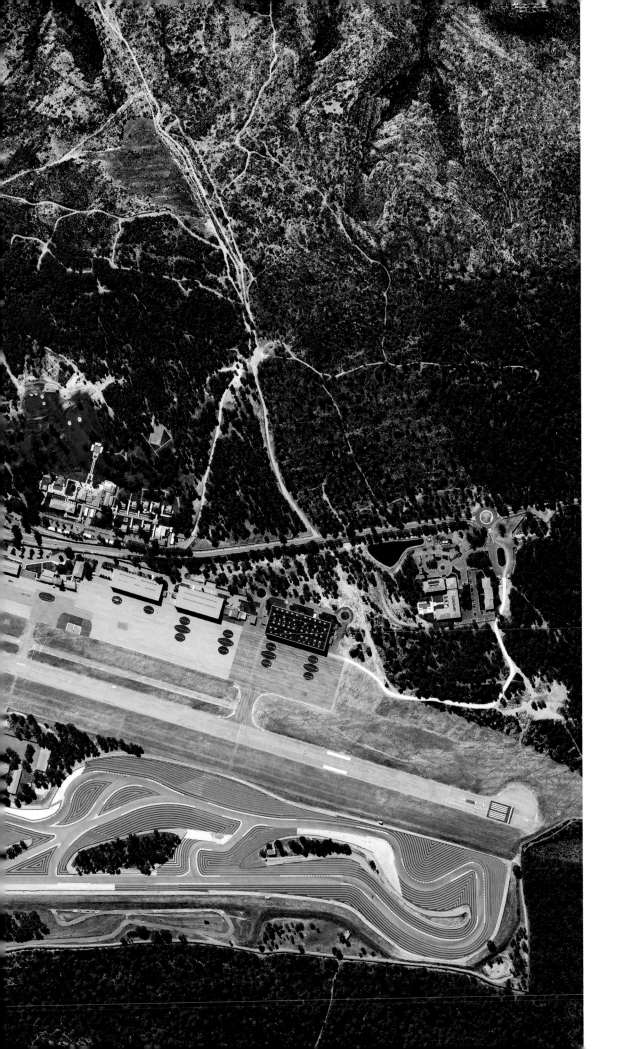

CIRCUIT PAUL RICARD

43.251140°, 5.790250°

Circuit Paul Ricard is a race-car driving track at
Le Castellet, near Marseille, France. The track is known
for its distinctive black and blue run-off areas called
the "Blue Zone." Additional, deeper run-off areas, known
as the "Red Zone," use a more abrasive surface designed
to maximize tire grip and minimize braking distance.

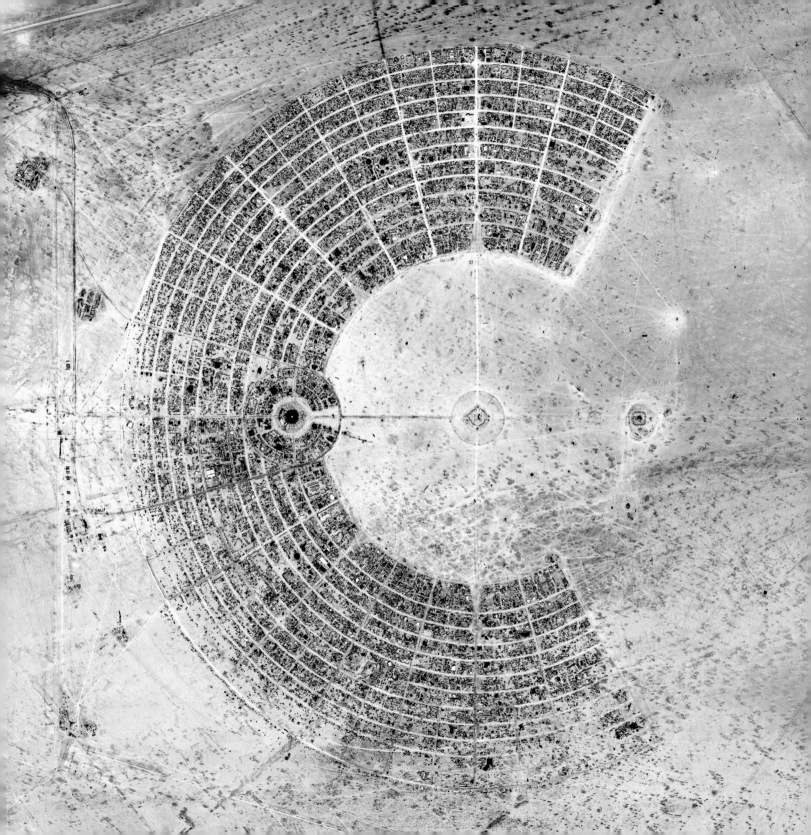

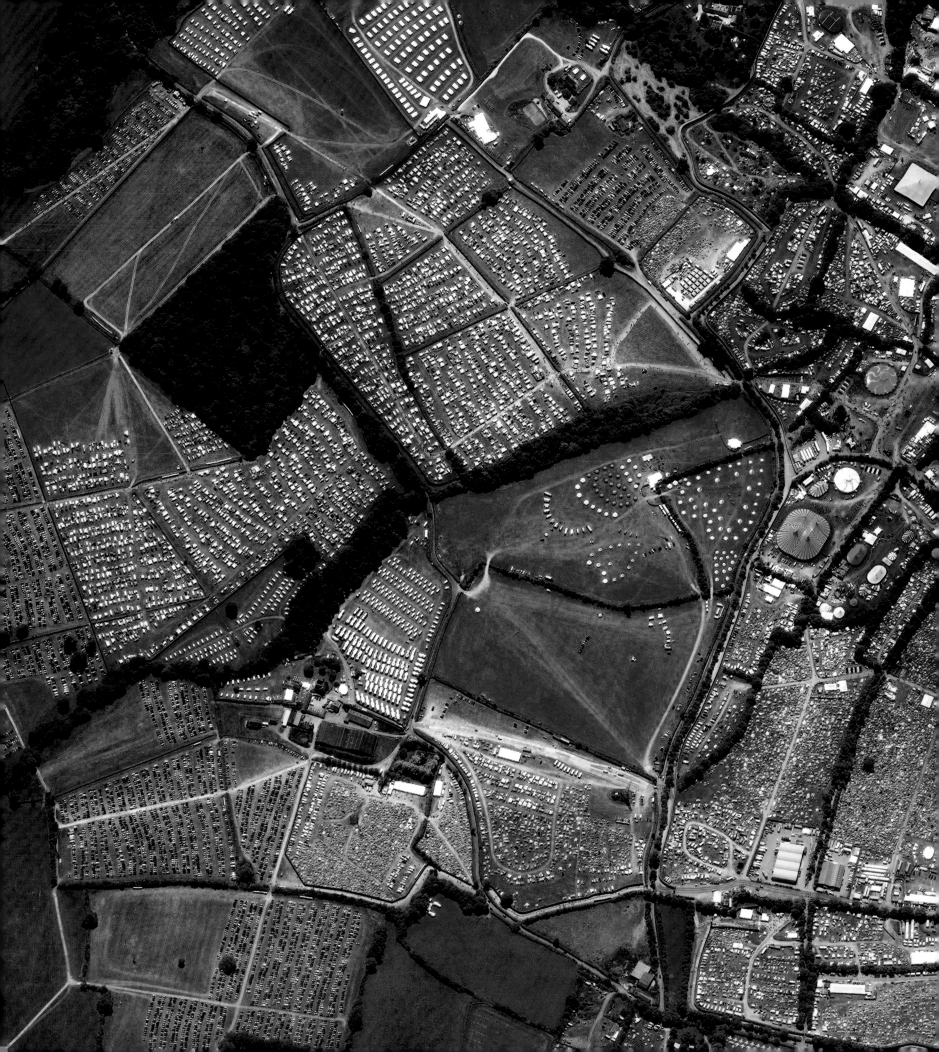

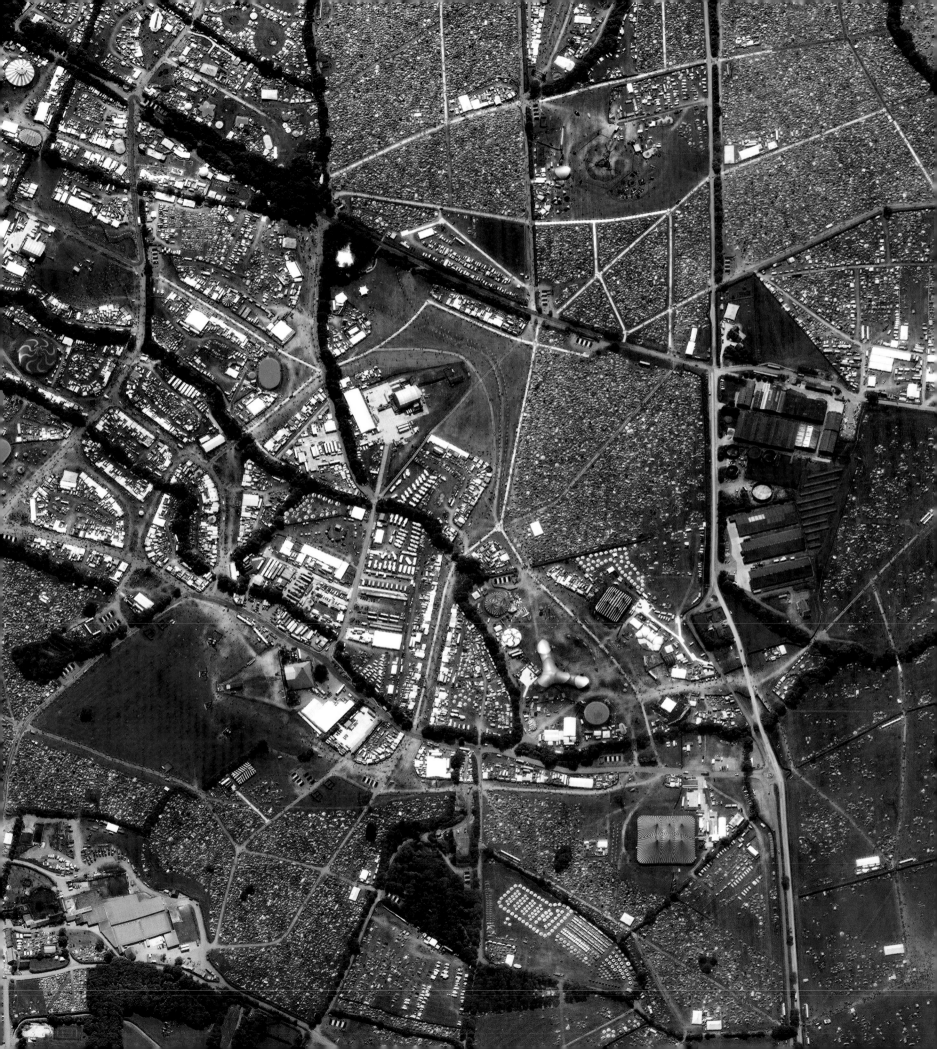

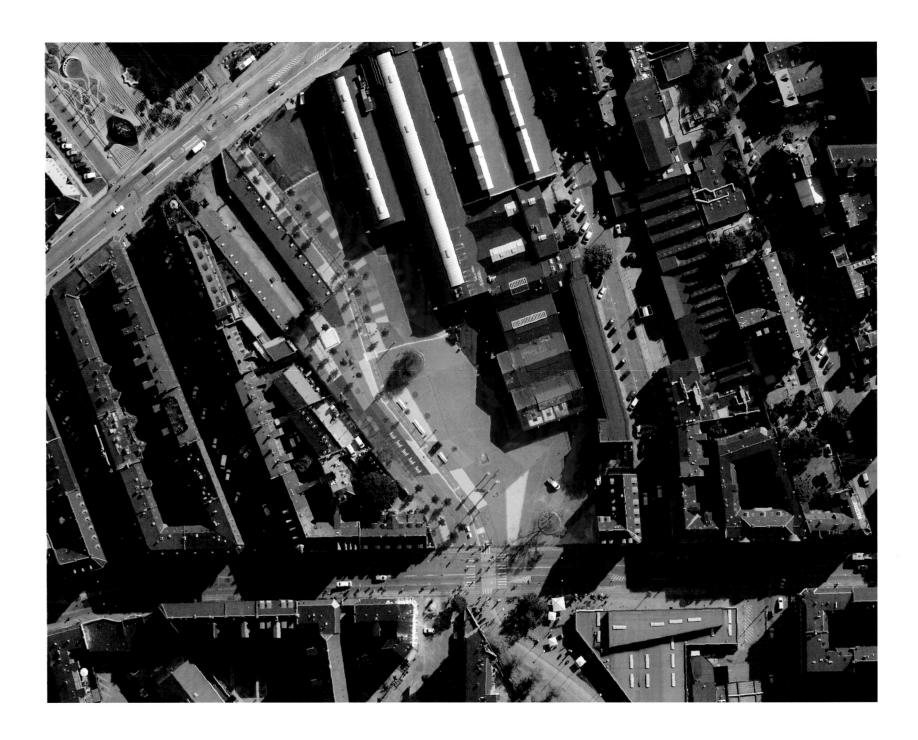

PREVIOUS PAGE
GLASTONBURY FESTIVAL
51.152237°, −2.699307°
The Glastonbury Festival is hosted annually in Pilton, England. The five-day music event attracts a crowd of more than 135,000 people. Concert-goers are provided with a campsite at the venue but must bring their own tents, which vividly dot the landscape in this Overview. The population of Pilton on the other 360 days of the year is 998.

ABOVE
SUPERKILEN
55.699733°, 12.541789°
Superkilen is a public park in the Nørrebro district of Copenhagen, Denmark. The colorful space aims to celebrate global diversity, designed as a universal exposition with ideas and artifacts gathered from over 50 countries around the world.

RIGHT
VONDELPARK
52.358003°, 4.865806°
The Vondelpark is a public park in Amsterdam, Netherlands, that attracts more than 10 million visitors each year. In addition to its ample green spaces and ponds, the Vondelpark contains an open-air theater, sculptures, athletic facilities, and numerous playgrounds.

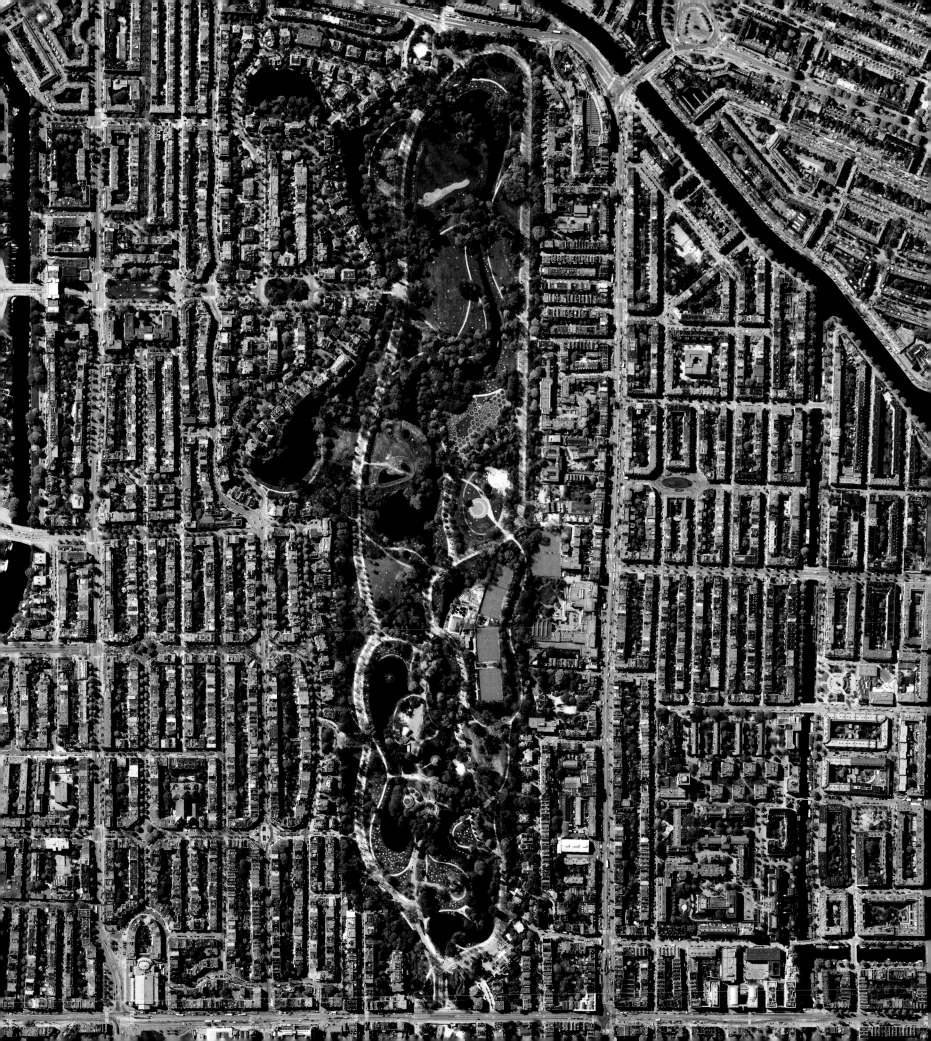

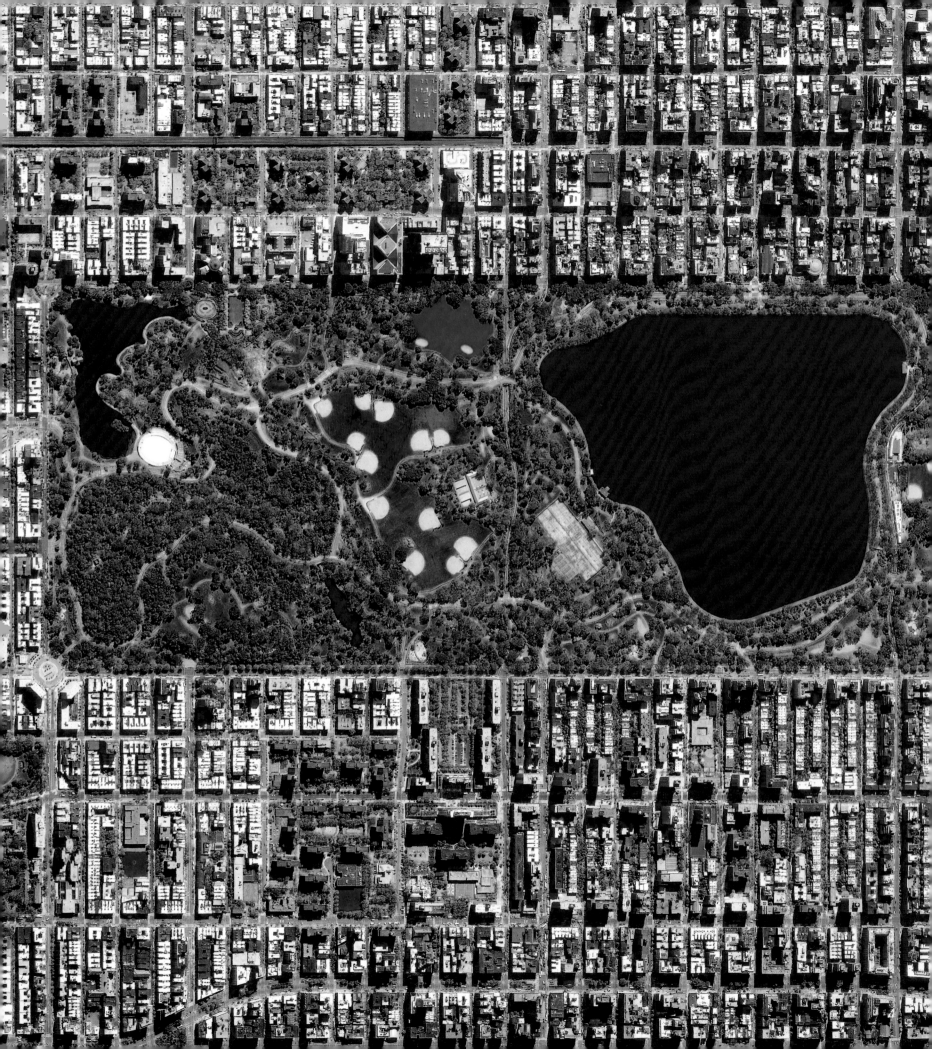

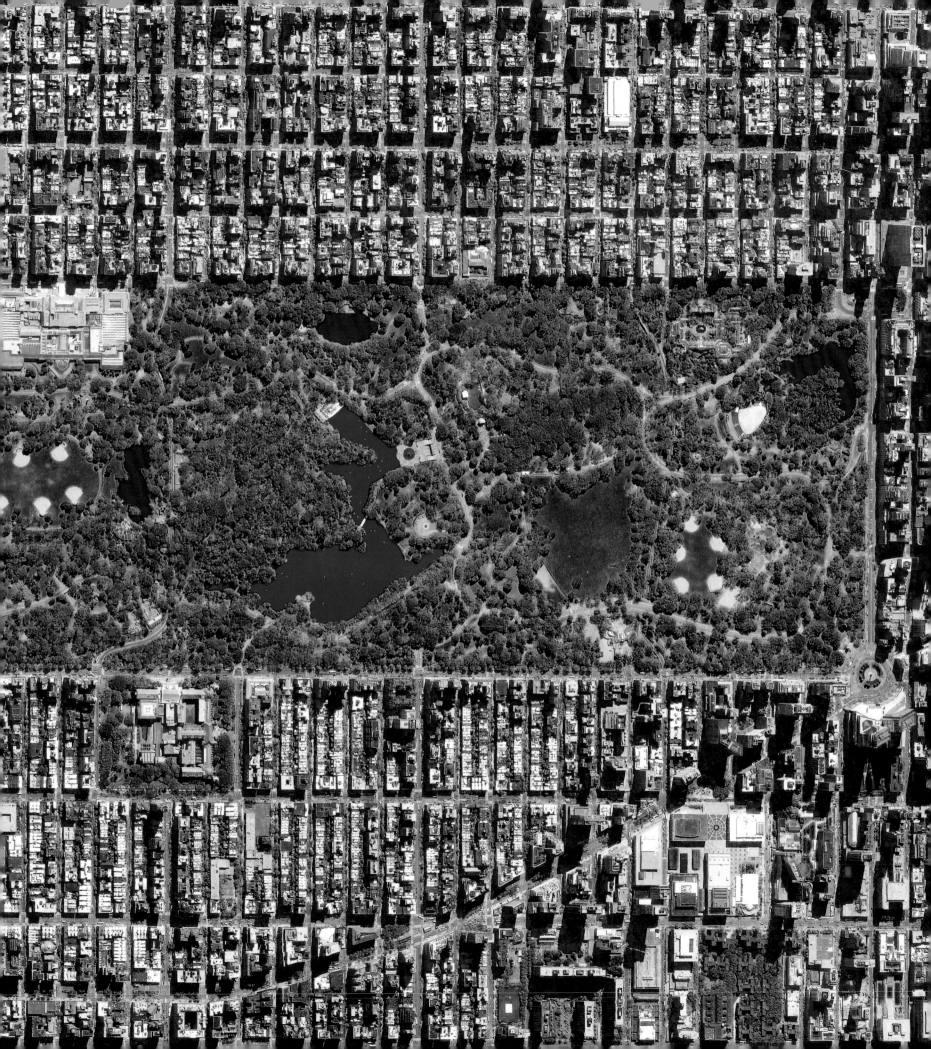

PREVIOUS PAGE
CENTRAL PARK

40.782997°, −73.966741°

Central Park in New York City, USA, spans 843 acres (341 hectares), which is 6 percent of the island of Manhattan. One of the most influential innovations in the park's design was its "separate circulation systems" for pedestrians, cyclists, horseback riders, and cars. The park contains numerous tennis courts and baseball fields, an ice-skating rink, and a swimming pool. It also serves as the finish line for the New York City Marathon and New York City Triathlon.

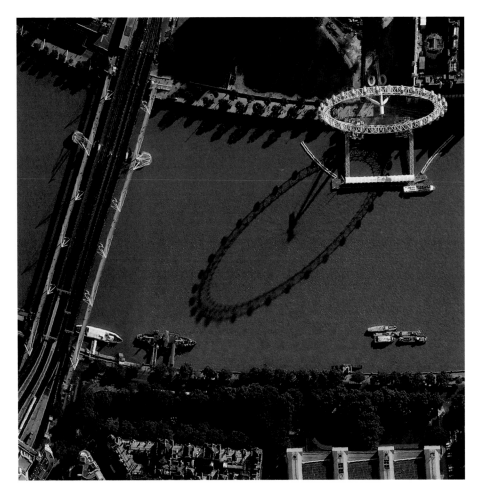

ABOVE LEFT
LONDON EYE

51.503184°, −0.119509°

The London Eye, a Ferris wheel on the River Thames in London, England, receives 3.75 million annual visitors. The structure is the fourth tallest of its kind in the world at 443 feet (135 meters), and has a wheel diameter of 394 feet (120 meters). Each one of the 32 passenger capsules holds up to 25 people, who have the ability to sit or walk around freely while the wheel rotates.

ABOVE RIGHT
BRIGHTON PIER

50.816392°, −0.139416°

Brighton Pier, also known as Palace Pier, is constructed off the coast of the city of Brighton in England. Extending 1,719 feet (524 meters) into the English Channel, the structure contains numerous amusement park rides and roller coasters.

MUNSU WATER PARK

39.039177°, 125.780009°

Munsu Water Park is a state-run water park in
Pyongyang, North Korea. The facility is open
year-round with waterslides, indoor and
outdoor swimming pools, various sport courts,
and a rock-climbing wall.

ABOVE RIGHT

TROPICAL ISLANDS RESORT

52.038927°, 13.746420°

Tropical Islands Resort is a tropical theme park in Brandenburg, Germany. The park is located
in the world's largest freestanding hall (194 million cubic feet or 5.5 million cubic meters) that
was initially designed as an airship hangar. Tropical Islands is open 24 hours a day, every day
of the year, and contains the biggest indoor rainforest in the world, a beach, swimming pools,
and numerous waterslides.

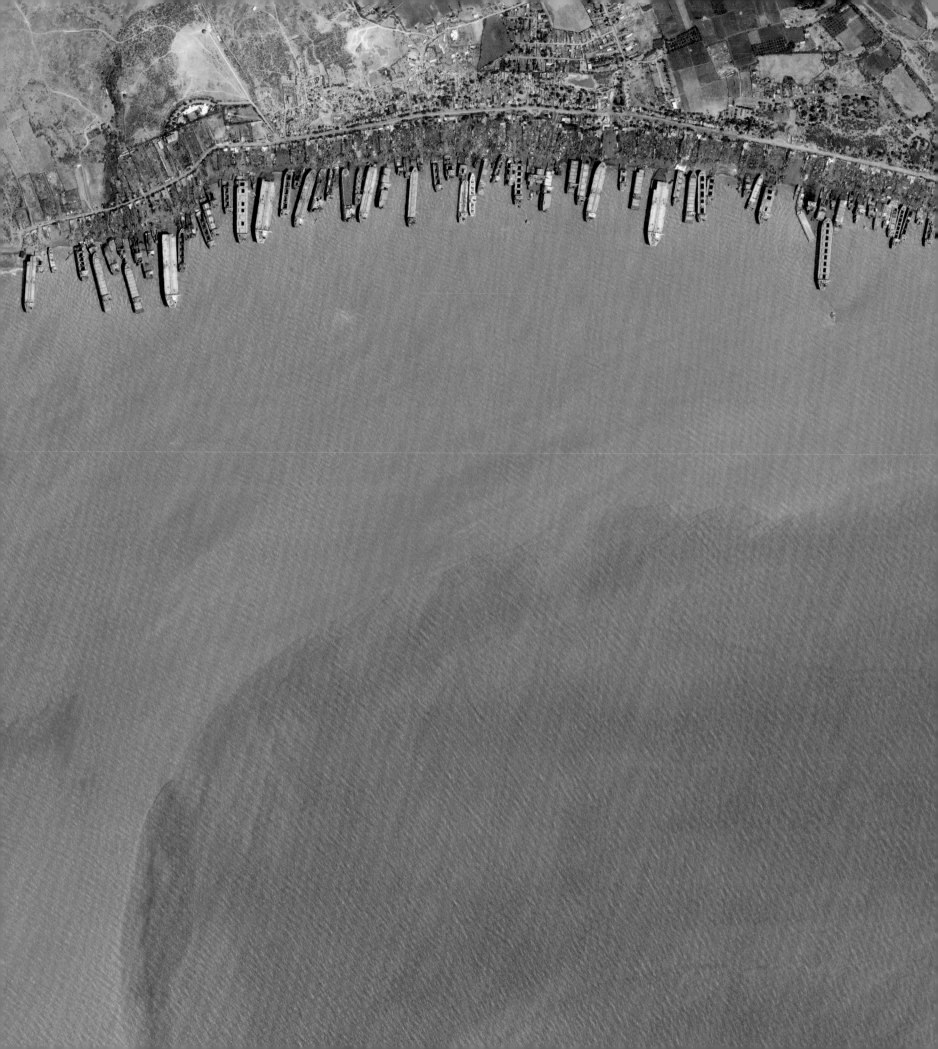

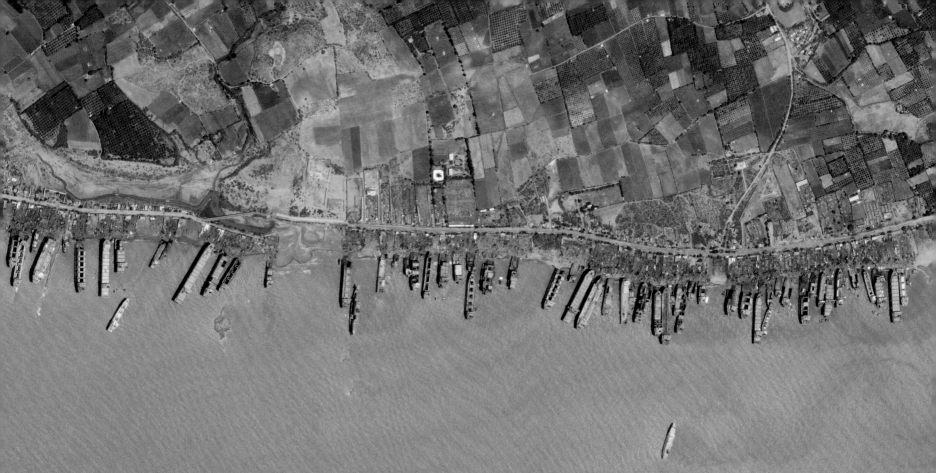

WHERE WE WASTE

> "The richer you are, and the more educated you are, the more stuff you will throw away."
>
> Adam Minter, *Junkyard Planet: Travels in the Billion-Dollar Trash Trade* (2014)

PREVIOUS PAGE

ALANG SHIPBREAKING YARD

21.406714°, 72.193885°

The shipbreaking yards on the Arabian Sea in Alang, India, account for approximately half of all ships salvaged around the world. The *Seawise Giant*—the longest ship ever built, extending 1,504 feet (458.5 meters)—was taken here to be scrapped in 2009. To read more about how shipbreaking takes place, turn to page 249.

LEFT

IRON ORE MINE TAILINGS POND

46.407676°, –87.530954°

Tailings are the waste and by-products generated by mining operations. The tailings seen here were pumped into the Gribbens Basin, next to the Empire and Tilden Iron Ore Mines in Negaunee, Michigan, USA. Once the materials are pumped into the pond, they are mixed with water to create a sloppy form of mud known as slurry. The slurry is then pumped through magnetic separation chambers to extract usable ore and increase the mine's total output. For a sense of scale, this Overview shows approximately 1 square mile (2.5 square kilometers) of the basin.

WHERE WE **WASTE**

Everyone has his or her own definition of waste. For our purposes here, we will consider waste to be things that have been discarded or abandoned, or quite simply, waste we generate from our bodies. This chapter serves as a reminder that all of the processes operating in a modern human civilization do not end there. A significant effort has been made to manage and clean up the waste that we are constantly generating.

The places of waste that we can see from space are primarily where we collect and gather. In many instances, this chapter shows the final product of other subjects in this work—the by-products of mining, the outdated vehicles of massive transportation systems, or the infrastructure needed to support millions of people living in modern cities. By observing these sites, we get a better sense of what is required to make our society function and run cleanly. It is also worth noting that most of these places are far removed from our normal existence—located in the middle of deserts, outside of city limits, even on separate islands that we have constructed explicitly for this purpose.

Waste is not usually at the forefront of our minds. Perhaps it is this physical separation from the places where our waste goes that makes it something we rarely consider. Flush it down, sell it, throw it away. But what would happen if we thought about it more often? We can reconsider our relationship with waste and begin to take more ownership, not only of what we choose to consume, but also what we decide to do with it after. Can we get more creative with our waste? Brilliant people are thinking about waste not as a problem but as an opportunity. Can these materials be reused? Can we convert more landfills into parks? Are we doing everything we can? Perhaps by taking a closer look at where we waste, we are observing not the world we are throwing away, but instead the world we are making.

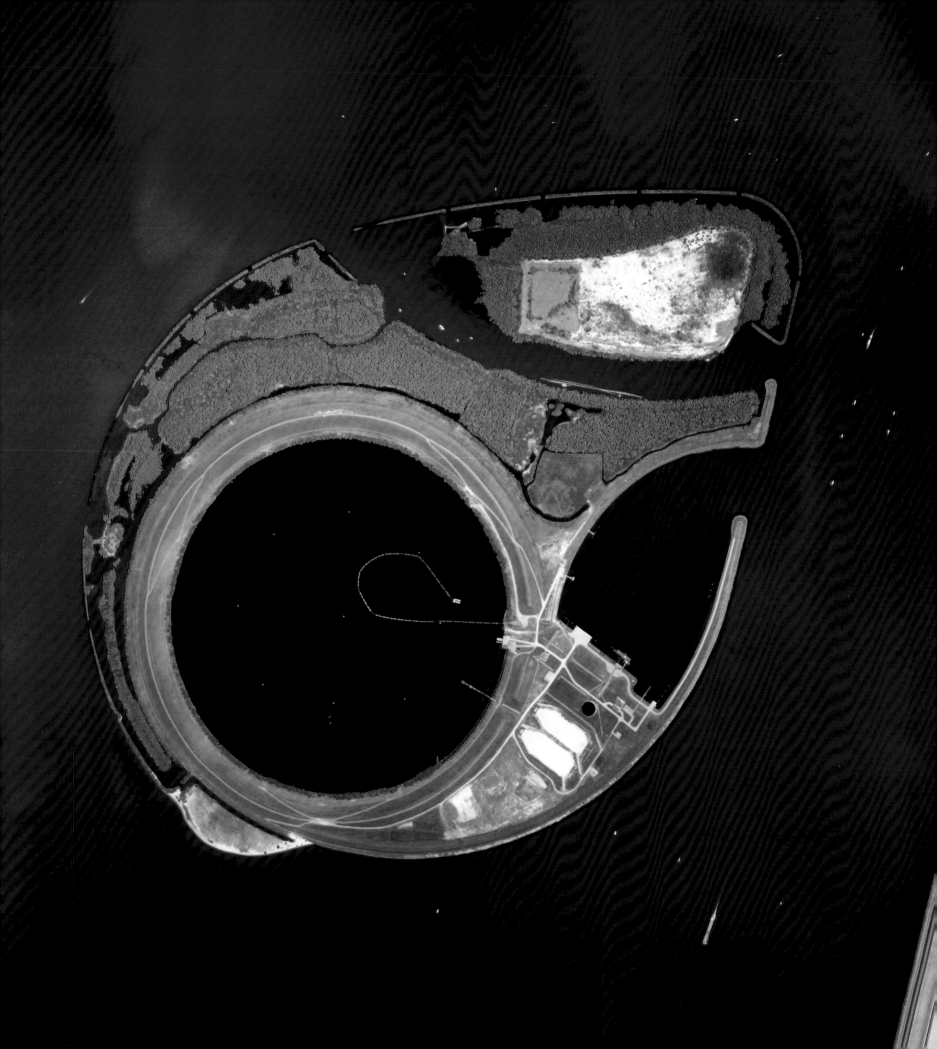

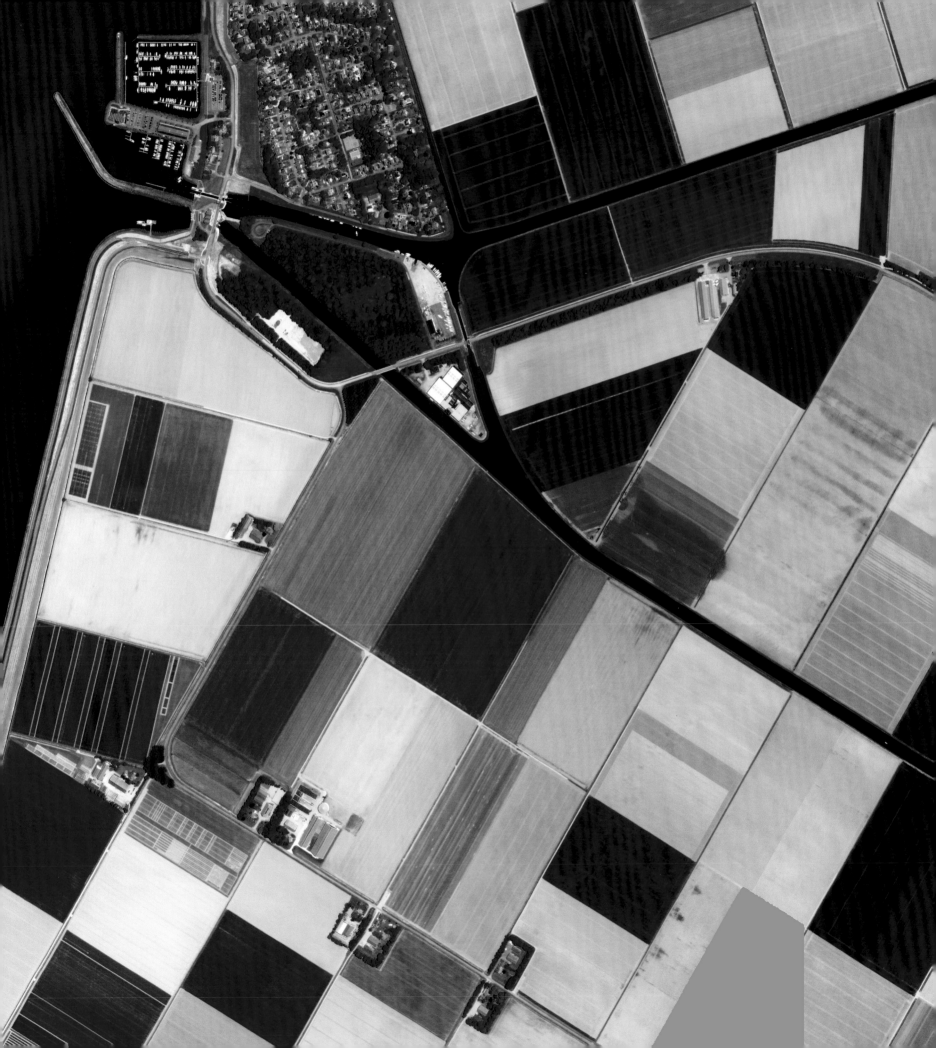

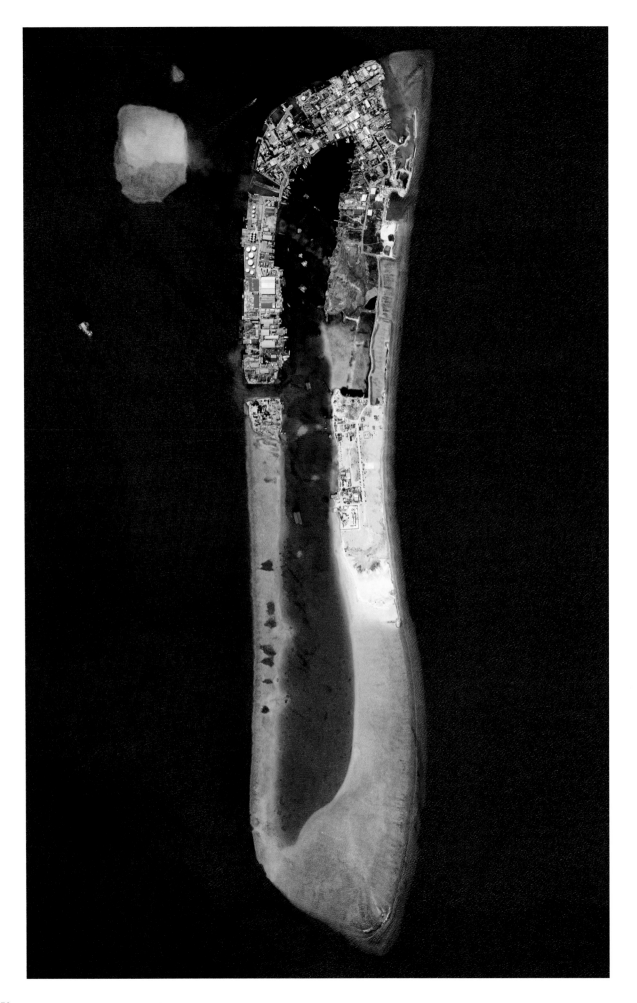

PREVIOUS PAGE

IJSSELOOG

52.599113°, 5.741851°

IJsseloog is an artificial island used as a depository to store polluted silt in the middle of the IJssel River in Flevoland, Netherlands. Silt is granular material, smaller than sand but larger than clay, and may occur as soil or as sediment mixed in suspension with water. IJsseloog can hold 706 million cubic feet (20 million cubic meters) of silt.

LEFT

THILAFUSHI

4.182612°, 73.440497°

Thilafushi is an artificial island built from reclaimed land that receives all of the waste generated in the Maldives. It is estimated that 330 tons of waste is brought to Thilafushi every day, most of which comes from Malé (as seen on page 120). Because the waste is used to continue the land reclamation process and increase the size of the island, the area of Thilafushi is growing at 11 square feet (1 square meter) each day.

RIGHT

UMI NO MORI

35.596614°, 139.806126°

In Tokyo Bay, Japan, there is an island built on top of 12.3 million tons of municipal waste, buried there from 1973 to 1987—primarily waste from Tokyo's water purification plants, sewage, city parks, and streets. In recent years, an ambitious environmental project called Umi No Mori has been enacted to convert much of the landfill area into a "sea forest," with half a million trees planted across 217 acres (88 hectares). The organizers hope the project serves as a symbol of human beings striving to live in harmony with nature.

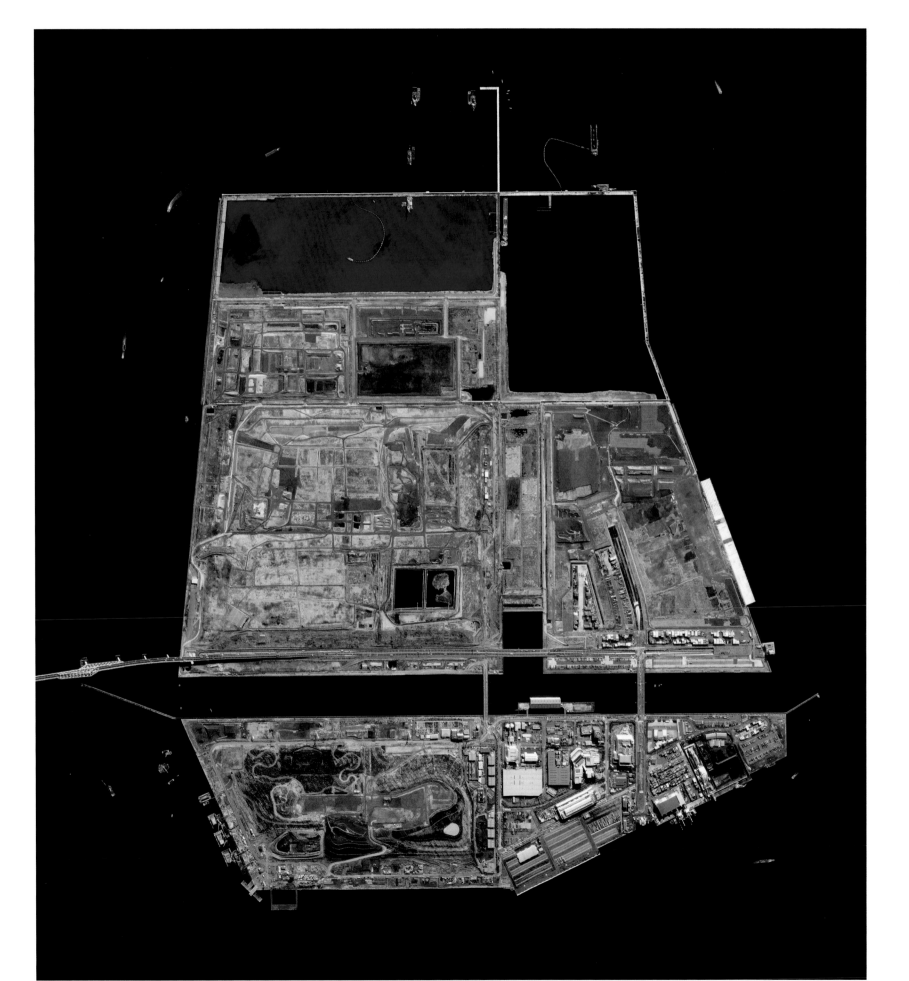

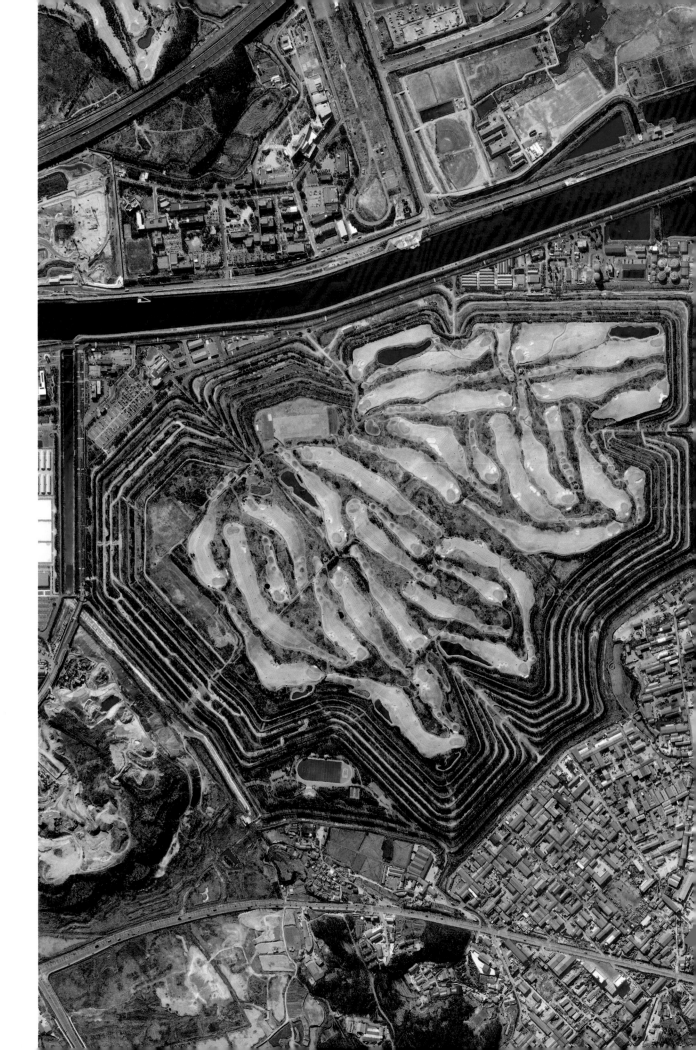

SUDOKWON LANDFILL

37.575339°, 126.612551°

The Sudokwon Landfill is the destination of nearly all of the waste generated by the 22 million people and happenings in the metropolitan area of Seoul, South Korea. One of the landfill's two sections is filled to capacity, enabling its top layer of land to be converted into a golf course. For the active landfill section, city and local administrators are conflicted about whether to continue adding more waste to the site. Even though there is more space to fill, many believe the facility poses significant environmental risks and creates foul odors that seep into the surrounding residential areas. Because there is no existing alternative to collect the city's waste, the 2016 date when officials intended to close the facility has been delayed and indefinitely extended.

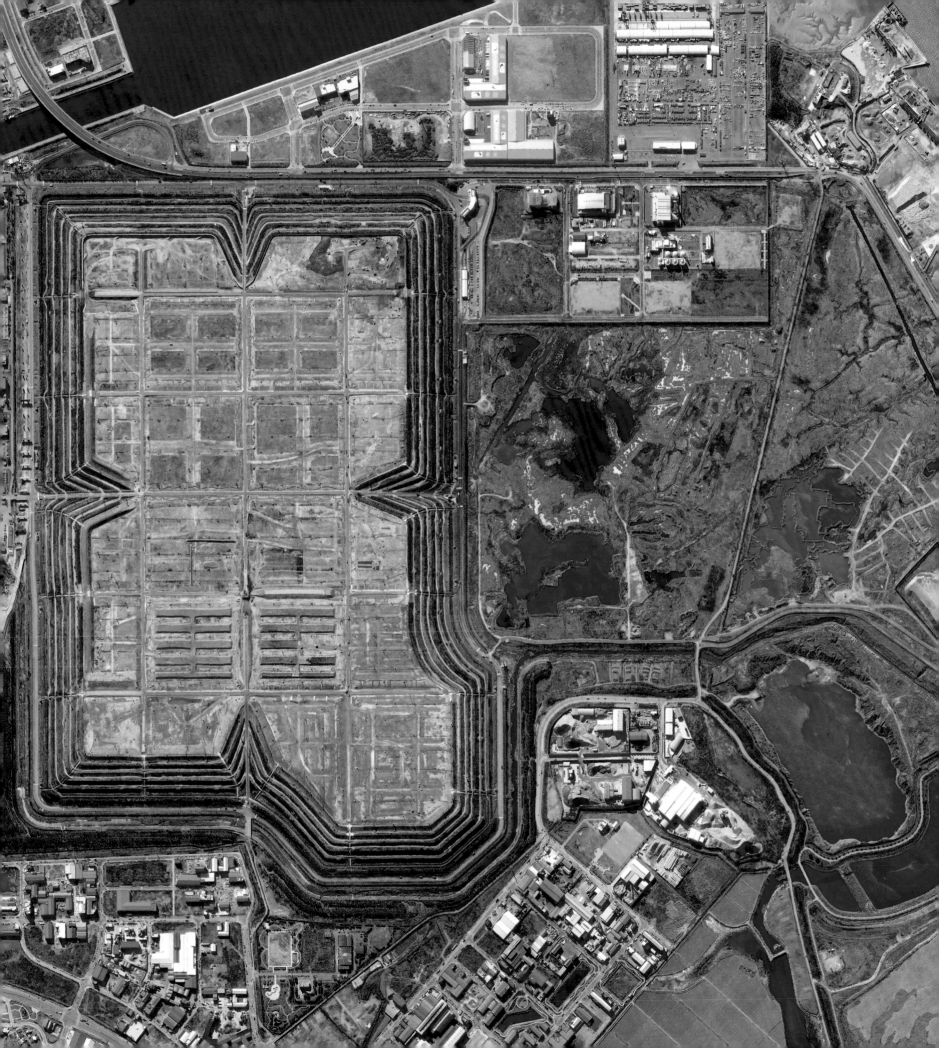

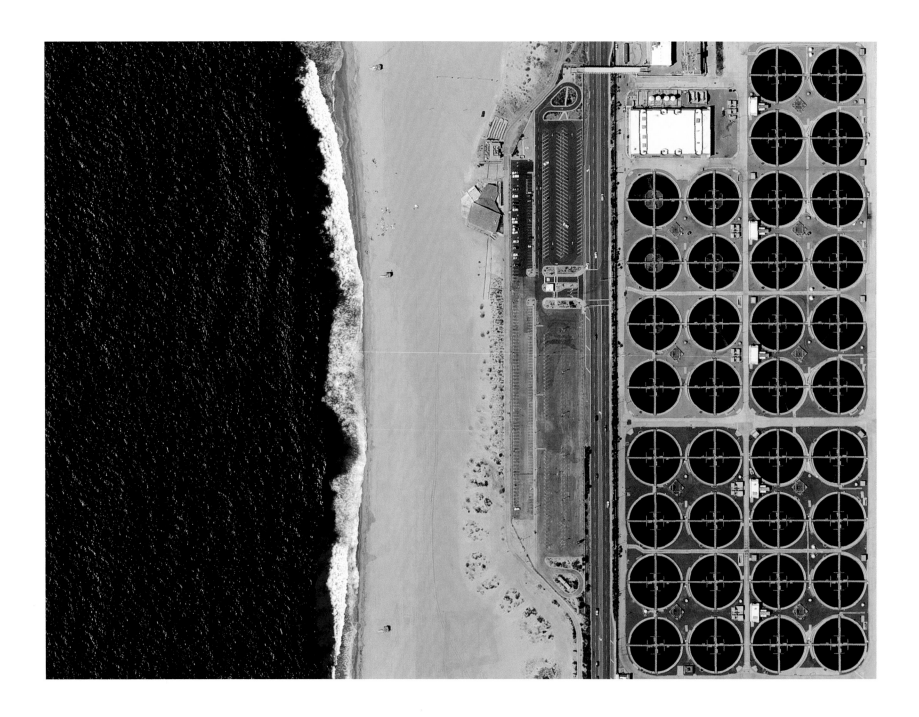

ABOVE

HYPERION TREATMENT PLANT

33.922326°, −118.429921°

Until 1925, raw sewage from the city of Los Angeles, USA, was untreated and discharged directly into Santa Monica Bay. The Hyperion Treatment Plant was built in 1950, though due to the ever-growing size of the nearby city, 25 million pounds (11.3 million kilograms) of sludge per month was still sent through 5- and 7-mile (8- and 11-kilometer) pipes into the ocean. From 1980 to 1987, the city spent $1.6 billion USD to complete an extensive sludge removal effort in the bay and in 1998, completed a full update of treatment technology at the facility.

RIGHT

FRESNO-CLOVIS WASTEWATER TREATMENT FACILITY

36.699766°, −119.903360°

Every day, this facility in Fresno, California, USA, receives 71 million gallons (268 million litres) of wastewater that is routed to the facility through 1,500 miles (2,400 kilometers) of sewer lines. During the purification process, the wastewater is pumped into the large pools seen in this Overview. Here, any material that was not removed during earlier screening processes will either float to the surface or settle at the bottom of the basins.

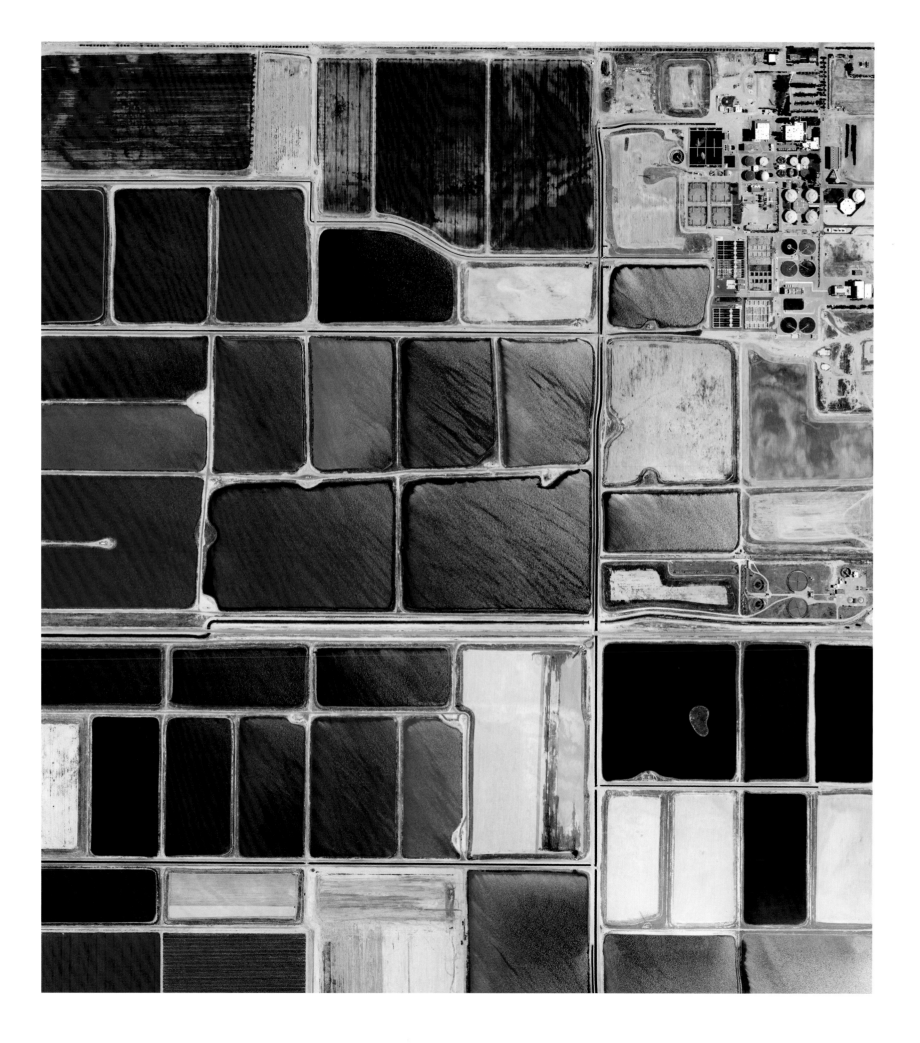

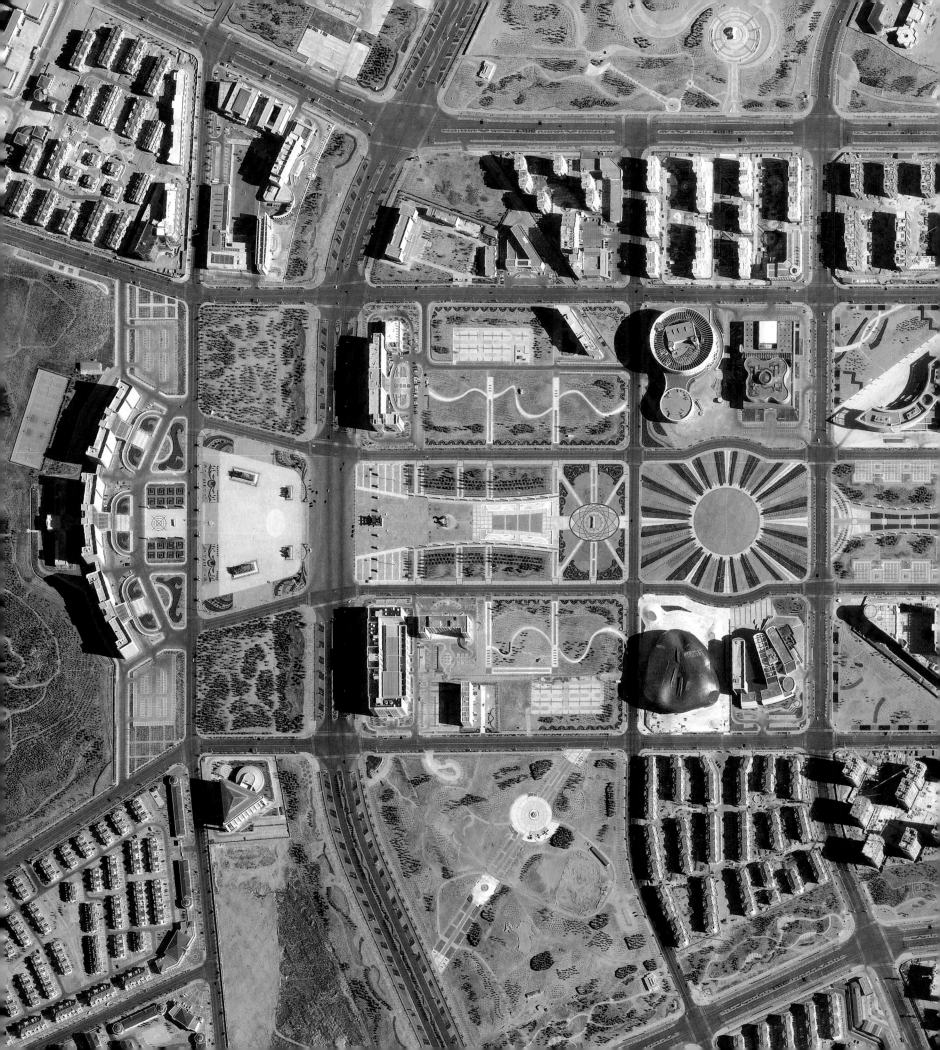

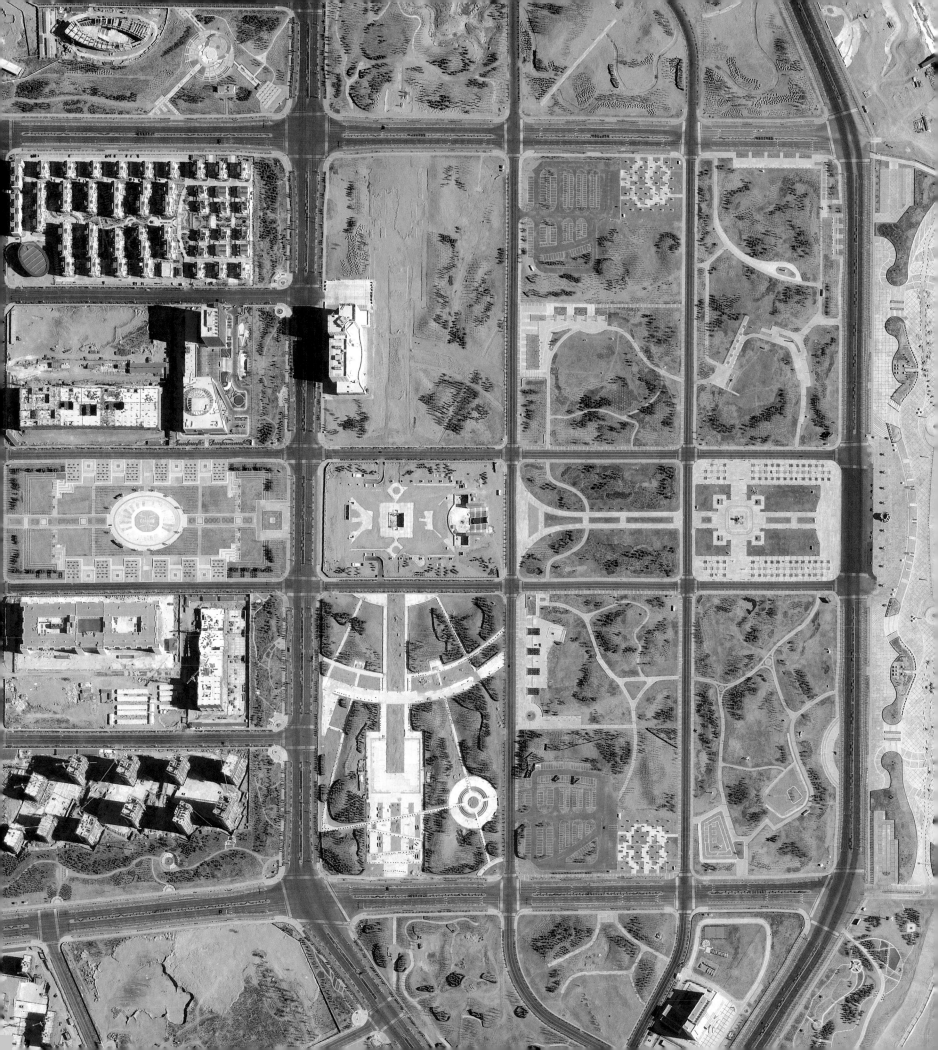

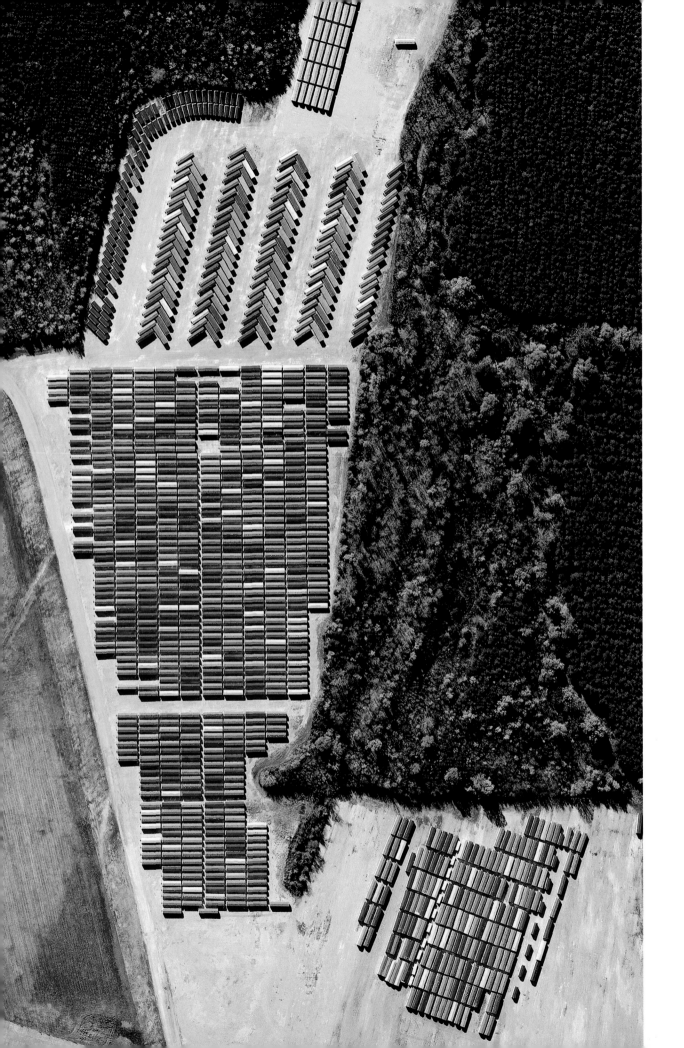

PREVIOUS PAGE
ORDOS GHOST CITY
39.599654°, 109.780476°

Ordos, China, is considered by many accounts to be the largest ghost city in the world. In the last decade, construction projects increased the housing and population capacity of the city to more than 1 million people. However, reports as of 2016 suggest that only 2 percent of the new buildings have been occupied and many of the city's other construction projects have been abandoned. The Kangbashi New Area, seen here, contains many of the city's new, modern-designed cultural attractions, but noticeably, very few cars.

LEFT
UNUSED MOBILE HOMES
33.722348°, −93.667627°

Mobile homes that were supposed to be distributed to victims of Hurricane Katrina remained vacated and unused at Hope Municipal Airport in Hope, Arkansas, USA. This Overview was captured in 2011, more than five years after the catastrophic storm hit the Gulf Region of the United States. At one point, there were 10,770 unused trailers on the airport grounds that could not be supplied to victims, primarily due to federal regulations that forbade the placement of trailers within a floodplain such as the hardest-hit city, New Orleans, Lousiana.

RIGHT
EPECUÉN
−37.132842°, −62.811438°

Villa Epecuén was a tourist village located on Lago Epecuén in Argentina. Developed in the 1920s, Epecuén had a thriving tourism industry as vacationers traveled from Buenos Aires via train to the therapeutic salty waters of the lake. However, on November 10, 1985, a standing wave caused by a rare weather pattern ruptured a nearby dam and the dyke protecting the town. With the surge of water, the lake rose 33 feet (10 meters) and submerged the village. Villa Epecuén was declared uninhabitable and never rebuilt.

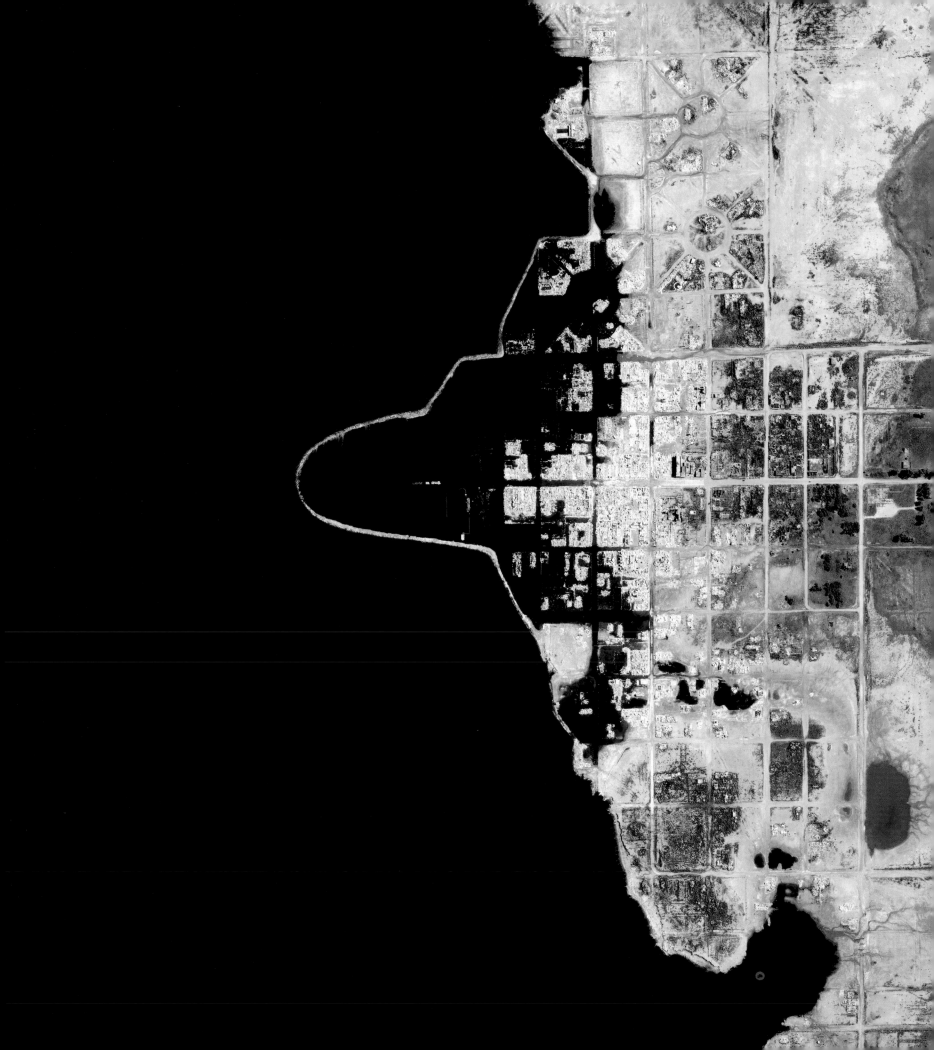

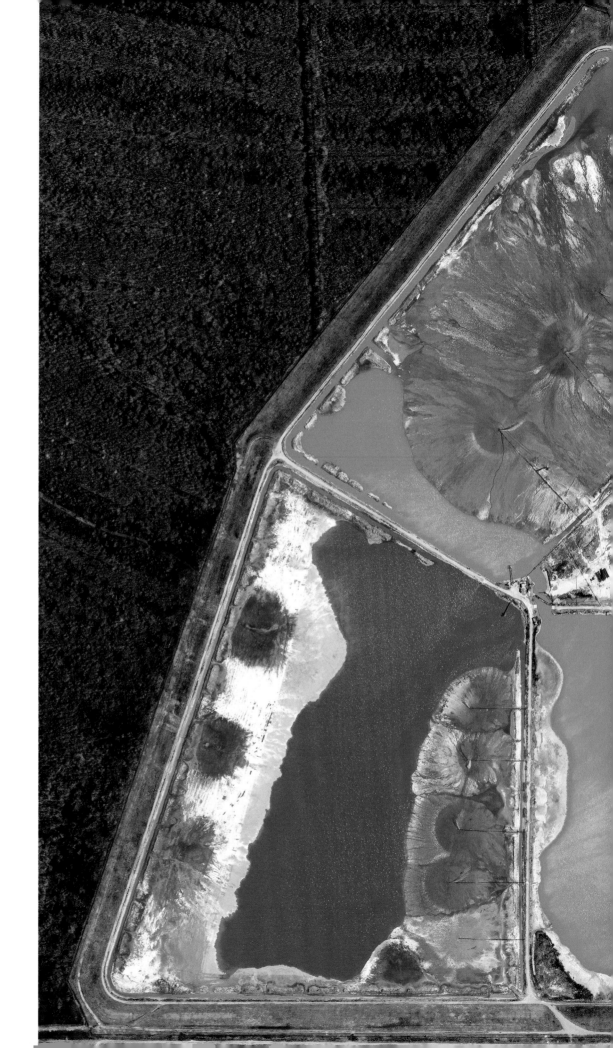

RED MUD POND

30.157888°, −90.906310°

A red mud pond is visible in Darrow, Louisiana, USA. Approximately 77 million tons of red mud, also known as red sludge, is generated every year due to the industrial production of aluminum around the world. To read more about aluminum production, turn to the Juxtapose feature on pages 66–67.

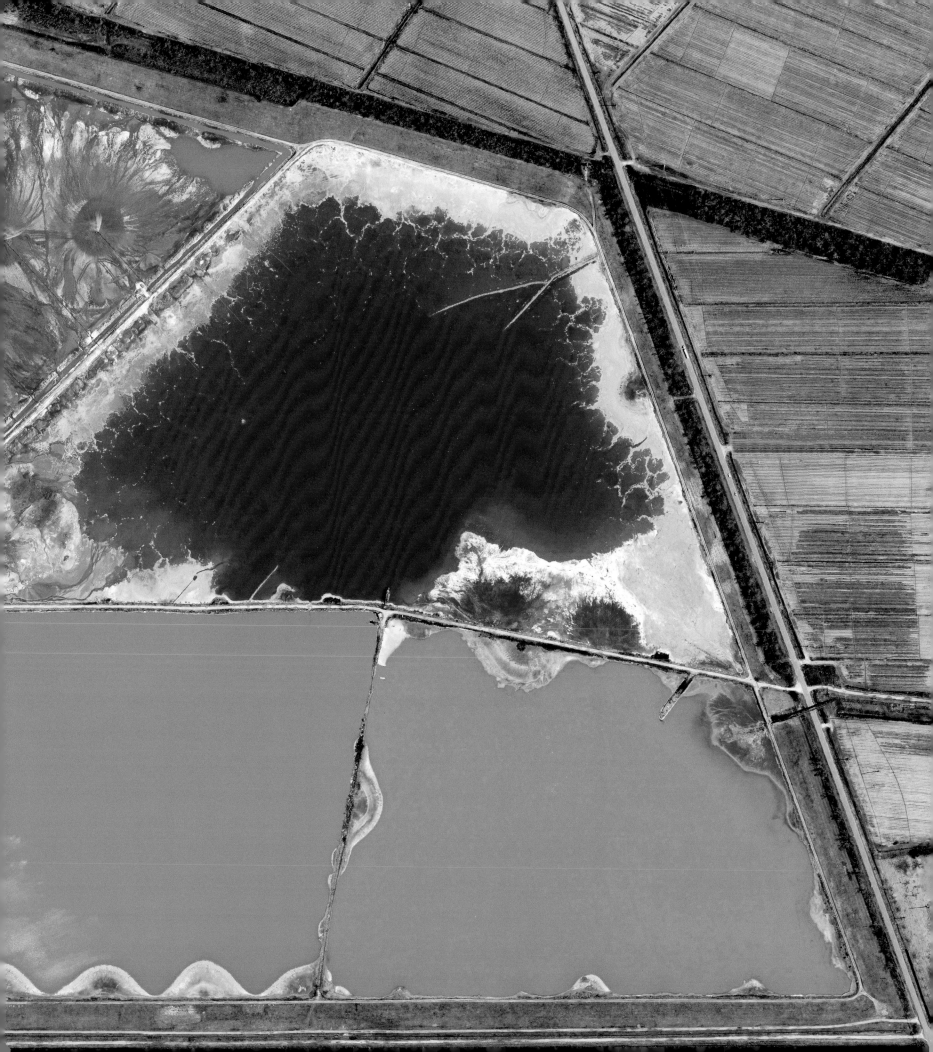

MINING WASTE DISASTER −20.237096°, −43.421697°

On November 5, 2015, two dams collapsed at an iron ore mine in southeastern Brazil. News outlets estimated that approximately 81 million cubic yards (62 million cubic meters) of toxic wastewater (similar to the red mud on the previous page) was unleashed. As seen in this Juxtapose, the immediate release of sludge wiped out the village of Bento Rodrigues, resulting in the death of 17 people.

JULY 21, 2015

Because of this pollution, more than half a million people did not have access to clean drinking water or water to irrigate crops for an extended period of time. Furthermore, within two weeks of the dam rupture, the contaminated waters had spread across a 400-mile (644-kilometer) stretch of the Doce River and entered into the Atlantic Ocean, killing significant amounts of plant and animal life along the way. Officials are concerned that the toxins will continue to threaten the Comboios Nature Reserve, a protected area for the endangered leatherback turtle.

LEFT

**BAOGANG STEEL AND RARE EARTH
MINE TAILINGS POND**

40.634502°, 109.684273°

Multiple pipes pump thick chemical
sludge into a waste pond next to the
Baogang Steel and Rare Earth Mine in
Inner Mongolia, China. This contaminated
mixture is primarily a by-product of the
refining process taking place in numerous
facilities around the lake. Rare earth
elements are essential components in a
wide array of modern technologies, such
as magnets, wind turbines, electric car
motors, and smartphones. China produces
approximately 95 percent of the world's
supply of rare earth elements and the mine
in Baogang accounts for 70 percent of the
world's reserves.

RIGHT

**ATHABASCA TAR SANDS
TAILINGS POND**

57.013932°, –111.662197°

Of Canada's total reserves of 173 billion
barrels of oil, 168 billion are located in
the Athabasca Oil Sands in Alberta.
Large volumes of tailings are produced
and pumped into massive tailing ponds
at the facility as a by-product of bitumen
extraction (semi-solid petroleum).
In 2013, a government report stated
that tailings ponds in the oil sands
covered an area of nearly 30 square miles
(77 square kilometers).

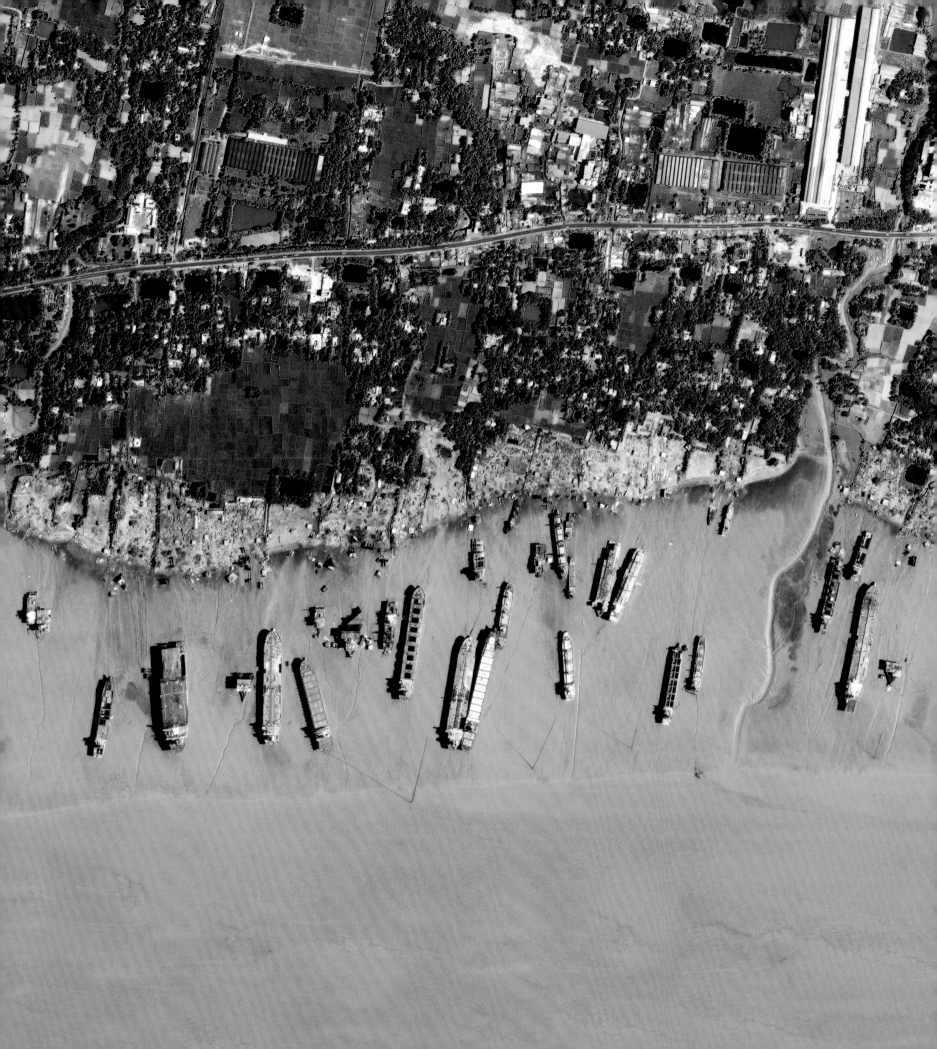

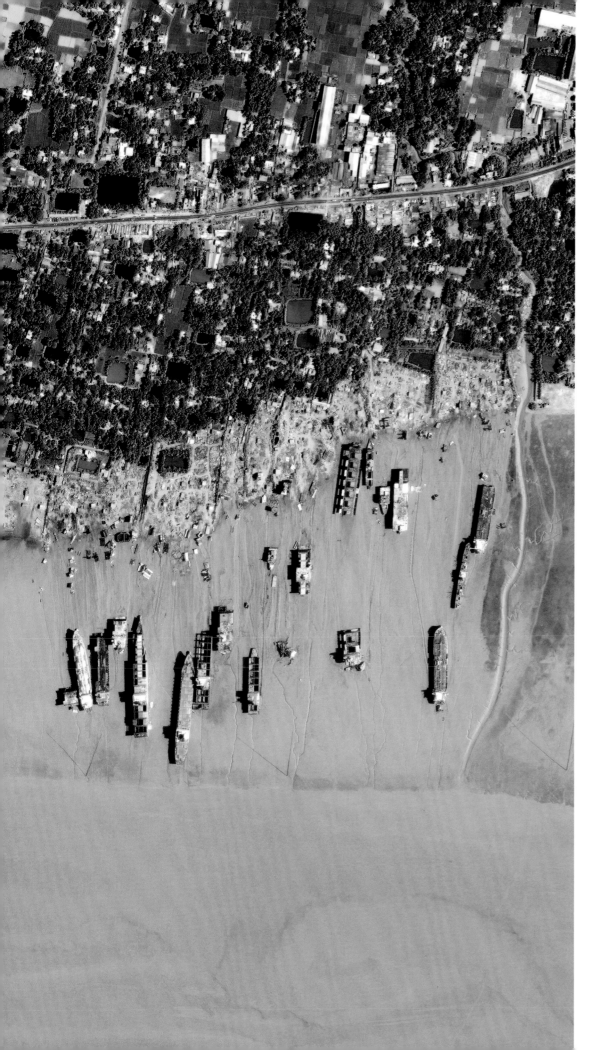

CHITTAGONG SHIPBREAKING YARD

22.452777°, 91.726809°

The Chittagong Shipbreaking Yard is located on an
11-mile (18-kilometer) strip of the Bay of Bengal in
Chittagong, Bangladesh. Ships are sold to shipbreaking
companies here, brought to the shore at high tide, and
are purposefully beached as the water recedes. Once the
ships are anchored to the beach, they are taken apart by
a massive force of migrant laborers; more than 200,000
are believed to work at the yard in Chittagong. Human
rights advocates have called attention to the abysmal
conditions that these workers face on a daily basis in
the yards amid explosions, perilous machinery, and
toxic fumes.

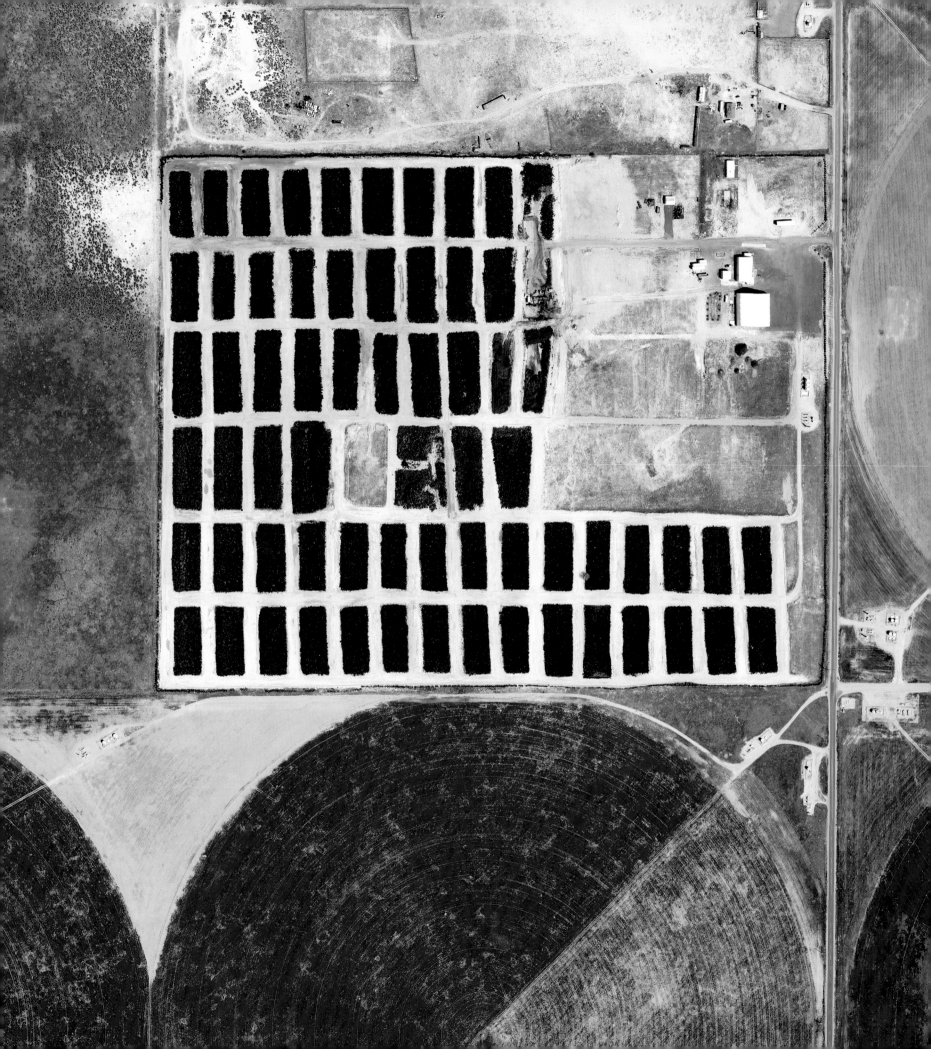

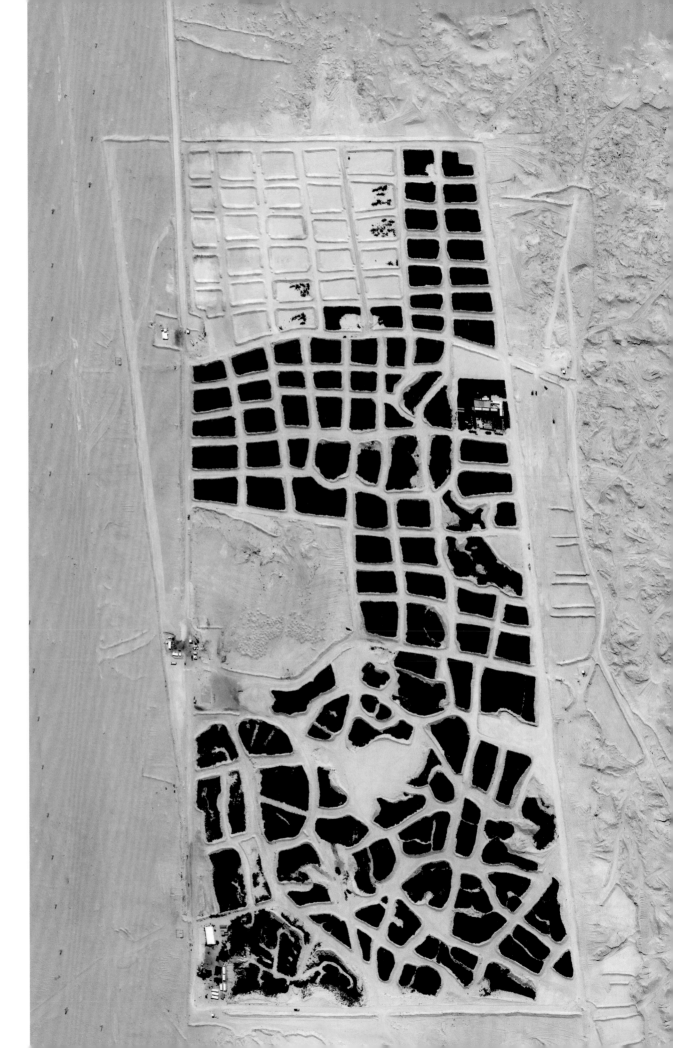

LEFT

COLORADO TIRE GRAVEYARD

40.177084°, −104.684722°

The world's largest tire dump is located in Hudson, Colorado, USA. The facility contains 50-foot-deep (15-meter) pits filled with approximately 60 million scrap tires. An estimated 1.5 billion tires are discarded each year worldwide. Of that amount, more than half are burned for their fuel.

RIGHT

KUWAIT TIRE GRAVEYARD

29.259079°, 47.671489°

Approximately 7 million tires are buried in giant holes at a dump in Sulaibiya, Kuwait. The discarded tires are from Kuwait, along with other countries that have paid to send them here. For example, the European Union banned the disposal of tires in its landfill sites in 2006, leaving 480,000 tons of rubber that must be exported or shredded somewhere else each year.

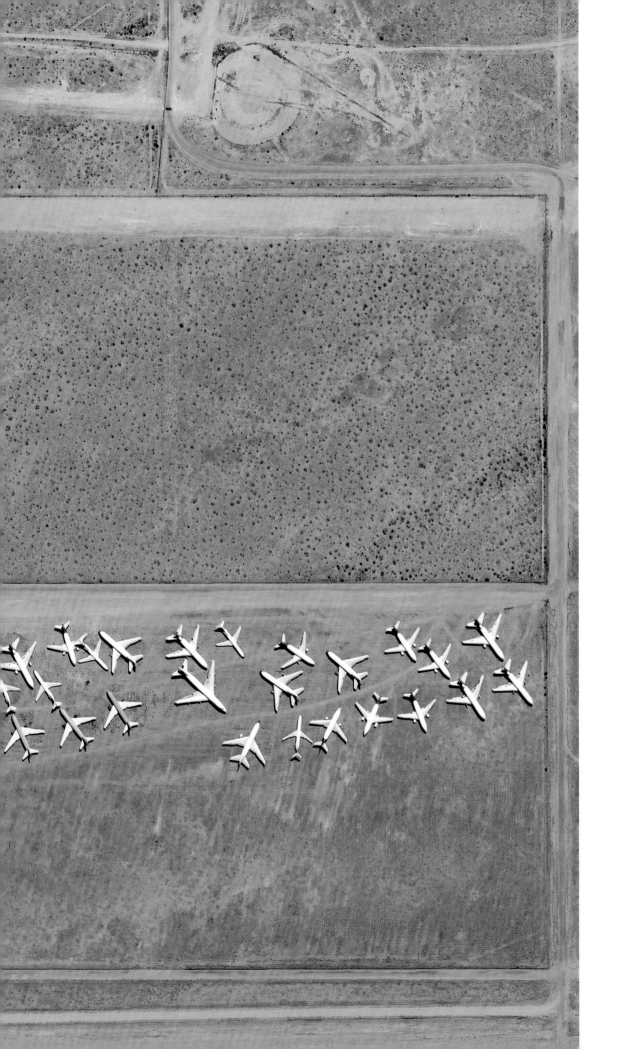

SOUTHERN CALIFORNIA LOGISTICS
AIRPORT BONEYARD

34.611367°, −117.379784°

The Southern California Logistics Airport in
Victorville, California, USA, contains an aircraft
boneyard with more than 150 retired planes. Because
the demand for jumbo jets has dropped significantly
in the last two decades in favor of smaller, more
affordable twin-engine planes, many large aircraft, such
as Boeing 747s and Airbus A380s, have been retired.
The dry conditions in Victorville—located on the edge
of the Mojave Desert—limits the corrosion of metal,
meaning planes can be stored here for years while
they are stripped for spare parts.

WHERE WE ARE NOT

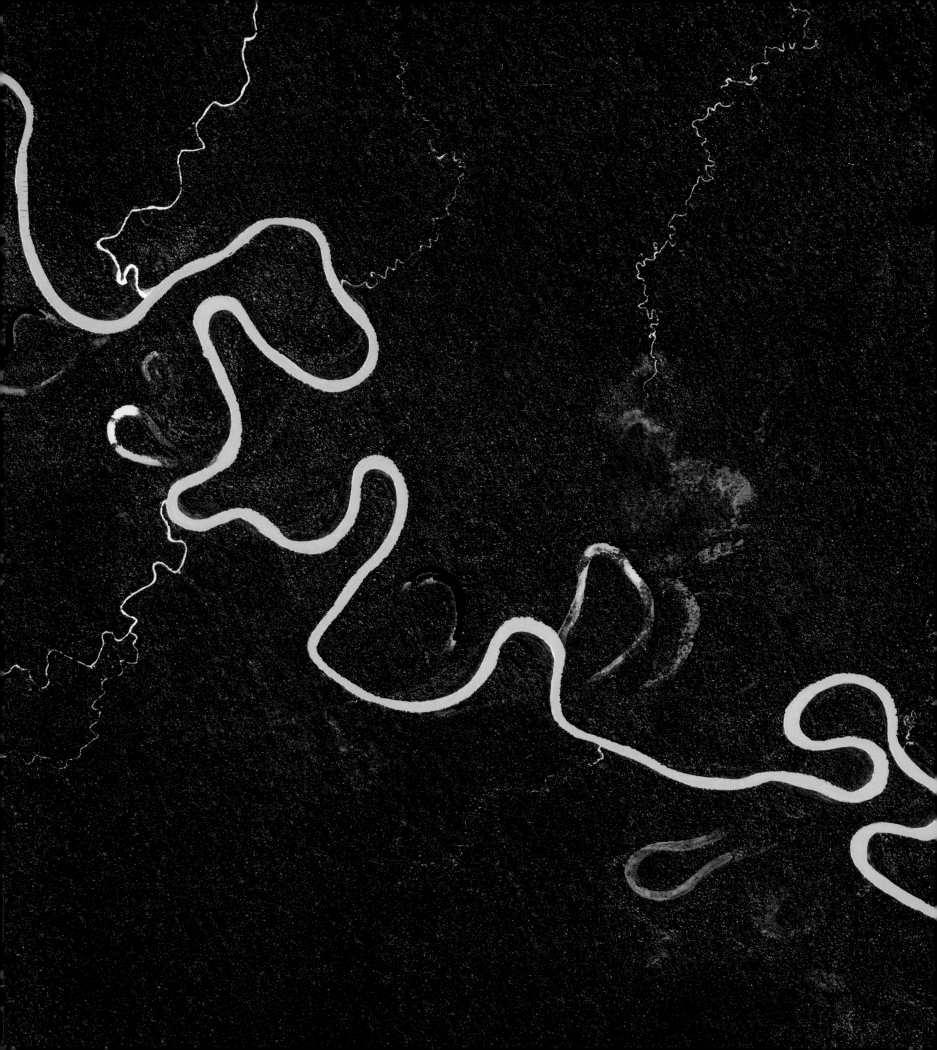

> "Look deep into nature, and then you will understand everything better."
>
> Albert Einstein

WHERE WE **ARE NOT**

While the focus of this book up to this point has been on our artificial world, this chapter serves as a poignant reminder of the beauty that exists everywhere else. In many ways, what we call "nature" is simply an area where human impact has not yet been felt. The images in this chapter show little to no human presence. The impact that is visible here is often the result of our effort to access the landscape and revel in the beauty of the surrounding untouched world.

When we look at the places where we are not, we are often struck by an overwhelming sense of time. In stark contrast to the relatively recent development seen in other chapters—most of those places were constructed in the last century—the images in this chapter often show geographic forms that were developed over an almost unfathomable time span. The shifting flows of a river, the sprawling swirls of a geological formation, or the gradual rise of a mountain all took place over hundreds of human generations. The scale of our newfound thirst for unending growth and modern development pales in comparison to what has developed in these places.

Humans have occupied the surface of the planet for only a small sliver on the grand timeline of our universe. Yet our impact has been drastic and most pronounced in recent years—just a tiny sliver of that other sliver. This book is geared toward the artificial, yet this chapter serves as a lasting reminder that our planet was here long before we arrived. Here we see what it might look like without us: a planet that we must appreciate, protect, and preserve while we still can.

PREVIOUS PAGE
DASHT-E KAVIR
34.646619°, 54.019581°
Dasht-e Kavir is a large desert situated in the middle of the Iranian plateau. The desert gets its appearance from the existence and subsequent evaporation of an ancient ocean. As the ocean dried up, it left behind a layer of salt that is now roughly 3 to 4 miles (6 to 7 kilometers) thick. Geologists also believe that many of the swirls that stretch across the landscape result from tectonic plate activity that has taken place since the layers of salt formed.

LEFT
RIO MADRE DE DIOS
-11.888269°, -71.408443°
The Rio Madre de Dios swirls in the rainforests of Peru. Oxbow lakes—the U-shaped branches coming off the main river—form when a wide meander from the main stem of a river is cut off, creating a freestanding body of water.

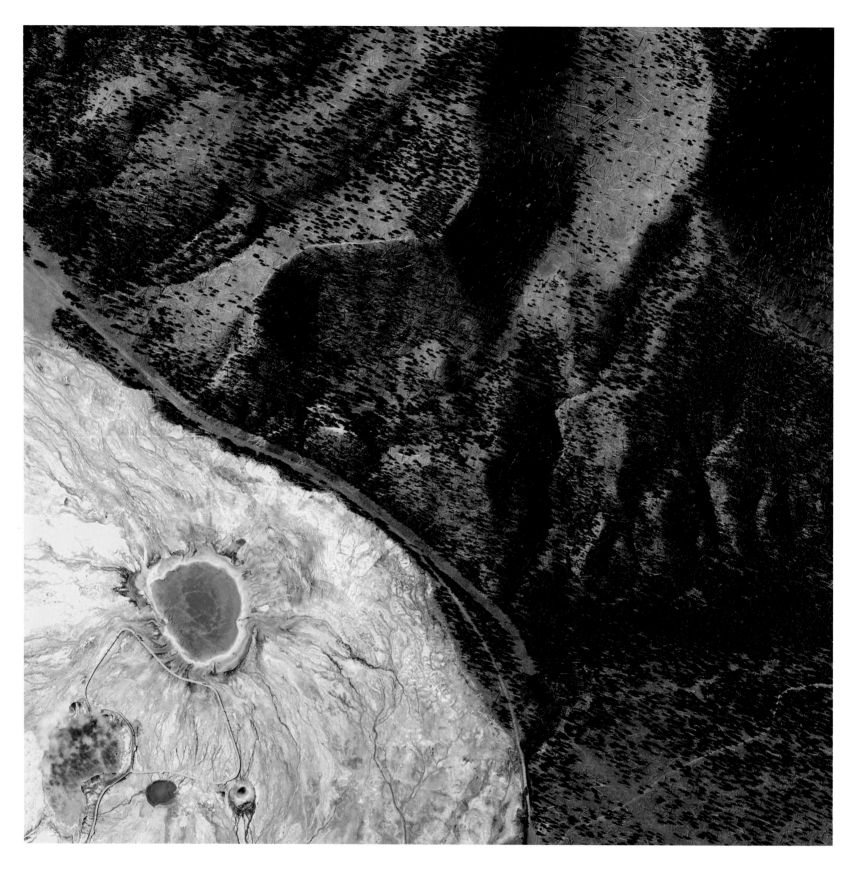

GRAND PRISMATIC SPRING 44.524974°, –110.839339°

At the Grand Prismatic Spring in Yellowstone National Park in Wyoming, USA, visitors can get a close-up view on a series of elevated boardwalks. The hot spring gets its vivid color from pigmented bacteria that grow around the edge of the mineral-rich water.

ULURU –25.345946°, 131.039142°

Uluru, or Ayers Rock, is a large sandstone formation in the Northern Territory of Australia. The monolith—towering 1,141 feet (348 meters) high with an expanse of 2.2 miles by 1.2 miles (3.5 kilometers by 1.9 kilometers)—is a sacred site to the Aboriginal people of the area who first settled there 10,000 years ago. The first Australian tourists arrived at Uluru in 1936, and by the year 2000, annual visitor numbers rose to over 400,000. Increased tourism at the site provides regional and national economic benefits, but also creates an ongoing challenge to balance conservation, cultural values, and visitor needs.

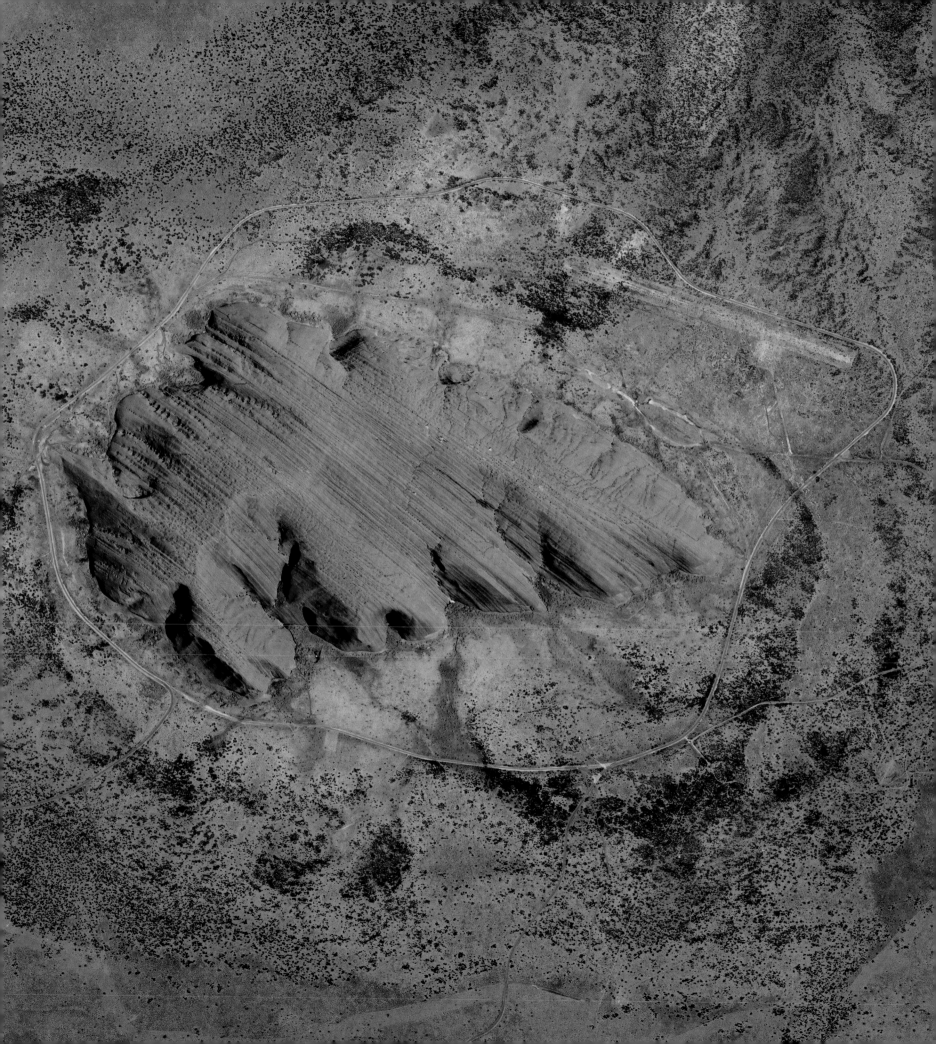

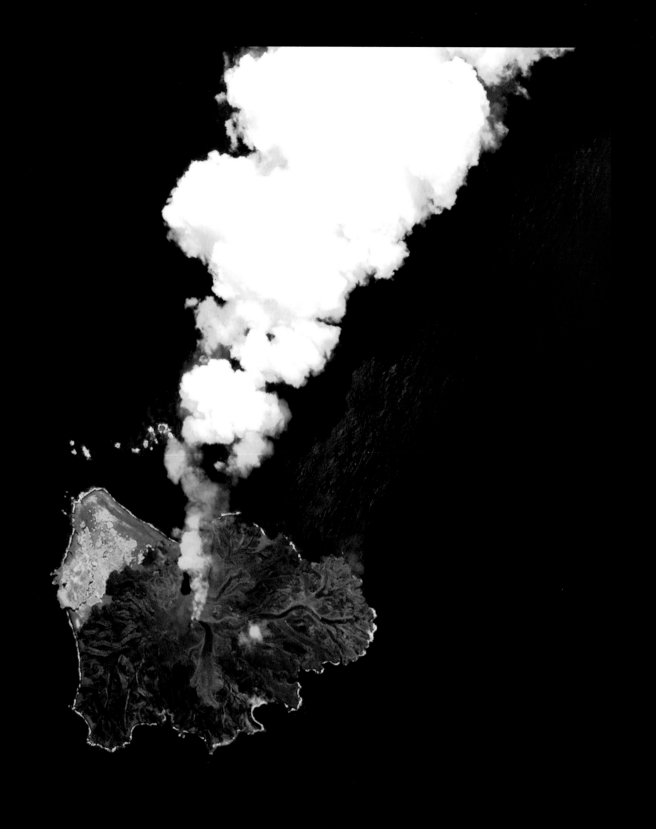

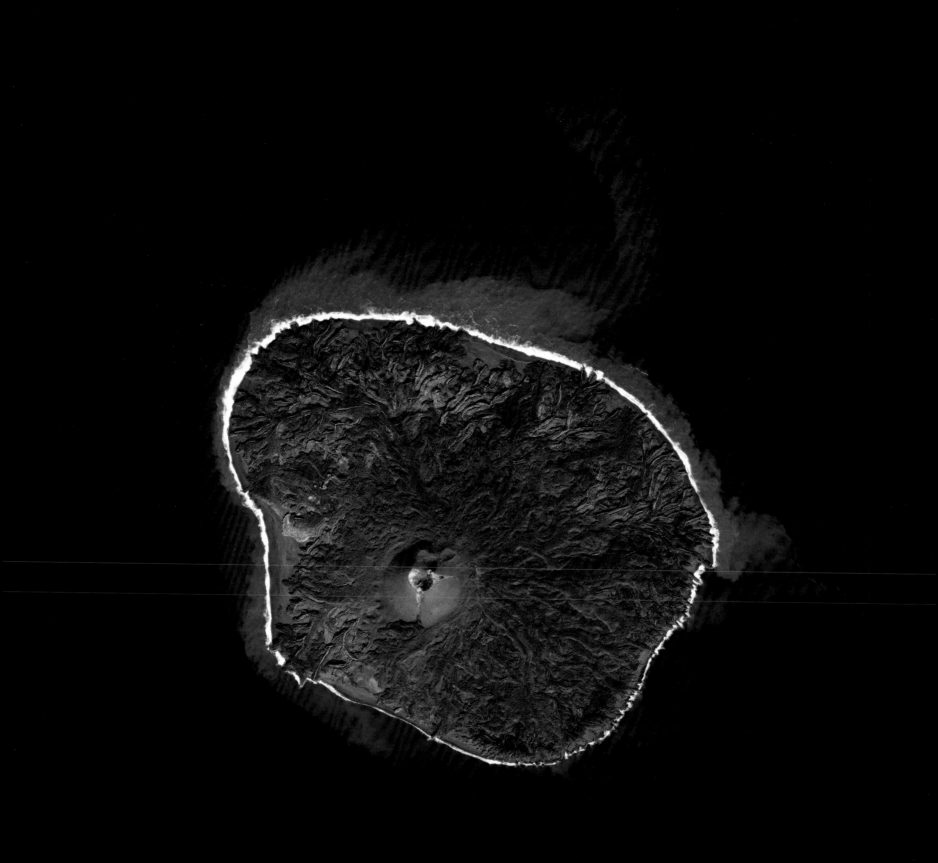

NISHINOSHIMA VOLCANIC ACTIVITY 27.243362°, 140.874420°

Nishinoshima is a volcanic island located 584 miles (940 kilometers) south of Tokyo, Japan. Starting in November 2013, the volcano began to erupt and continued to do so until August 2015. Over the course of the eruption, the area of the island grew in size from 0.02 square miles (0.06 square kilometers) to 0.89 square miles (2.3 square kilometers). This Juxtapose shows the island mid-eruption in July 2014, and once again in the same location in January 2016, after the eruption ceased.

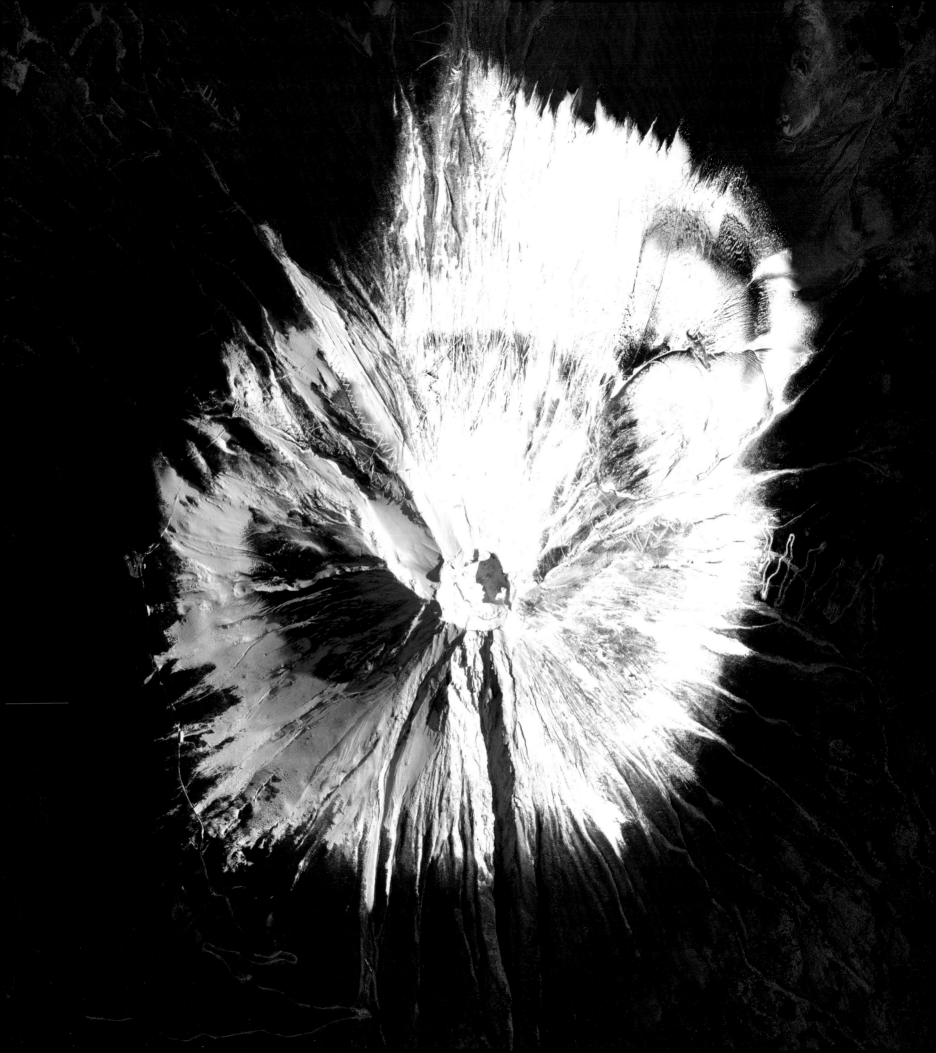

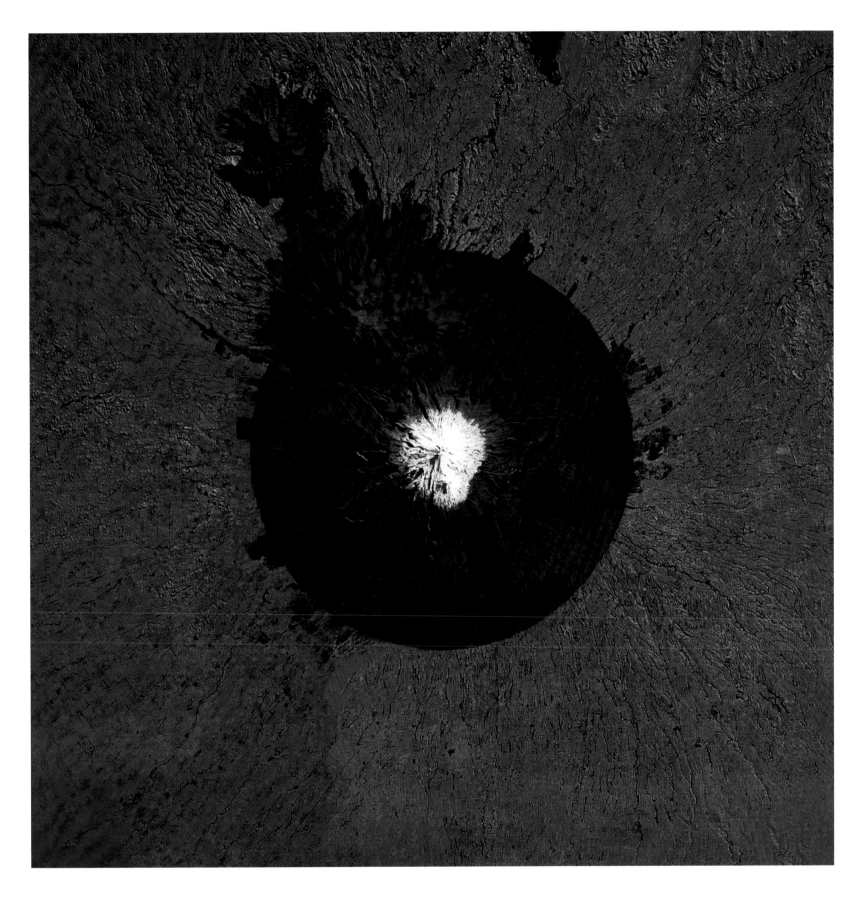

MOUNT FUJI 35.359911°, 138.714718°

Mount Fuji is an active stratovolcano and the tallest peak in Japan, rising 12,389 feet (3,776 meters). As seen in this Overview, Fuji has an extremely symmetrical cone, which is snow-capped several months of the year. During warmer months, climbing routes make it possible for hundreds of thousands of people to scale the volcano each year.

MOUNT TARANAKI −39.296766°, 174.045846°

Mount Taranaki, also known as Mount Egmont, is an active stratovolcano on the west coast of New Zealand's North Island. A change in vegetation is sharply delineated between the protected national forest that encircles the volcano and the surrounding land comprised of intensively farmed dairy pastures.

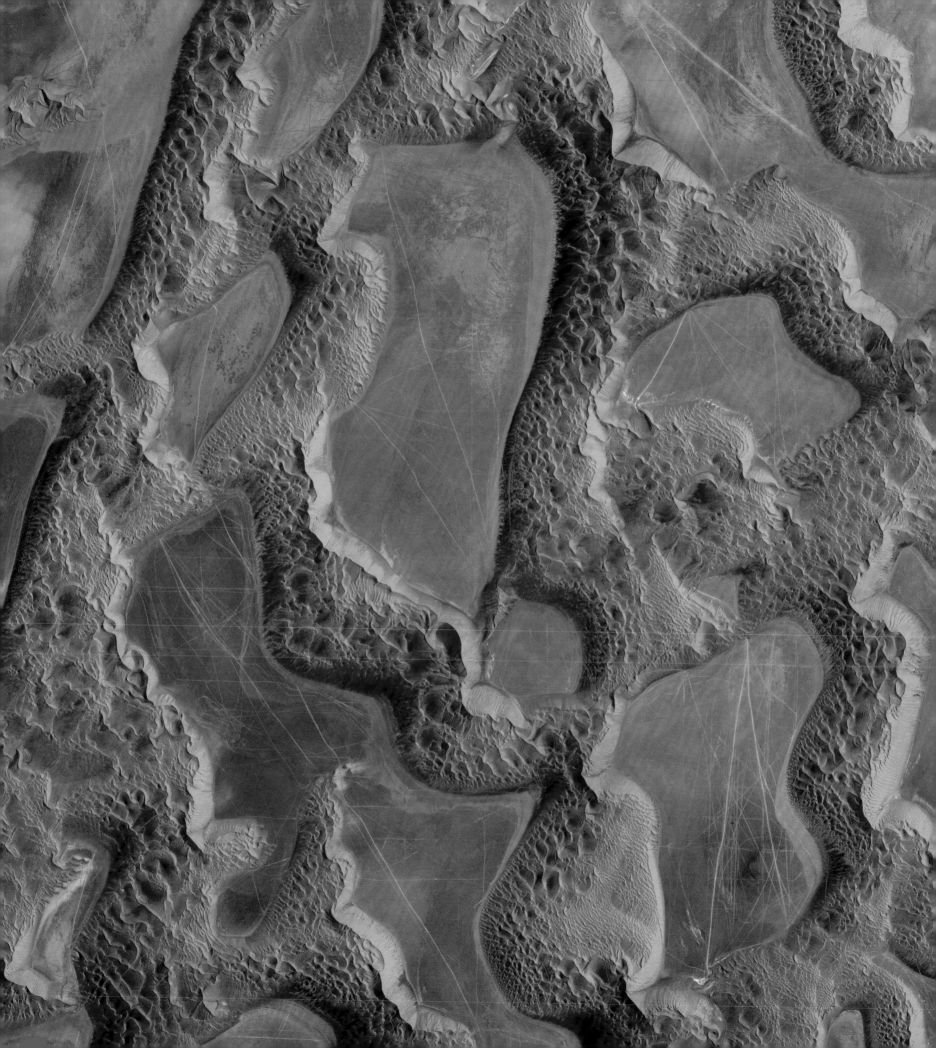

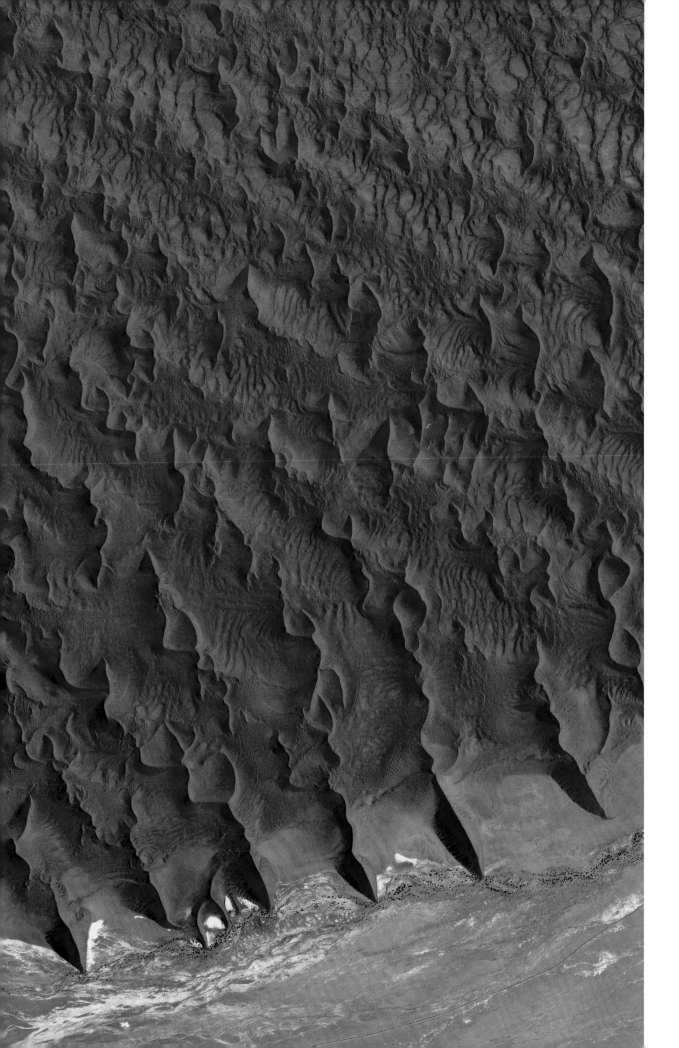

PREVIOUS PAGE

THE EMPTY QUARTER

22.182760°, 55.134184°

Rub' al Khali, or The Empty Quarter, is the
largest sand desert in the world. It covers
251,000 square miles (650,000 square
kilometers), and includes parts of Saudi
Arabia, Oman, Yemen, and the United
Arab Emirates. In the center of the desert
there are a number of raised, hardened
formations that were once the sites
of shallow lakes thousands of years
ago. For a sense of scale, this Overview
shows approximately 135 square miles
(350 square kilometers) in Saudi Arabia,
near the border with Oman.

LEFT

SOSSUSVLEI

−24.695316°, 15.419383°

Sossusvlei is a salt and clay pan located on
the edge of the Namib Desert in Namibia.
These reddish sand dunes of the desert,
seen in the top half of this Overview,
are among the tallest in the world, with many
rising more than 656 feet (200 meters) in
height. This Overview shows approximately
116 square miles (300 square kilometers).

RIGHT

ADELAIDE RIFT

−29.791018°, 137.823068°

Rock formations of the Adelaide Rift
Complex are visible in the South Australian
Outback. The swirling patterns are composed
of sediments that were deposited in a large
basin more than 540 million years ago.
Since then, the land has folded and faulted
to become a large mountain range, and then
experienced extensive erosion to become
the relatively low ranges that are visible
today. For a sense of scale, this Overview
shows approximately 100 square miles
(260 square kilometers).

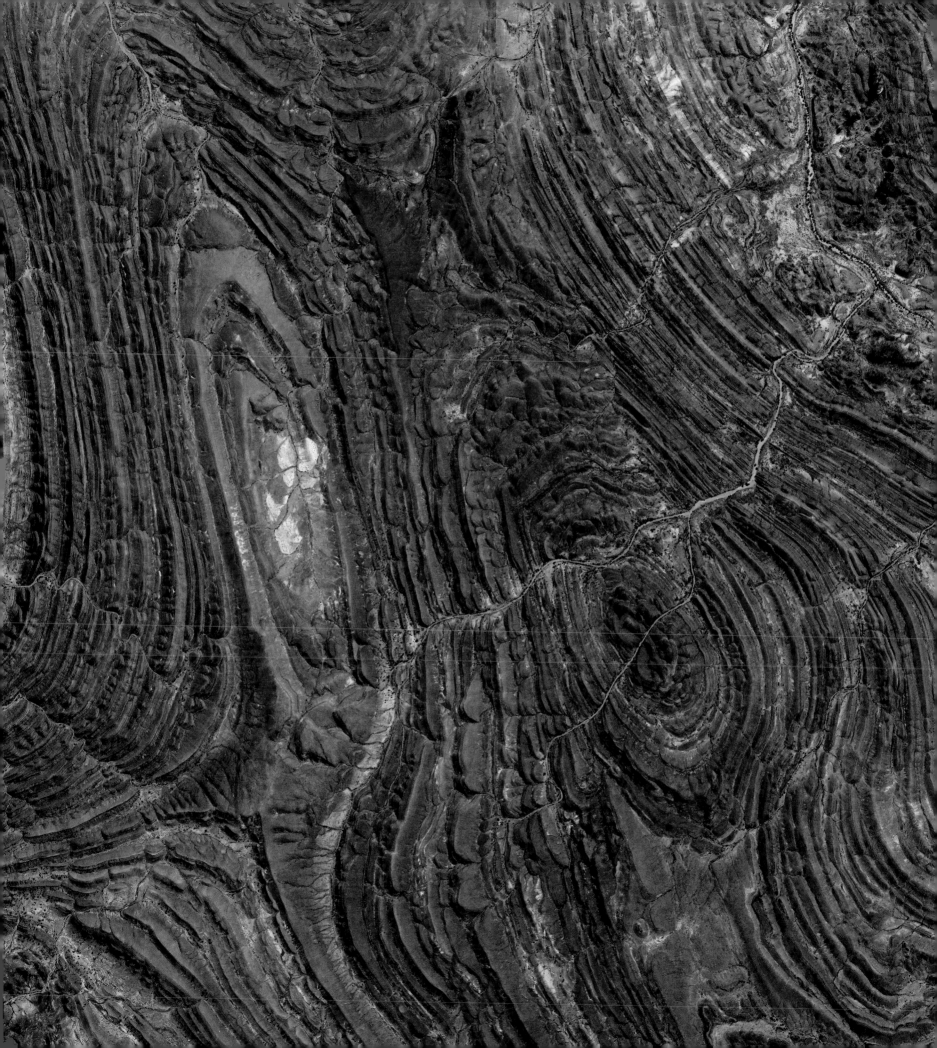

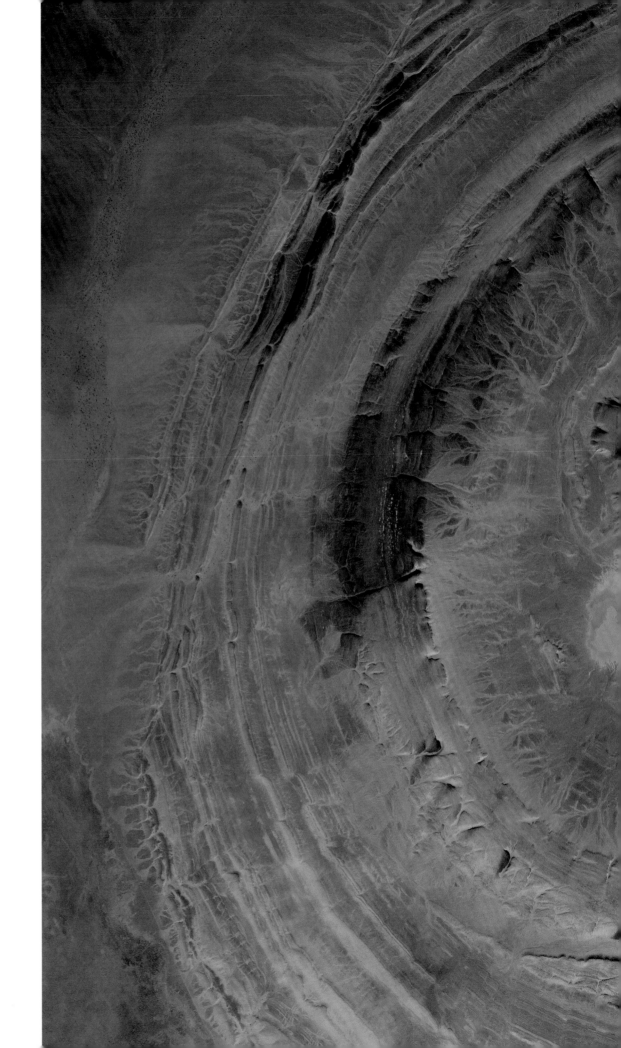

RICHAT STRUCTURE

21.123998°, -11.406376°

The Richat Structure is a prominent, circular landmass
in the Sahara Desert of Mauritania. With a diameter
of nearly 31 miles (50 kilometers), the structure is
frequently spotted and easily recognized by orbiting
astronauts. While many people initially believed that
the structure was formed by a meteorite impact,
it is now thought that it results from a phenomenon
known as symmetrical uplift—a large-scale, consistent
vertical elevation of the Earth's surface.

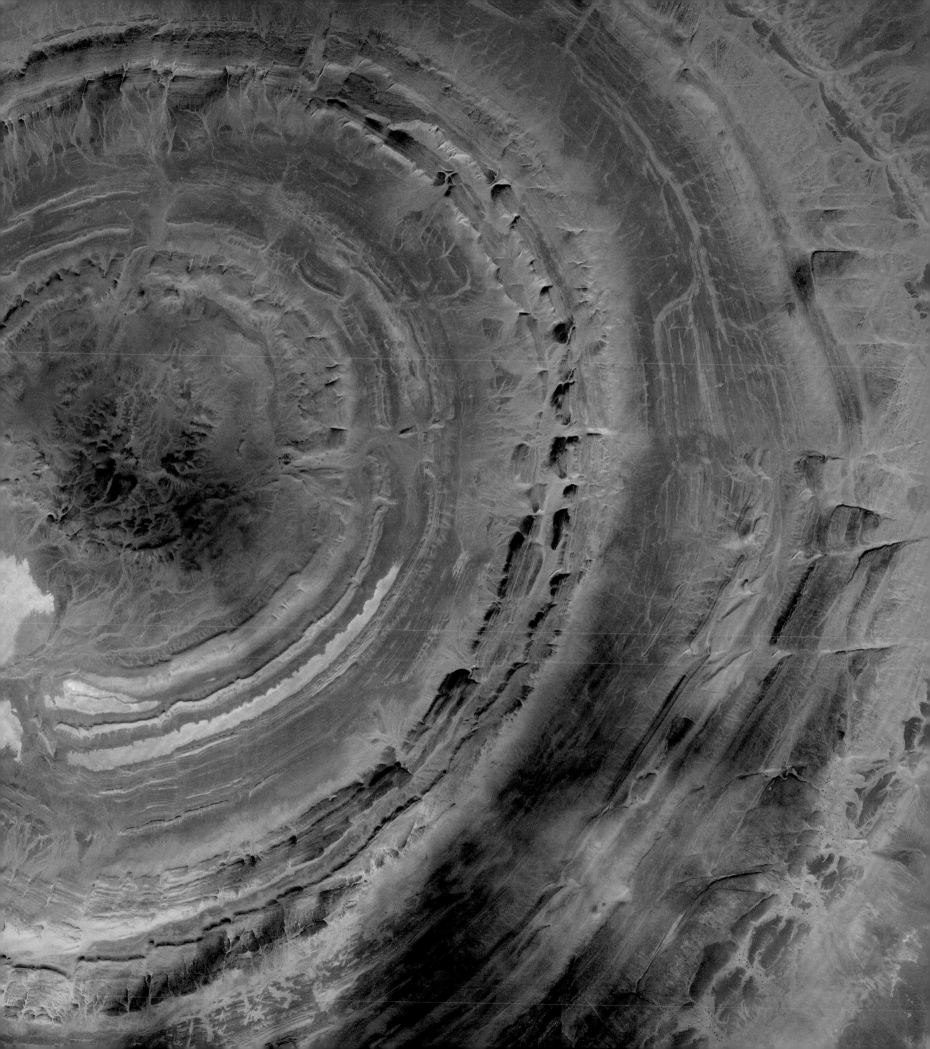

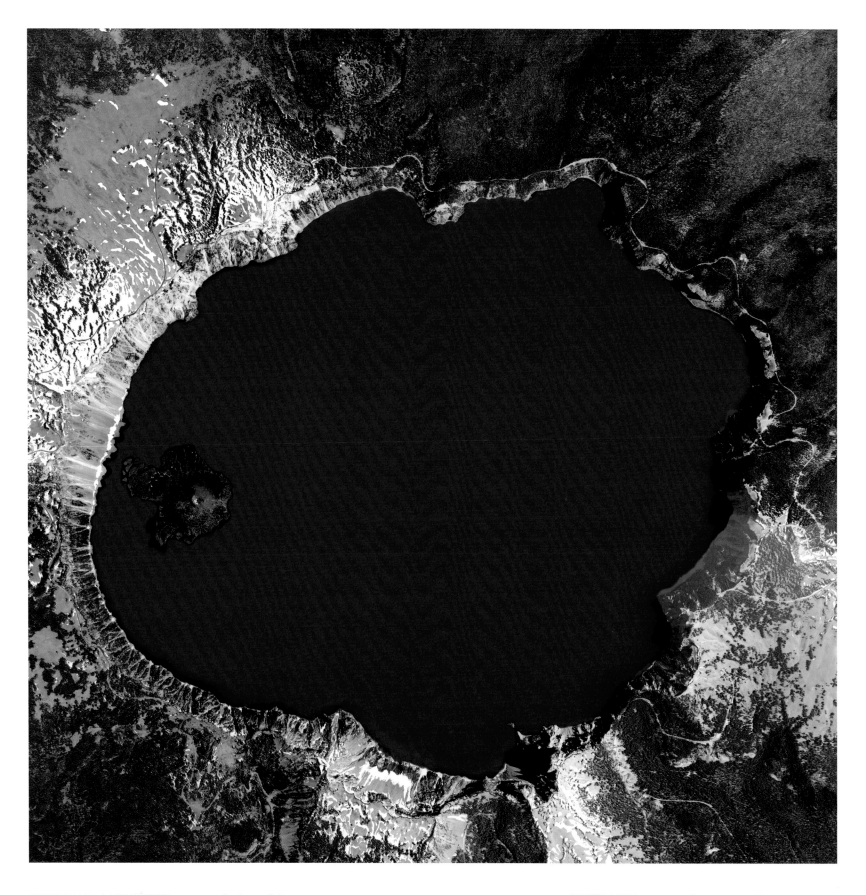

PREVIOUS PAGE **LAKE NATRON** −2.413923°, 36.037784°
Lake Natron is located in northern Tanzania. The lake is less than 9.8 feet (3 meters) deep and varies in width depending on its water level. As water evaporates rapidly during the dry season, salinity levels increase, leading to a proliferation of a particular kind of cyanobacteria that thrives in salty water and produces a photosynthesizing pigment that changes the color of the water to a deep red.

ABOVE **CRATER LAKE** 42.949999°, −122.170109°
Crater Lake is located in Fort Klamath, Oregon, USA. The awe-inspiring, intense blue water sits in a crater that was formed 7,700 years ago by the collapse of a volcano. As no rivers flow into or out of the crater, the evaporation is compensated for by rain and snowfall. At 1,943 feet (592 meters), the lake is the deepest in the United States.

LAKE MEAD 36.061653°, -114.319758°

Lake Mead—located on the Colorado River, 24 miles (39 kilometers) southeast of Las Vegas, Nevada, USA—is the largest reservoir in the United States. The lake was formed with the creation of the Hoover Dam in the 1930s (see page 99). Due to a combination of drought and increased water demand in the surrounding states (specifically California, Nevada, New Mexico, and Arizona), the lake's water level has lowered drastically in recent years. In 2015, the lake reached a record low of 1,075 feet (328 meters), only 25 feet (8 meters) above one of the major intake pipes for Las Vegas's supply of drinking water.

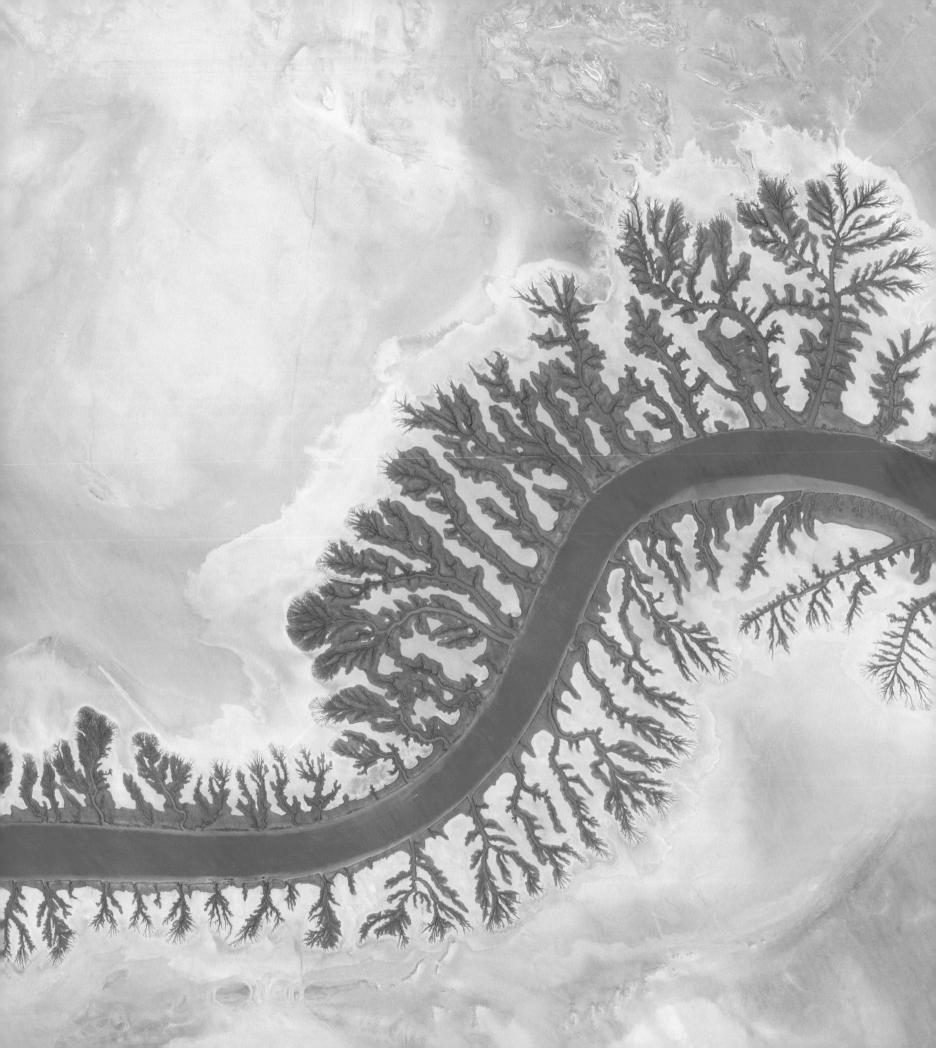

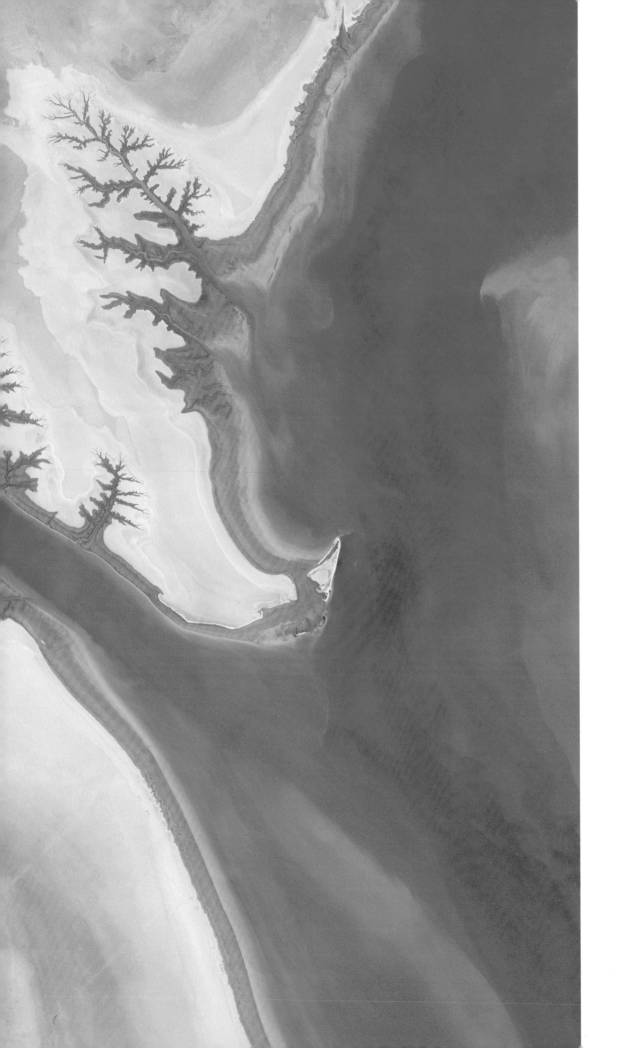

SHADEGAN LAGOON

30.327274°, 48.829255°

Dendritic drainage systems are seen around the
Shadegan Lagoon by Musa Bay in Iran. The word
dendritic refers to the pools' resemblance to the
branches of a tree, and this pattern develops when
streams move across relatively flat and uniform rocks,
or over a surface that resists erosion.

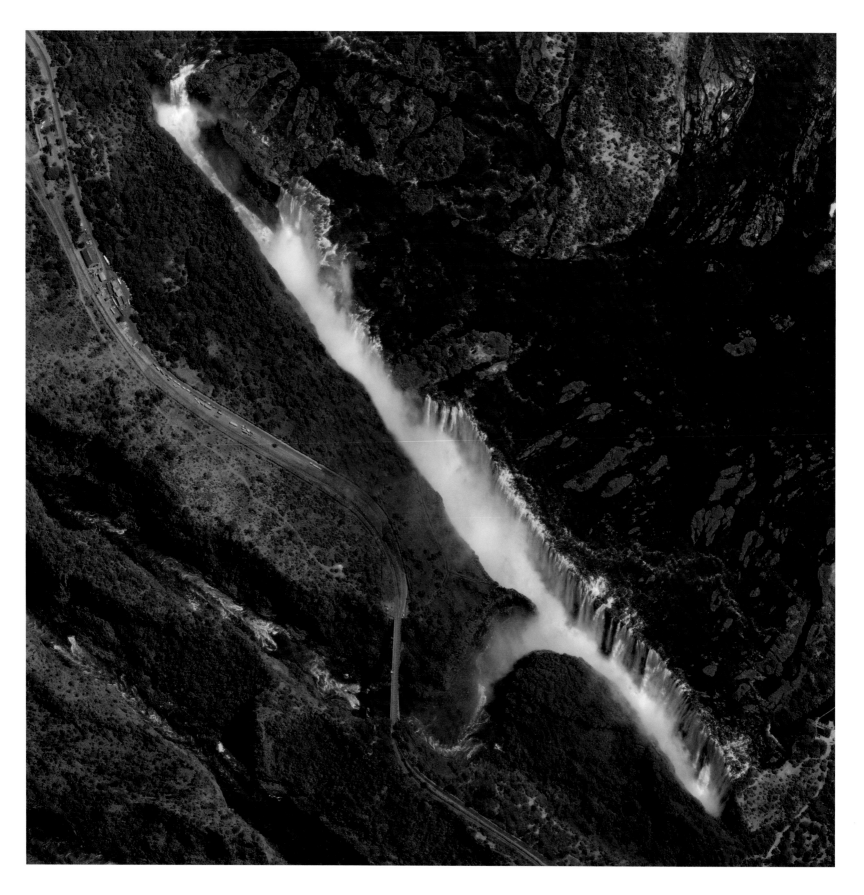

ABOVE **VICTORIA FALLS** −17.924709°, 25.856055°

Victoria Falls is a waterfall located on the Zambezi River at the border of Zambia and Zimbabwe. While it is neither the highest nor the widest waterfall in the world, it is classified as the largest, with a width of 5,604 feet (1,708 meters) and height of 354 feet (108 meters). Accordingly, the falls contain the world's largest sheet of falling water with a flow of approximately 38,422 cubic feet (1088 cubic meters) per second.

RIGHT **THE SUNDARBANS** 22.155602°, 89.680560°

The Sundarbans is a region that covers 3,900 square miles (10,000 square kilometers) of southern Bangladesh and a small section of eastern India. This region is densely covered by mangrove forests and contains the largest natural reserve for the Bengal tiger. Over the past two centuries, approximately 2,600 square miles (6,700 square kilometers) of the Sundarbans' land has been developed.

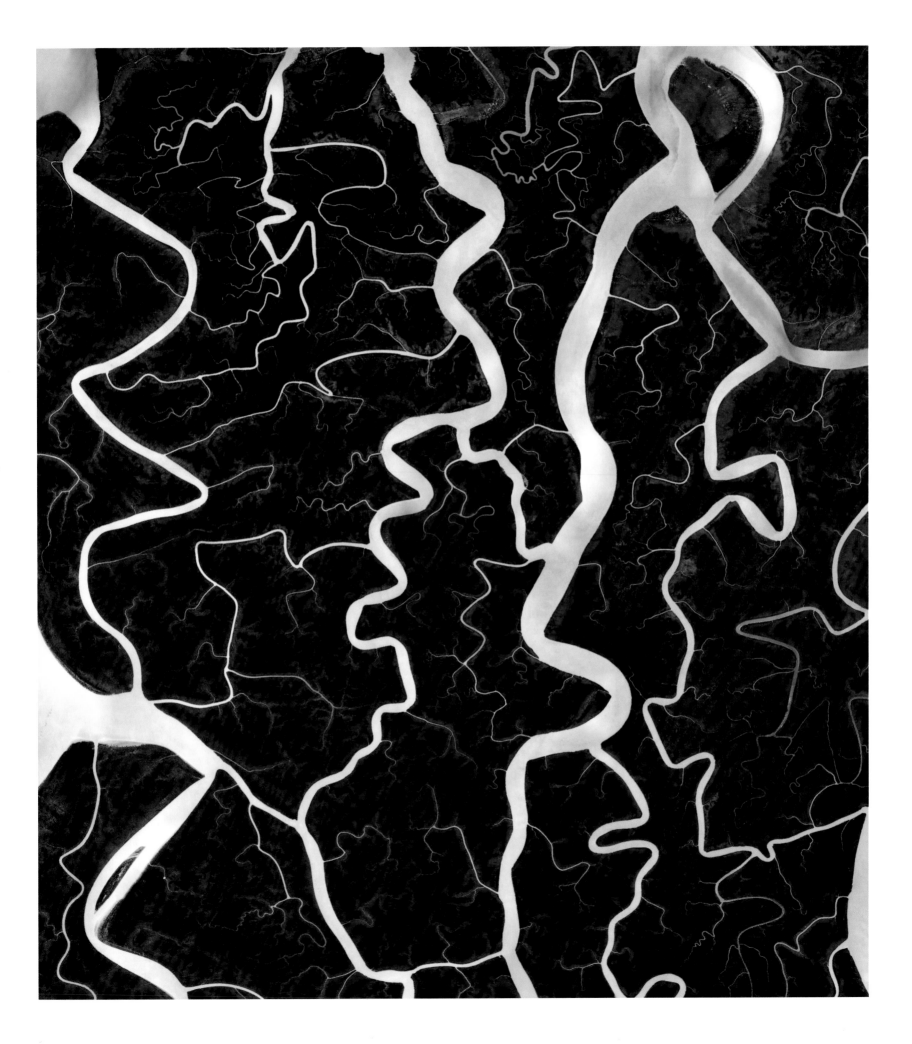

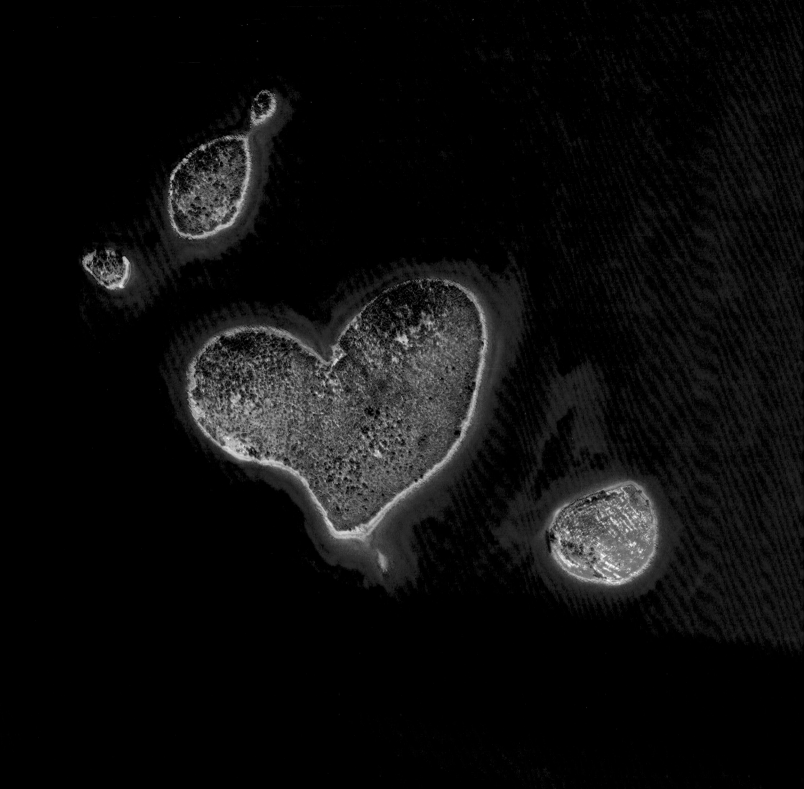

PREVIOUS PAGE
PERITO MORENO GLACIER

−50.536843°, −73.195237°

The Perito Moreno Glacier is located in Santa Cruz Province, Argentina. The 97-square-mile (250-square-kilometer) ice formation stretches for 19 miles (30 kilometers) in length. Approximately 2.3 square miles (6 square kilometers) are shown in this Overview. The entire frozen field of ice represents the world's third largest reserve of fresh water.

LEFT
GALEŠNJAK

43.978331°, 15.382505°

Galešnjak—seen here at center and commonly known as "Lover's Island"—is a naturally occurring, heart-shaped island off the coast of Croatia.

ACKNOWLEDGMENTS

To my family—thank you for your unfaltering love and support.

To Pat, Zach, and Duncan—thank you for your biting critique.

To Graham and Adam—thank you for helping me to always think bigger.

To Katie—thank you for your remarkable vision.

To Trevor, Lizzy, and the team at Penguin Random House—thank you for recognizing the full potential of these images and this work as a whole.

To Clara and the team at Ten Speed—thank you for bringing this book back home.

To Tim—thank you for your precision and your patience.

To Sean, Jay, and the team at DigitalGlobe—thank you for trusting me.

To Miki and Why Not—thank you for making the space (and coffee) to let this idea flourish.

To Tom, Vivian, and Mavis—thank you for your true partnership in the past year.

To Bethany, Imri, Jeff, and Nick—thank you for helping me get started.

And to everyone who ever followed, liked, or shared an Overview on social media—thank you for giving these images life and for helping me realize what was possible.

To see more of Daily Overview,
please visit www.dailyoverview.com

Instagram, Facebook, Tumblr, Twitter: @dailyoverview

INDEX

Entries in **bold** indicate Overview titles.

Names: Grant, Benjamin, author, photographer. | Digital Globe Incorporated.
Title: Overview / by Benjamin Grant.
Description: Berkeley : Ten Speed Press, [2016] | Collection of satellite
 images of Earth provided by DigitalGlobe annotated and reformatted by
 Benjamin Grant. | Includes bibliographical references and index.
Identifiers: LCCN 2016020107 (print) | LCCN 2016024090 (ebook) |
Subjects: LCSH: Remote-sensing images. | Earth (Planet—Pictorial works. |
 Photography in geography. | Nature—Effect of human beings on—Pictorial
 works. | Human geography—Pictorial works. | Global environmental
 change—Pictorial works.
Classification: LCC TR810 .G675 2016 (print) | LCC TR810 (ebook) | DDC
 778.3/5—dc23
LC record available at https://lccn.loc.gov/2016020107

Hardcover ISBN: 978-0-399-57865-6
eBook ISBN: 978-0-399-57866-3

Printed in China

Design by Tim Barnes, herechickychicky.com

10 9 8 7 6 5 4 3 2

First American Edition